ROMAN INSCRIBED AND SCULPTURED STONES
IN THE HUNTERIAN MUSEUM
UNIVERSITY OF GLASGOW

ROMAN INSCRIBED AND SCULPTURED STONES IN THE HUNTERIAN MUSEUM UNIVERSITY OF GLASGOW

BY

Lawrence Keppie

UNIVERSITY
of
GLASGOW

Britannia Monograph Series
No. 13

Published by The Society for the Promotion of Roman Studies
Senate House, Malet Street, London WC1E 7HU
1998

BRITANNIA MONOGRAPH SERIES No. 13

Published by The Society for the Promotion of Roman Studies
Senate House, Malet Street, London WC1E 7HU

This monograph was published with the aid of grants from
the University of Glasgow and the Trustees of the Haverfield Bequest

Copies may be obtained from the Secretary of the Roman Society

British Library Catalogue in Publication Data
A catalogue record of this book is available from the British Library

ISBN 0 907764 22 3

Front cover: Distance slab of Second Legion (No. 12)

Printed in Great Britain by Short Run Press Ltd, Exeter

CONTENTS

LIST OF PLATES

LIST OF FIGURES

ACKNOWLEDGEMENTS

For welcoming me to their institutions or responding to my enquiries, I must thank the staffs of the National Library of Scotland, Edinburgh; the Scottish Record Office, Edinburgh; the Andersonian Library, University of Strathclyde; Edinburgh University Library; the Department of Special Collections and Archives, University of Aberdeen; the Ashmolean Library, Oxford; the Bodleian Library, Oxford; the British Library, London; Library of the Rijksuniversiteit, Leiden; and the British School at Rome; and local history librarians in Kirkintilloch, Paisley, and East Kilbride. My particular thanks go to Dr Iain Gordon Brown (NLS), the late Peter Vasey (SRO), W.H. Kelliher (British Library), J. Malcolm Allan (University of Strathclyde), and Don Martin (Kirkintilloch).

Among friends and colleagues who have helped me at various times, I am glad to have here the opportunity to thank Dr Miranda Aldhouse-Green (University of Wales, Newport); Lindsay Allason-Jones (Museum of Antiquities, University of Newcastle upon Tyne); Douglas Annan (Messrs T. & R. Annan and Sons, Glasgow); Philip Bartholomew (Haddenham); Dr T.F.C. Blagg (University of Kent at Canterbury); Professor A.L. Brown (University of Glasgow); Professor Michael Crawford (University College, London); Dr Charles Crowther (Centre for the Study of Ancient Documents, Oxford); David Easton, Royal Commission on the Ancient and Historical Monuments of Scotland; Jack Harrison (Rothesay); Dr Martin Henig (Institute of Archaeology, Oxford); John Higgitt (University of Edinburgh); Dr Birgitta Hoffmann (Manchester); Oberstleutnant E.A. Hoffmann (St Augustin, Germany); Fraser Hunter (National Museums of Scotland, Edinburgh); Dr Philip McWilliams (North Lanarkshire Council); Dr Mihály Nagy (National Archaeological Museum, Budapest); Dr Jürgen Oldenstein (Johannes Gutenberg Universität, Mainz); the late Professor Anne S. Robertson (formerly Hunterian Museum); Dr W.D.I. Rolfe (formerly National Museums of Scotland, Edinburgh); Dr Helen Whitehouse (Ashmolean Museum, Oxford); and Stephen Wood (Scottish United Services Museum, Edinburgh Castle). For responding to my enquiries regarding the fate of a distance slab despatched to Chicago in 1869, I am grateful to Janice Klein (Field Museum of Natural History, Chicago), Ralph Pugh (Chicago Historical Society), Raymond Tindel (The Oriental Institute), and Richard A. Born (Smart Museum of Art, University of Chicago). His Grace, The Duke of Montrose, helpfully responded to my enquiries about the slab presented to Glasgow University by his ancestor in the later seventeenth century.

Among more immediate colleagues, I have to thank the staffs of Glasgow University Archives, especially Lesley Richmond, and of the Special Collections Department of Glasgow University Library, especially David Weston and Elizabeth Watson, for their unfailing assistance over many years. Within the Hunterian Museum, I am grateful to Professor Malcolm McLeod for his never-failing support and encouragement, to Dr John Faithfull for advice on geological matters, and to Gordon Johnston, Michael Jewkes, and Aileen Nisbet for their help during preparations for photography and in moving stones. Graeme Campbell prepared FIGS 2–3 using Freehand on a Power P.C.

Two voluntary helpers deserve a special word of praise for their contributions to the final publication. Margaret H. Maxwell searched out references to Roman stones in the Arts Faculty Minutes and Senate Minutes of the University of Glasgow for the period between

1660 and 1900. Elizabeth Bell scrutinised accounts and receipts, and other documents relating to University history, preserved in Glasgow University Archives, as well as early Minute Books of the Glasgow Archaeological Society, the Whitelaw of Gartshore Papers in Glasgow University Archives, and examined the written accounts of visits to Glasgow and its University by numerous scholars and travellers from the seventeenth century onwards. John Hood investigated the surviving papers of local landowning families and followed up various lines of enquiry.

Dr Iain Gordon Brown (NLS) gave generously of his time to advise me on matters relating to Scottish antiquarianism in the eighteenth century, and allowed me to consult his unpublished doctoral thesis (see Bibliography).

Dr John Patterson, Magdalene College, Cambridge, drew my attention to the unpublished diary of Princess Izabela Czartoryska and I am grateful to Mrs Agnieszka Whelan for allowing me to reproduce a passage from it, in her translation (below, p. 31).

For permission to quote from unpublished archival material I am grateful to the Keeper, National Library of Scotland (Robert Wodrow letters); Sir John Clerk of Penicuik, Bt. (Clerk of Penicuik Muniments); the Librarian, University of Edinburgh (letter of Thomas Tanner and Gregory papers; Letter Book of Robert Wodrow); Andersonian Library, University of Strathclyde (John Anderson lecture texts); the Board of the British Library (MS Stowe 1024 and MS Cotton Julius VI); the Earl of Dalhousie (letter with notes by Alexander Edward); the British Railways Board (Minutes of the Forth & Clyde Navigation Co.); the Board of Trinity College, Dublin (MS notebook of Edward Lhwyd); the Committee for the Ashmolean Library (annotated copies of the *Monumenta Romani Imperii*, and Stukeley's *Account of a Roman Temple*); the Bodleian Library, University of Oxford (MS notebook of Edward Lhwyd); the Archivist, Glasgow University Archives (University Records and Whitelaw of Gartshore Papers); and the Special Collections Department of Glasgow University Library (Hunterian Museum Records). The Clerk of Penicuik Muniments, the letter of Alexander Edward, and the Minute Books of the Forth & Clyde Navigation Co. are cited here with the approval of the Keeper of the Records of Scotland.

Certain descriptive passages in Chapter 3 (the Catalogue) have been carried over from, or are closely based on, entries in the *Scotland* fascicule of the *Corpus of Sculpture of the Roman World* (Keppie & Arnold 1984). I am grateful to the British Academy and to my co-author, Mrs Beverly Arnold, for agreeing to their use here.

For permission to reproduce photographs I am grateful to Mr J.H. Duff, Rector of Kelvinside Academy (FIG. 21), University of Strathclyde Archives (FIG. 13), the Hunterian Art Gallery (FIGS 5–6, 9), the Librarian, Glasgow University Library (FIGS 7, 18), the Committee for the Ashmolean Library (FIG. 8), the Trustees of the National Museums of Scotland (FIGS 25–26), T. & R. Annan & Sons (FIGS 10–11, 15, 17, 19–20), Media Services Unit, University of Glasgow (FIGS 16, 22), and Caledonian Newspapers Ltd (FIG. 1).

A generous grant from the John Robertson Bequest, University of Glasgow, enabled me to visit museums in England and Wales during the Easter vacation 1994, in search of comparative epigraphic and sculptural material. During my tenure of a Hugh Last Fellowship at the British School at Rome, in March–May 1996, and during a visit to Austria and Hungary in July 1996, I searched out parallels for sculptural motifs and epigraphic detail.

The line drawings are the work of Dennis Gallagher (Nos 18–29, 31–37, 39–43, 45–54, 59–66, 70–80), the late Margaret Scott (Nos 1–17, 55–58, 67–69), and the author (Nos 30, 38, 44). The photographs were prepared by Trevor Graham, Stephen McCann and their colleagues of the Media Services Unit at Glasgow University, except for PL. XIV (No. 40) by the Scottish Museums Council Conservation Service, PL. XV (No. 43) by Hugh Forbes, and PL. XXIII (No. 73) by W.A.C. Sharp.

Professor John Wilkes read the complete text (on behalf of the Editorial Committee of the Roman Society) and Dr Roger Tomlin was the source of helpful comments. Margaret Robb provided unfailing enthusiasm and consistent support throughout the writing of the book. Dr Iain Gordon Brown read a draft of Chapter 1 and Dr Glenys Davies a draft of Chapter 2. Alfred Bertrand (Princeton University) checked bibliographical references; John Hood read a draft

version of the whole and compiled the index. Dr Lynn Pitts saw the manuscript and illustrations through to publication with her customary efficiency.

The author and publisher are grateful to the Roman Research Trust and the Jennie S. Gordon Memorial Foundation for financial assistance towards the costs of line illustration and photography. Generous grants towards the cost of publication were received from the University of Glasgow and the Trustees of the Haverfield Bequest.

It is appropriate also to record a debt to those antiquaries, scholars, and historians, many of them members of staff at the University of Glasgow, by whose efforts the collection grew through the centuries, and who saw to its safekeeping, through good times and bad, to the present day, especially William Dunlop (Principal Regent, 1690–1700), the Rev. Robert Wodrow (Librarian, 1697–1703), Robert Simson (Professor of Mathematics, 1712–61), John Anderson (Professor of Natural Philosophy, 1757–96), Dr John Buchanan (Banker and prominent member of the Glasgow Archaeological Society, in the early 1870s), Professor John Young (Keeper of the Hunterian Museum, 1866–1902), and Professor Anne S. Robertson (Under-Keeper and later Keeper of Cultural Collections, Hunterian Museum, and of the Hunter Coin Cabinet, 1939–1975), who sadly died as this book was about to go to press.

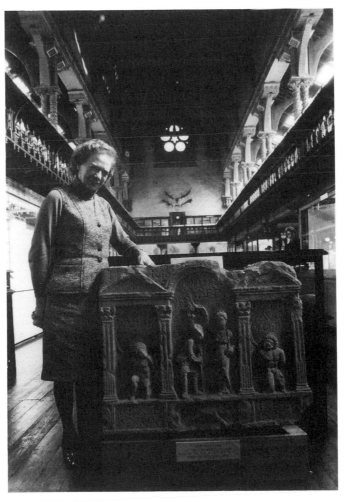

FIG. 1. Professor Anne Robertson, photographed beside No. 9 (1974). Reproduced by permission of Caledonian Newspapers Ltd.

INTRODUCTION

'The two principal collections in *Scotland* are those of the University of *Glasgow*, and of Baron *Clerk*; for I do not know of three inscriptions together in any other place in *Scotland*.' (Horsley 1732, 181)

'Of the Sculptured Stones upon this Wall the greatest and most valuable Collection is that belonging to Glasgow College.' (Anderson 1771, f. 30)

The present work is not the first published catalogue of Roman inscribed and sculptured stones now in the Hunterian Museum, University of Glasgow. A series of copperplate engravings was prepared in 1768 (the *Monumenta Romani Imperii*; below, p. 22), the only written accompaniment being brief captions identifying the donor and the date of donation where known (University of Glasgow 1768); an extended series was issued in 1792, for wider distribution (University of Glasgow 1792).

In 1897 a more recognisable catalogue in the modern sense, the *Tituli Hunteriani*, was prepared by Dr James Macdonald, one-time Rector of Kelvinside Academy, Glasgow, and father of Sir George Macdonald, the distinguished numismatist and archaeologist. It consisted of a written text supported by superb photographic plates prepared by the eminent Glasgow photographer, Thomas Annan (Macdonald 1897). The present publication marks its centenary.

In more recent times those inscribed stones known up to the end of 1954 were included in the first volume of *The Roman Inscriptions of Britain* (Collingwood & Wright 1965; cf. Tomlin 1995); sculptured pieces found a place in the *Scotland* fascicule of the *Corpus of Sculpture of the Roman World* (Keppie & Arnold 1984). However, no account of the collection as a whole has appeared since 1897.

The Glasgow collection had its origins in the later seventeenth century (below, p. 5). Though the stones are now housed in the Hunterian Museum, it is important to remember that the foundations of the University's collection predated the establishment of its Museum by more than a century. Today the stones form one element of the wide-ranging Roman collection now housed in the Hunterian Museum, which largely derives from excavations and chance finds at forts along the line of the Antonine Wall and in south-western Scotland. But before the beginning of organised archaeological excavations at the end of the nineteenth century, the Roman collection consisted almost solely of inscribed and sculptured stones. The catalogues of 1768, 1792, and 1897 thus listed the entire Roman collection, not just one aspect of it.

A substantial chapter here is devoted to the acquisition and development of the collection from the later seventeenth century onwards. I was fortunate in having had access to a wide range of archival sources, many unpublished. Letters to and from Robert Wodrow, Librarian at Glasgow University, 1697–1703, provide a snapshot at an important moment. Numerous letters of Alexander Gordon, author of *Itinerarium Septentrionale* (1726), and of John Horsley, author of *Britannia Romana* (1732), preserved by their recipient, Sir John Clerk of Penicuik, provide contemporary testimony about discoveries in the early decades of the eighteenth century. Minutes of the Forth & Clyde Canal Committee help to pinpoint donations of material found

during its construction, in 1769–73, as do the manuscript lectures of Professor John Anderson (1770–73). Minutes of the Faculty of Arts and successor bodies at Glasgow University, covering the period from the early eighteenth century onwards, and other documents preserved in Glasgow University Archives, reveal not only donations, but details of storage, payment of bills and arrangements for publication in 1768, 1792, and 1897: the precise dates of publication of the two editions of the eighteenth-century catalogue, the *Monumenta Romani Imperii*, were not hitherto precisely known to scholars. Surviving Donations Books of the Hunterian Museum, which cover the period 1807–55, include archaeological material but are not a complete record. It is hardly to be doubted that examination of such archival material, where it is likely to survive, would illuminate the history of other epigraphic collections, in Britain and beyond. I can only encourage scholars to search it out. Particular attention should be paid to annotated copies of the major antiquarian works, especially when these have passed through the hands of later scholars.

Not only does such testimony form a valuable commentary on antiquarian enthusiasms at Glasgow, but shows that the dates and circumstances of discovery of individual stones, and the dates of their donation to Glasgow University, are often incorrectly transmitted in modern publications. These records also allowed the present writer to effect some progress in linking records of donation with stones which seemed to have no provenance (below, Nos 38, 44; p. 69). The spelling and punctuation of antiquarian accounts have been retained here, wherever possible.

In the eighteenth century, professors at Glasgow took great pride in possession of the stones, typical of an antiquarianism which concentrated on the Roman period (below, p. 13). Such pride is less evident in the surviving records for much of the nineteenth century (below, p. 33), but the publication of the *Tituli Hunteriani* in 1897 sparked renewed interest. The collection was further added to by the discovery of stones during excavations at Bar Hill (1902–05), Balmuildy (1912–14), Cadder (1929–31), Castledykes (1937–55), Bothwellhaugh (1975), and Bearsden (1973–81) together with chance discoveries at Hutcheson Hill (1969) and Old Kilpatrick (1969).

The writing of this catalogue constituted a long-held wish on the author's part to draw attention to the collection of Roman stones held at the Hunterian Museum and the history of their acquisition by the University of Glasgow. My own direct involvement with the collection began in June 1969 when, as a temporary Research Assistant employed at the Museum, I was present, weighing coins for a volume of *Roman Imperial Coins in the Hunter Coin Cabinet*, when a telephone call to Professor Anne Robertson brought news of the discovery of a distance slab (below, No. 9), at Hutcheson Hill north of Glasgow. After its subsequent arrival at the Museum (a small ex-gratia sum was paid to the farmer on whose land it was discovered), I was assigned the task of removing the whitewash which had come to adhere to it, when farm buildings were repainted, in the several weeks it had lain in the farmyard.

The stones have been illustrated many times, originally as pen sketches, then as copperplate engravings. The *Tituli Hunteriani* (Macdonald 1897) were ornamented by the photogravures of Thomas Annan. The present catalogue must itself constitute a statement of the condition of the collection at a fixed date. I was fortunate therefore to be able to call upon Trevor Graham and his colleagues of the Media Services Unit, University of Glasgow, who photographed the collection afresh in 1997.

Lawrence Keppie,
Hunterian Museum, University of Glasgow, October 1997

CHAPTER ONE

THE HISTORY OF THE COLLECTION

1. THE EARLIEST RECORDS

The memory of a Roman occupation of Scotland was never entirely lost during the Middle Ages. The rediscovery of classical manuscripts in the Renaissance provided a valuable historical framework, especially for events in the later first century A.D. when Julius Agricola campaigned in North Britain (Maxwell 1989, 1ff.).

The earliest notices of inscribed stones from Scotland occur in the mid-sixteenth century. On 12 April 1565 Queen Mary, learning of the discovery of an altar to the god *Apollo Grannus* at Inveresk, Midlothian (*RIB* 2132), wrote an urgent note to be conveyed to the magistrates of

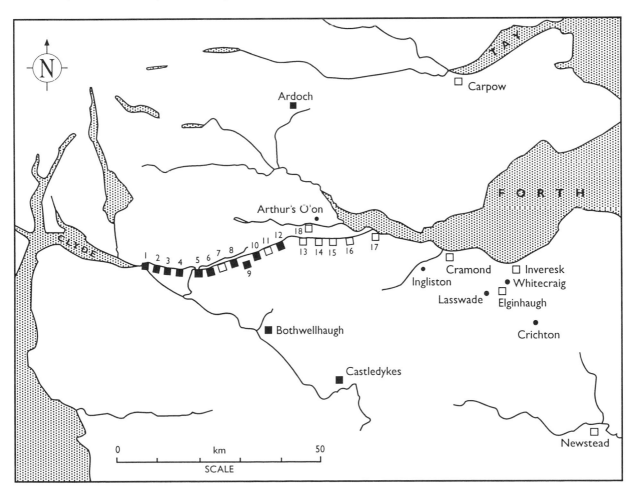

FIG. 2. Map showing location of Antonine Wall and other sites mentioned in the text. Sites yielding material discussed in this volume are shown as solid squares. (1, Old Kilpatrick; 2, Duntocher; 3, Castlehill; 4, Bearsden; 5, Balmuildy; 6, Cadder; 7, Kirkintilloch; 8, Auchendavy; 9, Bar Hill; 10, Croy Hill; 11, Westerwood; 12, Castlecary; 13, Rough Castle; 14, Falkirk; 15, Mumrills; 16, Inveravon; 17, Carriden; 18, Camelon.)

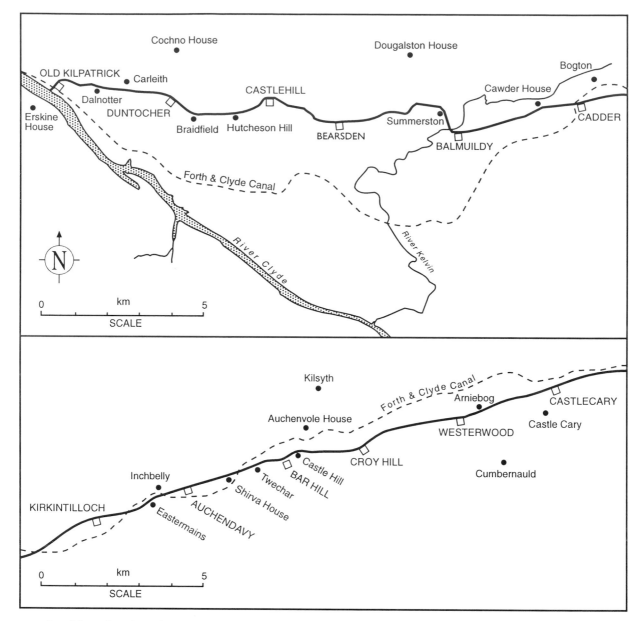

FIG. 3. Map showing the course of the Antonine Wall between Old Kilpatrick and Castlecary, with place-names mentioned in the text, and the course of the Forth & Clyde Canal.

nearby Musselburgh, 'charging thame to tak diligent heid and attendance, that the monument of grit antiquitie new fundin be nocht demolishit nor brokin down' (Cummyng 1831, 294; Deman 1967, 147ff.; Tomlin 1995, 796). This commendable intention seemingly came to nothing: John Napier of Merchiston reports that the idolatrous relic had been 'utterlie demolished' (Napier 1593, 210, ch. 17, v. 3). Paradoxically Napier, the famous inventor of logarithms, presented a stone of the Second Legion to his father-in-law, Sir James Stirling of Keir and Cawder, at Cawder north of Glasgow, in or soon after 1572 (*RIB* 2209); it is still preserved at Cawder House.

George Buchanan, poet, playwright and tutor to the young King James VI of Scotland, in his *Rerum Scoticarum Historia* published in 1582, alludes, for the first time, to inscribed stones as a historical resource in relation to the Antonine Wall. 'Many celebrated Roman writers mention this wall; many vestiges are extant; many inscribed stones are dug out, on which are engraved either the record of some deliverance experienced by tribunes and by centurions, or some monumental epitaphs' (translated from Buchanan 1582, fol. 6, ll. 20-4). A century later Sir Robert Sibbald could not identify stones in each of the categories referred to by Buchanan:

'most of the first kind seem to have been removed by private Men, or worn out by time, for few of them are seen' (Sibbald 1707, 47). Stones of which Buchanan could have been aware include the Musselburgh altar (*RIB* 2132), a tombstone (now lost, then built into Kilsyth Castle; *RIB* 2172), a building record (*RIB* 2209), and a 'distance slab' from the Antonine Wall (*RIB* 2186), both then built into a towerhouse at Cawder, and the latter eventually to be in the Glasgow collection (No. 4 below).[1]

The publication in 1585 of William Camden's *Britannia* (in Latin, the international language of scholarship) was a landmark in British historical studies; the volume was to dominate the field for more than two centuries (Piggott 1951; Levy 1964). Camden himself oversaw a number of subsequent editions during his own lifetime, and later enlargements brought more material to public knowledge (Camden 1585; Gibson 1695, 1722; Gough 1789, 1806). The section initially devoted by Camden to Scotland was brief. He never visited what was until 1603 a separate country, though he did travel north to Hadrian's Wall. The earliest editions reported no epigraphic material from Scotland, but the 1607 edition recorded five stones, the 1695 edition seven, and the 1789 edition upwards of 30. Camden himself, and later editors, acknowledged help from other scholars (cf. below, p. 8). Camden sent details of the *Apollo Grannus* altar at Inveresk to Janus Gruter at Heidelberg for inclusion in the latter's all-embracing corpus of Roman inscriptions (Gruter 1602, p. xxxvii, no. 12). Shortly after 1600 we learn of the activities of two German scholars, Crispin Gericke (from Elbing in West Prussia)[2] and Servaz Reichel (from Silesia), who noted stones in central and north-east Scotland (Haverfield 1911, 343); but we know nothing of the context of their visit. Gericke, who is known to have been in London in 1604, transmitted details of three inscriptions (*RIB* 2172, 2186 = No. 4, 2209) to the great scholar Joseph Scaliger at Leiden (Scaliger 1606, *Animadversiones*, p. 175) and to Gruter (Leiden MS *Papenbroekianus* 6, f. 110). Reichel, travelling with other German noblemen on a tour of 'France, Scotland and Britain', visited the schoolmaster Reginald Bainbrigg at Appleby in Cumbria, and told him of a distance slab (below, No. 1) then at Dunnottar Castle, Kincardineshire, where it had been set up in a prominent place by George, Fifth Earl Marischal (Haverfield 1911, 371f.). Reichel also sent directly to Camden (1607, 699) information on the slab at Dunnottar and the distance slab at Cawder Castle (Nos 1, 4). The place of Scotland in the Europe-wide study of Roman antiquities was becoming established.

During the early years of the seventeenth century the Scottish geographer Timothy Pont (Cash 1901, 399; 1907, 574; Kinniburgh 1968, 187; Moir & Skelton 1968) assembled information on the Antonine Wall, and on likely fort-sites along it, which was eventually incorporated, after subsequent editing by Robert Gordon of Straloch, in the fifth volume of Johannes Blaeu's *Thesaurus Orbis Terrarum* (Amsterdam, 1654). Robert Gordon's own 'Notes relating to the Walls and Ramparts' (Macfarlane 1907, 336-9), which were likewise incorporated by Blaeu, report inscribed stones then at Cawder House (*RIB* 2209) and at Dunnottar (No. 1). According to Sir Robert Sibbald, who had access to Pont's (now lost) papers, 'He [Pont] observeth that several Stones bore the Record and Memoirs of two legions, beside their Auxilia which were employed there and lay in Guard upon this Wall, the one *legio Secunda Augusta*, the other *legio Vicesima valens Victrix*' (Sibbald 1707, 27).[3]

2. THE BEGINNINGS OF THE GLASGOW COLLECTION

The University of Glasgow (also referred to frequently, up to the later nineteenth century, as Glasgow College) was founded in 1451 by a Papal Bull issued by Nicholas V. Teaching was in the hands of a small number of Regents, or Masters, under the direction of a Principal Regent.

[1]The towerhouse at Cawder (Cawder Castle) was replaced in 1625 as the family residence of the Stirlings of Keir and Cawder by Cawder House, now a Golf Clubhouse. The spellings Cawder, Calder, and Cadder are all employed in contemporary sources for the same location.

[2]An academic lawyer, who was co-author (or possibly examiner) of a dissertation submitted at Frankfurt in 1594. I am grateful for this information to Oberstleutnant E.A. Hoffmann.

[3]Rather later in the century, the physician and philologist Christopher Irvine traversed the Wall several times, located the sites of many forts, and recorded at least one stone, now lost, at Cumbernauld (Irvine 1682, 122; *RIB* 2152); Sir Robert Sibbald (below) made use of his papers.

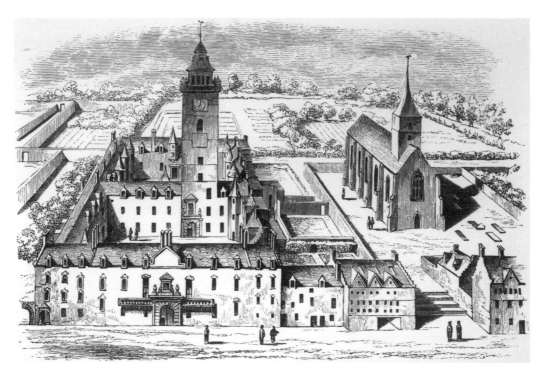

FIG. 4. Bird's eye view of Glasgow College, 1693, by Captain John Slezer.

At first classes took place in the adjacent Cathedral or in rented accommodation nearby. During the seventeenth century an extensive construction programme produced handsome sandstone buildings fronting on to the High Street (FIG. 4), which were to endure until 1870 when the site was sold to a railway company, and the University moved to its present location west of the city centre (below, p. 35).

As the sole seat of higher learning in the West of Scotland and guardian of knowledge, the University of Glasgow was a natural repository for works of art and natural curiosities. The earliest of what was to become a substantial collection of Roman antiquities was presented before 1684 by the Third Marquess of Montrose (below, No. 16).

However, the true foundations of the Glasgow collection were laid during the final decade of the seventeenth century, at the close of a period of intense political and religious turmoil, when there was an explosion of antiquarian activity, new discoveries, and academic interest. The Principal Regent of the College, from 1690 until his early death in 1700, was William Dunlop (FIG. 5), known to have been interested in Roman antiquities; his *Description of Renfrew Shire* includes a detailed account of a supposed Roman fort at Paisley, where his father had been Minister and he himself had grown up (Wodrow 1836, 521–2; Hamilton 1831, 142–5; Sharp 1937, 60, no. xxv). Unfortunately there is no record of acquisitions in the very sketchy administrative records of the College at this time.

One of the earliest of the group of stones presented to the College during Dunlop's tenure, indeed probably the first, was discovered in or before 1694, on the lands of John Graham of Douglaston, north of Glasgow (No. 5). Robert Wodrow (on whom, see below), describing the removal of the foundation cobbling of the Antonine Wall for material to build field dykes, on a much later visit to the estate's then owner in 1729, observed that: 'At the place where they were digging, the heuen stone with inscription, gifted by Dougalstoun, 1694, to the Colledge, was turned up' (Wodrow 1843, 66). Soon after, two stones were donated by William Hamilton of Orbiston, who lived at Erskine House on the south bank of the Clyde, opposite the western terminus of the Antonine Wall at Old Kilpatrick, where he had extensive estates (Nos 14, 15; Hamilton 1933, 647).

The Dougalston stone was presumably found above or adjacent to the foundation cobbling of the Antonine Wall itself, whose stones were in demand as building material; one of the Orbiston stones presented in 1695 is stated to have been found 'by ploughing' (BM MS Stowe

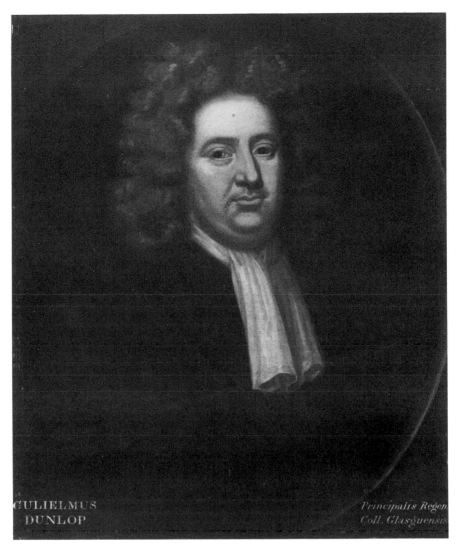

FIG. 5. William Dunlop, Principal of Glasgow College, 1690–1700. Oil on canvas, *c*. 1698. Hunterian Art Gallery.

1024, f. 87). In other cases we have no specific information. Doubtless the stones were carried on their discovery first to the country houses (which at this time might still mean the substantial stone towerhouses) of landowners for preservation and display (Sibbald 1707, 29).

We may easily suppose that Dunlop or his fellow Regents were able to exert influence on local landowners, not least because some had been their pupils at the College: James, Third Marquess of Montrose, who presented the first stone, matriculated in 1672 at the age of fifteen; James Hamilton, younger brother of Hamilton of Orbiston, matriculated in 1674; the latter's son, James Hamilton, 'Junior de Orbiston, Scotus', entered the 'third class' in February 1692. Robert Hamilton of Barns, son of the donor of a stone presented in 1699 (No. 10; below, p. 82), matriculated in 1698; another son, later to present a further stone (No. 13), matriculated in 1714 (University of Glasgow 1854, iii, 128, 150, 165, 205, 208).

The stones were placed in the College Library, and came under the direct care of the Librarian. John Simson, later Professor of Theology in the College and subsequently involved in heated theological disputes, was Librarian in the early to mid-1690s (Hoare 1991, 31). No records survive of his involvement in the acquisition of stones at this time, but he reappears later as a correspondent of Sir John Clerk of Penicuik (see below, p. 18). In 1697 Robert Wodrow (FIG. 6), son of the then Professor of Divinity, and newly graduated in Arts, was appointed Librarian at the age of seventeen, and held the post until 1703 (Durkan 1977). Later he became Minister of Eastwood, on the southern outskirts of Glasgow, and is best remembered today as an eminent

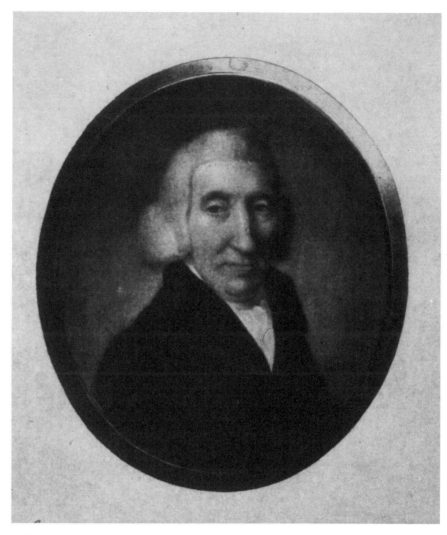

FIG. 6. Robert Wodrow, Librarian of Glasgow College, 1697–1703. Photographic reproduction (late nineteenth century), from an eighteenth-century miniature, artist unknown. Hunterian Art Gallery.

historian of the Church of Scotland (Wodrow 1828, pp. i–viii; Burton 1863, 332–46). The young Wodrow corresponded with Sir Robert Sibbald in Edinburgh, Edward Lhwyd, Keeper of the Ashmolean Museum, Oxford, William Nicolson, then Archdeacon and later Bishop of Carlisle (Nichols 1809; Ware 1901), and others, about new discoveries and their interpretation, as well as on a wide range of theological, geological, and historical matters. Thanks to the survival of many letters to and from Wodrow, we can follow, for a brief period, the story of the new discoveries in a detail that is hard to match later.[4]

Sir Robert Sibbald, the leading scholar of this time in Scotland (Emerson 1988; Mendyk 1989, 213ff.), and author of a number of treatises on Roman antiquities and the history of Roman incursions into Scotland, mentions several stones, some of them at 'Glasgow Library' (Sibbald 1707, 47, 49–50).[5] In 1695 Sibbald contributed a short treatise, with the title *The Thule of the Ancients,* to Edmund Gibson's enlargement of Camden's *Britannia* (Sibbald 1695, 1089ff.); Sibbald's treatise included a sketch of Ardoch fort and one of an inscription (below, No. 47), both drawn by the architect and draughtsman John Adair (Sibbald 1695, 1101). In his *Prodromus* (1684), Sibbald signals various drawings by Adair which would ornament his projected

[4]The originals of Wodrow's own letters have mostly not survived, but his own copies of them are preserved in Edinburgh University Library (Letter Book of Robert Wodrow, MS La.III.255; published in Sharp 1937); those of many of his correspondents, preserved by Wodrow, were formerly in the Advocates Library, Edinburgh, but are now held by the National Library of Scotland.

[5]Sibbald's papers, now in the National Library of Scotland, include transcriptions of relevant passages from the published works of Camden and Gordon of Straloch. I am grateful to Dr I.G. Brown for alerting me to this material.

Description of Scotland; they included a plan of Ardoch fort, of the Antonine Wall, a drawing of a Roman altar, 'of certain monuments with their inscriptions and sculptured ornaments', and 'various inscriptions taken from stones' (Sibbald 1684, *catalogus;* cf. Dalrymple 1705, 19). Adair himself had plans to publish a work on the Antonine Wall (Nicolson 1702, 22), though it was never realised and was subsequently subsumed into Sibbald's enterprises (Brown & Vasey 1989, 353–60).

Two recently published sets of drawings of stones, one prepared by Adair himself, the other deriving from his work, constitute a valuable digest of the inscriptions available for scholars by about 1699. The first, now in the Scottish Record Office (from the papers of Sir John Clerk of Penicuik), contains nine neatly finished drawings (SRO GD 18/5077;Vasey 1993, fig. 1; Nos 1, 4, 5, 6, 12, 13, 15, 22; *RIB* 2209). The second, consisting of two sheets, now in Edinburgh University Library, shows drawings copied from Adair by John Urry (see below); they soon came into the possession of David Gregory, Professor of Mathematics at Edinburgh, 1683–91, and then of Astronomy at Oxford, 1691–1708 (Nos 4, 5, 6, 13, 14, 15, 22; *RIB* 2209, 2154); Gregory's own annotation states that 'all these were communicated to me in Aprile 1698 by Mr John Ury of Christs Church Colledge in Oxon. He saw them all in Scotland, when he was there in 1696, 1697 and 1698, and these Draughts were given him by Mr John Adair in Scotland' (EUL Dk.1.2, A74; Vasey 1993, fig. 2). Further, on a drawing of a distance slab from Carleith (No. 13), from papers of the antiquary John Anstis now in the British Library, there is the following marginal note (probably in Anstis' hand rather than Urry's): 'Out of Mr Urry's papers, who had them from Mr Adair's Collections, therefore I desire you to mention him rather than me. [signed] J. Urry' (BM MS Stowe 1024, f. 89).

John Urry, born in Dublin but of Scottish descent, was a Student (i.e. Fellow) of Christ Church, Oxford and an editor of Chaucer's works. Evidently he had met, and was perhaps even travelling with, Adair. He also sent information about the stones he had seen to Dr Thomas Tanner, then Fellow of All Souls, Oxford, later Bishop of St Asaph's, who on 13 April 1699 passed on the details to Edmund Gibson, the editor of Camden, addressed to him as Chaplain to the Archbishop of Canterbury at Lambeth. Drawings of four stones (Nos 6, 13, 22, *RIB* 2154), and of another (No. 5) subsequently scored out, are included on slips of paper attached to the letter, but there were probably other slips, which have not survived, on which he drew another three stones (Nos 5, 14, 15). The descriptions of provenance are so similar as to indicate a common origin in details sent by Urry to his two Oxford colleagues. Tanner comments: 'The enclosed Roman inscriptions were taken last summer [i.e. 1698] in Scotland by Mr U̲r̲r̲y̲, Student of Ch[rist] Ch[urch], by whose leave I send this Copy of them to you. He is a very curious Gentleman, and therefore I believe you may safely depend upon their being exactly taken. The fifth [no such drawing survives with the letter] and sixth [here, No. 5] have a great deal of carv'd work about them, w[hi]ch I would not pretend to delineate, neither was it drawn very well in Mr U̲r̲r̲y̲'s papers ... I thought these might be of use to you, if ever you should put out a Latin Camden' (EUL MS La.II.644/7). Urry's visit to Scotland has thus been dated by scholars to 1698, but the recently published Gregory testimony must indicate he made a number of visits. Indeed Urry's name recurs in Edward Lhwyd's correspondence in 1704 (Gunther 1941, 502, no. 260); he was again in Scotland in June 1709, when he personally delivered a letter from Lhwyd to Sibbald in Edinburgh (Maidment 1837, 149, no. 14). Many of Wodrow's correspondents, and other visitors to the Wall at this time, had an Oxford connection, as Fellows or former students of Colleges there (see below).

There were other visitors ranging along the Wall. The 'Anonymous Traveller' (whom it is tempting, though probably wrong, to identify with Urry) rode on horseback westwards from Edinburgh, along the line of the Wall, in July 1697 (HMC 1893, 54–7), and recorded an inscription at Castlecary Castle (*RIB* 2154). Unfortunately the account covers only the eastern half of his journey; the rest, from Kilsyth to Glasgow, appears lost.[6] Gottfried Christian Götz

[6]William Stukeley reports (MS note in own copy of Stukeley 1720, copy in Ashmolean Library, at p. 5), 'I have met with another Inscription in a letter from an Anonymous Gentleman in Edinburgh to Mr William Brome of Herefordshire, dated 13 Oct. 1697'. Whether this gentleman can be identified with the traveller just mentioned remains unknown.

(Gotofredus Christianus Goetius) from Leipzig, who had travelled in England, France, and Italy, passed information on two newly found stones (Nos 6, 14) to the Italian scholar Rafaele Fabretti who was then preparing an epigraphic corpus (Fabretti 1699, 756).[7] The texts of two of the newly found stones, from Old Kilpatrick (No. 14) and from Castlehill (No. 6) were sketched by the architect and former churchman, Alexander Edward, also a correspondent of Wodrow (Sharp 1937, nos 75, 79, 121–3), on the back of a letter dated February 1700 (SRO GD 45/26/140; Maxwell 1989, 6, fig. 1.2).

In the summer of 1699 Sir Robert Sibbald visited Glasgow, and was courteously received by Robert Wodrow at the College, where he viewed the stones kept in the Library. Soon after, on 29 August, he wrote to Wodrow: 'I shall entreat the favour yow may send me a copy of the inscriptions, and gett some who heth skill to draw the figures that are upon them, and give me your conjectures about them . . . yow will be pleased to gett me a copie of the inscription, the Principal heth, and give my service to him, I ame sorrowfull I saw him not' (Maidment 1837, 133, no. 2). Sibbald presumably refers here first to the existing College collection of some four stones, then to a recent acquisition which later correspondence allows us to identify as the 'Lollius Urbicus' slab from Balmuildy (below, No. 22); perhaps it had not yet been placed with the rest. Wodrow replied on 8 September, promising to enclose a copy of the text, but noted that 'I have not as yet (having been much out of toun since I received yours) fallen upon a persone that would undertake to draw the figures that are on them' (Sharp 1937, no. 8). In fact he was unable to despatch the text until the following day: 'I would gladly have your thoughts upon them [the various lines of text], particularly the first and latter end of the 3rd about quhich I am not as yet satisfied' (Sharp 1937, 22 no. ix); Wodrow did not keep a copy of the drawing, and the original does not survive.

On 28 September 1699 Wodrow wrote to Archdeacon Nicolson at Carlisle: 'I have a prospect of getting some mo[r]e Roman Inscriptions on stone for our Library, of quhich I shall, quhen they come to my hand, give you an accompt. Ther is one already come to my hand, but is miserably broken' (Sharp 1937, no. xi). Nicolson's reply makes it clear that this was the fragmentary slab from Balmuildy (No. 22) mentioning the governor Lollius Urbicus. 'Your Roman Inscription proves that Lollius Urbicus was sometime near the place where this Monument was found; and may be some help towards the determining the grand Controversy (which [has] so long been bandy'd betwixt the Antiquaries of both Kingdoms) [who] were the founders and restorers of the two famous Walls' (NLS Wod. Lett. Qu. I., ff. 86-7, letter no. 60). Nicolson, who also copied out some of his own notes on the literary evidence for the various Roman walls in Britain, for Wodrow's benefit, was thus evidently the first to recognise the particular importance of the Lollius Urbicus stone as confirming the location of the Antonine Wall, so long a matter of uncertainty (cf. Sibbald 1707, 49; Gordon 1726, 63). Wodrow acknowledged the helpful information on the historical context 'quhich as it has been usefull to you will be much more to me, that I am soe unskilled and need soe much help in these matters' (Sharp 1937, p. 26 no. xii).

A further letter from Wodrow to Sibbald, written on 28 October 1699 (Sharp 1937, no. xiii), announced: 'Ther is just nou come to my hands a large clear Roman inscription, with very curiose sculpture about it'; but he decided to 'deferr it to ane other occasion', leaving Sibbald in suspense! On 11 November Sibbald, in a letter to Wodrow from Edinburgh, congratulated him on the new acquisition, and asked for a drawing (Maidment 1837, 133, no. 3). This second new stone is further mentioned in a letter from Wodrow to Nicolson on 21 December 1699: 'I have gote another stone to the Library, the copy of quhich you shall have per nixt' (Sharp 1937, no. xv). Nicolson reminded him on 13 January 1700 about his promise to send a drawing of 'your late discover'd Roman monument' (NLS Wod. Lett. Qu. I. f. 92, letter no. 66). On 29 March, Wodrow replied, appending a sketch which allows the stone in question to be identified as a distance slab of the Twentieth Legion (No. 10), ornamented with its wild boar emblem, designated by Wodrow in his crayon sketch (in the copy of the letter he retained for reference)

[7]Götz was probably a member of a family later resident at Dresden, which in subsequent generations produced a senior official in government service, and a painter and expert on heraldry, both with the same three names.

as 'swine' (Sharp 1937, 62, no. xxv; cf. no. xxxviii). Finally Sibbald, in further letters dated 31 August 1700 and 15 October 1702, asked Wodrow to keep him informed of any future discoveries (Maidment 1837, 135, no. 4, 142 no. 8).

In the last months of 1699 the eminent philologist and antiquary Edward Lhwyd (or Lluyd), 'Keeper of the Ashmolean Closet' (Sharp 1937, 93, no. 43), i.e. the Ashmolean Museum, Oxford, was twice in Glasgow, as part of an itinerary taking him far into the Highlands (Campbell & Thomson 1963), preparatory to the publication of a major scholarly work, in the end only partially realised, on the archaeology and natural history of the British Isles (Ellis 1907; Emery 1969). His correspondence with Scottish and other scholars reveals the extensive preparations for his visit. The Bodleian Library holds a notebook, which a later note inside the front cover states 'is all in the hand-writing of Ed. Lhwyd'. Though evidently carried by Lhwyd on his travels, it is not a diary and includes no drawings of the inscriptions we know he recorded. However, it contains, copied out by Lhwyd, a suggested itinerary sent to him by Sibbald: 'Directions for his hon[oure]d friend Mr Lhwyd how to trace and remarke the vestiges of the Roman wall betwixt Forth and Clide' (Bod.Lib. MS Carte 269, fols. 129d–135; Haverfield 1910). This offered him a resumé of what was known about archaeological sites along the Wall, from east to west, and where to find inscriptions and other antiquities. The account of the eastern half of the wall is detailed and specific; further west the instructions are only in note form, but the phraseology is recognisably Sibbald's, deriving ultimately from Christopher Irvine (see p. 5, n. 3). The notebook also has the scribbled names of other antiquaries whom Lhwyd hoped to meet, or did meet (fol. 140v), among them Wodrow, Lachlan Campbell (below, p. 12), and a Mr Strachan (see below). About the latter a note inside the front cover says 'enquire for Mr Strachan at Mrs Midleton's ab[ou]t half a dozen doors higher [than] Dr Sibbald's, Edinburg'. Another of Lhwyd's notebooks, now in Trinity College, Dublin, though mainly given over to lists of English words and their Gaelic equivalents where known, also contains the names of some places on his itinerary, including Cawder, Kirkintilloch, and Castlecary, and a list of professors at Glasgow, ending with the Librarian, presumably Wodrow, but the ink has faded (TCD MS 1369, ff. 108v, 109v).

Lhwyd had travelled from Oxford first to Wales and then to Ireland, crossing over to Scotland from Ballycastle to Kintyre (Campbell & Thomson 1963, p. xvi). His itinerary took him to Glasgow and then to Edinburgh where on 14 December 1699 he was entertained by Sibbald (Gunther 1941, no. 213). On 17 December, presumably while he was retracing his steps westwards, Lhwyd wrote from Linlithgow to Dr Richard Richardson in Yorkshire about his recent visit to Glasgow College: 'The Principal of the College shew'd us Stones, he had lately procured for the Library; having Roman inscriptions. These we copied, and several others elsewhere of the same Date; whereof some are printed in Camden (tho' not very correctly) and other not yet publish'd. They keep these stones at Glascow very carefully in the Library; and the Principal was daily expecting two or three more that had been promised him' (Lhwyd 1713, 100 = Gunther 1941, no. 215).[8]

Lhwyd (or perhaps his companion, David Parry) made drawings of the stones, which came later into the hands of William Stukeley, and formed the basis of a splendid frontispiece to the latter's *Account of a Roman Temple* (1720). The content of the frontispiece (FIG. 7) provides an effective digest of Lhwyd's travels, which also included Cumbernauld and Cramond near Edinburgh (Stukeley 1720, 11f.).

A letter from Wodrow to James Paterson in Edinburgh illuminates the later stages of Lhwyd's itinerary, evidently en-route westwards from Edinburgh to Glasgow: '. . . he was a night with Castlecary [i.e. Alexander Baillie, the owner of Castlecary Castle, who gave him two Roman fibulae] . . . and another with Mr Charles Maitland and gote the inscription [below, No. 4] at Calder [i.e. Cawder House], quhich you have in Dalrymple's Cambden' (Sharp 1937, no. xix; Dalrymple 1695, 99). Clearly Lhwyd was targeting the known locations of stones which he

[8]No other stones are known to have arrived in the College at this time. However we could suspect that Dunlop and Wodrow hoped to acquire two more distance slabs (No. 6, from Castlehill, which was at the College by 1720, and No. 13, first reported by Urry at Cochno House in 1696–98, but not donated until *c.* 1740).

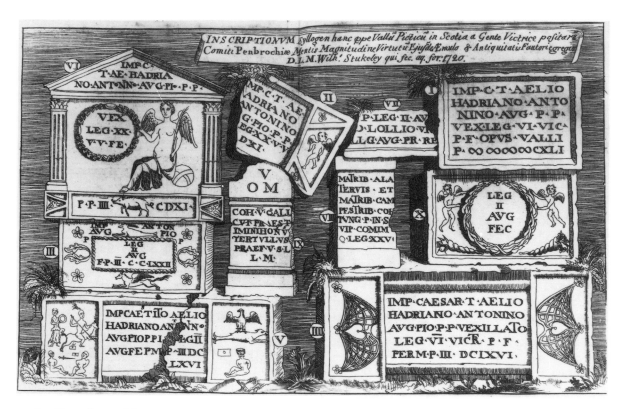

FIG. 7. Drawings of Roman inscribed stones: frontispiece in W. Stukeley, *An Account of a Roman Temple* (1720). Glasgow University Library.

wished to see and record. He had returned to Glasgow by 20 December (Campbell & Thomson 1963, 4–5). In a letter to Nicolson on 21 December, Wodrow notes 'The curiose Mr Ed. Lhuyd has been heer this day and is gone to Ireland by way of Kintyre . . . He will be at Oxford at July, laden with curiose rarities' (Sharp 1937, no. xv; cf. nos xvii, xix; cf. also Gunther 1941, no. 217). It was presumably on his first rather than this very brief second visit to Glasgow that Lhwyd and Wodrow found time to go 'lithoscoping' (i.e. geological prospecting) together, at the Auldhouse Burn, south of the city, as Wodrow reminded him in 1709 (Maidment 1834, 377, no. cviii). Writing subsequently from Londonderry on 2 April 1700, Lhwyd thanked Wodrow for his 'Extraordinary Civility and Kindnesse', indicating that he would be glad to hear of 'any more Inscriptions or other Antiquities discover'd since our leaving the countrey' (NLS Wod. Lett. Qu. I. f. 121, letter no. 87). Sibbald too was anxious to know from Wodrow if Lhwyd had made any fresh discoveries along the Wall (NLS Wod.Lett. Qu.I. f. 96, letter no. 70). Lhwyd himself published just one newly found stone, a distance slab from Castlehill (below, No. 6), in the journal *Philosophical Transactions* (Lluyd 1700, 791).

Drawings of distance slabs and other stones at one time in the collection of the antiquary John Anstis (above, p. 9), now in the British Library, incorporate some of Urry's papers and Lhwyd's papers. Next to one of these drawings (of distance slab No. 14, presented by Hamilton of Orbiston, 1695) is the note: 'In Scotland communicated by Mr Strachan of Baliol College' (BM MS Stowe 1024, ff. 87, 93). William Strachan, a student at Balliol College, Oxford, 1689-1690, and later a lawyer in Edinburgh, is presumably the Strachan mentioned in Lhwyd's notebook (above, p. 11).

In the spring of 1702 Lachlan Campbell (above, p. 11), a Glasgow graduate who had recently studied in Leiden, wrote to Wodrow from London, evidently with the suggestion that Wodrow inform the eminent Professor J.G. Graevius at Utrecht of the new discoveries, probably with a view to their inclusion in a revised edition of Gruter's epigraphic corpus, which Graevius was then preparing (Graevius 1707). The letter itself appears not to survive, but in May 1702 Wodrow sent the following reply: 'As to your kind overture anent our Roman inscriptions, I am not soe fond of having my name known in holland as to engage in a correspondence with

Grevius. I know my insufficiency for so great a task, however I will fall on a way to transmitt the inscriptions if possible to him' (Sharp 1937, no. cxiv). But, so far as I can establish, none of the newly found Glasgow stones finds a place in his pages.

3. THE EIGHTEENTH CENTURY

The eighteenth century saw important developments at Glasgow University. Professors were appointed to teach individual academic subjects, in place of the Regents who had often taught over a range of disciplines (Coutts 1909, 207). This was the period of the Scottish Enlightenment (Hook & Sher 1995; Brown 1987b), and many internationally distinguished scholars held chairs at the College (Scott 1937, 66–110; Emerson 1995). The Scottish nobility and landed gentry, and in due course the newly enriched industrial entrepreneurs, sent their sons on the Grand Tour of France, Germany and especially Italy (Skinner 1966; Brown 1988, 1996; Wilton & Bignamini 1996; Ingamells 1997), from which they might return with heightened awareness of Roman art and architecture, a context within which to set the Roman occupations of their own country. Robert Wodrow never travelled outwith Scotland, but several professors in subsequent generations visited European countries, before or after their tenure at Glasgow, sometimes as tutors to sons of the nobility; they themselves lacked the means to indulge in the Grand Tour.[9] The College's collection of Roman stones was considerably augmented, often by chance discoveries, such as at Shirva near Kirkintilloch in 1726 and 1731 (below, p. 15), and as a result of construction works associated with the building of the Forth & Clyde Canal in 1769-73 (below, p. 25). Authors such as William Stukeley, Alexander Gordon, and John Horsley brought knowledge of the collection to a wider audience.

William Stukeley's *Account of a Roman Temple and other Antiquities, near Graham's Dike in Scotland* (1720) dealt principally with Arthur's O'on, an enigmatic Roman structure on the banks of the River Carron near Falkirk, but it also contained an extensive citation of inscriptions from the Antonine Wall, with details of their provenances (Stukeley 1720; Brown 1974, 283; Piggott 1985; Brown & Vasey 1989, 353–60). A particularly valuable copy of the treatise is Stukeley's own, now in the Ashmolean Library, Oxford, with marginal notes in his own hand and addenda covering a period of fifteen years or more, which report new discoveries down to the mid-1730s (Ashmolean Library cxiv.c.28A).

Stukeley himself never visited Scotland, but he was able to draw on the '*Manuscript* Collections of the Learned and Indefatigable Mr *Edward Lluyd*' (Stukeley 1720, 9; cf. above, p. 11). He observed that Lhwyd's 'collections' had passed to Sir Thomas Seabright, but that Mr Anstis, 'Garter King at Arms' (above, p. 12) had favoured him with copies of Nos 14-15, and presumably others seen by Lhwyd on his Scottish travels (1720, 9). Stukeley also received information from a number of other travellers and antiquaries, including a Dr Jurin, presumably the distinguished physician James Jurin, Fellow and soon-to-be Secretary of the Royal Society: 'My worthy Friend and Collegue Dr Jurin . . . who travelled along it [the Antonine Wall] and took all the inscriptions he met withall' (Stukeley 1720, 4). Jurin was a correspondent of Professor Robert Simson at Glasgow (below, p. 18), on mathematical questions (GUL MS Gen. 1096).[10]

Sir John Clerk of Penicuik, who held office as a Baron of the Exchequer in Scotland (hence he is often addressed as Baron Clerk), was a pivotal figure in the study of Roman archaeology in Scotland during the early eighteenth century (Brown 1980b). It is interesting to speculate whether Clerk, indefatigable accumulator of stones to form his own collection at Penicuik House

[9]William Rouet, Professor of Oriental Languages 1751–52, then of Ecclesiastical History 1752–60, deserted his post (though not his salary) to act as tutor to Charles, Lord Hope, heir to the Earl of Hopetoun (Ingamells 1997, 825f.; Coutts 1909, 239ff.; Brown 1988, 726); Adam Smith, Professor of Logic 1751–52, then of Moral Philosophy 1752–64, resigned in order to accompany the Third Duke of Buccleuch to France; John Anderson, Professor of Oriental Languages 1755–57 and then of Natural Philosophy 1757–96 (below, p. 25), travelled to Holland and Paris as a tutor in 1750–55 (Butt 1996, 2–3).
[10]Stukeley also mentions an informant, Mr Strachey, not otherwise identified, who had visited forts and recorded at least one stone [No. 4] (MS notes at pp. 6, 10).

south of Edinburgh (Horsley 1732, 181; Brown 1977, 201ff.; 1980a),[11] had received an early impetus to his enthusiasms at Glasgow, where he was a matriculated student between 1692 and 1694, just at the time when the first stones were being brought in to the College (University of Glasgow 1854, vol. 3, 152; Clerk 1892, 12), before going abroad to study at Leiden, and thence to the Rhineland, Austria, and Italy; it was five years before he returned to Scotland.[12]

Clerk's correspondence with his fellow antiquaries indicates how information about new discoveries was then disseminated and their attempts, not always accurate, to interpret the Latin texts (Lukis 1887, 419ff.). Clerk's papers include several drawings of inscriptions from Scotland and Northern England. On 10 May 1721 in response to a request from Clerk, John Simson, former Librarian at Glasgow College and now its Professor of Theology, sent him drawings of inscriptions at Glasgow, including the Lollius Urbicus stone (No. 22), which he described as 'unluckily broken in the turning up' (SRO GD 18/5019); Clerk may well have known John Simson from his period as a student at Glasgow in the mid-1690s.[13]

Clerk maintained a regular correspondence with Stukeley (Brown 1977; 1987a), and unpublished letters to him from both Alexander Gordon and John Horsley are of exceptional value in illustrating the progress of their researches and steps towards publication of their respective works (see below). Clerk was an important patron, whose favour both Gordon and Horsley, and other scholars, were concerned to acquire and retain.

Alexander Gordon's preparations for the writing of his *Itinerarium Septentrionale* i.e. his 'Journey over the North' (London, 1726; see Wilson 1874; Macdonald 1933, 32-5; Brown 1980a) brought him to Scotland in the summers of 1723-25. In August 1723 Gordon wrote to the antiquary James Anderson in Edinburgh about his plans to visit Glasgow, Stirling and Perth, and asked to borrow Anderson's copy of Sibbald's *Historical Inquiries* (Sibbald 1707) for use on an 'antiquary peregrination or virtuoso tuer' (NLS Adv. MS 29.1.2 (iv) f. 75 = Piggott and Robertson 1977, no. 22 with discussion by I.G. Brown). On 19 September 1723 Gordon wrote to Clerk, to tell him of his journeyings along the western half of the Antonine Wall and a visit to Glasgow: 'I have likewayes (with as much Exactness as I could) drawen the Stones in Glasgow Colledge' (SRO GD 18/5023/3/1).[14]

Clerk's enthusiasm for acquiring stones for his collection was well known to his correspondents. An illuminating episode is documented in two letters from Gordon, who had travelled northwards to his home town of Aberdeen, where he stayed with his merchant father. On arrival there Gordon went to visit the Principal of the city's Marischal College, Professor Thomas Blackwell the Elder, to discuss a proposal from Clerk regarding the distance slab long preserved at Dunnottar Castle but which had recently been presented to Marischal College (No. 1). On 8 November 1723 he reported to Clerk: 'On my arrival here I imediatly went & visited Mr Blackwell but did not broach my design nor comission from you till after I have seen the stone which this morning I did & send you its rough draught. It is very curious entire & legible & about 3 feet & a half square. Next visit to Blackwell I shall do what lies in the compass of mine or relations power to gett you it' (SRO GD 18/5023/3/2). The purpose of the visit is confirmed

[11]The collection was donated to the National Museum of Antiquities of Scotland in 1857 (see Clerk *et al.* 1860, 37–43), with the exception of *RIB* 2157 (for which see below, p. 68).

[12]Letters between Clerk and his father, relating to his time as a student in Glasgow, provide a valuable picture of student life at this time, and parental expectations (SRO GD 18/5191, 5194).

[13]There were two professors Simson at Glasgow in the early eighteenth century, John Simson (Theology) and Robert Simson (Mathematics), his nephew. The latter was soon to play a particularly prominent role in the acquisition and publication of the stones (see below, pp. 18, 20).

[14]Gordon was accompanied on part of this expedition by James Glen of Linlithgow, who was as keen to purchase Roman antiquities for his collection as Gordon was to secure them for Clerk. While in Glen's company Gordon deliberately followed a route along the Wall which avoided places where he knew inscriptions were to be seen (SRO GD 18/5023/3/1); Glen was nevertheless able to purchase an uninscribed altar from Bar Hill (Keppie & Arnold 1984, no. 96), and a small fragment of another. To console Clerk for this loss, Gordon described the latter as 'not worth one farthing' (SRO ibid.). Though Gordon in his private correspondence reports the relationship with Glen on the journey as somewhat chilly (Gordon uses the Italian 'aliquanto freddo'), in print he describes his companion as 'my curious and honoured friend James Glen Esq., present Provost of Linlithgow' (Gordon 1726, 55). One of Clerk's tenant farmers, Richard Burn, followed in Gordon's footsteps to collect stones that had been promised him; at times he had to employ 'flatory, drinking and other methods' to secure them (SRO GD 18/5024/3; cf. 5023/3/1, 5024/1, 5320/7).

in a second letter dated 22 November: 'having promised to solicite Mr Blackwell to procure you that Stone having spoke to him I found him extreamly inclined to indulge my sute for your getting it. Only tells me a meeting of the other Masters must be called to procure their consent . . . however he himself is willing since I told him you would give the College some of your Natural Curiosities in lieu of it and by the by I think you have the opportunity to make sure work of it if it sutes your inclination to favour and speak (as we say) a good word to my Lord Justice Clerk or who has the disposing of the post: vacancy of Regent in our College, seeing Mr Blackwell's son is a candidate' (SRO GD 18/5023/3/3). In the event, on 28 November, perhaps even before Clerk had received Gordon's letter, or had had time to respond, Thomas Blackwell the Younger was made Professor of Greek in Marischal College; later he became its Principal.[15] Nepotism in the Scottish colleges was a familiar feature of the age (Emerson 1992; Emerson 1995, 27). The stone itself remained at Aberdeen until 1761.

On 7 December 1724, David Verner, Professor of Philosophy at Aberdeen, wrote to his relative Robert Wodrow at his manse in Eastwood: 'The enclosed is from Alexander Gordon, the famous singer, who has travelled Italy severell times [Gordon had studied and performed music in Italy], and has view'd all our Scots remains of Roman antiquities which are to be seen in the fields, and most of those which are in private custody' (Maidment 1837, 219–20, no. lxxxii). The enclosed letter shows that Gordon was anxious to see and draw Wodrow's small collection of Roman antiquities, including brooches and coins, which he asked Wodrow to send over to Edinburgh for this purpose; some artefacts were indeed described and illustrated in the *Itinerarium Septentrionale* (1726, 117-18, pl. LI).[16]

In August 1726 a remarkable discovery was made at Shirva, on the line of the Antonine Wall east of Kirkintilloch. Alexander Gordon, who was then working on a survey for a proposed canal to link the Forth and the Clyde, visited Shirva on 24 September. Immediately, in a state of high excitement, he wrote 'on rough Paper and in a Rough Place', to his patron, Sir John Clerk: 'I was directed to see a place on Grahams Dike which the plough has discovered viz. a hollow mausoleum within the very fossa where stones with inscriptions were found about 6 weeks I think ago. On one is the legio 2da [= *secunda*] Augusta eligantly engraven [No. 21] but the stone broke in 3 parts and part of it where the noble ornaments are is still lying in the ground undugg. It is one of the largest and most noble stones that has been as yet found in our island' (SRO GD 18/5023/3/36; cf. Gordon 1732, *Additions*, 5). He saw and sketched four stones in all (Nos 21, 49–51). 'I beg of you Baron see if you know any body that knows the Proprietor Mr Calder of Shervey, merch[an]t in Glasgow, and endeavour to procure one or more of them in time. I saw the place where they were dug and God knows how many noble antiquities may be found. Three or four of us have appointed to go with the Proprietor and dig up the rest carefully' (SRO, ibid.). Though Gordon was then lodging with Professor Robert Simson at Glasgow College, his loyalty was to Clerk. But the stones were in fact all donated by the proprietor to the College, the first batch arriving a little before 5 March 1728 (GUA 26635, p. 31). It may be that Robert Simson acted quickly to secure them.

Some time after the initial discovery at Shirva in 1726, John Horsley, a graduate of Edinburgh University, and then Minister at Morpeth, Northumberland (Hodgson 1918; Macdonald 1933; Birley 1958; Birley in Horsley 1974), visited Shirva House during preparations for the writing of the *Britannia Romana* (Horsley 1732). Horsley also paid a visit to Glasgow College, and discussed the wording of individual inscriptions with some of the professors (Horsley 1732, 197).[17] Early in 1729 Horsley went to see Sir John Clerk at Penicuik House. 'Mr Horseley [sic]

[15]The younger Blackwell subsequently became a frequent correspondent of Clerk's on linguistic and epigraphic matters (SRO GD 18/5036, 5037; see below n. 17).

[16]For Wodrow's continuing interest in Roman antiquities, see also McCrie 1842, 171–3, letter no. 55 (November 1710).

[17]The prospect of a publication to rival the *Itinerarium Septentrionale* was not to Alexander Gordon's liking. As Professor Thomas Blackwell the Younger wrote to Clerk on 17 December 1728, '[T]here's still another mortification abiding him [Gordon], viz that some person, an Englishman, I'm told, now at Ed[inburgh] is resolving to publish the brittish antiquities after a more accurate manner than hitherto has been done. He has sent to this College to have our stone [No. 1; cf. above, p. 14] drawn anew with the Height, Breadth and Distance of every letter, etc.' (SRO GD 18/5036).

has been in this Countrey, and did me the favor of a visitt', as Clerk wrote to Roger Gale on 15 February (Lukis 1887, 390).[18] Clerk was greatly impressed by Horsley's learning and judgement; they discussed the readings on various stones from Scotland and Northern England (SRO GD 18/5033, 5035, 5038). 'At *Skirvay*', Horsley reports (1732, 198), 'about a mile and a half west from *Kilsyth*, I saw the inscriptions and sculptures represented in this and the three following numbers [1732, pls x–xiii]; besides which there are two altars quite defaced, and some other stones both *Roman* and curious. They were dug up at a place a little east from this house (I suppose at *Barhill* fort or near it) which belongs to Mr *Calder*, who expected to find more at the same place. All these stones, except N. XIV, are now removed to the university of *Glasgow*.'[19]

A few years later, in the summer of 1731, further discoveries were made at the same site, so improving awareness of the size and shape of the 'mausoleum'. Details were first communicated in a general account sent to Gordon and others by James Robe, Minister at nearby Kilsyth.[20] 'As to the *Roman* Tumulus discover'd in Mr. *Cathen* of *Schervy*'s Ground, it was found by some illiterate Country People digging stones for a Park-Wall; what is found lies from West to East; Upon the West-side lies an exact half Round, each End of the Diameter running out to the East in a Wall built of about seven or eight Courses of hewn Stones, many of them of rais'd Diamond-work. There are several Pillars, but how or where situated is not known; and some Pedestals with a square Hole in the Top very well cut; Upon the Wall on the South-side near the Bottom, was found a large Stone with the Image of a Man carv'd upon it [No. 52], leaning on his left Arm, a *Roman Toga* covering him to the Feet, and seem'd to be ty'd with a Belt over the left Shoulder, his Tunic appearing to his Middle; there is the Figure of a Dog standing on his Gown, with his Tail erected; all is admirably well carv'd. Before this Stone was another, covering the Image close to it; upon the North-wall, opposite to the carv'd Stone was another Stone [No. 53], much the same Dimensions, with a Man carv'd upon it also, with a Quadruped towards his Back where he reclines, but of what Kind I know not, the Head being much broke; a little farther, a large Whin-stone, crossing from one Wall to the other like a Lintel, five Feet and a half long; so I reckon the Distance between the two Walls might be four Feet and a half; There was a good deal of Ashes found, and a Piece of an Urn; there was also a Stone with an Inscription, *Flavius Lucianus, Miles, Leg. secundae Aug.* in *Roman* Letters and Figures [No. 48]; there are also other Stones, which of only Parts are found, having D.M. for *Diis Manibus* [No. 50]; but the remaining Parts are not yet found; I judge only a Part of this Burying-place is found, so that the Masters of the University of Glasgow have a Design to cause dig this Ground after Harvest. The whole was in the *Fossa*, close by the Wall; the Faces of both carv'd Stones looked North. And upon the North-side, four or five years since, there was found a Stone, among several others, with *Simanes posuit Simani* [No. 49]. It would be doing more than I should, to give you any Conjectures about it. If in any thing I can serve you, shall be very glad to know wherein' (Gordon 1732, *Additions*, 7).[21]

Robe seems to have prepared a drawing (FIG. 8) of the sepulchre (SRO GD 18/5041/1), which he sent to Clerk and which presumably forms the basis of the illustration published by Gordon in the *Additions and Corrections* to his *Itinerarium Septentrionale* (Gordon 1732, pl. lxvi.A). There is no reference in the Faculty Minutes of Glasgow College to any excavation being undertaken by the 'Masters', i.e. the Professors.

The exact date of discovery of this second tranche of stones can be narrowed down by reference to letters from John Horsley to Sir John Clerk. By 25 June 1731 Horsley had evidently

[18]SRO GD 18/5034 is a letter of introduction to Clerk, written for Horsley by Professor William Hamilton of Edinburgh.

[19]Horsley's visit to Shirva thus predates March 1728, the date by which the stones had been donated to Glasgow College (see p. 15).

[20]A Glasgow graduate, James Robe (or Robb) was one of the foremost theologians of his day; he ministered at Kilsyth from 1713 until 1753, and is buried in Kilsyth churchyard (Anton 1893, 121ff.).

[21]Robe wrote an almost identical letter direct to Clerk (SRO GD 18/5041), and in another written on 8 December 1731 he promises in future to acquire or purchase for Clerk's collection any other stones found on the Wall, to send to Penicuik (GD 18/5042/4); but when an altar was found at Bar Hill in 1733, Robe presented it to the College (No. 30).

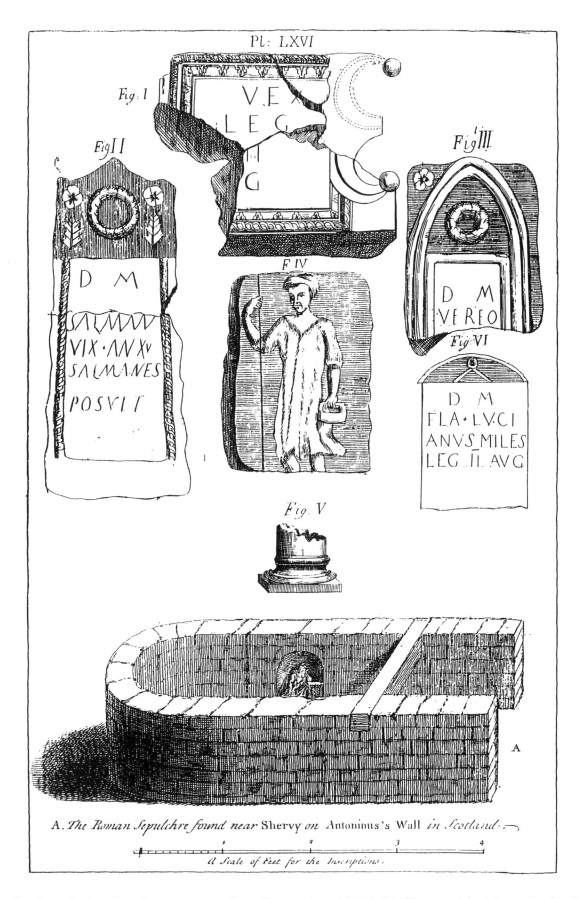

FIG. 8. Inscribed and sculptured stones from Shirva, found 1726–31. Illustrated in Alexander Gordon, *Additions and Corrections by Way of Supplement to the Itinerarium Septentrionale* (1732), pl. lxvi. The Committee for the Ashmolean Library.

received the text of Robe's letter (as cited above), when he wrote to Clerk for further information (SRO GD 18/5038/11). Further letters from Horsley to Clerk in the ensuing weeks, still in search of details, become increasingly insistent, as the deadline for the publication of his *Britannia Romana* (which he describes in one letter as his 'tedious expensive work') approached (SRO GD 18/5038/12–14). The knowledge that Alexander Gordon was also planning to include the new discoveries in his *Additions and Corrections* (Gordon 1732) provided added impetus to his requests.

The newly found stones seem to have passed quickly to the College at Glasgow, by 26 July 1731 (SRO GD 18/5041/1), and the exasperated Horsley soon resolved to write direct to Glasgow, to 'Professor Simpson' (John Simson—see below; GD18/5038/15–16). Eventually drawings reached him, much to his relief, by 31 December, to be despatched immediately to London (SRO GD 18/5038/17; see Horsley 1732, pl. (Scotland) xxxiii). However, within a few weeks Horsley was dead; he did not live to see the publication of *Britannia Romana*.

From Horsley's letters alone we should conclude that Clerk had been inactive, but in fact we know from other correspondence that preparation of the drawings had been in hand at Glasgow, presumably as a result of a request from Clerk. On 8 September John Johnstoune, Professor of the Practice of Medicine, wrote to Clerk that 'as I cannot deseing well, I have gott Mr Robison to doe them at his leasure. They will be very exact' (SRO GD 18/5041/2). Professor John Simson reported progress to Clerk on 1 November: 'Dr Johnstone has had the drawings done by Mr Robison the painter'; Simson himself then checked them against the originals (SRO GD 18/5042/3). Alexander Gordon too wrote in October 1731 to Clerk in the hope of obtaining drawings (SRO GD 18/5023/3/54), which reached him by 23 November (SRO GD 18/5023/3/55; see Gordon 1732, pls lxvi, lxix, drawings which are noticeably inferior to those Gordon had drawn himself).[22]

Professor John Anderson, writing in 1771, refers back to the discovery of the Shirva 'tumulus': along with the inscribed stones there were found, he tells us, 'a small Roman Milnstone with several Medals and an altar without any Inscription' (Anderson 1771, f. 25); but no such items have survived, and the columns and column bases mentioned by Robe are similarly lost (Gordon's drawing of a base is reproduced by Stuart 1845, pl. xiii.6), as are the diamond-broached building stones mentioned by Robe (SRO GD 18/5041/1); they may well have been left on site. Unfortunately, despite these detailed contemporary accounts, the precise location of the 'tumulus' cannot be established.[23]

Almost contemporary with this discovery is an interesting notice, already referred to. Robert Wodrow, one-time Librarian at Glasgow and now Minister at Eastwood (above, p. 7), describes in the *Analecta* (Wodrow 1843, iv, 66) a visit to the lands of Dougalston in 1729, at which time estate workers were seeking building stones for a field wall: 'At the place where they wer digging, the heuen stone with inscription, gifted by Dougalston, 1694, to the Colledge, was turned up [No. 5]. No other freestone has been gote. The workmen are bound down to care, by the promise of a croun [five shillings], for every figured and lettered stone they find.' No additional finds appear to have been made at this time, despite the incentive.

The discoveries at Shirva prompted a renewed interest in Roman antiquities among members of the Faculty of Arts at Glasgow College. The moving force was Robert Simson, Professor of Mathematics, 1712–1761 (FIG. 9). In the Faculty Minutes Simson's name appears under an entry for 5 March 1728, in connection with a press (wooden cupboard) to be made to hold 'the Roman Stones, lately gifted by Mr Cader of Shirvay and [they] appoint Mr Robert Simson to thank Mr Cader in their name for said Gift and to entreat him to preserve any other such stones as he shall find in his grounds for the use of the University' (GUA 26635, pp. 31f.; see also

[22]Small fragments of two of the stones (Nos 21, 50), not mentioned or drawn by either Gordon or Horsley, may conceivably have been found a little later.

[23]'The situation of this monument is about a mile to the southward of the kirk of Kilsyth in the parish of Kirkentilloch on Mr Cathen of Shirvay's ground in the fossa to the northward of the wall in the midway between the forts of Barrhill and Achindavy', Robe to Clerk, 26 July 1731 (SRO GD 18/5041/1). Horsley alone provides the detail that it was located 'at a place a little east from this house (I suppose at *Barhill* fort or near it)'. Estate maps of the period indicate that Mr Calder's property extended *c.* 600 m eastwards from Shirva House, into an area now partly covered by housing at Twechar Village (GUA UGD 101/14/269, UGD 101/14/245).

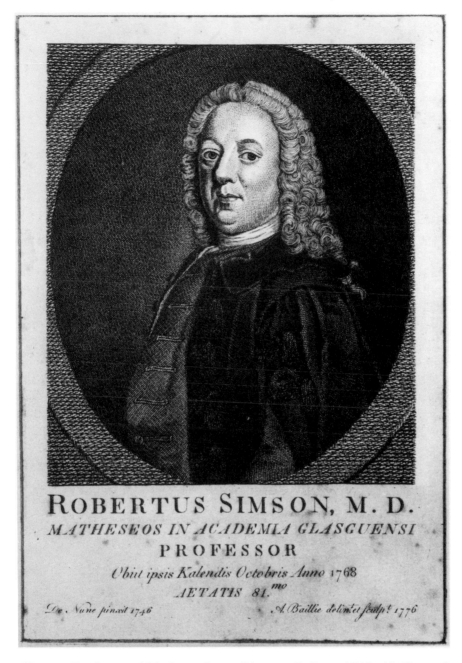

ROBERTUS SIMSON, M. D.
MATHESEOS IN ACADEMIA GLASGUENSI
PROFESSOR
Obiit ipsis Kalendis Octobris Anno 1768
AETATIS 81.mo
De Nune pinxit 1746 A. Baillie delin'et sculp! 1776

FIG. 9. Robert Simson, Professor of Mathematics at Glasgow College, 1712–61. Engraving by A. Baillie after P. de Nune, 1776. Hunterian Art Gallery.

below, p. 19). On 19 January 1738 Simson reported to the Faculty the arrival of a stone found at Ardoch, Perthshire, donated by the 'Honourable Mr Drummond at Drummond Castle' (below, No. 47): 'The faculty appoint Robert Simson to write a letter of thanks in their name for the said Stone and appoint Two Guineas to be given to the Servants who brought it . . . and the Stone is appointed to be put in the new Press with a suitable inscription in Honour of the Donor' (GUA 26648, p. 32). On 26 June 1744 Robert Simson was to be paid 'thirty six Shill[ings] Sterl[ng] for Expenses laid out by him in purchasing and bringing from Kirkintilloch a large Stone of the Roman Wall with an Inscription . . .' [No. 2], found four years previously (GUA 26648, p. 163). Such personal interventions were needed, if stones were not to fall into others' hands. It may be this stone which is referred to again in a later entry in the Faculty Minutes, dated 20 February 1755: 'The Roman Stone which is not yet placed among the rest is ordered to be put in a press in the room where it now stands' (GUA 26640, p. 135).

Robert Simson was a well known figure in the College for over fifty years. A bachelor, he

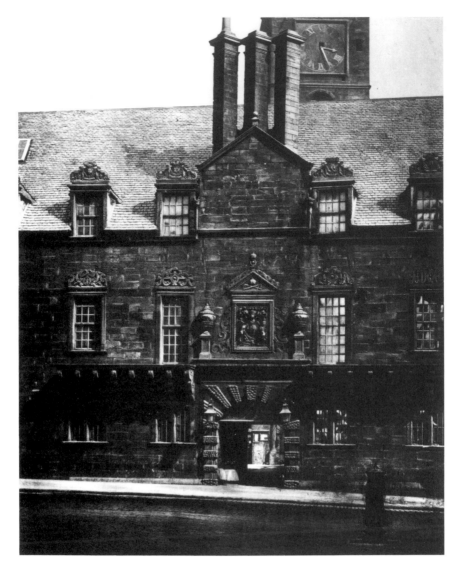

FIG. 10. Main entrance to Glasgow College from the High Street (1870), by Thomas Annan. Reproduced from *Glasgow University Old and New* (1891).

was an early member of the Glasgow Literary Society which met weekly during term on a Friday evening at the College for poetry readings, play readings and to hear lectures (see below, p. 26), and was also a member of the Anderston Club which convened weekly at a hostelry (some suitable distance from the College) on Saturday afternoons for convivial conversation (Strang 1856, 2ff., 19ff.; McElroy 1969, 162f.). Alexander 'Jupiter' Carlyle, a student at Glasgow and later Minister at Inveresk near Edinburgh, wrote of Simson thus in 1744–45: 'He paid no Visits but to Illustrious and learned Strangers, who wish'd to see the University. On such occasions he was always the Cicerone. He shew'd the Curiosities of the Colledge which consisted of a few Manuscripts, and a large Collection of Roman Antiquities, from Severus's Wall or Grahams Dyke in the Neighbourhood, with a Display of much Knowledge and Taste' (Kinsley 1973, 41). Similarly Bishop Richard Pococke, reporting on his tour of Scotland in 1747, says that on 10 October 'Mr Professor Simpson showed us the College and the Library', and presumably the stones that were kept there (Pococke 1887, 3). Though Simson retired on full salary in October 1761 on the eve of his 74th birthday, he continued to live in the College, and to push forward to completion what was to be a culminating achievement, the preparation of copperplate engravings of the stones (below, p. 22).

Much has already been said about the pride felt by some professors in the collection which the College possessed. At first they were kept in the Library (e.g. Sibbald 1707, 49–50 with

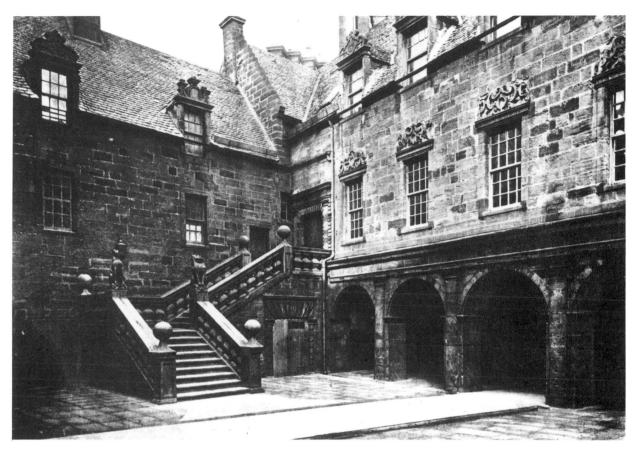

FIG. 11. Outer Court of Glasgow College (1870), by Thomas Annan. Reproduced from *Glasgow University Old and New* (1891).

figs; see above, p. 7), but as the space was soon required for the growing collection of books, the stones were moved to adjacent passageways, and placed in locked wooden cupboards, or 'presses', already mentioned several times (above, pp. 18–19). From the Faculty Minutes we learn something of the problems in finding suitable storage locations within the cramped confines of the College (FIGS 10–11), and concern for their security. New presses were built, as the collection grew, in 1728 (GUA 26635, pp. 31–3), 1760 (GUA 26642, p. 49), and 1771 (GUA 26690, p. 43). On occasion it is possible to link the provision of new presses with the acquisition of stones (below, p. 29). In addition a number of accounts submitted and receipts for payment provide insights into the construction and maintenance of the presses themselves.[24]

The new press built in October 1760, at a cost of £2-5-3, was to house 'the Roman Stones in the passage to the garden from the Inner Court' (GUA 26642, p. 49).[25] Very probably these included No. 13, donated by James Hamilton of Barns some years before, if not also No. 2 (see pp. 19, 85). Another acquisition was soon to join them: among the 'sundry necessarys' for which the Bedellus [chief College porter and general factotum] recorded payments in 1761–62 is an item under 8 December 1761: 'To paid the Carage of a Roman Ston from Leith to the College: seventeen shillings' (GUA 58247). This stone was presumably the distance slab (No. 1) presented at an otherwise unrecorded moment in that year by Marischal College, Aberdeen. Evidently therefore it had travelled down the east coast of Scotland by sea. The entries immediately following, in the Bedellus' list, are similarly instructive: 'To expences geting it in being very hevie: nine pence' (8 Dec.); 'To masons helping it into the press & a Stone put in preeceding this: six pence' (12 Dec.); 'To paid Mr. Wilson [Professor of Astronomy] the postage

[24]For example, on 18 August 1756 a new 'slip bolt' was purchased for 'the press at the entry to the College Garden' (GUA 58260).

[25]On 3 October 1760 William Shaw submitted his account for it: 'To a press for holding a Roman stone: £1-18-0; To a pair of hinges: £0-5-3, To a lock and 2 shields: £0-2-0' (GUA 58246).

of letters about it: eight pence' (12 Dec.).[26] Exactly how large these presses were cannot at present be established. Probably they were of different sizes; some certainly accommodated more than one stone. They had hinged doors, and were locked. Labels were attached to the stones, or perhaps to the presses themselves, which gave such details as were known about provenance and donor. Errors in captions accompanying the copperplates issued in 1768 may have arisen from these labels becoming detached.[27]

Despite being locked in their wooden presses (and so not on permanent public view), the stones were accessible to scholars and interested visitors, from whose published accounts we sometimes gain additional details. Sir John Clerk, writing to his friend Roger Gale on 7 August 1739 with instructions and an itinerary for a journey from 'Edenborough' to Glasgow, advises that: 'In the College you will see a good many Roman stones and inscriptions from the Vallum Antonini' (Lukis 1887, 414); but Gale seems not to have included Glasgow in his itinerary. Other visitors included Bishop Pococke in 1747 and 1760 (Pococke 1887, 3, 52), the poet Thomas Gray in 1764 (Murray 1913, 95), and the naturalist Thomas Pennant in 1769 and 1772 (Pennant 1774a, 232–3; 1774b, 138–9).

4. *MONUMENTA ROMANI IMPERII*

On 9 June 1767 a proposal to prepare a series of engravings of the collection was approved by the Faculty of Arts. 'The meeting orders the Inscriptions & Ornaments upon the Roman Stones to be engraved on Copper under the Direction of Dr Simson & Mr Muirhead [Professor of Latin]; the Copper Plate is to be kept by the Clerk & no Copies to be sold without an Order from the Meeting' (GUA 26643, p. 225). The decision seems a sudden one, but it was doubtless preceded by some lobbying, most probably on the part of Robert Simson, now retired from the chair of Mathematics.

For convenience in the following pages, the resulting collection of engravings is termed the *Monumenta Romani Imperii* ('Memorials of the Roman Empire'), or, more briefly, the *Monumenta*. These certainly are the opening words on the title page of an expanded edition issued in 1792 (below, p. 30). However, it is by no means clear that the initial compilation had a title page; the publication is given no special title in the Faculty Minutes of these years (below, p. 23).

By March 1768 the work of engraving had been carried out and an account submitted: 'On account of Drawing and Engraving the forms of Twenty Stones found in the Roman Wall which extended to the two Firths, with the Inscriptions, Figures and other Ornaments, exactly copied as they appear on the Stones themselves. Also there is engraved on each plate the Scale by which the size of each Stone may be known. Also the Names and Designations of the Noblemen and gentlemen who presented them to the University, except one [No. 4] of which no record had been kept. The particular place where some of them were found is mark'd, but generally omitted because not known' (GUA 56183). The document also gives the cost of each plate; they are all different. The total cost was £40. On 31 March 1768 the account was submitted to the Faculty for approval: 'an Account of £40 for Drawing & engraving the Roman Stones . . . was referred to Mr Anderson [Professor of Natural Philosophy (below, p. 25)] and Dr Wilson [Professor of Astronomy] as a Committee', who were to report at the first meeting after ten days hence (GUA 26643, p. 269); it was approved on 19 April (GUA 26643, p. 271). The account itself reveals that the work had been carried out by Robert and Andrew Foulis, printers to the University, already famous for their editions of Greek and Latin classic authors (cf. Pennant 1774b, 232f.). Some of the copperplates themselves survive.

Though it might seem that the resulting sets of engravings were available for distribution, it

[26]The same event is recorded in an account submitted by 'Robert Muire, mason': 12 Dec. 'Setting the Roman Stones and other jobs. Two masons 1/2 a day each: one shilling' (GUA 58246).

[27]The almost identical Latin wording beside drawings in BM MS Stowe 1024 (*c.* 1700) and on captions in the *Monumenta Romani Imperii* (University of Glasgow 1768) could suggest that such labels were already in place by the end of the seventeenth century (BM MS Stowe 1024, ff. 88, 93, 112).

FIG. 12. Distance slab of the Twentieth Legion (No. 16) found at Old Kilpatrick. Copperplate engraving by Foulis Press, published in *Monumenta Romani Imperii* (1768), Pl. I.

seems that this was not so, nor indeed was it the Faculty's intention. Rather, the work of engraving was seen as an end in itself, the subsequent printing, binding, and distribution being a quite separate matter. On 21 February 1770 the Foulis Press submitted an account for four shillings, 'To Binding in Calf a copy of the Roman Inscriptions, large pap[er] fol[io] for Aberd[ee]n College. Delivered to Dr. Traill', Professor of Divinity (GUA 58186). The presentation of a distance slab by Marischal College, Aberdeen, in 1761 (No. 1; above, p. 21) was doubtless the reason for this gift; the copy is preserved in Aberdeen University Library.

However, other sets of the engravings were subsequently made up: on 11 June 1770, a bill for £3-18-10 from the Foulis Press was received, for foolscap paper and printing costs 'to casting off 62 off each Plate' (GUA 58186; cf. GUA 26644, p. 196). Of these sixty-two sets, eight were printed on 'French paper' at greater expense, presumably as special copies for presentation. Two days earlier, on 9 June 1770, 'The Copper Plate Copies of the Roman Stones and the Plates themselves were delivered to the Meeting; which orders one Copy to be given to each of the Members of Faculty, one to General Oughton and one to Mr Hamilton of Barns' (GUA, 26644, p. 185). General Sir Adolphus Oughton was currently Deputy to the Commander-in-Chief of the army in North Britain (Carman 1989, 127; Wood 1995, 75).[28] Claud Hamilton of Barns (Hamilton 1933, 122), who died soon after, was the son of a recent donor of a distance slab, James Hamilton, and the descendant of another (above, p. 7; see Nos 10, 13).

On 11 June the instructions were reformulated: 'One Copy . . . [to] be sent, in the name of the University, . . . to each Family which have contributed to the Collection; and Dr Moor [Professor of Greek] and Mr Anderson are appointed in their Name to send the Copies' (GUA 26644, p. 190). It had evidently also been agreed to prepare a specially bound copy, suitably inscribed in gold leaf on the cover, to be sent to the distinguished former Glasgow student, later

[28]A noted antiquary, known to Boswell in Edinburgh literary society, and to Dr Johnson, Oughton had recently been made a Burgess of the City of Glasgow, and also composed Latin inscriptions which were placed on newly-built stone bridges in the Highlands. He is known to have suggested a satirical Latin epitaph for the tomb of David Hume in Edinburgh (Brown 1991, 112). Whether Oughton had any closer connection with the College remains unknown.

physician and medical teacher, Dr William Hunter, then at the pinnacle of London society: 'To Binding in Morroco (sic) a Book of Prints being the Roman Inscriptions at Glasgow, a Present from the University to Dr Hunter', at a cost of £1-1-0 (GUA 58284; cf GUA 26690, p. 76). Interestingly no effort was made to make copies more widely available to scholars, antiquaries, or professors of relevant subjects in other universities.

 The work consisted of twenty plates, with the stones drawn at a standard scale of 1/6, each plate incorporating, as the Foulis invoice states, the name of the donor, and year of acquisition where known, and the measurements of the original stone. The information was doubtless taken from the labels attached to the stones or their presses (above, p. 21). The slab illustrated as Plate I (FIG. 12) is likely to have been the earliest donated to the College (here No. 16), but it would be wrong to suppose that the plates are presented in a deliberately chronological sequence. The order of plates, for stones acquired before the 1730s, follows the sequence in Horsley's *Britannia Romana* of 1732: they are reported from west to east (Plates I-XIII). Thereafter the plates give, in rough order, the later slabs found at Shirva (presented 1731), Bar Hill (1733), Ardoch (1738), Kirkintilloch (1744), and the stone transferred from Marischal College,

FIG. 13. John Anderson, Professor of Natural Philosophy, 1757–96. Print by William Kay, 1792. Strathclyde University Archives.

Aberdeen (1761). There is no Plate IX, but two plates bear the number XII. This seems not a mistake by the engraver, but can be linked to the fact that no. ix in Horsley's sequence was a slab then as now immured at Cawder House, Bishopbriggs (*RIB* 2209), and so not part of the Glasgow collection (Anderson 1771, f. 37 notes the error and tells us which stone was meant as Plate IX). The sequence was presumably decided by Robert Simson (Anderson 1771, f. 33).

On his second visit to Glasgow in 1772, the naturalist Thomas Pennant notes: 'Here are preserved, in cases, numbers of monumental, and other Stones, taken out of the wall on the *Roman* Stations in this part of the kingdom . . . Many of these sculptures were engraven at the expense of the university; whose principal did me the honour of presenting me with a set' (Pennant 1774b, 138). Pennant goes on to describe selected stones in some detail. His account was much used by later travellers, who repeat his wording (Lettice 1794, 64–5; Denholm 1797, 104; 1804, 185f.; Laskey 1813, 76f., following Denholm).

The publication of the *Monumenta* can be seen as the culmination of a lifetime's enthusiasm on the part of Robert Simson, who died in October 1768 at the age of eighty. However, the College was fortunate that an enthusiastic and committed successor came immediately on the scene, who was over the next few years to expend time and effort on the preservation and augmentation of the collection. This was John Anderson, Professor of Natural Philosophy (Physics) from 1757 until his death early in 1796 (FIG. 13).

In the 1750s the multi-talented Anderson had set the young instrument-maker James Watt on his way to the invention of the Separate Condenser, made numerous advances and inventions of his own in a variety of fields, including munitions and firearms, and in particular held strong views on the need to broaden higher education to the ever-growing urban masses. Anderson quarrelled, often bitterly, with colleagues he saw as lacklustre and unimaginative, with the result that on his death he left his considerable estate and private collection of scientific instruments to support the foundation of a rival university in the city, the Andersonian, or Anderson's College, which has since evolved into the present-day University of Strathclyde (Muir 1950; Butt 1996). Anderson has been credited with being the driving force behind the publication of the *Monumenta* in 1768 (Hübner 1873, 185; Macdonald 1897, 3; Collingwood & Wright 1965, p. xxiii), but nothing to support this view can be gleaned from the Faculty Minutes. It is only in the aftermath of its publication that he assumes a leading role.

5. THE FORTH & CLYDE CANAL

The collection was soon to receive a boost from discoveries made in the course of construction of the Forth & Clyde Canal, at the forts of Auchendavy, Cadder, and Castlecary. In May 1771, at Auchendavy east of Kirkintilloch, 'in the very middle of the tract' (Anderson 1771, f. 45), workmen chanced upon a large pit, nine feet deep, with a diameter of seven feet at ground level tapering to three feet, from which a number of altars were recovered, just outside the fort to the south (Nos 33–7, cf. No. 59).[29] On 7 June 1771, the Faculty learned of the find: 'They appoint Mr Anderson to go and endeavour to obtain these Stones for the College, or any other Antiquities that may be found in carrying on that Work' (GUA 26690, pp. 29–30). One of the most revealing documents now preserved in Glasgow University Archives is the 'travel and subsistence' claim submitted by Anderson (in his own hand) in the aftermath of his visit, which provides a picture of his activities and the practicalities of recovering the stones (GUA 58282). It deserves to be quoted in full:

Glasgow College Dr [=debtor] to Mr Anderson P.N.P.[Professor of Natural Philosophy] for Money expended by Him in procuring the Antiquities lately found in the Tract of the Roman Wall between Forth and Clyde.

[29]It may be supposed, from Anderson's description, that the workmen had effectively sectioned the pit, thus allowing its measurements to be accurately reported. A torso (No. 59) and two iron mallets were also recovered.

	L.S.D.
June 8th 1771	
Hire of Horses to Achendavy	0-4-0
Drink-Money to the Workmen where the Altars were found	0-10-9
Bill at Kirkentilloch for Horses, & to the Director of the Workmen	0-19-3
June 12th	
Hire of Horses and other Expences during four days in waiting upon some of the Managers of the Canal, viz. Major Chambers near Falkirk, &c., &c.	2-3-6
June 20th	
Twenty three Copies of Memorials for the Members of the Committee appointed by Parl[iamen]t, and others	0-5-6
Thirty one Letters to the Members of the Committee &c. signed by Mr Anderson, which & the Memorials were written by Mr Thomson.	0-5-0
Postages of Answers to Letters, Wax and Gilt Paper	0-8-11
Expences in going to Edin[burg]h to sollicit Sir L. Dundass and in waiting near three Weeks there for a meeting of the great Comm[itt]ee of the Proprietors of the Canal	4-0-0
Expences in returning by Falkirk and Kerse, & Money to the People who took Care of the Altars at Falkirk; they having been carried from Achendavy notwithstanding Mr Anderson's Remonstrances to the contrary.	1-5-0

£10-1-11

Though the journey took place in June–July 1771, it was not until 24 April 1772 that Anderson's claim for reimbursement came before the Faculty: 'An account amounting to £10-1-11, of Money expended in procuring the Antiquities lately found in the Track of the Roman Wall between Forth and Clyde, was laid before the meeting. Mr Muirhead and Dr Williamson are appointed a Committee to examine it and to report' (GUA 26690, p. 64); it was paid on 5 May (GUA 26690, p. 65).

In consequence of the new discoveries, the Faculty minutes report that, on 17 October 1771, 'A Drawing of the four Roman Altars lately found at Auchendavy . . . is appointed to be made upon Copper Plates similar to those formerly made of the Roman Stones at the Expense of the College' (GUA 26690, p. 41). Presumably the excitement generated by the new discovery prompted this informal supplement to the sequence of plates (see also below, p. 31).

A manuscript in John Anderson's hand, datable to 1770–1771 (but with supplementary pages, on religious and historical aspects of the epigraphic material, written probably in the last quarter of 1773), now in the Andersonian Library, University of Strathclyde, is the draft text of lectures on the Romans in Scotland, under the title 'Of the Roman Wall between the Forth and Clyde, and of some Discoveries which have been lately made upon it' (Anderson 1771; 1773). The lectures were given to the Glasgow Literary Society (Anderson 1773, f. 103).[30] The text (of which there is also a 'fair copy') consists of an historical outline, a description of the Antonine Wall and its remains, and an account of the stones known to him, described according to the sequence adopted in the *Monumenta*. The general account of the Wall yields little that is original, drawing as it does upon Sibbald, Gordon and Horsley, though it does incorporate the results of Anderson's personal observations, especially at the time of the construction of the 'Great Canal' between Forth and Clyde; there are some line drawings, by Anderson, of stones newly

[30]According to the Minute Book of the Society, now in the Royal Faculty of Procurators, Glasgow (copy in Glasgow University Library), Anderson delivered one lecture in December 1760; but others belong in 1771.

found at Castlecary (below, p. 28; see Nos 18, 27). We must be grateful for this extended account of personal observation by an interested contemporary source. His account of the stones is effectively a commentary on the *Monumenta*.

Anderson simultaneously prepared a more polished account of the discoveries at Auchendavy and Castlecary, dated 2 January 1773, which was eventually published as an Appendix in General William Roy's *Military Antiquities of the Romans in Britain* (Roy 1793, 200–4). This Appendix (hereafter cited as Anderson 1793) also appeared, updated but with fewer plates, as a separate publication from the press of his friend Andrew Foulis the Younger, signed and dated: 'J. Anderson, Glasgow College, Jan.2, 1793' (sic). This publication appeared only after Anderson's death (Anderson 1800).

The acquisition by the College of the stones found at Auchendavy is also reported under 3 July 1771 in the Minutes of the Forth & Clyde Canal Committee. 'A Memorial for the University of Glasgow setting forth that four Roman Altars of Common Free stone with inscriptions upon them were discovered in Digging the Canal near the east ellum [in error for castellum] at Auchindavy; and requesting that these might be added to the Collection of the Roman stones in Glasgow College; being read. Ordered these four Roman Altars of Common free Stone to be carefully delivered by the Resident Engineer to any person the Memorialists shall appoint to receive the same. And Recommended to the preses [chairman of the meeting] to write a Letter to the Rector acquainting him that it is with pleasure this Committee embrace the opportunity of testifying their respect to his Lo[rdshi]p & the University' (SRO, FCN 1/2, p. 181; cf. Anderson 1771, f. 45). It is interesting that the altars are formally offered to the Rector, the titular head of the University, who at this time was Richard Orde, Chief Baron of the Exchequer. Anderson's endeavours go unmentioned.

From Anderson's own manuscript it is clear that five (rather than four, as above) altars were found together at Auchendavy in 1771 (below, Nos 33–37; cf. Anderson 1793, 204; 1800, 4, 8); the broken altar to Silvanus (No. 37) is regularly ignored in near-contemporary accounts.

FIG. 14. Altars found at Auchendavy, 1771. Copperplate engraving by James Basire, engraver to the Society of Antiquaries of London, accompanying article by Richard Gough. Reproduced from *Archaeologia* iii (1775).

Richard Gough, future editor of a much expanded version of Camden's *Britannia* (Gough 1789), saw the Auchendavy stones at Glasgow in Anderson's possession, and promptly read a paper on them to the Society of Antiquaries of London, on 13 February 1772, which was soon published in the journal *Archaeologia* (Gough 1775; see FIG. 14). One wonders whether this 'scooping' of his find prompted Anderson to write his own formal account. Gough also observed that 'two smaller stones, one inscribed to Fortuna, the other centurial, are in private hands' (1775, 123). He is surely referring here, somewhat inexactly, to discoveries at Castlecary (Nos 18, 27).

Important discoveries were also made at Castlecary. The Minutes of the Canal Committee record under 7 November 1769 that 'on the night of friday the 20th [October] Mr Clerk having been informed that a party of the Companys men who were ordered to look for Stone Quarries had fallen upon some Roman Buildings or Walls near Castlecary Bridge he went there with Mr Mackell on Saturday Morning, and having observed that they had discovered and were pulling to pieces some fine Buildings, he ordered them to take down no more of the Walls. But to continue to remove the rubbish above till the Sense of this Committee should be known. The Stones in this Building are very proper for the purpose of the Canal and easily got. But it would be great pity to pull them to pieces till they are seen by the Curious and Sir Lawrence Dundas the proprietor wrote to on the Subject' (SRO, FCN 1/2, p. 115; cf. Nimmo 1777, 6).

When Anderson was compiling his lecture texts in 1770–1771, he was able to note, in regard to the finds made at Castlecary, that 'Sir Lawrence Dundas has been so obliging as to say to the Lord Rector that he will make a present of them both (sic) and of all the Stones of the same kind which may be found upon his ground to the University of Glasgow' (Anderson 1771, f. 45). The altar to Fortuna (No. 27) and the statuette of Fortuna (No. 54) were at that time 'in the Summer house at Kerse', the home of Sir Lawrence Dundas (now within modern Grangemouth), and the building record of *cohors I Tungrorum* (No. 18, found in 1764) was 'in the brew house at Castle Cary' (Anderson 1771, ibid.). In 1774 they were all presented to the College. Again the most vivid source is in the form of the account subsequently submitted by Anderson to the Faculty for the recovery of his expenses (GUA 58284):

Glasgow College. To Mr. John Anderson P.N.P., Dr [=debtor]

1774 Oct. 5th To packing boxes for the Roman Antiquities given by Sir Lawrence Dundas as per Accompt	£0-7-0
To drink money to Servants at Castle Cary and to people who went errands & assisted in lifting the stones	0-8-6
To expences at Inns during three days and Horse hire for my servant	1-2-6
	£1-18-0

On the same day the College accounts note: 'paid Edward McKinzie for 2 Cart of Roman stones from West Carse to this as agreed on by Mr Anderson, £1-2-0' (GUA 58284).[31]

On 10 October 1774 Anderson made a verbal report to the Faculty about the discoveries at Castlecary, which helps to identify the individual stones and the circumstances and dates of discovery. The stones are itemised as follows:

[31] Just a few days later Robert Tennent undertook painting work as follows: '3 sides of Doors Red where the Roman Stones are Kept (£0-4-6)'; and 'To whitening the Back of the Presses (£0-2-6). To Painting and Gilding Two Boards for the Roman Stones Containing three hundred and fourty Letters (£1-10-0)' (GUA 58284). These are presumably boards displaying the findspots with names of donors, such as appear on the Plates of the 1768 and 1792 compilations.

'A large stone found at Castle Cary in the year 1764, with this Inscription IMP. CAES. T. AEL. AN. AVG. PIO P. P. COHORS. I. TVNGRORVM. FECIT. ∞ [below, No. 18].

A mutilated Altar found a few years ago near Castle Cary and inscribed DEAE [below, No. 28].

A Figure of Good Fortune with a wreath upon her head a Cornucopia in one hand and a Clavus Trabalis in the other [below, No. 54].

A Columnar Altar with the following Inscription upon it FORTVNAE. VEXILLATIONES. LEG. II. AVG. LEG. VI. VIC. P.S.P.L.L. the last two letters being almost totally obliterated [below, No. 27].

The Figure of Fortune and the Altar inscribed to her together with three Stones supposed to be the side of a Nich (sic) were found in the year 1771 [in fact, very probably in 1769; see above] within the Castellum at Castle Cary.' (GUA 26690, p. 258)

The acquisition of the Auchendavy altars (above, pp. 25ff.) prompted some reorganisation of storage arrangements: on 22 October 1771, 'The Roman Stones now standing in the passage at the Greek Class are ordered to be removed to the passage which leads to the two rooms below the University Library, and the Roman Altars lately discovered are appointed to be put in the same place in proper Presses' (GUA 26690, p. 43). On 19 October 1774, Faculty remitted to Anderson the task of finding the stones from Castlecary a secure resting-place within the College: 'Mr Anderson is appointed to deposit the above in the same Press with those formerly recovered from the Proprietors of the Canal between Forth and Clyde with an Inscription having the Donor's name and the places where they were found, and hearty thanks are given to Mr Anderson for his zeal in procuring these Roman Antiquities and such as he formerly got'. The meeting agreed to repay his expenses (GUA 26690, p. 259). A flurry of activity in refurbishing the existing presses is also reported, presumably linked to the new acquisitions and growing size of the collection.[32]

A further discovery, made on the line of the Canal in 1773, is known only through the supplementary pages of Anderson's own manuscript lectures and the Minutes of the Canal Committee: 'In digging the Canal near the village of Cadder close upon the track of the Roman Wall, the workmen found the top of an altar together with an upper and the half of a nether quernstone' (Anderson 1773, f. 103). The Canal Minutes report, under 2 August 1773, that 'There was Read a letter from Mr John Anderson in name and by Appointment of the University of Glasgow Craving that the Committee would be pleased to give the University two Roman Mallets, a Quern, and the Top of a Mutilated Alter found in the Tract of the Canal'. The Committee agreed to present them (SRO, FCN 1/2, p. 344): 'These . . . were in October last given to this University by the Proprietors of the Canal, and are to be deposited in the same place with the former Presents from that publick spirited company' (Anderson 1773, f. 103). The mallets (now lost, but see Roy 1793, pl. xxxviii) were those found at Auchendavy in 1771.

The 'mutilated alter' (probably No. 38) is absent from the 1792 edition of the *Monumenta*; the quernstones are illustrated there, but are said to derive from Auchendavy (University of Glasgow 1792, pl. 26). It is easy to see how the findspots of the various items became confused.

Anderson was soon to quarrel with his fellow professors, but the Faculty's interest in Roman antiquities continued. A locally born author, John Knox, in his unusual volume, *A View of the British Empire, more especially Scotland*, notes the collection at Glasgow as 'highly entertaining to the antiquary' (Knox 1785, 611), and goes on to give an account of the investigation in 1775 of a Roman building discovered by chance on the line of the Antonine Wall at Duntocher, north-west of Glasgow: 'Some professors in the University of Glasgow, and other gentlemen, having unroofed the whole, discovered the appearance of a Roman hot-bath....; in the bath was

[32]On 3 September 1772 an account was submitted 'to altering a key of the Roman stone press' (GUA 58283), on 13 August 1773 another 'to painting the presses for the Roman stones measuring 35 yards at 6d per yard' (GUA 58284); on 17 November 1773 'to a key and oiling the locks of the Roman stone presses' (GUA 58284); on 24 June 1774 a lock on one of the presses was mended (GUA 58284), and on 11 October of the same year a bill was submitted 'to providing a kie and dresing 8 looks for the Roman stone presses' (GUA 58284). Perhaps therefore there were (at least) eight presses at this time. On 12 May 1776, Robert Hood presented a bill 'to cleaning and oiling the locks of the Roman stone presses' (GUA 58274).

placed the figure of a woman cut in stone [No. 66], which, with a set of tiles and other curiosities found in this place, is deposited in the University' (cf. Gough 1789, 362). No record of this archaeological excavation, perhaps the first conducted by Glasgow University staff (but see above, p. 16), appears in the Faculty Minutes. The building was the fort's extramural bath-house, whose position was subsequently marked on Ordnance Survey sheets; the location was rediscovered by chance in 1977, and briefly investigated.

6. THE *MONUMENTA* RE-ISSUED

On 16 February 1788 the Faculty decided to reissue the *Monumenta*, to take account of discoveries made since the initial compilation: 'The Meeting appoint that a new Impression be taken from the Copper Plates, of the Stones found in the Roman Wall, and that some fit person should be employed to make proper drawings of such ancient Stones as have been added to the Collection in Possession of the College since the time that the former Plates were engraved; and that Engravings be made from these Drawings in order to make part of the intended new Impression, and Mr Wilson [Professor of Astronomy] is appointed to superintend the whole of this business; and to get it executed with all convenient speed' (GUA 26693, p. 285).

Sundry craftsmen were employed. James and John Brown submitted a bill considered by the Faculty on 15 October 1788 'for painting and gilding the four Dial Plates of the College Steeple and for painting a variety of other work belonging to the College and for making Drawings of several Stones found in the Roman Wall amounting in whole to £43-17-10d. Mr Cumin, Mr Jardine, and Mr Wilson are appointed a Committee [to assess the account]' (GUA 26693, pp. 351-2). James and John Brown were 'oil, colour men and painters', with a shop at No. 69 Trongate, near the College. James Lumsden, Engraver, based at No. 51 Trongate, undertook engraving and printing, and supplied the paper. His account for £19-8s-6d, a very untidy document, covering the printing of 100 copies of each plate, was submitted on 14 May 1789 (GUA 58305). On 1 June, after a committee found the account 'justly stated and rightly summed', the Faculty agreed that it be paid (GUA 26694, p. 4). In fact the arithmetic is incorrect, the printer having undercharged for his work by one shilling.

The need for a title page now arose, perhaps for the first time. On 2 April 1790 the Faculty Minutes report that 'The Principal is appointed to grant a precept on the College Factor, in favour of Andrew Foulis, for furnishing an Impression of the Title page of the Roman Inscriptions, his accompt for that work amounting to £0-18-10' (GUA 26694, p. 56). Andrew Foulis was the son of Robert Foulis, and the last surviving member of the now all but defunct printing firm. The work of binding was placed in the hands of Dunlop & Wilson, Booksellers, whose account for binding '102 copies of the Roman Antiquities' was presented on 19 June 1792 (GUA 26694, p. 191).

The title-page bore a wordy Latin text:

MONUMENTA ROMANI IMPERII, IN SCOTIA, MAXIME
VERO INTER VESTIGIA VALLI, AUSPICIIS ANTONINI PII
IMPERATORIS, A FORTHA USQUE AD GLOTTAM
PERDUCTI, REPERTA, ET IN ACADEMIA GLASGUENSI
ADSERVATA, ICONIBUS EXPRESSA

'Memorials of the Roman Empire, found in Scotland, especially among the vestiges of the wall laid out under the auspices of the emperor Antoninus Pius, from Forth to Clyde, and preserved at the Glasgow Academy, illustrated.'

By 1 June 1792 the imprint was ready for distribution: '. . . one copy of the Engravings of the Roman Stones to be given to each of the Professors; and they desire the Principal, when he waits upon the Lord Chancellor of this University [James, Third Duke of Montrose], to carry two copies of the said Engravings to be presented, in name of the University, to his Grace;

likewise a copy of the Alphabetical Catalogue of the Publick Library [i.e. the University Library] all handsomely bound' (GUA 26694, p. 245).[33]

It is noticeable that Anderson's name is absent from these proceedings. For some years he had been at daggers drawn with his colleagues, so that some politicking on both sides may be supposed. We might also suspect that some dissatisfaction with the resulting publication of 1792 lay behind the eventual, though posthumous appearance of Anderson's account, with its own plates, much superior to those in the College's own publication (Anderson 1800).

The description of a visit to the College by a Polish Princess, Izabela Czartoryska (1746–1835), on 11 August 1790 has recently come to light: 'We went with Mr Wilson [Professor of Astronomy] to the College, we saw the famous types of the print. They have here perfect English, Latin, Greek and Hebrew types. From there we saw the College of Physics. We saw the stones taken from the wall, known as the Antonine Wall, which was an earth rampart raised by the Romans to hold back the Caledonians. The stones bear inscriptions which show which legion worked there and the name of the centurion. Some of these are made by Roman legions, others by the Spanish soldiers in their pay [No. 47], and even by German mercenaries [No. 18]. There are on others some crude sculptures, which resemble Victories, eagles, wild boars [Nos 1, 5, 8, 10, 16]. In the same spot several stones from tombs were found, one of these with a simple wreath was intended for a young girl [No. 50]. The inscription says that she was the daughter of the captain or commander of a legion. They also found excellently preserved altars dedicated to Jupiter, Diana, Apollo, to the Genii of the country [Nos 35, 33, 34], and to Fortune which is represented by a woman who holds a horn of plenty in one hand [No. 54], and after a poem of Horace, an iron nail in the other, to symbolise that you must nail her down in order to keep her. There is also the emblem of a goddess called Eponime, who after a passage in Tacitus, was worshipped by the Germans [No. 36]. . . . Mr L'Huiller has made a description of the College. The Professor of Physics, a fat and very humorous man, who looked at my feet a lot.' It is not difficult to identify the stones which she is describing, or indeed the Professor of Physics, John Anderson.

Other visitors included the Rev. John Lettice (1794, 64–5), who was shown the collection by 'Professor Cummins' [Patrick Cumin, Professor of Hebrew]. It was described by James Denholm in his 'guidebooks' to Glasgow (Denholm 1797, 104; 1804, 185f.), and by Professor Thomas Reid in an entry on the University contained in *The Statistical Account of Scotland*: 'In an adjoining apartment [i.e. adjoining the Library] the College has placed a number of *mile-stones*, *altars* and other *remains* of *antiquity* which have been discovered in the ancient Roman Wall between the Forth and the Clyde' (Reid 1799, App. p. 48; Hamilton 1863, 738).

Glasgow University Library possesses a single bound copy of the 1768 edition of the *Monumenta*, that presented to William Hunter (above, p. 24), which returned to Glasgow among books bequeathed by him to the University in 1783. The format (foolscap) is larger than that adopted for the later version (1792), of which some twenty copies are held in Glasgow University Library.[34]

From consulting these copies of the 1792 edition, and from scattered references elsewhere, it becomes evident that some additional plates were subsequently prepared (cf. above, p. 26), as new stones were found, with a view presumably to their inclusion in a future edition. Inserted into one of the Glasgow University Library copies (GUL H.7.28) are ink drawings and finished engravings (perhaps proof copies) of two stones (here Nos 11, 12) which we know were discovered in 1812 and in the period 1826–44. In 1837 the antiquarian John Hodgson of Northumberland was sent a copy of the 1792 edition by his correspondent W.D. Wilson of

[33]The present Duke of Montrose retains one of these copies at Buchanan Castle.

[34]One of these copies of the 1792 edition is marked 'College Museum' (GUL H.7.34); another is inscribed 'Hunterian Museum, Glasgow, 1811' (H.7.36). Another, dated 1816, is described as 'belonging to the Room in which are the Fragments of which the following are Engravings', a note signed by 'JC', presumably James Couper, Professor of Astronomy and Keeper of the Museum, 1809–36. In this copy the reverse sides of the pages bearing the plates are extensively annotated in JC's hand with comments derived from Horsley's text, often transcribed verbatim. The notes peter out when Horsley was not available to be quarried, i.e. for post-1732 discoveries. The Hunterian Museum itself holds one copy of the 1792 edition, purchased in the 1980s.

Glenarbach;[35] Hodgson refers to three additional plates it contained (Hodgson 1840, 271, nos ccxc, ccxci, ccxcii), which were of a distance slab found at Braidfield in 1812 (No. 11), an altar found at Castlehill in 1826 (No. 41), and a building record from Bar Hill, probably found before 1796 (No. 19). Glasgow University Library also holds a slim volume of bound drawings of the same three stones, and the following handwritten note on the title page: 'Three Drawings of Roman Monuments, now in the Hunterian Museum, Glasgow. They have been added to the Collection since 1770; about which time, the Volume engraved at the expense of the College, is supposed to have been published. On comparing the Engravings with the Originals in the Museum, some of them were found to be very incorrectly executed—These three drawings (by P. Fyfe) are done with scrupulous accuracy' (Smith 1841). It is the drawings added to form the 1792 edition which were inaccurate, not those prepared by the Foulis Press. In 1860 Joseph Irving, describing the Braidfield stone (found 1812), observes 'this stone is preserved in the Hunterian Museum, Glasgow, and has been engraved in their catalogue of Roman Antiquities' (Irving 1860, 12).[36]

In May 1787, security measures to protect the stones were reviewed, and improved: 'The Faculty, considering that the Roman Stones now placed in the Passage under the publick Library are liable to be damaged by too general access to them, order John McLachlan [the Bedellus] to get the Locks upon the different Presses altered and that in future, there shall be only two keys for opening said Presses, one to be kept by the Principal and the other by the Clerk of Faculty for the time being. And the Principal and Clerk for the better security of these valuable antiquities, are hereby directed never to lend the keys in their Possession, except upon an application in Writing, signed by two Professors' (GUA 26693, pp. 236–7). On 28 April 1795, the belligerent Professor John Anderson (above, p. 25), who had himself added to the collection, wrote to the Principal to express his disquiet: 'The Principal gave in to the Meeting a Letter from Professor Anderson accompanied with a Memorial relating to the better preservation of the Roman Stones in the possession of the College'. A committee was appointed 'to converse with Mr Anderson upon that subject and to make every other necessary enquiry respecting that Business and to report' (GUA 26695, p. 22). As a result a separate committee was soon after appointed 'to consider of a more proper place for depositing the Roman Stones and to remove them if they find it necessary' (GUA 26695, pp. 41–2). We hear nothing more on this matter.

Anderson, now in poor health, died soon after in January 1796. His will, dated May 1795 (Muir 1950, 141), contains two interesting provisions. The first is among the arrangements for establishing his own University in the city: Article Seventh, item 5: 'Mr John McEwen, writer in Glasgow, to be Professor of Roman Antiquities'. In 'Codicil Fourteenth', dated 4 January 1796, just nine days before his death, Anderson instructs his executor: 'To get from Mr Gartshore of Gartshore my Essay on Roman Antiquities and any other stones that he may have found'. The essay is presumably that still surviving in manuscript form at the Andersonian Library, University of Strathclyde (above, p. 26). Mr John Gartshore's lands, east of Kirkintilloch, included the fort at Bar Hill (cf. below, p. 43). An inscribed stone (No. 19) was found there towards the end of the eighteenth century; Anderson's allusion is a valuable indicator of the date of its discovery.

[35]For Glenarbach, see Stuart 1845, 283; it is to be equated with Glenarbuck House, west of Old Kilpatrick.
[36]I have not met with a copy of the 1792 edition bound with any additional Plates. However, in a copy preserved in the Ashmolean Library, Oxford (cxiv.c.28A), with manuscript commentary based on Horsley but exhibiting local knowledge, in what is thought to be a late eighteenth-century hand (Macdonald 1934, 403), the one-time owner has penned some addenda, including details of three stones (below, Nos 3, 19; *RIB* 2121) and the information that 'on the east bank of this Burn, the remains of the Roman Sudatorium No. 33 was discovered'. There is no Plate xxxiii in any surviving copy of the *Monumenta* known to me, but this is clearly a reference to the excavation in 1775 of the bath-house beside the Duntocher Burn, from which the statuette of a water-nymph (No. 66) was recovered (above, p. 29).

7. THE ROMAN STONES AT THE HUNTERIAN MUSEUM

The growing collection of Roman stones had been preserved over the centuries in Glasgow University Library, and later in nearby corridors and passageways, inside their wooden presses. In 1783 Dr William Hunter, native of East Kilbride near Glasgow, former student in the Faculty of Arts, and subsequently wealthy physician and anatomist in London (above, p. 24), bequeathed to the College his substantial and varied private collections, together with sufficient money to build a Museum, soon to be known as the Hunterian Museum after its founder. Erected in the College gardens to the east of the old buildings, and facing towards the High Street, it opened in 1807 (FIG. 15). Antiquities formed only a very small portion of the Hunterian collections, though the latter were rich in ethnographic material from the South Seas, acquired as a result of Captain Cook's voyages to the Pacific in 1768–79. The collection of Roman stones of course predated the foundation of the Hunterian Museum, though they were soon transferred to it, as an entry in the Faculty Minutes for 30 May 1810 makes clear: 'The Faculty having agreed to present the Roman Stones to the Hunterian Museum, Dr Cumin, Mr Mylne, Mr Davidson and Dr Couper are appointed a Committee to see them deposited in it' (GUA 26697, p. 307).

An invaluable picture of the new museum, and the arrangement of collections within it soon after its opening, can be obtained from *A General Account of the Hunterian Museum, Glasgow*, compiled by Capt. James Laskey, an officer of the 21st Regiment of Foot, later the Royal Scots Fusiliers, then based at Dumbarton Castle, and published in 1813 by Glasgow booksellers, John Smith & Son. Laskey reports that the stones were placed in the basement of the new building: 'On the left side of the Hall of the Elephant, near the entrance, an apartment is appropriated for the reception of the Ancient Roman monuments that have been discovered principally in and about the Roman Wall' (1813, 76). The Glasgow University Calendar for 1868–69 similarly

FIG. 15. Exterior of the first Hunterian Museum (1870). Photograph by Thomas Annan. Reproduced from *Glasgow University Old and New* (1891).

states that 'in a side-room at the foot of the stair leading to [the large Hall on the Basement Floor], the visitor will find the inscribed stones that were dug up in the line of the Roman Wall' (University of Glasgow 1868, 56). Presumably the weight of the stones, as well as their peripheral importance to the purpose of the new building, governed the choice of a resting place. From the architect's drawings of the building, we can see that the room allocated to the stones measured (internally) *c*. 23 feet by 13 feet (7 x 4 m). It came to be known as the 'Roman Room' (Buchanan 1883b, 67).

Laskey gives a detailed account of several stones, based on the ordering of the *Monumenta*, and drawing (where he could) almost verbatim on the descriptions of a small number noted by James Denholm (1797, 104 following Pennant; above, p. 25). Laskey's account leaves the modern reader a little uncertain whether the stones were already in the building, or merely destined to be displayed there. Some accounts published in the succeeding decades imply or state that they were still in the Library, but this results from slavish copying of earlier publications (e.g. Wade 1821). In general we might think that visitors' accounts of the University and the new Museum, 'The great Hunterian Museum', in the words of José Vargas, later president of Venezuela, writing in 1813, which he placed ahead of the Prison, the Lunatic Asylum, the Royal Infirmary, and the Cathedral, in that order of precedence, as architecural attractions in the city (Celli 1984, 15), would provide useful insights into the collection during the nineteenth century; but specific references to Roman antiquities are rare (see Cleland 1816, vol. 2, 106; Wade 1821, 18). Indeed one may suspect that the impetus provided by the eighteenth-century professors was not maintained by their successors, for whom other, more novel enthusiasms were preeminent, and that the arrival of Hunter's collections put older acquisitions in the shade.

On Tuesday, 14 August, 1849, Queen Victoria and Prince Albert visited the College, only two weeks' warning having been given. As was normal at that time of year, the running of the College was in the hands of a Summer Committee which undertook thorough and extensive, though rushed, preparations (Keppie 1996, 12–15). The Forehall was redecorated, College servants provided with new uniforms, carpets laid and furniture re-upholstered. Fire engines played hoses on the soot-blackened College facade to clean it. '[T]he Committee could not lose sight of the possibility of Her Majesty, or of Her Royal Consort, extending their inspection somewhat farther, and particularly of the possibility of their paying a visit to the Museum. Here, likewise, therefore, some preparations required to be made, particularly in the way of cleaning, of laying down a stair carpet, and of having the chairs and settees in the Cupola room renovated. The Roman Stones were also taken out, thoroughly washed and arranged around the Museum Court, as an object likely to interest the Prince Consort should he pay a visit to the Museum.' However, the visit to the College itself lasted only a few minutes; most of the preparations were in vain as the committee, with commendable honesty, concluded. The stones went unseen (GUA 26701, pp. 190–4, 199).

In September 1866 Professor Emil Hübner, to whom had been assigned the task of compiling the British volume of the Berlin-organised *Corpus of Latin Inscriptions* (*CIL*), made a visit to Glasgow to see the collection (Hübner 1873, 186); his name appears in the Museum Visitors' Book under 19 September: 'E. Hübner, Professor University of Berlin, Prussia' (GUL MR 27/36). On his return to Prussia, Hübner delivered a paper before the Royal Academy of the Sciences in Berlin on his journeyings to various parts of the British Isles; it was subsequently published (Hübner 1867, 781-806). Hübner noted that the Antonine Wall ran parallel to the railway line from Edinburgh to Glasgow. He went to Edinburgh, to the then National Museum of Antiquities, and consulted Sibbald's papers in the Advocates' Library. At Glasgow College he was courteously received by W.P. Dickson, Professor of Biblical Criticism 1863–1873, then of Divinity, 1873–95. Dickson was also Curator of the University Library, and a translator into English of several of the important works of the Roman historian Theodor Mommsen. Hübner noted that 'The Hunterian Museum has some thirty of the most important inscriptions found along the Scottish Wall' (1867, 795). In the published volume, *CIL* VII, Hübner acknowledged, in the preface to the section entitled *Caledonia*, the help he had received during his visit, and after, from Professor Dickson and from the antiquary John Buchanan (Hübner 1873, 186, 203 on *CIL* VII 1136; below, p. 36).

In 1865 a distance slab was ploughed up on the slope of Hutcheson Hill, between Bearsden and Drumchapel, on the line of the Antonine Wall (below, No. 8). It was sold for £2 by the farmer to a Glasgow lawyer, Mr James Thomson, who had it moved to his office at St Enoch's Square in the city, but the latter soon disposed of it, again for £2, to Joseph Henry McChesney, formerly Professor of Chemistry, Geology and Mineralogy at the University of Chicago, and currently American Consul at Newcastle, who promptly shipped it to Chicago, apparently to be part of a museum, probably at the (old) University of Chicago (Andreas 1886, 815ff.).

The stone was first offered by the Glasgow lawyer to the University, but no interest was shown (so Macdonald 1934, 383f.). We can see the story unfolding in various contemporary sources. On 16 December 1867, the Minute Book of the Glasgow Archaeological Society reports a lecture on the new find by John Buchanan who exhibited to the meeting 'an impression or fac simile of the inscribed face of this interesting memorial, of the full size' (Buchanan 1883a, 14). The Society wrote to Professor McChesney to seek that the stone be placed in the Hunterian Museum. Buchanan's published paper (1883a, 11–28) has an appendix dated 23 November 1869, in which the sending of the stone to Chicago is reported: 'Notwithstanding all these applications and remonstrances, Mr McChesnay (sic) has most unwarrantably appropriated this interesting memorial of antiquity, and has, as already said, sent it to America.' However, J. Collingwood Bruce, a Glasgow graduate (M.A. 1825; Hon. Ll.D. 1892) and long-serving secretary of the Society of Antiquaries of Newcastle, succeeded in having a number of plaster casts prepared, one of which was presented to the Glasgow Archaeological Society and subsequently placed in the Hunterian Museum. On 1 February 1870, the Minute Book of the Society notes balefully: 'It is much to be regretted that so valuable a memorial should not have been placed in the Hunterian Museum as was much desired. In these circumstances the Council think it right to place on record the resting place of this truly national historical monument in case of future reference and to preserve evidence of its identity' (GUA DC 66 2/1/1, p. 66). The tale was promptly communicated by Dickson to Professor Hübner in Berlin, with the news that the slab had been destroyed 'in the recent fire' which devastated the centre of Chicago on 8–10 October 1871 (Hübner 1873, p. 313).[37]

8. THE MUSEUM COLLECTIONS AT GILMOREHILL

By the mid-nineteenth century the University of Glasgow's fine mediaeval buildings were falling into decay; moreover, they were now too small for the much enlarged classes and ever expanding range of disciplines taught within its walls. The carrying on of an educational establishment amid the industrial grime and pollution of the Victorian industrial city had become too repugnant to the professors. The College and its grounds were sold to a railway company, and in 1868–70 new buildings were erected on Gilmorehill, in the then western outskirts of the city, high above the River Clyde (FIG. 16). The old College buildings were demolished, as was the relatively new Hunterian Museum. The collections, including the Roman stones, were transferred to the new premises. A contemporary account refers to a convoy of carts and wagons, provided by the railway company, progressing through the streets of the city (MacUre 1872, 656). Jemima Blackburn, wife of the Professor of Mathematics, recorded in watercolour a scene outside the old Museum, where carts are piled high with some of the stuffed animals from the zoological collections (Fairley 1988, 159). There is no record of the moving of the Roman stones, although the Report of the 'Removal Committee', published in 1877, prides itself that no damage was sustained to any parts of the collections, the library's books, or laboratory equipment (Removal Committee 1877, 21). The last entry in the old Museum Visitors' Book is for 2 February 1870 (GUL MR 36), the month during which the Removal Committee notes that packing began

[37]The (old) University of Chicago, which, it is suggested above, was the intended resting place for the slab, suffered in the fire; when the University closed in the 1880s its Museum collections were transferred in part to the Field Museum of Natural History and in part to the Oriental Institute; but neither institution has any record of the slab being on its premises.

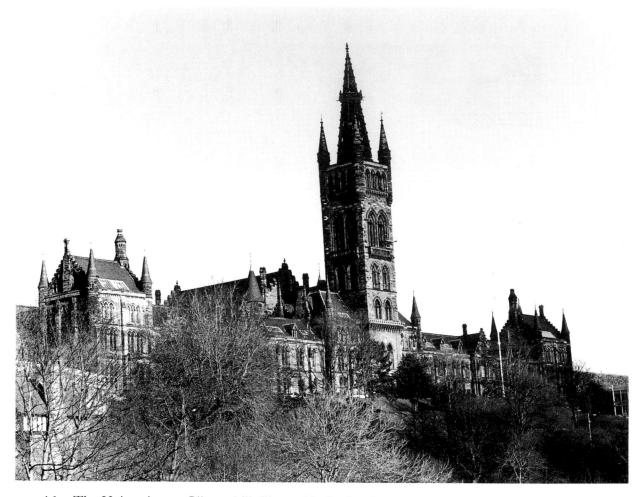

FIG. 16. The University on Gilmorehill. Photo: Media Services Unit, Glasgow University.

(1877, 21, 32). The move of the collections began in May of that year and was complete by the middle of August.

The Museum collections were assigned halls on two levels on the north side of the east quadrangle of the new buildings (matching the two floors assigned to the Library in the west quadrangle). As the fitting out of these halls was incomplete in 1870, the collections were stored in attic spaces. However, in the absence of suitable accommodation for official ceremonies and divine worship (the University's Bute Hall was not built until 1882, and the University Chapel not completed until 1929), the lower hall originally intended for the Museum (it is still known as the Hunter Hall) was assigned temporarily for that purpose. In fact, it was never handed over to the Museum, which was thus confined to the upper floor. By 1876 arrangements were complete and the Museum 'took possession of the new Halls' (Young 1889, 1–3).

An intriguing sepia photograph, unsigned and undated, long preserved in the Museum, shows a group of Roman stones deliberately placed for the camera, some resting on packing cases marked 'Keeper of the Hunterian Museum' (FIG. 17). In the background others of the stones can be seen, arranged on simple racking. The photograph almost certainly belongs to 1872 (see below); prominently featured are two sculptures from Arniebog (No. 17), which probably reached the Museum in that year at the earliest.

In October 1871 John Buchanan, Glasgow banker, one of the founder members (in 1856) and later Vice-President of the Glasgow Archaeological Society (FIG. 18), presented to the University various items from the Antonine Wall: 'A letter was read by Dr W.P. Dickson from Mr John Buchanan, Banker, presenting to the Senate two inscribed stones from the Roman Wall and several other objects of Antiquarian interest. The Senate request the Principal to thank Mr Buchanan in their name for his very interesting and valuable Donation' (GUA 26708, p. 176).

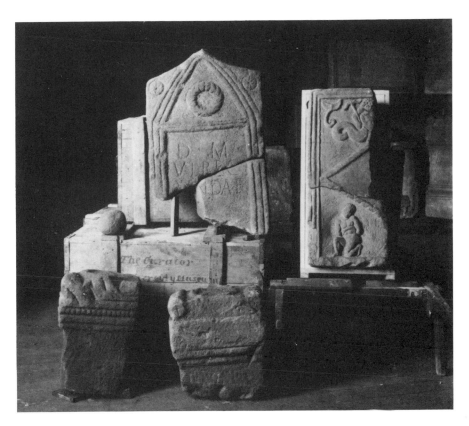

FIG. 17. A selection of inscribed stones, at the time of their transfer to the new Hunterian Museum. Photograph, probably 1872 by Thomas Annan (see p. 42). Hunterian Museum.

The donation consisted of two distance slabs (Nos 3, 7), an altar whose inscription was all but illegible (No. 42), a column capital (No. 72), an uninscribed altar (No. 45), two quernstones, and the head of an eighteenth-century statue, the latter apparently now lost. A letter in Buchanan's handwriting details his gift (GUL MR 50/49). The University soon after awarded him the honorary degree of Doctor of Laws (Anon. 1886, 49). The appreciation of his life in *One Hundred Great Glasgow Men* (Anon. 1886, 49-50), records that 'He knew every foot of our Roman Wall, and on it and the Roman occupation of Britain he wrote papers whose value was acknowledged in this country and on the Continent'. From his own writings we know that Buchanan walked the length of the Wall in 1826 and on other occasions (Buchanan 1858, 32), and that he was on hand in a vain attempt to rescue Roman material at Castlecary when the fort was cut through by the Edinburgh to Glasgow railway in 1841 (Stuart 1852, 348 fn). He was a prime mover and influence on Robert Stuart, whose *Caledonia Romana*, published posthumously (1845) after the author's premature death from cholera, brought together the improvements in knowledge over the previous century. Its second edition (1852) incorporated numerous footnotes by Buchanan, which reflected his lifetime's watch and ward along the Forth–Clyde frontier line.[38]

Buchanan had devoted considerable time and trouble, over many years, to the acquisition (sometimes by purchase) of Roman antiquities, which he kept at his Glasgow house. A footnote in Professor Daniel Wilson's invaluable *Archaeology and Prehistoric Annals of Scotland* is particularly revealing: 'The preservation of this Scoto-Roman relic [No. 7, found 1847] is due to the zeal of John Buchanan, Esq., its present possessor, who secured it after it had been in vain offered to the curators of the Hunterian Museum, as an appropriate addition to its Roman collection' (Wilson 1851, 377 fn.1).

[38]Preserved in Glasgow University Library is a copy of the first edition of *Caledonia Romana* (1845), with interleaved blank pages on which are manuscript notes by Buchanan and by Daniel Wilson (then Secretary of the Society of Antiquaries of Scotland, later Professor of History and English Literature at Toronto; see Ash 1981), which were incorporated as footnotes in the second edition

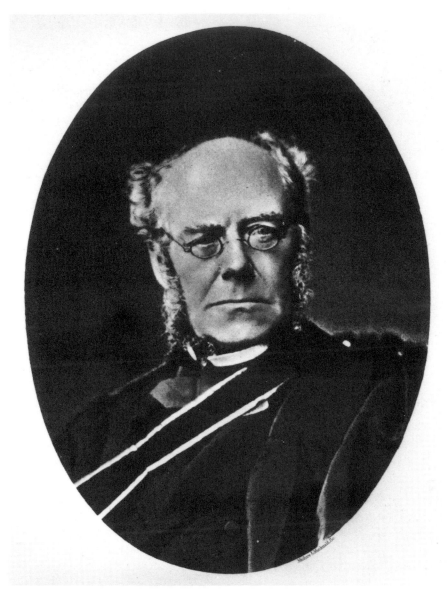

FIG. 18. Dr John Buchanan, banker and antiquary, reproduced from *One Hundred Great Glasgow Men* (1886). Glasgow University Library.

The Senate Minutes of 16 October 1871 (GUA 26708, p. 176; above, p. 36) indicate that the University was grateful for Buchanan's gift, but a much later minute (of 7 July 1899) reveals that the devotion to Roman antiquities was perhaps not so prominent as it had been in previous centuries: 'Dr Young [Professor of Natural History, Keeper of the Museum, 1866–1902] mentioned that in 1872 [sic] an inscribed stone from John Buchanan's Collection had been sent to the Museum by his representatives and in Dr Young's absence placed in the basement but not reported to him; that thereafter the basement was occupied as a joiner's shop and the stone lost sight of, till Mr Stitt lately asked Dr Young to remove materials belonging to the Museum exposed by the clearing away of joiner's lumber. The Stone was that from Westermains [No. 3], supposed to have been lost, and thus unfortunately wanting from Mr Macdonald's Tituli Hunteriani [the catalogue of 1897, see below]. The stone had never been in the Museum and thus was not photographed by the late Thomas Annan' (GUA 26717, p. 162). In general one may conclude that the University, then preoccupied with the move to new buildings, and with ever broadening educational horizons, was not then holding its Roman collections as a particular priority.

Before the Bute Hall was built to link the north and south ranges of the new University

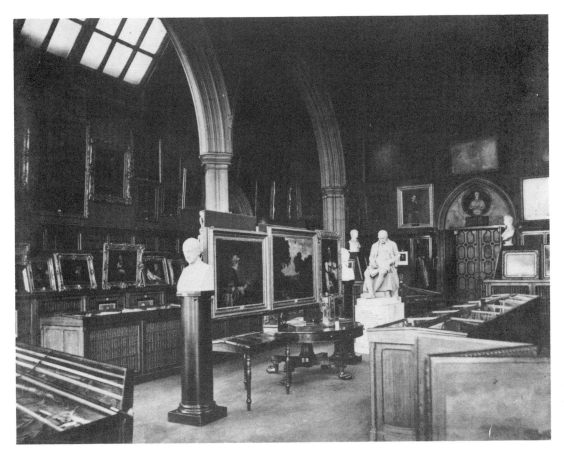

FIG. 19. The interior of the Hunterian Museum on Gilmorehill, showing pictures, sculpture and cases containing William Hunter's library. Photograph by Thomas Annan. Reproduced from *Glasgow University Old and New* (1891).

buildings, access to the Museum was gained by a 'temporary wooden stair' (Removal Committee 1877, 23), and it was on the landing outside the Museum's main doors that the 'interesting inscribed stones, altars etc from the Roman wall' were first placed (Removal Committee 1877, 33). Presumably they were protected by a roof or cover, but no contemporary photograph is available of these arrangements. There was certainly 'an entrance porch', in which details of recent accessions were displayed (University of Glasgow 1874, 74; this entry is repeated by the University Calendars annually, until the session 1880–81, after which, with the building of the Bute Hall, the porch was presumably swept away). By the early 1880s it can be assumed that the stones were moved from this location, to allow building work on the Bute Hall and associated apartments to be undertaken. A letter of November 1884 to the *Glasgow University Review* (signed by 'Y') complains that the Roman stones were not then on view: 'While in the Hunterian Museum lately I looked for but could not find the antiquities referred to. They are surely worthy of exhibition (provided that they are still in the possession of the University). Could anyone give information as to them and the Hunterian coins?' (*Glasgow University Review* November 1884, vol. 1, 3, 96). Most probably they then stood in the adjacent University library, for on 6 November 1884, 'Dr Young [the Keeper] stated that the Museum Committee deemed it advisable to remove the Roman Stones from the Library into the Antiquities Room and, for safety, to range them round the walls. Dr Young was authorised by the Senate to employ the College Servants in the removal' (GUA 26713, p. 67). One wonders whether the letter prompted this sudden activity. This room soon came to be known (like its predecessor in the first Hunterian Museum building) as the 'Roman Room'.[39]

[39]In 1888 some of the Roman stones were included in the Archaeological Section of the Glasgow International Exhibition, along with the University mace and John Anderson's model Newcomen steam engine (GUA 26714, p. 109).

FIG. 20. John Young, Professor of Natural History and Keeper of the Hunterian Museum, 1866–1902. Photograph by Thomas Annan. Reproduced from *Glasgow University Old and New* (1891).

A record of the old and new University buildings, published in 1891, illustrated with photographs by Thomas Annan, includes views of the Museum interior (FIG. 19), but the Roman stones are not visible (Stewart 1891). It must be likely that they remained out of sight of the camera.

9. *TITULI HUNTERIANI*

The preparation of a fresh catalogue of the now enlarged collections was evidently long on the mind of the Keeper of the Museum, Professor John Young (FIG. 20). The Minute Book of the Glasgow Archaeological Society reports on 2 February 1869 that 'Dr Young concluded [a lecture] by referring to the Roman collection and regretted that no satisfactory plates of its contents had been prepared, those already published being defective. He contemplated a series of photographs, which being carefully done and accompanied by descriptive letterpress, might form a volume worthy of dating in the first year of the new university' (GUA DC 66 2/1/1, p. 60). Photographs were in fact taken in 1872 (below), but no publication appeared at that

FIG. 21. Dr James Macdonald, author of the *Tituli Hunteriani*. Photographed when Rector of Kelvinside Academy. Reproduced from D.M. Low (ed.), *Kelvinside Academy 1878–1928* (Glasgow/Edinburgh, 1928).

time. On 19 April 1878 Young delivered a lecture to the Glasgow Archaeological Society on 'The Asiatic Style of Ornament on Stones in the Antonine Wall' (GUA DC 66 2/1/1, p. 124). The lecture was not published in the Society's Transactions, but, from its title, the talk presumably included discussion of the *pelta*-motif which decorates the distance slabs and other building records (below, p. 62).

In the early 1890s James Macdonald (FIG. 21), author of several articles on the Roman occupation of southern Scotland, and Rector of Kelvinside Academy, Glasgow (1883–95), prepared a brief account of the stones, under the title 'The Roman Room of the Hunterian Museum, University of Glasgow', which was published in the course of 1895 in the short-lived magazine *Scots Lore*, in a series of four short contributions, which were subsequently reprinted as a separate booklet 'for private circulation' (Macdonald 1895). The account is brief, and without illustrations, but it serves as a valuable record of the contents of the Room at a fixed date. Professor Young evidently realised that this booklet could form the written part of the catalogue for which he still retained Thomas Annan's photographs. The resulting compilation, under the title *Tituli Hunteriani, an Account of the Roman Stones in the Hunterian Museum, University of Glasgow*, appeared in 1897–98, published by T. & R. Annan & Sons. Macdonald's

own introduction modestly refrains from any reference to his own previous publication (Macdonald 1897, vii–ix), noting only an original intention to produce a 'Handbook to the Plates', subsequently expanded to a fuller account with help he had received from others', especially from Francis Haverfield, Camden Professor of Ancient History at Oxford, who had visited the collection in 1893 (along with Professor Sir W.M. Ramsay of Aberdeen, eminent epigrapher of Anatolia), and to whose notes James Macdonald assigns the sole scholarly merit of his own contribution (Macdonald 1897, vii; Glasgow Archaeological Society 1899, 5).

The preparation of the catalogue was heralded in a Report to Senate of the Museums Committee on 20 December 1894: 'The Court granted permission to the Keeper and Messrs Annan to publish photographs of the Roman stones illustrative text (sic). The engraved catalogue issued in 18[vacat] (!) being now out of print as well as incomplete [see above, p. 31], Dr James Macdonald has kindly undertaken the preparation of the text' (GUA 26716, p. 76). The story is continued in a further Report dated 1 April 1897: 'The MS has been placed in the hands of Messrs Annan; the work will therefore soon appear. Before that event, however, the Keeper asks special acknowledgement now of the generous action of the late Mr Thomas Annan, who, at Dr Young's request, in 1872, photographed the stones before they were placed in the Museum. The photographs were most carefully done, and without this the present publication would be inferior to its promise, for the difficulty of photography in the Roman Room is great' (GUA 26716, p. 291).

To the modern reader the text seems the more important element, with the photographs, placed together at the back, serving merely to illustrate it. This was not however how the publication was viewed in the 1890s. The Senate Minutes imply that the text was seen as an appendage to the photographs, which constituted an update on the copperplate *Monumenta*, using a different medium (GUA 26717, p. 49). The flyer issued to elicit subscribers promised 'photogravures of the best style of art, and [which] represent each stone, as it now is, with the utmost distinctness and accuracy'.[40] It also boasted that Professor Haverfield 'has obligingly read the proof sheets'.[41] Two hundred copies were printed, and the book was put on sale at 15 shillings (Neilson 1901, 107f.). On 14 July 1898 it is reported that 'Dr Young handed over to the Hunterian Library the presentation copy of the *Tituli Romani* just issued, and suggested that the Court should be asked to take copies of the work for presentation to the more important foreign libraries' (GUA 26717, pp. 14, 35). An anonymous but well-informed reviewer writing in the London journal *The Athenaeum* (19 Feb. 1898) notes that 'Since [the publication of the *Monumenta*] some more stones have been acquired, but the University seems to have taken no interest in them beyond providing shelter', that the collection now numbered forty-five stones, and that one stone is 'altogether omitted without explanation' (No. 3; for the reason, above, p. 38).

The publication of *Tituli Hunteriani* reawakened interest within the University, as scrutiny of the Senate Minutes reveals. On 21 July 1898, 'Dr McVail [a member of the Museum Committee] suggested that, with a view to the better display of the Roman Stones, they should be exhibited on the west wall of the landing outside the present room, protected by plate glass, the space being sufficient' (GUA 26717, p. 53). On 1 December the matter was discussed, and 'the scheme approved generally' (GUA 26717, p. 89). Thus they were placed on the landing outside the Museum's main door, against the wall. Moreover, on 24 March 1899, among various reported donations was 'a set of the photogravures of the *Tituli Romani* by Messrs Annan, to be arranged by the Convener in a case on the north wall of the Museum staircase as a guide to the inscribed stones now exhibited in cases on the west wall' (GUA 26717, p. 131). The photographs themselves have long since disappeared. On 6 April 1899 the result of this activity was warmly commended in the Senate Minutes: 'The *Tituli Romani* by Dr James Macdonald in illustration of the Annan Photogravures, issued some time ago, has had its usefulness increased by the exhibition of the Stones in glazed cases on the Museum staircase, while the photogravures

[40]Currently preserved in GUL Mu.-a.4, at p. 289.
[41]Though the title page of the Macdonald catalogue bears the year 1897, the proofs were still in the hands of the printer in December of that year (GUA 26716, p. 358), becoming available to the public in February 1898 (GUA 26717, p. 35).

presented by Messrs Annan have been arranged in a frame on the north wall for reference' (GUA 26717, p. 141). Again we see that Macdonald's text was subordinated to the photographs, which, as a fairly new technological development, got pride of place (cf. Neilson 1901, 107). The transfer of the stones left the Roman Room empty, so that on 7 July 1899 it was suggested that the newly donated collection of Etruscan pottery presented by Mr and Mrs Campbell of Tullichewan would fill 'the room formerly occupied by the Roman Inscribed Stones' (GUA 26717, p. 162). Consideration was postponed meantime. It must be presumed that the display on the stairs was seen only as a temporary exhibition, and that the stones would return to their former home before too long. The stones were still on the landing in 1901: '. . . the museum, where most of them stand in two large cases which face the visitor on the stair landing by which the inner door of the museum is approached . . . There are in the Museum upwards of forty vallum stones' (Neilson 1901, 107f.).

10. THE TWENTIETH CENTURY

The final few years of the nineteenth century and the opening years of the twentieth witnessed a succession of excavations undertaken at Roman forts along the Antonine Wall, and elsewhere, under the auspices of the Society of Antiquaries of Scotland and, later, the Glasgow Archaeological Society; the finds went to augment the collections held at the National Museum of Antiquities, Edinburgh, or the Hunterian Museum, Glasgow. In November 1902 excavation began at Bar Hill fort on the Gartshore Estate, by this time the property of Mr Alexander Whitelaw. The estate factor, Alexander Park, oversaw the work on behalf of the absentee owner, drawing upon the help and advice of Dr (later Sir) George Macdonald. Copies of letters from Park to the landowner, to Macdonald and others, long preserved at Gartshore House, and now in Glasgow University Archives, reveal details of the progress of the work between 1902 and 1905, discussion of the more interesting finds, the conservation of leatherwork and of an altar (No. 31), the reception at the site of distinguished visitors (the Glasgow–Edinburgh express train was halted several times at Lenzie Station near Bar Hill, by special arrangement, to allow Professor Haverfield and Dr Macdonald to alight or board there), and progress towards formal publication of the results of the work (Macdonald & Park 1906). In January 1903, Principal Story wrote from Glasgow University to seek the deposition of the finds at the Hunterian Museum, a course of action that Park firmly opposed. 'As you know [he wrote to Whitelaw], they have a very large collection of Roman stones in the Hunterian, but nobody so far as I have been able to find goes to see them—the place is so much out of the way' (GUA UGD 101 2/10, pp. 718–19). Park consulted Dr David Christison, Secretary of the Society of Antiquaries of Scotland, with a view to their being despatched instead to Edinburgh (GUA UGD 101 2/10, p. 872). Whitelaw himself must have demurred, since the finds remained in the stable block at Gartshore House, before eventual presentation to the Hunterian some thirty years later.[42]

On 11 July 1908, members of the Society of Antiquaries of Newcastle and the Glasgow Archaeological Society made a joint visit to the Hunterian. 'The company met at 10 a.m. in the Hunterian museum, Glasgow university, where they were welcomed on behalf of principal MacAlister by professor Cooper [Professor of Church History] . . . On the stair landing at the entrance to the museum, the inscribed stones from the Antonine Wall are collected in large cases. A preliminary examination of them was made by the party, which included many of those who had taken part in the proceedings of the previous day [visits by rail and carriage to Rough Castle and Bar Hill forts on the Antonine Wall]. Dr George Macdonald had decided, as the best way of expounding the inscribed stones, to show them by photographic lantern slides, as the position of the stones themselves on the staircase landing facing what little light there is from the staircase window, makes it very difficult to read the inscriptions. For this purpose the company adjourned to the Zoological laboratory' (Anon. 1908, 232). In 1910 Dr George

[42] The present writer plans an article on this newly discovered correspondence, to mark the centenary of the Bar Hill excavations of 1902–5, to be offered to the *Glasgow Archaeological Journal* for publication in due course.

Macdonald delivered at Glasgow a series of Dalrymple Archaeological Lectures on the Antonine Wall, which formed the basis of *The Roman Wall in Scotland*, published in the following year; one lecture was devoted to the inscribed stones (Horne 1910, 272; Macdonald 1911, vii). In 1911 two inscribed stones (Nos 20, 31), three busts (Nos 55–57), a number of columns, and other material from Bar Hill, all still in private hands, were loaned for exhibition in the Palace of History, part of the Scottish Exhibition of National History, Art and Industry, held in Glasgow (Glaister *et al.* 1911, 953ff.).[43]

In 1913 it was proposed to move the stones from the landing to the 'Antiquarian Room' (i.e. the former Roman Room), but the plan was postponed, presumably because of war conditions, and not implemented till 1919 (University of Glasgow 1913, 109; 1919, 90). A decade later they were transferred to what was to be their home for fifty years, on racking at the west end of the Museum's main hall, perhaps because the collection had outgrown the available space (University of Glasgow 1928, 46; 1929, 47). Professor Anne Robertson recalled in 1995 that, while working as an assistant in the Museum in 1932–33, she witnessed some stones being moved into position on the racking in the main hall, to join the majority already there; at which time she offered advice on their positioning. The stones appear on this racking on a photograph dated 1938, and on subsequent photographs, with minor changes in their positions.

On 27 February 1935, Professor G.Q. Giglioli, Director-General of the *Mostra Augustea della Romanità*, wrote from Rome to Professor T.H. Bryce, in his capacity as Honorary Keeper of the Museum, seeking plaster casts of eight stones (Nos 1, 11, 13, 16, 22, 34, 35, 41) for inclusion in an exhibition at Rome to commemorate the Bimillennium of the birth of the Emperor Augustus (Giglioli 1937, 486; Room xvi no. 193; xvii nos 31, 54, 91, 92; lvii no. 13; lviii no. 26). Giglioli had evidently already been in correspondence with Sir George Macdonald, who had recommended Messrs Giusti, a local firm in Glasgow capable of undertaking the work (GUL MR 55/16). Messrs Giusti were 'moulders and figure makers', based at No. 328 Saint Vincent Street, Glasgow. In 1955, the casts were incorporated in a permanent museum, the *Museo della Civiltà Romana*, in Rome's EUR suburb, and were seen there by the present writer (before large sections of that museum were closed to the public) in the early1970s.[44]

In earlier generations the stones, and indeed from 1807 substantial non-medical parts of the Hunterian collections newly arrived from London, were largely seen as decorative and entertaining, but lacking any educational role. However, from the early decades of the twentieth century the stones formed an object of study in Roman History classes conducted first by S.N. Miller, lecturer in Roman History 1912–44 and the excavator of Balmuildy and Old Kilpatrick (who also held the title of Curator of the Roman Collection in the Museum, 1932-44), and by A.R. Burn, lecturer and subsequently Reader in Ancient History, 1946–69. The appointment of Miller in 1912 was signalled by a fresh entry in the University Calendar: 'Tutorial classes will also be formed to study texts and inscriptions, and the archaeology of Roman Scotland' (University of Glasgow 1912, 79). At first the class was offered to second-year students, but later it was transferred to the Honours (third-/fourth-year) syllabus. In the course of the 1931–32 session, J.E. Harrison, a student of the Roman History class under Miller, suggested a fresh interpretation of the text of one of the distance slabs (No. 3; see below, p. 75), which was communicated by Miller to Sir George Macdonald and incorporated in the second edition of *The Roman Wall in Scotland* (1934, 368 n. 2).[45] Today the stones are also the subject of a practical class for first-year students of the Department of Archaeology, and a centrepiece in activities for school classes of all ages.

The preparation of *The Roman Inscriptions of Britain*, planned by Francis Haverfield, brought its long-serving editor, Professor R.G. Collingwood of Oxford, to Glasgow in 1922, when he

[43]Some loans were also made to the Empire Exhibition, Glasgow in 1938 (Official Guide 1938, 119).

[44]A similar request to the Senhouse family, owners of the very substantial collection of inscribed and sculptured stones from the fort at Maryport, Cumbria, led to one altar (*RIB* 831) being despatched to Rome, presumably in the absence of local facilities to make a replica; it was never returned.

[45]Macdonald subsequently presented a signed copy of the book to Mr Harrison, which is still preserved by its recipient, along with an accompanying letter, dated 18 July 1933, and another letter of Macdonald to Miller formally commenting on the suggestion. Mr Harrison kindly supplied photocopies of these letters in July 1997. The present writer was a member of the same class in 1967–69.

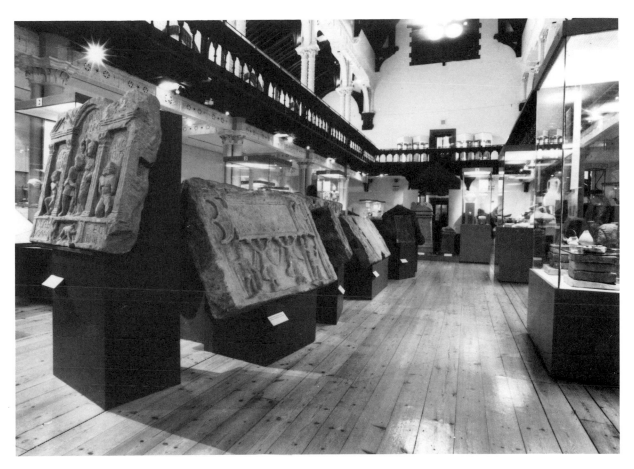

FIG. 22. Inscribed stones shown as part of exhibition 'Roman Scotland: Outpost of an Empire', in the main hall of the Museum, 1997. Photo: Media Services Unit, Glasgow University.

drew most of the stones, and his collaborator and successor, Dr R.P. Wright, in 1948, 1954, and 1956, when the latter completed the necessary drawing work (Collingwood 1939, 145f.; Collingwood & Wright 1965, v–vi).[46]

In 1976 the stones were washed in distilled water, and in 1979 cleaned with a detergent recommended by the National Museums of Scotland, possibly for the first time since 1849 (above, p. 34). This changed the colour of many stones from black or dark grey (presumably the result of storage and some degree of pollution from their long sojourn in Glasgow's Victorian industrial centre) to yellowish-buff. Paradoxically this has made some harder to photograph, as a dark uniformity has given way to variegated colours, the results of iron-staining.

The stones were finally removed from the racking, and mounted on individual plinths, for the visit to Glasgow in 1979 of the 12th International Congress of Roman Frontier Studies (the *Limeskongress*). They have since been displayed in several locations within the Museum, and currently (1997) have a central position in the main hall, as part of the exhibition 'Roman Scotland, Outpost of an Empire' (FIG. 22). In 1994 those stones not on display were transferred to outlying storage, but are now more easily inspected than for many years. Some of the stones can now be accessed via the Museum's Web Site at *http://www.gla.ac.uk/Museum*, some with audio clips of the Latin inscriptions and, very soon, Quicktime Virtual Reality sequences.

The survival of much information about the collection through the centuries, from the arrival of the first stone in the 1680s to the present day, allows us to view its gradual expansion. The

[46]The full-size contact drawings prepared by Collingwood and Wright are now in the Centre for the Study of Ancient Documents, Oxford. Notebooks compiled by Haverfield and Collingwood, now in the Ashmolean Library, document epigraphic itineraries. Collingwood was at the Hunterian Museum from 23 to 26 August 1922; a sketch in his Notebook for that year (no. vi, f. 47) shows the general layout of stones in the Roman Room. The Ashmolean Library also holds a card index of inscribed stones with comments by both Collingwood and Wright. For their methods of working, see Wright 1955; Collingwood & Wright 1965, pp. xiii–xviii.

Monumenta of 1768 included twenty stones, the extended version of 1792, thirty-two (including querns); Laskey (1813, 6) states that there were 'not fewer than 33' in 1813; Hübner lists 'about 30' inscribed stones (1867, 795); James Macdonald reports 'upwards of 40' in 1897 (of which thirty-six were inscribed); at the time of the visit by the Society of Antiquaries of Newcastle in 1908 there were 'not fewer than 38' inscribed stones (Anon. 1908, 232). At present the collection, catalogued here, comprises forty-six inscribed stones and thirty-four sculptured stones, including architectural fragments.

CHAPTER TWO

THE CONTENT OF THE COLLECTION

1. THE HISTORICAL CONTEXT

The collection of Roman inscribed and sculptured stones at the Hunterian Museum consists wholly of material recovered over the last four centuries, either by chance discovery or, in more recent times, by organised archaeological excavation, at or near Roman installations in central and southern Scotland.[1] As such it relates to the brief periods of Roman occupation of the northern half of the island of Britain in the later first, mid-second, and early third centuries A.D., that is to the Flavian, Antonine, or Severan periods. In fact the great majority of stones manifestly relate to the construction of the Antonine Wall or the occupation and use of forts and other installations along its line, or of forts built at the same time along routes of communication between central Scotland and the Tyne–Solway isthmus. A single stone (No. 47), from Ardoch in Perthshire, can be plausibly assigned to the Flavian period of the later first century. An altar from Old Kilpatrick (No. 43) has been dated by some scholars to the Severan reoccupation of the early third century, but in my view on as yet insufficient grounds (see discussion at p. 110).

The construction of the Antonine Wall is reported in a biography of Antoninus Pius written some two centuries later: *Britannos per Lollium Urbicum vicit legatum, alio muro caespiticio summotis barbaris ducto* (Scriptores Historiae Augustae, *Vit. Ant. Pii* 5.4): 'He won a victory over the Britons through his legate Lollius Urbicus, having driven back the barbarians and having built another wall, of turf' (Macdonald 1934, 1ff.; Hanson & Maxwell 1983, 59ff.). By December 142 the emperor Antoninus had taken his second imperial salutation as *imperator II*, to mark the success in northern Britain and the extension of the province. This salutation is reported on coins issued in 142-44, which depict on the reverse a figure of Victory with a laurel wreath and the letters BRITAN. Antoninus took no other such salutations in the course of a twenty-three-year reign, though the frontiers were advanced in other provinces, which should indicate that the northwards advance in Britain was seen as a very special achievement. The designation *imperator II* is not found on any of the inscribed slabs from Scotland.

The Antonine Wall was occupied for only a brief period, perhaps no more than twenty years, in the mid-second century A.D. Currently most specialists suppose that the Wall was abandoned *c.* A.D. 163–65, when troops were withdrawn to bolster campaigns in the Middle East and subsequently to counter military reverses on the Danube frontier.

Traditionally this Antonine occupation of southern and central Scotland has been subdivided into two phases, Antonine I (142–155) and Antonine II (158–*c.* 163 or later), but a recent study has emphasised that many forts witnessed only a single phase of occupation, with varying evidence of refurbishment or reconstruction (Hodgson 1995). It seems clear, however, from both epigraphic and sometimes ceramic evidence, that the garrisons of some forts did alter, but the change may have occurred very early in the lifetime of a fort, perhaps already in A.D. 142–43 when the number of forts along the line of the Antonine Wall was substantially increased and

[1]Excluded from this catalogue are numerous building stones, voussoirs and other items without sculptural decoration beyond simple mouldings, from such sites as Bearsden, Bar Hill, and Balmuildy. Also excluded here, of necessity, is an inscribed ash-chest in Carrara marble, probably from the city of Rome and perhaps a souvenir of the Grand Tour, presented by Sir George Campbell in 1974.

garrisons spread more thinly than before. Some forts have yielded evidence of two regiments of auxiliaries, either as builders or (apparently) resident garrisons over a long period, or of legionaries as well as auxiliaries (for the details see Hanson & Maxwell 1983, 152ff.). The temptation is to see such units as garrisons in successive periods, but the evidence needs to be scrutinised with care, and not pressed too hard. In the catalogue entries (below, pp. 71ff.) reference will be made to 'primary' and 'secondary' garrisons, without associating these changes with particular constructional phases, unless the evidence seems secure.[2]

Whichever precise scenario is accepted, this relatively secure context within the Antonine period helps to date the inscriptions, rather than vice versa; most inscriptions include no exact date, except that building records regularly begin with a dedication in honour of the reigning emperor Antoninus Pius (who succeeded Hadrian in A.D. 138 and died in 161). Q. Lollius Urbicus, from Cirta in modern Algeria (though descending perhaps from an Italian family long resident there), was governor of Britain (*legatus Augusti pro praetore*) from *c.* A.D. 139–43; he later became Prefect of the City of Rome (A.R. Birley 1981, 112–15). Lollius' name appears inscribed on building records, one datable to A.D. 139–40 at Corbridge (*RIB* 1147–1148) and at High Rochester (undated, *RIB* 1276), Northumberland. On the line of the Antonine Wall the governor is named on two slabs (Nos 22–23), both recording building work by legionaries at Balmuildy fort, but not on any of the known distance slabs recording construction of the Wall itself or building records erected by regiments of auxiliaries (below, p. 51).[3] The distance slabs (below, p. 51), which commemorate the construction of the Antonine Wall, bear no exact date in the form, say, of the 'regnal' year of the emperor (expressed in the number of years he had held the tribunician power),[4] or by number of consulships held; no stones from the Antonine frontier are datable by the names of the consuls of a particular year.

In general little can be deduced about dating from an examination of the lettering on the stones (below, p. 59), or the use of particular phrases or formulae. The graveslab from Ardoch (No. 47) employs the initial phrase *Dis Manibus*, 'to the spirits of the departed', written out in full, which suggests a date not after the very early second century A.D.; hence it should belong, in a Scottish context, to the Flavian period of the later first century. Three inscribed graveslabs from the Antonine Wall in the Hunterian collection (Nos 48–50) use the same formula in the fully abbreviated form *D M*, which helps to confirm that they were erected in the Antonine period or later.

The sculptured reliefs and few pieces of sculpture 'in the round' are not capable of close dating, though hairstyles depicted on Nos 9 and 16 belong easily in the Antonine age. The use of the *pelta* motif on building records is concentrated in the second century A.D., but later examples are also found in Britain and elsewhere (see also below, p. 62). As the personnel who occupied the forts on the Antonine Wall had in many cases been transferred to Scotland directly from forts on Hadrian's Wall or its hinterland, or were to return there after Scotland was abandoned, some overlap in styles can be looked for.

2. THE MILITARY OCCUPATION OF SCOTLAND

The stones were erected in a primarily military context, either to commemorate building work which Roman soldiers had themselves undertaken, or in memory of their comrades or their families, or were dedicated to gods and personfications they wished to venerate.

Roman legions and regiments of auxiliaries are documented on the stones now at the Hunterian Museum. The three legions forming the garrison of Roman Britain in the mid-second century A.D.—II Augusta based at Caerleon in South Wales, VI Victrix at York, and XX Valeria

[2]An alternative view, that the primary phase of occupation (Antonine I) ended *c.* A.D. 155 and resumed from *c.* 180 until *c.* 192 (Antonine II), is advocated by, among others, Professor J.C. Mann (Mann 1988, 131–7; 1992, 189–95).

[3]By contrast, A. Platorius Nepos, the governor in A.D. 122–124, who oversaw the construction of Hadrian's Wall, is recorded on several stones found along its length, especially those at milecastles (A.R. Birley 1981, 100ff.).

[4]A building record (*RIB* 2110), from Birrens, Dumfriesshire, is the only inscription known from Scotland dated in this way.

Victrix stationed at Chester—all participated in the conquest of southern Scotland early in Antoninus' reign, and in the contruction of the new frontier barrier; thereafter many, perhaps most, legionaries returned to bases in the South. Each legion consisted of some 5,000 legionaries, but some men were doubtless left in their southern bases, or were engaged on duties elsewhere in Britain at the time of the northwards advance into Lowland Scotland. The fact that on the distance slabs and many building records from Scotland, work undertaken by Legions VI and XX is most frequently ascribed to 'detachments' (*vexillationes*, operating under a *vexillum*-flag rather than the legion's *aquila*), while at the same time work by Legion II is ascribed to the legion as a whole (e.g. Nos 4, 5, 12, 13, 21–23), has led to the conclusion that the latter was present in full strength, while the others were represented by groups of perhaps one or two thousand legionaries. However, the task of building the Wall seems to have been divided evenly among the three legions, without any special weighting towards Legion II; the distinction in epigraphic commemoration of their activities may therefore lack the significance often placed on it.[5]

Legionaries built the Wall itself, and some buildings within the forts; but auxiliaries also undertook building work, and commemorated their activities in stone (Mann 1986, 191–3). It was, for the most part, the latter who occupied the forts on a longer-term basis. There is, however, a growing realisation that, during the Antonine period, parties of legionaries did remain in southern and central Scotland once the construction phase was over, or were brought back to act as garrisons in smaller forts, with their own centurions as commanders. The latter were also employed as commanders of part-units of auxiliaries, as the army struggled to find the manpower to maintain control over the now enlarged province (see No. 43).

The regiments of auxiliaries attested in Scotland, each some 500 or less commonly 1,000 men strong, had been originally recruited among particular tribes or communities in many different parts of the Roman Empire; soon they came increasingly to draw their manpower from whichever province they were stationed in (Cheesman 1914; Holder 1982). Those regiments garrisoning forts on the Antonine Wall and elsewhere in Scotland doubtless contained many recruits from Britain itself, but it is difficult to identify the homelands of individuals (A.R. Birley 1988, 101ff.; *RIB* 2142).

3. THE MAIN CATEGORIES OF INSCRIPTION

Several categories can be distinguished (see Chapter 3 below): official building-records (1); altars dedicated to deities and personifications (2); gravestones (3) and funerary relief sculpture (4); relief sculpture and sculpture in the round (5); and architectural sculpture (6). A few miscellaneous stones (7) and some smaller fragments (8) complete the collection.[6]

3.1 BUILDING-RECORDS (Nos 1–26)

Essentially these are the formal records on stone of work undertaken by soldiers of the Roman army in constructing military installations or frontier works, set into the side of the structure being commemorated. The dedication is generally to the emperor Antoninus Pius whose name and titles occupy a considerable portion of the available space. Next come the name and title of the military unit responsible for the work; the structure itself is normally not described or otherwise identified. The passerby would see from the location of the building-record *what* had been constructed.

These building-records are generally thin slabs, rectangular or square in shape with the inscription set within a raised border. Sometimes the attractiveness of the slab is enhanced by sculptured decoration and motifs (below, p. 62).

[5]The right-hand side-panel of the Bridgeness distance slab (*RIB* 2139) depicts a *vexillum* inscribed with the name of the Second Legion; conversely, the slab from Hutcheson Hill (below, No. 9) shows the Eagle of the Twentieth Legion, though only a vexillation is there credited with building work.

[6]For these last two categories the reader is referred to the appropriate entries in Chapter 3.

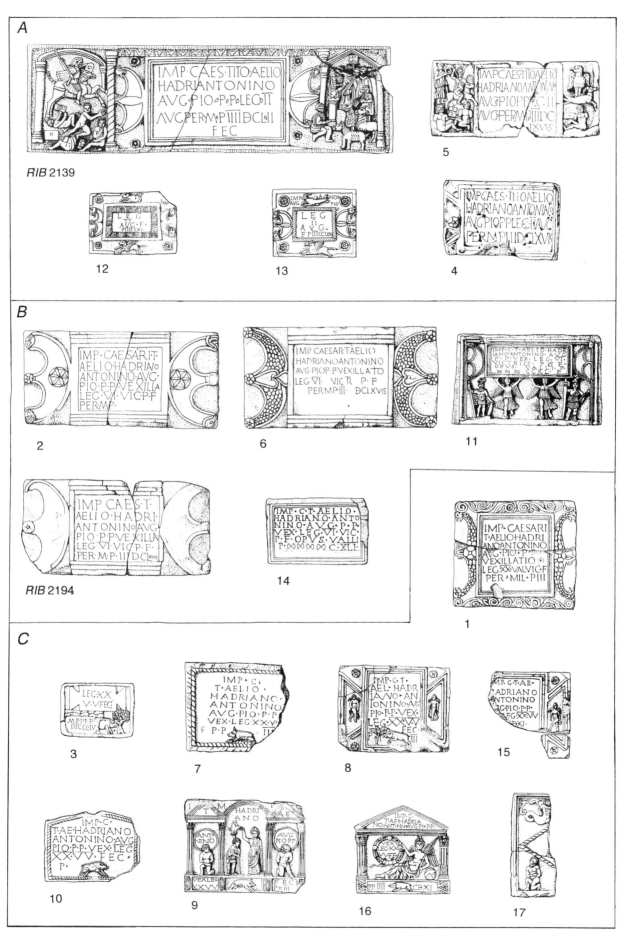

FIG. 23. The distance slabs, according to legion responsible. A = Second Legion; B = Sixth Legion; C = Twentieth Legion. Drawings by Margaret Scott. All are in the Hunterian collection, except the slabs from Bridgeness (*RIB* 2139), now in the National Museums of Scotland, Edinburgh, and from Millichen near Summerston (*RIB* 2194), now in Glasgow Art Gallery & Museum, Kelvingrove. All at scale 1:30.

The names and titles of Antoninus occur on such building records in a standard, official sequence, generally *Imperator Caesar Titus Aelius Hadrianus Antoninus Augustus Pius, Pater Patriae* ('emperor Caesar Titus Aelius Hadrianus Antoninus Augustus Pius, Father of his Country'). Born Titus Aurelius Fulvus Boionius Arrius Antoninus, the future emperor's name was altered to Titus Aelius Hadrianus Antoninus on his adoption by his predecessor Hadrian in A.D. 138; he acquired the soubriquet Pius on accession soon after. Other titles such as *Imperator, Caesar* (originally the surname of Julius Caesar and his descendants), *Augustus* (a title assumed by Octavian, the first Roman emperor, in 27 B.C.), and *Pater Patriae* were normally conferred on each incumbent in turn.

Distance slabs (Nos 1–17)

This is the name given to a series of building-records, recovered over three centuries or more along the line of the Antonine Wall, which record work-contributions to its construction by detachments drawn from the three legions of the garrison of Britain (FIG. 23). The name 'distance slabs' was coined in the late nineteenth century (Bates 1898, 106; Haverfield 1913b, 622); it reflects the primary purpose of the slabs, to record the distances or lengths of the Wall's curtain completed. Earlier antiquaries, in the eighteenth and nineteenth centuries, referred to these slabs as 'walling tablets' or 'milestones'. Stones were erected at either end of the completed sector; in some sectors there were two stones at either end (below, p. 53), most plausibly one set into the front and one into the back of the rampart stack.

A total of eighteen slabs have survived (including one known only from a plaster-cast; see below, No. 8). A few more can plausibly be identified among stones reported by early observers but now seemingly lost (*CIL* VII 1110a; Macdonald 1934, 392; Keppie 1979, no. 20).

The inscriptions follow a standard format, normally beginning with the names and titles of the emperor, followed by the numeral and titles of the legion responsible for the work in the particular sector, and (most important) the numerals detailing the exact length completed. The name of the emperor is omitted on the smallest slabs (Nos 3, 12) and added only as an afterthought on No. 13. The governor of Britain is not named on any of the slabs, though he presumably oversaw the extension of the province; sinister reasons for the omission have been advanced (Davies 1977c, 391f.).[7]

It can be seen that different legions, or their commanders, preferred particular formulae, sculptural styles and motifs, and abbreviations for standard parts of the text (below, p. 63). The work of individual sculptors can be identified: one craftsman, working for, or serving in, the Twentieth Legion, was responsible for at least six slabs erected in the short stretch of Wall between Castlehill and Old Kilpatrick (Nos 7, 8, 9, 10, 15, 16; below, p. 64). Elsewhere we can see the same motifs employed by craftsmen of widely differing ability (No. 5, *RIB* 2139 of the Second Legion; Nos 12, 13 of the same legion). Only two slabs, both erected by men of the Sixth Legion west of Castlehill, in any way specify what had been built, in the phrase *opus valli*, 'the work of the rampart-mound' (Nos 11, 14); it could be simplest to conclude that this encompasses all the main features of the frontier line including the ditch.[8]

Of the eighteen surviving slabs, all but two are in the Hunterian collection, being gifted to, or purchased by, the University at various times from the late seventeenth century onwards; one slab is in the Glasgow Art Gallery and Museum, Kelvingrove (*RIB* 2194; Keppie 1979, no. 7), and another in the Museum of Scotland, Chambers Street, Edinburgh (*RIB* 2139; Keppie 1979, no. 1). The slabs were not found at uniformly regular intervals along the Wall: there is a marked concentration in the western half of the Wall's length, especially in the four mile stretch between Castlehill and Old Kilpatrick.

Most of the slabs were recovered in the course of normal agricultural activities in open

[7]The governor in A.D. 139–142 was Q. Lollius Urbicus (above, p. 48). Lollius' unknown successor, presumably coming into office in A.D. 143, was evidently disgraced, if we accept the current interpretation of *RIB* 2313, a milestone from Ingliston near Edinburgh dated to A.D. 140–144, on which the governor's name is erased (Maxwell 1983); if the work being commemorated on the slabs fell within his governorship rather than Lollius', the stonemasons might have thought it wise to omit all reference to him.

[8]cf. *RIB* 2034, where *vallum* can be taken to mean the stone structure of the Hadrian's Wall frontier barrier.

farmland adjacent to the Wall. Three slabs of the Twentieth Legion, all belonging to a single work-sector between Castlehill and Hutcheson Hill, had evidently been deliberately buried, presumably by Roman forces, in specially dug pits either just to the south of the Wall (Nos 8, 9) or on the berm (No. 7), perhaps to prevent disfigurement or destruction at the hands of the resident local population. Concealment occurred, we can suppose, at the close of Roman occupation, before the troops withdrew; if there was indeed a break in occupation *c*. 154-55, concealment might have occurred then. Two other slabs were found some distance south of the Wall (No. 17, *RIB* 2194), perhaps similarly buried. Others found atop the stone base of the Wall (No. 5), or (in one case) in the ditch north of the Wall (No. 3), could have remained *in situ* after the Romans left Scotland. Some for which we lack detailed accounts of the circumstances of discovery but which are in a crisp condition, hardly weathered, may also have been deliberately buried. Most of the slabs known to us have survived complete, though sometimes breakage or damage occurred at the moment of discovery (No. 5), or later (No. 1).

The slabs have been studied by numerous scholars over many generations (Sibbald 1707, 47f.; Stukeley 1720, 11; Gordon 1726, 50ff.; Horsley 1732, 158ff., esp. 161–2; Roy 1793, 165ff.; Stuart 1845, 355; Wilson 1851, 376f.; Hübner 1873, 193f.; McCaul 1863, 235f.; Bates 1897, 105ff.; Macdonald 1897; Gibb 1901a–d, 1902a–d, 1903a–b; Macdonald 1903, 49; Macdonald 1911, 268ff.; Macdonald 1921, 1ff.; Macdonald 1934, 359ff.; Steer & Cormack 1969, 122; Maxwell 1974; Phillips 1974; Keppie 1976b, 57; Keppie 1979; Close-Brooks 1981; Hanson & Maxwell 1983, 104ff.; Hassall 1983; Maxwell 1985, 25; Maxwell 1989, 150ff.; Strang 1990).

The distances were calculated to the nearest pace, half-pace, or foot. The precise measurements and findspots allow, in some areas, the distribution of the slabs to be plotted with some accuracy; sometimes known slabs lacking a secure provenance can be inserted, often with confidence, into the sequence; but the picture is far from complete. Already in the early eighteenth century Horsley (1732, 193f.) calculated the total lengths completed by each legion. Stuart (1845, 355) was the first to realise that some duplication must have occurred, i.e. that some work sectors must have been commemorated by more than a single slab. The growing realisation that the number of paces reported exceeded the total length of the Wall prompted Hübner to consider the possibility that the distances were expressed in feet rather than paces; he also floated the idea that some slabs, where identical numbers were inscribed, represented later repairs to the same work-sectors (1873, 193f.). Cadwallader Bates (1898, 105ff.) can be credited with the important realisation, which has stood the test of time, that two different systems of measurement were in use: while most of the slabs did record distances in paces (each of five Roman feet), those erected between Castlehill and Old Kilpatrick were in feet. Undoubtedly a factor in this change of measurement-unit was the fact that the distances to be recorded were much shorter than those completed further east. Computing the distances in feet rather than paces allowed a figure five times as large to be inscribed, superficially matching the numerals reported for sectors further to the east (Macdonald 1934, 394; Keppie 1976b, 62). Alexander Gibb, in a series of papers published in 1901–1903, drew on unpublished manuscript sources to clarify the provenances of several slabs, but then with some arbitrariness reassigned them to fit his own theories on wall-building, so undercutting the genuine value of his research which has been largely ignored. Sir George Macdonald (1921, 1ff.; 1934, 359ff.) reassessed our knowledge and elucidated the sequence of construction (see also below, p. 53).[9]

The slabs constitute an invaluable source towards our understanding of the process of building the Antonine Wall. It seems likely that the original intention was to subdivide the length of some 37 miles (40 Roman miles/60 kms) into nine work-sectors, to be evenly allocated among the three legions involved, constructed from east to west. However, unknown factors, perhaps difficulties in completing the central sector where the ditch had to be rock-cut, or the drawing off of troops to other duties, or interference from local tribesmen, disrupted the sequence, so that the final, most westerly sector of the intended nine, running from Castlehill to Old Kilpatrick,

[9]In an unpublished dissertation Dr A. Strang has recently remeasured distances on the ground and made ingenious suggestions on the allocation of work (Strang 1990).

remained for a time unbuilt. To complete it at speed, detachments from all three legions were summoned, and the single sector subdivided into six sub-sectors, carefully calculated so that the work was divided almost exactly evenly among the three legions (FIG. 24). We cannot say how long the Wall and the forts took to build, though it is possible (and probably necessary) to envisage the work as carried out over two summers (Hassall 1983). Iconographically, a progression from east to west is also indicated: the Bridgeness slab (*RIB* 2139), erected at or near the eastern terminus, features a *suovetaurilia*-sacrifice, appropriate to the commencement of a great enterprise (Phillips 1974); further west are images of victory (Nos 5, 9, 11), with Victory herself at rest beside the Clyde at Old Kilpatrick (No. 16).

The information on work-sectors gleaned from the distance slabs can be set alongside a study of the component parts of the frontier barrier as revealed by archaeological excavation: the width of the stone base, the composition of the superstructure, the width of the berm and the ditch. Added to this is a study of the distribution, along the line of the Wall, of labour camps discovered through aerial reconnaissance, so establishing a picture of the Wall building process and the contribution of the three legions towards it. This non-epigraphic evidence is especially valuable when we try to establish responsibility for wall-building in the eastern half of the line where only one distance slab has so far been recovered (Keppie 1974, 151; 1976b, 74; Hanson & Maxwell 1983, 104ff.).

It seems clear, from the presence of dovetail crampholes in the top surfaces and sides of most, though not all, of the distance slabs (Nos 1, 2, 4, 5, 7–10, 13–17, *RIB* 2139), that they must originally have been set into a timber or more probably stone structure (Keppie 1976c, 62). The crampholes would have held iron cramps, perhaps secured by lead. Such crampholes sometimes appear on other stone tablets recording building work at forts (here No. 20), which were inserted into the walls of stone buildings. If we assume that the distance slabs were fixed in some way to the Wall itself, the problem facing the construction squad was to ensure that they remained upright and did not slip backwards into the body of the turf stack as the mound settled (Keppie 1976c, 62f.). This could have been achieved most effectively by the construction of a stone platform to support each slab, built up from ground level; no such platforms have yet been revealed by excavation (but see Keppie & Breeze 1981, 239f.).

From the number of slabs recovered it seems certain that both ends of each sector were marked by at least one slab, and in the Castlehill–Old Kilpatrick stretch, less certainly in all sectors, possibly by two slabs, perhaps one in the rear and one in the front face of the rampart stack (FIG. 24). The findspot of one slab of the Twentieth Legion may indicate deliberate concealment on the berm between Wall and Ditch (No. 71); another stone was recovered from the Ditch itself (No. 3).

The most authoritative and convincing discussion of the findspots and resulting distribution of the slabs came from the pen of Sir George Macdonald, who with his customarily persuasive prose established provenances for those whose findspots were uncertain (Macdonald 1921, 1934). But the realisation that some, indeed maybe all, the sectors were commemorated by four slabs, instead of the two previously suggested, inevitably undercuts some of his conclusions. He had been compelled to record one slab (No. 10) as a 'waster', where the number of the paces or feet was left blank, because, as he supposed, the sector was already commemorated by the required two slabs (Macdonald 1921, 23; 1934, 366, 387); but the possibility of two slabs at each end of a sector had already been foreseen by Stuart (1845, 355 fn) and by Bates (1898, 108). A second slab is similarly incomplete, without numerals in its final line (No. 2). Since both were found on or near the Wall, it is very probable that they had in fact been used for the intended purpose.

If we suppose that all fifteen sectors were marked by four slabs, then a total of sixty were originally set up. (If only the six sub-sectors between Castlehill and Old Kilpatrick were marked by four slabs, then the total is forty). Of these we know of twenty (Keppie 1979), of which two (or three, if we include No. 8) are now lost. Whichever total is preferred, this is an abnormally high rate of survival to modern times. For Roman inscriptions in general, the average survival rate is thought to be about 1–5 per cent, the upper figure in areas where the chance of survival was especially favourable (Duncan-Jones 1982, 360–2). By comparison, the survival rate of

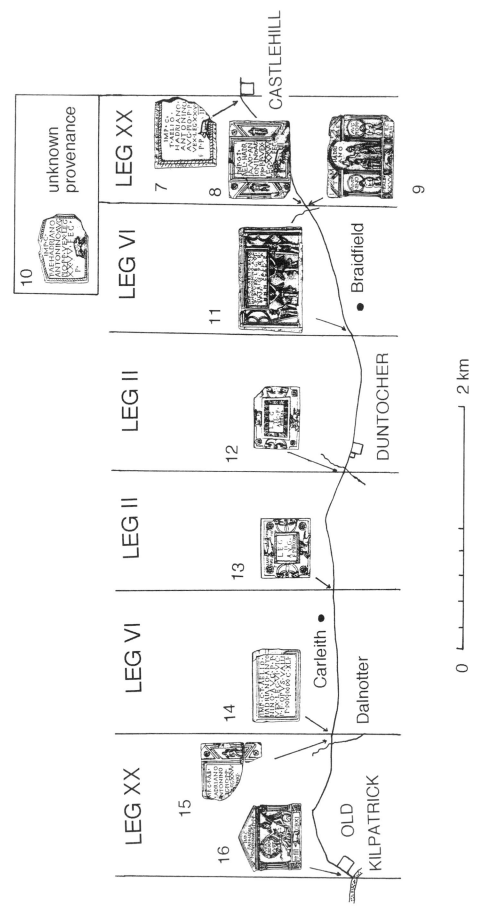

FIG. 24. Map showing likely findspots of distance slabs between Old Kilpatrick and Castlehill. Drawings by Margaret Scott.

slabs erected to commemorate the construction of milecastles on Hadrian's Wall under Platorius Nepos in A.D. 122, is 6.5 per cent (Keppie 1991, 34). For this very high rate of survival on the Antonine Wall, we may thank the decision to bury and conceal at least some of the slabs (above, p. 52). None, so far as we know, were carried off for re-use elsewhere in the vicinity of the Wall (e.g. at Shirva, below, p. 67).[10]

It seems likely that the slabs were prepared in the nearby quarries, with standard elements in the inscription (the names and titles of the emperor, the numeral and title of the legion) inserted, and with space left for insertion of the numerals of the distance completed, which might not then be known. Sometimes the space left for the numerals was insufficient (see Nos 5, 13; RIB 2194). On two slabs (already referred to) the space remained blank; perhaps the numerals were painted in, but they may never have been added at all.

Given that the slabs were erected for a single purpose and (as we suppose) over a very short time-span, it is surprising that they exhibit such a variety of shapes, sizes, and styles. A degree of freedom was evidently accorded to the stonemasons, and we could imagine some measure of competition or rivalry among the legions. In general, while we can identify the handiwork of a sculptor of the Twentieth Legion west of Castlehill (below; see Nos 7, 8, 9, 10, 15, 16) and note the plain style adopted or preferred by craftsmen of the Sixth Legion between Castlehill and Kirkintilloch (Nos 2, 6, RIB 2194), the slabs are not easily categorised on grounds of shape, size, and iconographic representation (above, FIG. 23). It is easy to understand that slabs erected at the termini of the Wall might be especially large (as RIB 2139, Bridgeness), or especially ornamented (so, No. 16), but less easy to see why the slab found on Hutcheson Hill in 1969 is so elaborate (No. 9). One possibility might be that, where the ends of a sector were marked by two slabs, the slab erected on the south face of the rampart might be elaborate, and that on the north much simpler.

So far as we are aware, the series of distance slabs from the Antonine Wall is unique in recording building work on a Roman frontier in such detail. The building of a fort rampart at Carvoran on Hadrian's Wall is reported with measurements on a series of thin stone plaques (RIB 1816, 1818, 1820, 1822). Sir George Macdonald (1921, 12) drew attention to a series of upright pillars on the banks of the River Tiber at Rome, which recorded the strengthening of embankments, with the distance marked, some times to the nearest half-foot, to the next pillars in the sequence, on either side (see CIL VI 1235ff., 31524; ILS 5924; Hülsen 1891, 130–6). He also noted inscriptions dated to A.D. 170 recording the refurbishment, by legions and auxiliary cohorts, of the city walls at Salona, Dalmatia, where the distances are expressed in feet (1934, 358 n. 2; Wilkes 1969, 116–17). A series of legionary tablets, resembling the distance slabs in general style, records construction of the Hadrianic aqueduct at Caesarea (Isaac & Roll 1979, 59–60).

One of the distance slabs (No. 4), erected by the Second Legion, lacks a decorative right-hand panel to match that on the left; however, the stone is neatly finished off at the right-hand edge, and has dovetailed cramp-holes symmetrically positioned for the stone as we have it. It could be possible to argue that the missing portion was carved on a separate block of stone which has not survived. On the other hand, Hanson and Maxwell have drawn attention also to the trimming of the right-hand side-panel on the slab from Bridgeness (also the work of the Second Legion), with the suggestion that slabs needed sometimes to be shortened or reduced in size, if they could not be fitted into the pre-built plinth or enclosing masonry framework (Hanson & Maxwell 1983, 113). It does however seem odd that a building record honouring the emperor would have been cut back at this stage, rather than enlarging the framework.[11]

The building of Hadrian's Wall was commemorated by 'centurial' and 'cohortal' slabs set as normal building stones in the faces of the Wall; these briefly note the century or cohort

[10]We could suppose, as an alternative explanation, that the number of slabs originally erected was much larger than hitherto believed, which would be the case if in fact they commemorated two separate building phases, in A.D. 142–43 and a later reconstruction, say in A.D. 157–58. But as yet there is insufficient evidence to recommend such a radical reinterpretation.

[11] The location of the cramp-holes on the tops and sides of many slabs ought to show that the frameworks could not have been finished off before the slabs were inserted into them.

responsible, without reporting the distance completed. Perhaps the extension of the province under Antoninus to incorporate southern Scotland was felt to be a special achievement, worthy of additional commemoration. The scenes on the distance slabs depict Roman victory and the defeat and subjugation of native tribes, which presumably preceded or accompanied the construction work. None of the sculptured scenes on the slabs allude to the building work itself. Clearly the soldiers found here a useful occasion to celebrate their success on the far north-western frontier of the Empire.

Fort-building records (Nos 18–26, 76–77)

There are in the Hunterian collection a number of inscribed stones, not to be confused with distance slabs, which are records of construction work at forts. These are thin rectangular slabs shaped for insertion into a masonry wall. The inscription frequently consists, here too, of a dedication in honour of the emperor, in whose honour and by whose authority the work was done, followed by the name of the legion or auxiliary cohort.

The dedication is by the army unit responsible for the work. In records from Scotland this is normally confined to the numeral and title of one (or more) of the legions; or of the regiment of auxiliary infantry or cavalry. Sometimes the inscription names only the unit responsible, without mentioning the emperor (Nos 19, 21). The work of the Twentieth Legion and of the Second Legion is also commemorated by two smaller centurial stones, to be set into the masonry wall of the stone building whose construction they marked (Nos 25-26).

Dedications by legions which recorded building work at forts along the Antonine Wall have often been considered 'primary', i.e. erected in A.D. 142–43 when the new frontier was being built (here Nos 19, 21–23, 25–26), with the work of auxiliaries at the same sites being considered evidence of some secondary reconstruction (here Nos 18, 20, 24), but this distinction is difficult to maintain (Mann 1986, 191-3).

3.2. ALTARS (Nos 27–46, 79)

An altar, essentially, was a platform or plinth on which a sacrifice could be made to a god or goddess, in the hope of, or in recognition of, special favours or assistance. At a Roman temple the principal altar was a substantial rectangular structure, placed outside the temple itself, at the bottom of the access steps, where people could gather to view the ceremonies. But most altars known from the Roman world are relatively small. They consisted of squared-off upright columns of stone, usually differentiated by simple mouldings into three parts, normally designated 'capital', 'shaft', and 'base'. The capital might be elaborately moulded with architectural features imitating a column-capital, with bolsters to either side in imitation of volutes. Between the bolsters was a circular depression, sometimes in direct imitation of a metal dish, usually termed the *focus* (literally, a hearth or fire-place). It was here that offerings were placed, and liquids poured over them. In theory a fire was lit, so that aromas ascended to the heavenly abode of the gods; but we may suspect that the *focus* was often too small for a fire to be established.

Most of the altars in the Hunterian collection and elsewhere in Roman Britain were meant to stand adjacent to or inside temples or shrines. Often, it is clear, they were not intended to be seen from behind. Some very small altars may have stood indoors, in a niche or on a shelf. Sometimes, probably more often than we can document today, altars stood on stone plinths or in sockets, to improve their stability (Nos 29, 32; *RIB* 2120; cf. Thornborrow 1959, 8–25).[12] Some altars probably stood alone, but at other times the visitor might find several together, as for example we can document at Maryport, Cumbria (Jarrett 1976; Jarrett & Stephens 1987), Osterburken, Germany (Schallmayer & Preuss 1994, 15–73), and Sirmium (Sremska Mitrovica), Serbia (Popović 1989 on eighty-three altars found together). Some, as can be seen from the inscription, were erected as official dedications, by a prefect or centurion, on behalf

[12]Though contemporary accounts make no mention of such bases, and certainly none now survives, engravings in Anderson 1800 depict distinctive plinths for Nos 34 and 35; Stuart 1945, 338f. refers to bases or 'pedestals' belonging to Nos 27 (see his pl. xiv.2), 33 and 35 (pl. xi.2-3).

of his men. It is known that soldiers renewed their vows annually to the emperor and to the gods at the beginning of January.

The inscriptions on altars are generally confined to the smooth front face of the shaft. Occasionally the inscription may begin on the front of the capital (Nos 35, 36, 43). This habit is considered by some to be indicative of a dating in the third century A.D. (below p. 110).

The dedication generally begins with the name or names of the gods or goddess being venerated, generally in the dative case, followed by the name of the dedicator in the nominative case. The inscription can end with the formula V S L L M, that is the first letters of five words *votum solvit laetus libens merito* (or *laeta*, if the dedicator was female, or the subject of the sentence was a feminine noun such as *legio* or *cohors*). The appearance of this formula, to signify that the dedicator 'fulfilled his (or her) vow gladly, willingly and deservedly' (see Nos 32, 41, 43), indicates that the altar has been erected *post eventum*, in fulfilment of a vow or promise already made. The dedicator had, at some time in the past, promised to erect an altar and offer sacrifice, if the god provided the desired assistance. If no favour had been forthcoming, the dedicator had no obligation to erect the altar. Where this formula is absent, we may conclude that the altar was erected in advance of the god's favour, in the hope or expectation of it, and might see repeated use. We can deduce from the findspots of some surviving altars that they stood originally in the 'shrine of the standards' (*aedes principiorum*) within the headquarters building of a fort, or in its open courtyard; the discovery of an altar in the well of the headquarters building surely points to it having been erected within the building (No. 31), or nearby. The personification of Fortuna, Good Fortune, was frequently venerated in bath-houses (see Nos 27, 39, 64); evidently she protected the naked bather from sudden onslaught. Other altars stood outside the forts (Nos 29, 32, 40, 41, 43).

The most interesting group of altars in the Hunterian collection are those from Auchendavy fort, of which four (Nos 33-36) and almost certainly the fifth (No. 37), were dedicated by the centurion M. Cocceius Firmus. Found during construction of the Forth & Clyde Canal in May 1771, they lay in a deep pit just outside the southern defences of the fort. From the description provided by a contemporary, the pit itself is likely to have been for refuse, rather than specially dug to receive and conceal the altars (Anderson 1771, f. 45; above, p. 25); a small statue (No. 59) and two iron mallets, now lost, were also recovered. Four of the altars were broken across the shaft when found (Nos 33, 34, 36, 37), but this seems more likely to have been the result of collision with other stones when they were thrown into the pit, rather than a deliberate act with ritual significance. Though dedicated to a plethora of deities, we could suppose that all five Auchendavy altars stood together, unless Cocceius had assembled them only for the final act of disposal, before leaving the fort. The group calls to mind the numerous altars found at Maryport, Cumbria, in pits north of the fort (Wenham 1939; Jarrett 1976; Breeze forthcoming 2; Hill forthcoming).

Many of the deities venerated on the Roman frontier in Scotland are the gods and goddesses of the classical pantheon, introduced from the Mediterranean world, and important to the army and its soldiers, together with personifications such as Fortuna and Victory. Sometimes the classical deity is combined with a Celtic god (as e.g. Mars Camulus), or a Celtic deity is honoured together with classical gods (No. 36). The Hunterian collection contains no dedications to Celtic deities alone. Recent photography of a very worn altar (No. 38) has suggested a reading which indicates a dedication to Juno Regina, the consort of Jupiter Dolichenus, an oriental cult much favoured by the Roman army from the second century A.D. onwards (Speidel 1978; Birley 1978, 1517–19).

3. 3. GRAVESTONES (Nos 47–50)

Along the roads leading away from a Roman fort or legionary fortress were to be found the cemeteries housing the remains of former comrades and their families. Where a stone marker was used, memorials most often took the form of simple upright tombstones (here Nos 48–50). Occasionally more elaborate monuments were constructed (here No. 47), of which the inscribed panel was only one element, perhaps standing within a demarcated plot. The normal burial rite

was cremation, the ashes and burnt bone fragments being placed in a pottery, glass, or stone container, or within a tile-built box.[13] Soldiers, it is believed, contributed from their pay towards a burial club, which ensured suitable commemoration for any comrade who died on service. In the course of the second century A.D. a change in burial practice was taking place, from cremation to inhumation (Philpott 1991, 53); evidence for inhumation on the frontier in Scotland remains sketchy (Breeze, Close-Brooks and Ritchie 1976, 77–81).

Little work has been done to identify cemeteries outside the forts on the northern frontier in Britain, though many burial mounds have been plotted, and a few excavated, at High Rochester fort, Northumberland, south of Carter Bar, where the circular stone plinth of a sizeable monument survives today one course high (Charlton & Mitcheson 1984, 1–33). Within Scotland there is almost no evidence at all of cemeteries and no tombstone has ever been found *in situ*.

3.4 FUNERARY RELIEF SCULPTURE (Nos 51–53)

A few memorials were more elaborate, in that the inscription was accompanied by a representation of the standing figure of the deceased in military dress. The single, very worn, example of this type in the Hunterian Museum (No. 51) derived from the 'tumulus' found at Shirva near Kirkintilloch in 1726, as did two very substantial, though poorly carved blocks found in 1731 on one of which a figure reclines on a couch, and on the other a figure reclines within a canopied carriage (Nos 52–53). These monuments, and other gravestones from the same site, presumably deriving from the cemetery at an adjacent fort, commemorated both soldiers (No. 48, 51) and civilians, the latter demonstrating the likely presence on the northern frontier of an 'oriental' trader and his son (No. 49), and a female, perhaps a slave or a local girl (No. 50; cf. also below, p. 67).

3.5 RELIEF SCULPTURE AND SCULPTURE IN THE ROUND (Nos 54–66, 78)

Buildings within the forts, together with the normally extra-mural bath-houses and temples or shrines in the annexes or the seemingly sparse civil settlements, would be graced by sculpture, whether busts or statues of gods or of the emperor or members of his family. The style might be consciously Roman, or more usually, in a religious context, an amalgam of Roman and Celtic styles. Many of the pieces are clearly religious in nature, representing Roman or Celtic deities (Nos 54, 62, 64, 74, 75); several were designed to ornament fort bath-houses, with a more practical function (Nos 63, 65, 66). In the fort bath-house the bather could expect to encounter a statue of Fortuna (Nos 54, ?62, ?64; above, p. 57), while in the eastern annexe at Balmuildy we know of a shrine apparently jointly to Mars and Victory (Miller 1922, 56; Nos 40, 60–61). At Bar Hill male busts, perhaps depicting Silenus but more probably of local deities, were placed in various parts of the fort (Nos 55–58).

3.6. ARCHITECTURAL SCULPTURE (Nos 67–72)

Buildings within forts built on the northern frontier in Scotland in the Flavian period of the later first century A.D. were almost always (with the necessary exception of the bath-house) timber-built or timber-framed with wattle and daub walling. In the Antonine period of the mid-second century more use was made of stone, to construct the gates, the headquarters building, the granaries, or sometimes the commandant's house; but the use of stone was seldom extended to barracks.

It is clear that the use of architectural ornament in stone was restricted, or at least rarely survives. The elaborate drain cover-slab from the bath-house at Bothwellhaugh (No. 73) is of a sophistication rare in the Scottish context. The assemblage of column capitals, shafts and bases recovered from the well of the *principia* at Bar Hill fort is a particularly valuable index of the type of ornamental stonework which enhanced such buildings (see Nos 67–71). Column capitals might be decorated with leafy or geometric designs (Nos 69, 72).

[13]For a cremation within a coarse-ware jar at Croy Hill, see Frere 1977, 364.

4. THE GEOLOGY OF THE STONES

The stone itself was quarried locally. Most slabs, altars, or gravestones are in a greyish-buff or yellowish-buff sandstone of varying grittiness, widely available in central Scotland. The sculptors would not have had to travel more than a few miles to obtain and exploit it. We must suppose that in most cases the stone derived from the same quarries or rockfaces utilised for building material used at the forts themselves, or in the foundation cobbling (the 'stone base') of the Antonine Wall. Sometimes part at least of the inscribed text was almost certainly inserted at the quarry (see above, p. 55).

5. THE STONECUTTERS AND THEIR CRAFT

We have no information on the identity of the men who carved the stones and cut the letters on them. It is generally assumed, almost certainly correctly, that they were for the most part themselves soldiers. Equally we have no secure proof that the men who shaped the stones and carved the sculptural details also inscribed the Latin texts; but it must be highly likely. There is a wide variation in the quality of the carving of letters, and the skill shown. Unexpectedly perhaps, some stones carved by auxiliary regiments (e.g. Nos 20, 31, both the work of the *cohors I Baetasiorum*) are of a higher quality than those which were the work of the legions (e.g. Nos 4, 6). Even allowing for the effects of weathering on some of the distance slabs, the lettering seems poorly incised.[14] Sometimes this is a reflection of the type of sandstone, whose grittiness may preclude neatly chiselled lettering. We can occasionally detect the hand of individual stonecutters, for example on a group of distance slabs west of Castlehill (Nos 7–10, 15–16; above, p. 55), on the group of altars erected at Auchendavy on the authority of the centurion M. Cocceius Firmus (Nos 33–37), and on a building record and altar erected by the *cohors I Baetasiorum* at Bar Hill (Nos 21, 30).

While on many stones the lettering takes the form of the familiar 'Roman capitals', at other times we may suspect that the stonecutter reproduced something of the style of a written draft; sometimes lettering approximating to the *scriptura actuaria* ('writing for formal or public notices') familiar from the electoral posters at Pompeii (Nos 19, 39 cf. Ireland 1983); on others the style of lettering verges towards cursive script used in everyday writing (Nos 32, 48, 49). On the altar to Jupiter from Old Kilpatrick, the lettering appears to have oscillated between styles as the cutting proceeded (No. 43).

In general the lettering is quite in keeping with the mid-second century A.D. dating indicated, for the great majority of stones, by the archaeological contexts. Words are frequently abbreviated from their full grammatical forms so as to maximise the information which could be imparted on an often quite limited space; we can be sure however that the text was intelligible to those who commissioned it, and presumably to most of those who might care to stop and read it. Familiar words, such as the titles of the emperor, could be abbreviated to a few letters, even to a single letter (e.g. *Caesari* to CAES, even to C), though the names of the then incumbent, i.e. Antoninus Pius, are normally presented in full (e.g. Nos 7, 9, 10; but note No. 13).

In many cases, though not all, the inscription has been carefully arranged on the stone, so as to avoid splitting words between two lines (e.g. Nos 2, 4, 5, 6, 10, 19, 20, 36, 41) and abbreviations are suited to the space available. The stonecutter, or whoever commissioned the stone, or both, often exercised forethought in planning in advance how the text should be arranged (e.g. Nos 9, 11, 19). The wording in individual lines can be 'justified', sometimes with interpuncts to left and right (e.g. Nos 7, 14, 20, 21). At other times, the cutting seems casual and unplanned (e.g. Nos 29, 43, 49); perhaps no draft was presented, or at least not with the text divided into lines.

[14] At Birrens, several slabs and altars erected on the authority of the *cohors II Tungrorum*, in or soon after A.D. 158, show letter-cutting superior to those erected at the same site by legionaries (Keppie 1994)

Sometimes the positioning of the text has been ordained by guideliness, still faintly visible, scratched horizontally across the area to be inscribed (see Nos 14, 40, 41); at other times, the letters seem to be following a prescribed track (e.g. Nos 33, ll. 4–5, 36, l. 1), though guidelines are no longer visible; such lines may have been marked in chalk, charcoal, or paint (Susini 1973, 30ff.). Inscription and sculptured details need to be seen as a single composition (e.g. No. 9).

There is occasionally a reduction in size of lettering, from early to later lines, or even within the same line (e.g. No. 16, l. 5, No. 43, l. 5); at other times the clear impression is of a stonecutter's realisation, once chiselling was already underway and the text partly incised, that the lettering to be inscribed exceeded the space available (e.g. No. 13, l. 7).

The divisions between words are normally marked either by simple dots or triangular interpuncts, set halfway up the height of the letters; more elaborate forms of interpunct can occur, in the form of ivy-leaves, which are themselves decorative features on the stone (No. 11, l. 3; No. 20, ll. 1, 3; No. 34, l. 1). Sometimes no interpuncts are visible (e.g. Nos 33–35), or may be present between some words but not others (e.g. Nos 5, 22); weathering may have removed all traces, or they could have been rendered in paint. A horizontal bar may be inserted above some abbreviated words (e.g. No. 35, l. 4) and above numerals. Occasionally a bar can appear somewhat unexpectedly and perhaps in error (as over LEG for *legionis* in No. 10, l. 4); several times a bar appears above the letters V V, abbreviations for the titles *Valeria Victrix*, of the Twentieth Legion (No. 10, l. 5; No. 8, l. 6; No. 15, l. 5; No. 19, l. 3), where we must take care not to read them as numerals. A bar may also be used over numerals to indicate 'thousands', i.e. \overline{III} = 3,000, even where the phrase MP (i.e. *millia passuum*, 'thousands of paces') precedes the numerals; e.g. No. 5, l. 4.

There is one mistake in the text of a distance slab (No. 5, l. 4), and a letter omitted on another (No. 11, l. 3), the former (though perhaps not the latter) suggesting either inattention to detail, or unfamiliarity with the language. Sometimes we see divergences from the 'classical' spellings of words, reflecting the gradual changes in pronunciation and spelling, as the Latin language developed into the Late Empire (No. 41, l. 5, *pref* for *praef*; No. 40, l. 1, *dio* for *deo*; No. 36, l. 4, *Hercli* for *Herculi*; see Mann 1971; Smith 1983, esp. 899, 901).

Letters can be run together ('ligatured') to economise on space (e.g. A and N on No. 2) where the reader will have little difficulty in determining the order of letters, especially when the word was already familiar.[15] At other times such ligaturing can be more complicated, confusing early commentators (e.g. Nos 35, 36, 41); some letters, often a vowel (especially O) may be reduced in size, again to save space (e.g. No. 8, l. 5; No. 16, l. 3; No. 20, l. 2; No. 35, l. 2; No. 41, l. 2; No. 43, l. 5); or overlap (No. 43, l. 8). The letter T can be heightened, so that its horizontal cross-bar rises above the other letters, and so takes up less space (No. 5, l. 1; No. 19, l. 1; No. 20, l. 2); one letter may even be placed inside another (No. 36, l. 4). Such ligaturing may itself be aesthetically pleasing, and have been included as a positive feature, rather than an afterthought or necessity. There are no accents (*apices*) placed over any vowels in this collection. Occasionally symbols are employed: \bowtie or ∞ (Nos 11, 14, 18), variations of the Greek letter phi (ϕ), for the numeral 1,000; and γ, the notation for 'centurion' (Nos 33–36, 43).[16]

As we see them today, the stones are devoid of colour. But we know from evidence elsewhere that slabs, altars, and gravestones might on occasion be covered with a thin skin of plaster;[17]

[15]\widehat{AE} (No. 18, l. 1), \widehat{AL} (No. 35, l. 3), \widehat{AN} (No. 2, l. 2), \widehat{AV} (No. 8, l. 4), \widehat{ENT} (No. 41, l. 4), \widehat{ET} (No. 19, l. 2), \widehat{MP} (No. 35, l. 4; No. 36, l. 3), \widehat{NE} (No. 19, l. 1; No. 36, l. 2), \widehat{NI} (No. 5, l. 2), \widehat{NT} (No. 18, l. 1), \widehat{PI} (No. 41, l. 4), \widehat{RI} (No. 41, l. 3), \widehat{TE} (No. 43, l. 6), \widehat{TI} (No. 6, l. 3), \widehat{TR} (No. 6, l. 4), \widehat{VA} (No. 37, l. 1), \widehat{VM} (No. 43, l. 3).

[16]Among other points of epigraphic interest are use of horizontal bars across the middle of the letter D (e.g. No. 6, l. 5; No. 15, l. 6; No. 16, l. 7), a practice especially common in Gaul; distinctive angled bars on letters A and H favoured by the stonecutter who prepared the group of Twentieth Legion distance slabs west of Castlehill (Nos 7–10, 15–16); and the apparent absence of horizontal bars on A (No. 5, l. 4, worn?; No. 43, ll. 5–8).

[17]e.g. *ILS* 9140 recording T. Flavius Draccus, a soldier in the *ala I Flavia Britannica* at Vienna, in the Flavian period.

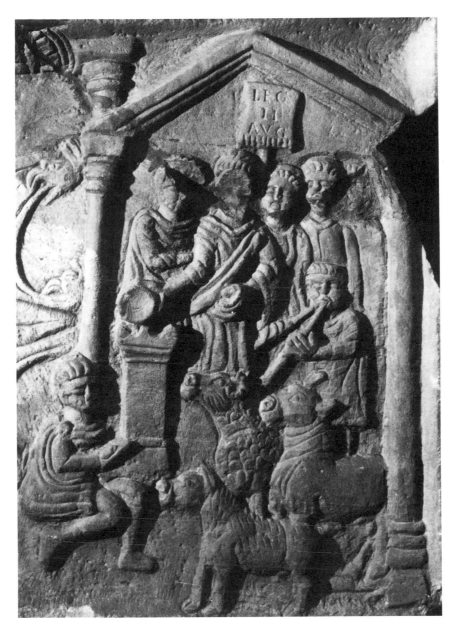

FIG. 25. Right-hand side-panel of distance slab from Bridgeness (*RIB* 2139), showing sacrifice in progress. National Museums of Scotland.

sculptural details and the incised letter-forms were picked out in red.[18] For the Hunterian stones there is no evidence of any plaster coating, except on the statuette to Fortuna (No. 54); but when the collection was cleaned in 1976, red paint was observed by the author in the lettering of a few stones (Nos 5, 21, 43, cf. No. 67; also *RIB* 2139, for which see Close-Brooks 1981). Perhaps therefore altars which today seem uninscribed (Nos 45–46, cf. No. 26) had the lettering painted on them.

6. SCULPTURAL DECORATION AND ARTISTIC STYLE

The inscriptions were regularly accompanied by, indeed at times seem almost subservient to, sculptural decoration. The latter frequently combines classical motifs and inspiration with the energy and exuberance of Celtic art. Stones from Scotland exhibit a wide variety of motifs which

[18]For the use of the pigment cinnabar (*minium*), see Pliny, *Nat.Hist.* 33.40.12; for lead-based paint on *RIB* 333, see Böon 1966, 56 n. 87; for water-soluble red paint on a stone from Vindolanda, see Frere 1977, 432. I am grateful for these references to Dr R.S.O. Tomlin.

were in common use throughout the Roman world, on which individual craftsmen were able to draw (Toynbee 1964, 147–50; Mattern 1989; Henig 1995, 42ff.).

The inscribed panel (sometimes termed the 'die') could be flanked to left and right by triangular or trapezoidal panels called *ansae* (lit. handles), which emphasised the central position of the inscription (e.g. Nos 4, 8, 15, 25). This common device derived from the shape of wooden tablets cut for mortising into a timber structure; examples of wooden panels shaped in this way can be seen on the Arch of Titus at Rome. Such ansate panels are familiar in other contexts including tombstones and sarcophagi, and can appear as decorative motifs in larger compositions (e.g. on Nos 3, 16).

Inscribed panels may also be flanked by more elaborate motifs called *peltae* (e.g. Nos 1, 2, 6, 11, 12, 13, 21, 23), the use of which was popular among military craftsmen in the Antonine age (Thompson 1968, 47–58). Depicted here was the side view of a crescentic shield, originally Thracian and used by Greek and Hellenistic mercenary troops in the eastern Mediterranean. Adopted as a symbol in Graeco-Roman art, it is found in many different contexts. The horns of the *pelta* can terminate in griffin-heads, the latter deriving ultimately from Egyptian and Greek art forms. On larger slabs the *peltae* or *ansae* could be supported to left and right by figures of Victory (Phillips 1977, nos 94–6; Coulston & Phillips 1988, no. 256), or Cupids (Keppie & Arnold 1984, no. 128; Coulston & Phillips 1988, no. 241). This general style can be paralleled in military dedications and building records elsewhere in northern Britain, especially on Hadrian's Wall and at its outpost forts, in the second and third centuries (e.g. *RIB* 1147, 1148).[19] Occasionally, on larger slabs from the northern frontier, the inscribed panel was flanked by sculptured scenes recording or symbolising Roman victory (see No. 5). The largest and most imposing of the distance slabs is that from Bridgeness, now in the Museum of Scotland, Edinburgh (*RIB* 2139; Phillips 1974; Keppie 1979, no. 1; Close-Brooks 1981). The right-hand side-panel depicts a religious ceremony of purification at the beginning of a great enterprise, at which a group of togate figures, perhaps including the legate of the legion, or even Lollius Urbicus himself, officiate at an altar (FIG. 25); this is a *suovetaurilia*, involving the sacrifice of a sheep, pig, and bull; the animals expectantly approach the altar. To the left, a cavalryman gallops across four naked warriors (FIG. 26), symbolising battle and the consequences of defeat for the local population in the face of Roman success (Ferris 1994). Coins issued at Rome in A.D. 143–44 also emphasise victory, but archaeological confirmation of conflict and devastation remains sketchy (Macinnes 1984, 237–8).

Legionary emblems are a familiar device carved on stones erected by soldiers in North Britain. The boar emblem of the Twentieth Legion is particularly familiar (here Nos 3, 7, 8, 9, 10, 16; Ross 1967, 308–21; Green 1992, 89ff., 164, 169, 218), as are the Capricorn and Pegasus of the Second Legion (Nos 5, 12, 13, 23, 26; Breeze 1989; Keppie 1993). The left-hand side-panel of a fragmentary slab from Carpow, Perth & Kinross, which belongs to the Severan period of brief reoccupation of Scotland in the early third century A.D. (Wright 1964), depicts Victory standing erect upon a globe, flanked by a capricorn; below her are a pair of confronting Pegasi and possibly an eagle. The peculiar juxtaposition of images recalls the right-hand side-panel of the distance slab from Summerston (No. 5).

Sometimes the wild boar of the Twentieth Legion is shown running towards a tree (Nos 3, 8; cf. Coulston & Phillips 1988, nos 261, 278; *RIB* 1284, 1956, 2184, 2198). Boar and tree can be found together in Celtic art and coinage (Ross 1967, 308ff.).[20] A horseman with spear poised against a boar emerging from (not moving towards) woodland represented by a single tree is common in hunting scenes including those on Roman sacrophagi (Andreae 1980, Taf. 86ff.); the composition recurs on the gravestones of cavalrymen (Speidel 1994b, nos 109, 225, 591–9). However, the tree has no known place among emblems of the Twentieth Legion.

[19]Notice, further afield, a slab dedicated to Antoninus Pius, dated A.D. 145, which once stood above an entrance to an amphitheatre at Aquincum (Budapest) in Pannonia, where the *ansae* are held by winged victories; also present are two Pegasi, the emblem of the garrison Legion II Adiutrix (Szilágyi 1956, Taf. xxxi).

[20]Horsley 1732, 194 supposed that the boar was an emblem of Caledonia.

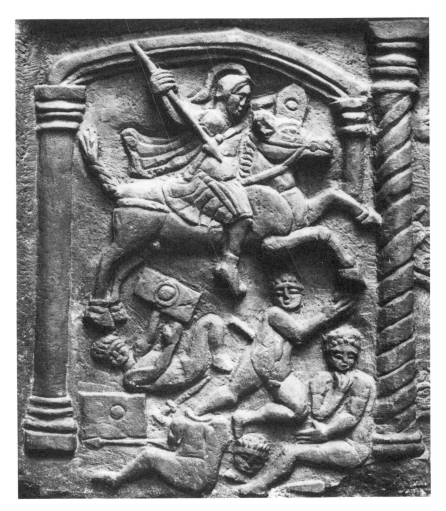

FIG. 26. Left-hand side-panel of distance slab from Bridgeness (*RIB* 2139), showing scene symbolising Roman victory over indigenous tribes. National Museums of Scotland.

The emblem or emblems of the Sixth Legion remain unknown, though numerous slabs erected by its members have survived in North Britain.[21]

The style and quality of the relief sculpture categorise it as 'provincial art', typical of the northern military zone of Roman Britain. If we have to look elsewhere for parallels at a similar date, these can most easily be found not, as might perhaps be expected, in the Rhineland, but in Rome's frontier provinces on and beyond the Danube, that is in Pannonia, Moesia, and Dacia. Much has been written about 'pattern books' which might have offered to sculptors a range of motifs to be drawn on at will (Toynbee 1964, 10–11). More probably there was a common tradition of familiar motifs and imagery, which could be used in a variety of contexts, and which the stonemasons would see around them in their everyday life.

Some of the sculptors who prepared stones on the new northern frontiers were perhaps brought north from legionary bases with the task of commemoration specifically in mind; but competent sculptors were responsible for only some of the resulting slabs, and certainly not always the largest. The same scenes or motifs can be handled by craftsmen of widely differing skills. The epigraphic and sculptural output of the legionary fortresses at Caerleon, York, and Chester offers few parallels. Indeed much the finest relief sculpture erected by the legions in Britain is to be found, not at their bases, but along the two northern Walls, and at the outpost forts.

The triumph of Roman arms over the native population of a province is a common theme of the victors. The depiction of a Roman horseman galloping over one or more hapless barbarians

in disarray is a scene found on coinage when the victories of the emperor are being portrayed, and on tombstones of auxiliary cavalrymen, where it has sometimes been thought to symbolise the victory of life over death (Gabelmann 1973, 132; Mackintosh 1986, 1; Schleiermacher 1984).[22] The representation of a cavalryman riding down four native tribesmen on the distance slab from Bridgeness is a particularly successful composition (cf. Phillips 1977, no. 259); but the same scene is seen in less expert hands on the slab from Summerston (No. 5).

Often, as on the slabs from Bridgeness and Summerston, the native warriors are not shown as active foes, but subdued and bound in defeat (Levi 1952; Gergel 1994; Ferris 1994, 24–31). The bound and captive onlooker, naked or trousered, is a familiar adjunct on coinage, relief sculpture (here Nos 5, 9, 17) or bronze cuirassed statues (Brilliant 1982, 2-17; Stemmer 1978, Taf. 37.1–4; Gergel 1994), and in the depiction of trophies (Picard 1957) at many periods in Roman art, down to the porphyry sarcophagus of Constantine's mother Helena now in the Vatican Museum, where trousered barbarians, some with hands tied behind them, fall before the onslaught of Roman cavalry (Kleiner 1992, 456).

The theme of Roman victory is repeatedly encountered, especially in the form of the goddess-personification of Victory, winged, with one foot poised on a globe, the symbol of her dominion, and seeming to fly through the heavens. This is a familiar image on coins, relief sculpture, and wall-paintings (Hölscher 1967; Fears 1981, 736–826). On the Sixth Legion slab from Braidfield (No. 11), winged Victory-figures hold the inscribed panel aloft. Similarly on a gable-topped antefix from Corbridge, Victory with one foot on a globe holds an ansate panel in front of her body, the panel being supported by two figures, Mars and Neptune, the latter carrying an anchor (Phillips 1977, no. 46). On the Braidfield slab, the Victories are flanked by Mars and by *Virtus Augusti*, 'Imperial Valour', the latter in a pose matched on coins issued at Rome in A.D. 140–44, which may have provided the inspiration (Mattingly 1940, 39, no. 255; cf. *RIB* 845, 1466).[23]

The distance slabs erected by the Twentieth Legion west of Castlehill excite particular interest, for their sometimes imaginative use of motifs in unfamiliar contexts. Of the six known slabs, two are plain except for the boar-emblem (Nos 7, 10). Two others take the form of ansate panels with cupids in the side-panels (Nos 8, 15), and two are decorated more elaborately (Nos 9, 16). Surprisingly perhaps it does not seem that each pair of matching slabs (e.g. Nos 7, 10; 8, 15; 9, 16; cf. Nos 13–14 of the Second Legion) commemorated the two ends of the same sector, though it could be supposed that the sculptors preparing them in the quarries expected them to be so positioned.

Cupids carrying grape-clusters and sickles, set within the *ansae* (Nos 8, 15), are an unusual feature; the sculptor presumably had in mind larger compositions in which Cupids supported, with one or both hands, the *ansae* themselves. Grape-clusters and (less commonly) sickles are to be found in the hands of a Cupid shown in the guise of a *Trauergenius*, a symbol of the harvesting of the vintage and the ending of summer (*RIB* 1131; Wagner 1973, no. 487; Phillips 1977, no. 51). Perhaps we are to conclude that the slabs were erected in late summer. Such figures appear also on monumental sculpture such as a triple-gateway at Antiochia Pisidiae in southern Turkey (Robinson 1926, 5–69).

On the distance slab from Old Kilpatrick (No. 16, FIG. 27), whose front face is carved in the form of a temple-façade, with the gabled pediment supported on pilasters topped by Corinthian capitals, the façade is occupied by a reclining figure of Victory depicted not in her usual pose flying through the heavens, but at rest, her labours over with the completion of the conquest of central Scotland, and with the building of the wall now brought to a successful conclusion. The pose recalls those of *Tellus* (Earth) in her guise of Mother Nature, but also, and more appropriately here (given the proximity of the River Clyde), river gods such as Tiber, Rhine, or Danube, as well as Neptune himself and water nymphs such as Coventina (Allason-Jones &

[22]cf. metopes of the Tropaeum Traiani at Adamklissi, Romania, which commemorated Roman conquest of Dacia beyond the Danube in A.D. 101–5; see Florescu 1960, figs 183–228.

[23]Dr Glenys Davies has helpfully pointed out that unfamiliarity with the iconography of *Virtus Augusti* may have prompted the insertion here of an appropriately inscribed *vexillum* identifying the figure.

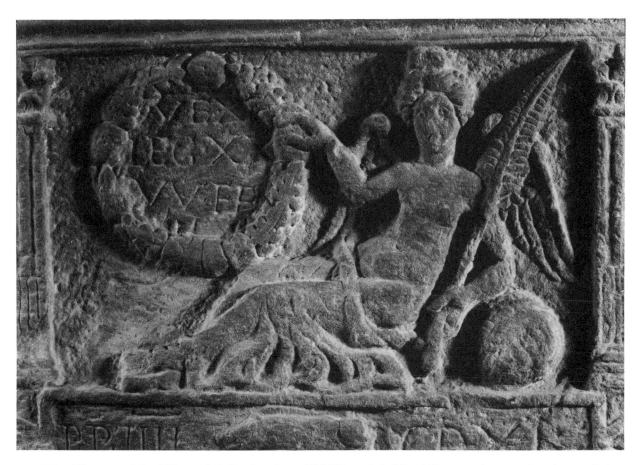

FIG. 27. Distance slab of Twentieth Legion from Old Kilpatrick (No. 16): central scene showing reclining figure of Victory.

MacKay 1985). The shape of this Old Kilpatrick stone also calls to mind the common *aedicula* type of graveslab where the niche contains the bust or busts of the deceased, with the accompanying inscription contained in a separate panel below. The same overall shape recurs on No. 10.

The design of the architectural façade is taken up again on the most recently found, and in many ways most spectacular slab in the Hunterian Collection, recovered on Hutcheson Hill, Drumchapel, in 1969 (No. 9, FIG. 28). The composition calls to mind three-bay triumphal arches at Rome (e.g. the Arch of Severus and Arch of Constantine), or honorary arches in the provinces (e.g. Arch of Orange; see De Maria 1988; Kleiner 1989, 69–81), or city-gateways built in the Augustan age and later, and indeed the monumental façades of elaborate tombs. A three-bay triumphal arch, with the passageways occupied by sculptured figures, is depicted on the Monument to the Haterii at Rome, now in the Vatican Museum (Kleiner 1992, fig. 165); statues are also shown within architectural façades on coins. However, architecturally an exact parallel is surprisingly difficult to find; we can note the Parthian Arch of Augustus in the Forum at Rome, long since destroyed but known from its depiction on contemporary coinage; similar arches of Severan date survive at a number of provincial sites (Hassall 1977). Interesting similarities to the design of the Hutcheson Hill slab can also be found in funerary art, on columnar sarcophagi from the Hadrianic period onwards, which feature a series of arches within which various figures are depicted (e.g. Kleiner 1992, figs 229–30; Kampen 1981, 47–58).[24]

Among the most substantial Roman stones from central Scotland surviving in the Hunterian Collection are two blocks from Shirva, both uninscribed, one showing the deceased reclining on a couch, the other in a carriage drawn by two mules (above, p. 16; below, Nos 52–53). The

[24] cf. Rodke 1997, part iii, Abb 176; Kollwitz & Herdejürgen 1979, Taf. 18.1. The chief styles are conveniently illustrated in Koch 1993.

FIG. 28. Distance slab of Twentieth Legion from Hutcheson Hill (No. 9): central scene showing *aquilifer* and tall female figure, perhaps Britannia.

sepulchral banquet scene (or *Totenmahlrelief*) is familiar in Roman art (Haverfield 1899b; Compostella 1992, 658–89). Its significance has been variously interpreted: a ritual meal which marked the ending of the formal nine days of mourning, a feast held to mark the anniversary of death or a heavenly meal and the blissful afterlife enjoyed by the heroised deceased (Cumont 1942, 47ff.; Thönges-Stringaris 1965, 1–99; Dentzer 1982). Generally (but not here) the relief also includes a small circular table on which food and drink are laid out; the deceased may have a cup in his hand. One or more members of his family or household often sit upright next to him, or stand beside the couch. The scene was especially popular with soldiers, and in frontier provinces; it is most common on the Rhine (Gabelmann 1972; Noelke 1974), but it also occurs frequently on the Danube and in Britain, where funeral banquet scenes are attested, for both males and females, in military contexts including Chester, York, and South Shields (Haverfield 1899b). It is found also in Rome, often among monuments to members of the *Equites Singulares Augusti*, the emperor's horse-guards, whose manpower was drawn chiefly from the northern provinces (Speidel 1994a. 145; 1994b, 7).

The depiction of the deceased in a covered carriage (No. 53) is unusual, though examples can be adduced from other provinces of four-wheel open-topped carts in which the deceased travels, sometimes with his family, to the other world (Amedick 1991, 46ff., Taf. 40ff.; Krüger 1970, nos 323–5; Kleiner 1992, fig. 272). Etruscan ash-chests show the deceased within a covered two-wheeled carriage; similarly on coins, dead empresses are shown on a similar journey in the two-wheeled *carpentum*, the use of which was permitted at Rome to (living) ladies of high standing. The banqueting and carriage scenes are so far unique in Scotland.

The Shirva slabs form a pair and presumably constituted part of a more substantial monument. There has been much discussion on the sex of the two figures, a debate which has been in progress since their discovery in the early eighteenth century (SRO GD 18/5042/4). Both have been seen as depicting males (so Gordon 1732, *Additions*, 4; Toynbee 1964, 207f.), the larger male and the smaller female (so Keppie & Arnold 1984, nos 112–13), or both female (so Mattern 1989, 788–9), a view to which the present writer now inclines. It may therefore be that both reliefs show the same woman, in two poses, reflecting stages in her journey to the afterlife.

The commission has not been well executed: the legs of the figures are shown as though from above, the dog is oddly sited atop the woman's thigh (No. 52), and the normal table is absent; on the carriage relief only two wheels, both at the front of the wagon, are sculpted.[25] The craftsman, it can be suspected, was not at home with a composition of such complexity, which he may have misunderstood. Perhaps he was following the terms of the deceased's will, without having seen an original of the sculptures depicted. Given the substantial nature of the monuments, we could think here of the wife of a centurion or prefect of a cohort, perhaps the commander of a fort, which on grounds of proximity should be Bar Hill or Auchendavy.[26]

7. RE-USE OF THE STONES IN POST-ROMAN TIMES

At the close of Roman occupation of Scotland, if not before it, several of the distance slabs were disengaged from the Antonine Wall and deliberately buried, with some care (above, p. 52). On two of the slabs, human faces have been defaced, but this presumably occurred while they were still *in situ* (No. 15, *RIB* 2139). Other slabs recording building work at forts were evidently dislodged during the general dismantling process of the buildings they had adorned: at Bar Hill such a slab, or fragments of it, and an altar which may have stood in the courtyard of the headquarters building, were toppled into the adjacent well, a convenient receptacle (Nos 20, 31).[27]

Elsewhere, however, it seems likely that such building records remained *in situ*, to fall from position as the buildings or structures deteriorated (No. 23). Sometimes altars too were deliberately hidden or disposed off (Nos 33–37, 43); but others were left within the buildings they had graced (e.g. Nos 27, 39, 40).

The builders of the 'tumulus' at Shirva evidently had within reasonable distance access to stonework in the form of building inscriptions, architectural fragments, and especially grave-stones. The latter must presumably have been left behind, in large numbers, when the Roman garrisons departed. The early antiquaries supposed, from the discovery of funerary reliefs and inscriptions built into the 'tumulus' at Shirva, that they had uncovered a Roman burial place (Gordon 1732, *Additions*, 6–7; Horsley 1732, 339); but the varied nature of the stonework and its location in the ditch rule out such an interpretation. Most probably the structure revealed at Shirva, with its parallel stone walls, semicircular end and flat roof slab, was a souterrain, or earth-house (Richmond and Steer 1957, 1ff.; Welfare 1984, 314ff.; Keppie & Walker 1985, 29), that is a dwelling-place or, better, storehouse of Iron Age date (Watkins 1980, 192ff.). The appearance of souterrains in central and southern Scotland has been linked to a southwards population movement in the wake of Roman withdrawal at the close of the Antonine period (Macinnes 1984, 235). Roman stonework was also incorporated into souterrains at Newstead and Crichton (Welfare 1984, 304; Keppie & Arnold 1984, nos 52, 58).

The Shirva souterrain was constructed in the convenient hollow of the Antonine Ditch,

[25]The wheel here occupies the position normally taken by the circular table placed in front of the deceased on sepulchral banquet scenes, evidence perhaps of further confusion on the part of the sculptor.

[26]The sepulchral banquet scene, as noted above (p. 66), was popular among the *Equites Singulares Augusti*, the emperor's mounted bodyguard at Rome (Speidel 1994a; 1994b), the corps from which it has been argued Marcus Cocceius Firmus, the legionary centurion attested at nearby Auchendavy, might have been promoted (Speidel 1994a, 50, 140).

[27]So at Birrens (*RIB* 2092). Another uninscribed altar was found there, on the steps leading to the strongroom (Macdonald & Barbour 1897, 34, no. 31, pl. 11.4; Keppie & Arnold 1984, no. 17).

presumably not too long after the withdrawal of the Roman garrisons; used in its construction were tombstones and funerary monuments (Nos 48–53), architectural elements, including diamond-broached building stones, columns and column bases, and inscribed building records (No. 21), brought there from one or more forts (Richmond & Steer 1957, 1–6). No Roman installation is known at or near Shirva, though a mile-fortlet has been postulated there on the grounds of spacing (Keppie and Walker 1981, 181); but such a site would probably not have had a cemetery outside its gate.

When seeking a source for the stonework recovered at Shirva, we could most easily think of the forts at Bar Hill or Auchendavy, both about 1 km from the site, respectively to east and west (Keppie & Walker 1985). The type of gritty sandstone in use for the Shirva gravestones (Nos 48–50) and the building-record (No. 21) resembles that of that group of altars (Nos 33-37) found at Auchendavy.[28] The column base from Shirva illustrated by Gordon (1732, pl. lxvi) is different in style from those found during excavation of the well in the headquarters building at Bar Hill in 1902; it may therefore also have derived from Auchendavy.[29]

The re-use of Roman stonework in post-Roman times is widespread throughout Britain, and in those parts of continental Europe and beyond, which had formed part of the Roman Empire. In southern Scotland, dressed stone blocks and voussoirs from a bath-house were re-used in cists at cemeteries of likely later Iron Age date at Parkburn, Lasswade (Henshall 1966, 209) and at Thornybank, Dalkeith (excavated 1996); the stonework seems likely to have derived from an adjacent first-century fort at Elginhaugh (Keppie 1990, 5). The re-use of Roman stonework in souterrains at Shirva, Newstead, and Crichton has already been noted. In the fifth century A.D. building stones were carried 6 kms from the fort-site at Birrens, Dumfriesshire, to monastic buildings under construction at Hoddam (Keppie 1994, 44ff.). Two or more altars were employed as building material at Jedburgh Abbey in the twelfth century (*RIB* 2117–2118; Keppie 1990, 8, fig. 8), possibly re-used from an earlier church on the same site (RCAHMS 1956, 194ff.). Landowners frequently walled up Roman stones in Late Mediaeval towerhouses, for example at Castlecary Castle (Keppie & Arnold 1984, no. 82) and at Cawder (No. 4, *RIB* 2209), not always with proper respect for, or any particular knowledge of, their significance. Sir John Clerk of Penicuik, writing in 1734, was scathing in his verdict of private individuals who accumulated stones in his day: 'I'll adventure to pick out at least fifty of their number [members of the Faculty of Advocates, Edinburgh], who if they found a Roman altar would thinke they had got a prize of a large stone to be a lintle or rebet to a stable or house of office' (SRO GD 18/5031/6; see Brown 1989, 168).

Though it is natural to suppose that a stone taken to a landowner's house was found on land owned by him, some care must be exercised. One distance slab was acquired by, or presented to, the Earl Marischal, at Dunnottar Castle, Kincardineshire (No. 1), but how it got there is unknown. Two others were kept for a time by the Hamiltons of Barns at Cochno House, Duntocher (Nos 10, 13); but the family appears not to have owned land immediately adjacent on the line of the Antonine wall itself (but see below, p. 83, n. 2). The earliest slab acquired by Glasgow College was gifted by the Third Marquess of Montrose (No. 16). The Marquesses (later Dukes) of Montrose did not hold directly any land on the Wall, but were considered powerful patrons by local families.

The story presented above has generally been one of discovery, and of the safekeeping of stones from that moment onwards. But some slabs noted by the antiquaries cannot now be traced (*RIB* 2154, 2172 = Keppie & Arnold 1984, no. 101; *RIB* 2132, 2138; Keppie & Walker 1985, 33-5). Three stones preserved for a time at Cumbernauld have disappeared from view (*RIB* 2151, 2147, 2152). Two others were lost when Kilsyth Castle, whither they had been taken by the late fifteenth/early sixteenth century, was blown up by Cromwellian troops in 1650 (*RIB* 2172, 2187, 2312), although part of one (*RIB* 2187) was recovered during limited

[28]The style of the three graveslabs (Nos 48–50) closely matches that of the now lost *RIB* 2172, built up into the fabric of Kilsyth Castle, and lost when the Castle was blown up in 1650.

[29]Salway (1965, 159) located the 'tumulus' at Shirva Dyke cottage, immediately east of Auchendavy, 1.5 km west of Shirva House. But in this case, the find would surely have been described as made at Auchendavy.

excavation at the site of the Castle in 1976 (Keppie 1978, 19–24). The loss of a distance slab in 1871 within six years of its discovery (No. 8), after having lain safely in the ground for some 1,700 years, is especially regrettable (above, p. 35). The recent rediscovery of an inscribed stone from Westerwood fort (*RIB* 2157), hitherto last attested in 1732 (Horsley 1732, 200), shows that hope should not be abandoned (see Tomlin 1995, 797).

8. STONES WITHOUT A SECURE PROVENANCE

There are in the Hunterian collection a number of inscribed or sculptured stones for which there is no information on their date of arrival at Glasgow University, or their donor, or place of discovery. Scrutiny of the Hunterian Museum Donations Books and other documents preserved at Glasgow University and elsewhere has revealed a number of donations at different times during the eighteenth and nineteenth centuries, where the details offered are insufficient to allow sure identification among those stones currently preserved in the Museum. We cannot of course always be certain that the donated stone was a genuine antiquity, though obviously the donor considered it so, or indeed that it has survived to the present day. For example, an 'uninscribed altar', column capitals and bases, and diamond-broached stones found at Shirva in 1726-31 have not survived (above, p. 16); indeed they may never have been removed from the site. The stones forming the 'nich' found at Castlecary in 1769 have similarly disappeared (above, p. 29).

Stones in the Hunterian collection without provenance include (1) a square panel (No. 74) with an enigmatic sculptured scene, of local sandstone, which had reached the University before *c.* 1790; (2) an altar which was at the Hunterian Museum by 1844 (No. 44); and (3) a badly battered altar which appears on a sepia photograph datable to 1872 (above, p. 42; FIG. 17), though it is not mentioned in any written account before 1934. The latter is very probably to be equated with 'the mutilated alter' (No. 38) presented in 1773, which was presumably felt to be too damaged to merit inclusion in the *Monumenta* of 1792 or indeed to be noticed by Stuart (1845) or James Macdonald (1895; 1897).

An entry in the Museum Donation Book for 1814, at 28 March, reports an item out of due sequence: 'Omitted to be entered at this date, a stone found at the Roman station near Cramond, Midlothian, sent by a person unknown (GUL MR 49/1, f.25; it was entered in mid-May 1814). The entry is omitted from a fair-copy of the same donation book compiled later (GUL MR 49/2, ff. 194-5); but it is tempting to identify the stone as No. 44.

More problematical is an altar known only from a donation letter dated 1881: 'taken out of the Wall by my Father, the late Mr William Murray, with his own hands in or about the year 1820 . . . he lived near the site of the Roman Wall . . .'; it was subsequently taken by the family to their new home at Monkland House, Airdrie (Letter from F. Murray to Professor John Young, May 1881, GUL MR 50/53). Mr William Murray had previously owned an ironworks in the vicinity of Banknock, Stirlingshire, only 1 km north of the Antonine Wall at Castlecary (Miller 1864, 107), so that a findspot there or at an adjacent fort seems likely. Mr Murray continues: 'I have been told that when it came into my father's possession, there were traces of an inscription in which the word "Mars" was clearly seen, but which time and exposure have rendered almost illegible now' (MR 50/53).

James Macdonald, in his preliminary account of the Hunterian collection (1895, 30), mentions four altars so weathered that the inscriptions could not be read; they are likely to be among Nos 28, 30, 38, 42, 44. In the *Tituli Hunteriani* (1897, 94) he notices (1) 'the top of an altar, much defaced' (probably No. 38), (2) 'a portion of a slab, greatly worn', (3) 'a small piece of another slab', which he suggests as the bottom-left corner of No. 15, but quite definitely its bottom-right corner (below, p. 86), and (4) 'a fragment of a third slab, so closely resembling [No. 17] that it may have been part of it' (1897, 94).[30]

[30]It may be identifiable as the small fragment here catalogued as part of No. 50. Three worn fragments from altars or sculptured slabs are known, long preserved in the Museum, with registration numbers which indicate that they arrived before 1900 (Inv. nos F. 35, 57, 58). One of these (F. 35) might be, or be part of, the altar donated by Mr Murray in 1882, but it is rash to think that we can securely match up every item.

9. CONCLUSION

The Hunterian collection, begun over 300 years ago, and hopefully continuing to expand as new material is found, contains many important inscriptions, especially the distance slabs erected to mark the construction of the Antonine Wall in A.D. 142–43. The present study has, it is hoped, added to knowledge, especially on the history of the collection, and the circumstances surrounding the discovery and donation of stones, activity which in past generations has reflected the enthusiasms, and sometimes the indifference, of individuals. The readings of the texts on a number of stones has been reassessed and at times, it is hoped, improved (see especially Nos 7, 30, 38, 40, 49).

Given the gains in knowledge of the early history of some stones recovered from hitherto unpublished contemporary documents, it is to be hoped that more such archival material will come to light, in national and local archives, and in papers still in the possession of individual families (cf. above, p. 2). The writer has been struck by how much easier it can be to reconstruct events of two or more centuries ago than those of more recent times. It always seems less necessary to document current activities, which can soon pass from memory. Fortunately modern museum documentation systems allow for proper recording of conservation, exhibitions, and loans, which should be of value to future researchers.

CHAPTER THREE

CATALOGUE

PREFACE

The stones are here divided according to category, following the order of discussion in Chapter 2 (above, p. 49); i.e. (1) building records, (2) altars, (3) gravestones and (4) funerary relief sculpture, (5) relief sculpture and sculpture in the round, (6) architectural sculpture, and (7) miscellaneous. A few small fragments are considered at the end (8). Within each category stones are generally listed from north to south, and, on the line of the Antonine Wall, from east to west, where appropriate.

Particular attention is paid to the earliest accounts of the discovery of a stone, which are often quoted verbatim. Thereafter all major authorities are cited; but I have omitted numerous publications on the Romans in Scotland or on the Roman world in general, when photographs of individual stones have merely been employed as illustrations. On the other hand, all line illustrations or photographs published before 1900, and occasionally thereafter, are noted. Where a book has had more than one edition, I have generally cited the earliest: for example the first (1845) rather than the second (1852) edition of Robert Stuart, *Caledonia Romana*. I have referred to the latter only where the original text was augmented by footnotes contributed by Dr John Buchanan or Professor Daniel Wilson. Similarly, for stones illustrated in the University of Glasgow's *Monumenta Romani Imperii*, I have noticed their appearance in the 1768 edition, citing the enlarged 1792 edition only where newly found stones are illustrated there for the first time. I have on the other hand cited both editions (1911 and 1934) of Sir George Macdonald's magisterial *The Roman Wall in Scotland*; separated by more than twenty years, they each offer a useful indicator of his views and knowledge at fixed dates. Where a recent scrutiny of antiquarian sources has altered the accepted date of discovery or findspot, as reported in *RIB* I (Collingwood & Wright 1965) or *CSIR* (Keppie & Arnold 1984), I have specified such changes, for the reader's benefit, under the appropriate entry.

For the most part, I have not offered a date for the carving and erection of individual stones. Most belong in the Antonine period of the Roman occupation of Scotland, i.e. A.D. 142–c. 165 (above, p. 47). Only where there are grounds for closer dating within these limits, or where stones can be assigned to other periods, has the matter been discussed in detail. The distance slabs are assumed to have been erected in A.D. 142–43, at the beginning of the Antonine occupation.

The findspot in each case is described in terms of the pre-1974 county-name, together with the current (post-1996) local authority-name placed in brackets; it is hoped this combination will allow for easy referencing. The heading for each entry gives the provenance, the date of discovery where known, and the Hunterian Museum Inventory Number. Dimensions are normally cited in the order: height (H), width (W), and depth (D), unless otherwise specified. The Bibliography for each entry is preceded by separate citation of the chief epigraphic references, for ease of consultation, together with a reference to the *Scotland* fascicule of the *Corpus of Sculpture of the Roman World* (Keppie & Arnold 1984), where appropriate.

I have identified the findspots of stones, where known, with a six-figure National Grid Reference. The latter, which can often only offer an approximate guide, should be utilised in conjunction with the accompanying descriptions of the discovery of the stones concerned.

In the *apparatus criticus*, I have cited alternative readings of the inscriptions advocated by the early antiquaries or more recent commentators, and credited also the scholar or scholars who first adopted the readings now generally accepted. The names of the authorities cited should be obvious, but can be confirmed by reference to the accompanying bibliography.

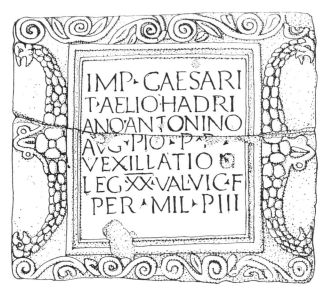

1

Scale 1:12

1. BUILDING RECORDS

A. DISTANCE SLABS

1. DISTANCE SLAB OF THE TWENTIETH LEGION PL. I

Unknown provenance, before *c.* 1603. Inv. no. F.1.

Findspot: The slab was first reported at Dunnottar Castle, Kincardineshire, in north-east Scotland, the home of the Earls Marischal, where it was seen in *c.* 1603 by Servaz Reichel (Haverfield 1911, 373), and reported by him to Camden: *In Scotia in Illustrissimi Comitis Mareschalli arce fortissima (Dumnotir vulgo dicta) in porticu muro inclusa est haec elegantissima inscriptio* (Camden, BM Cotton Julius F.VI, f. 295; cf. Camden 1607, 699, marginal note in his own copy, now Bod.Lib. MS Smith 1). Camden's description of the findspot in his *Britannia* (1607, 699), where he assigns it, on Reichel's authority, to the line of the Antonine Wall, led to confusion with No. 4 over provenance, both the anonymous author of *Respublica* (Anon. 1627) and Sibbald (1707, 50) allocating this stone to Cawder House.

Mr John Keyth, 'sometime Minister at Dunotir', writing in 1642, mentions a stone 'that was found in a Dike in ye Borders of England and Scotland, brought to Dunotir by Earle George Marischall, sometime Ambassadour to Denmark for Queen Anne . . . The Romans then hewed a stone

foursquare, the Eagle their Insignia drawn on the sides thereof with some letters in the Middest' (Macfarlane 1908, 236; Macdonald 1934, 365f.). From the date and content (as well as the earlier testimony of Camden), it presumably derived from the Antonine Wall rather than Hadrian's Wall, but the original findspot cannot be determined. '[It was] dug up in the Ruins of this wall, and made a present long ago to the ancestors of the late Earl' (Gordon 1726, 62).

George, Fifth Earl Marischal, who held the title 1581–1623, was a well known antiquary and traveller, who founded Marischal College, Aberdeen, in 1593. The earliest reports of the stone at Dunnottar place it in a porch or portico (Haverfield 1911, 371): *in porticu fortissimi propugnaculi* (BM MS Cotton Julius FVI, f. 311); *in porticu muro inclusa* (Bod.Lib. MS Smith 1, at p. 699; cf. Gibson 1695, 939; Macfarlane 1907, 337); later it was on view in a niche or alcove in the north wall of the gallery or ballroom, in a building erected sometime after 1550 ('fixed into his Gallery which is to be seen at this day [1642]' (Macfarlane 1908, 239; Simpson 1976, 43). It thus stood in a conspicuous position, in the Castle's finest apartment. It evidently survived the ferocious siege in 1652. After George, Tenth Earl Marischal (1712-78), was exiled for his Jacobite sympathies in 1716, and his estates forfeited, the Castle was dismantled in 1718. Soon after, probably *c.* 1723, the slab was placed in the safekeeping of Marischal College, Aberdeen, on the initiative of his mother, the Countess Marischal (Gordon 1726, 62; Horsley 1732, 204; Anderson 1771, f. 40). In the autumn of 1723 Sir John Clerk of Penicuik sought without success to secure it for his own collection (above, p. 14).

Sir George Macdonald located the slab on the line of the Antonine Wall 'somewhere east of Auchendavy', on the grounds that no available work-sector of appropriate length was available west of that fort (1921, 15; 1934, 365). His words must not be taken too literally (e.g. *RIB* sets it between Auchendavy and Twechar); we can say only that it must belong in the central stretch of the Wall where the building process is inadequately documented.

Donation: In or shortly before December 1761. 'When my Lord Mareschall was last in Scotland, the New College at Aberdeen, with his Lordship's approbation, added it to the Glasgow Collection' (Anderson 1771, f. 40). The Earl had returned to

Scotland, on the annulment of his exile, in 1760. Bishop Pococke saw the stone at Aberdeen in August 1760 (Pococke 1887, 209). The donation itself is not recorded in the Faculty Minutes, but the arrival of a stone at the College from the port of Leith is recorded on 8 December 1761, and its placing inside a wooden press on 12 December, in accounts subsequently submitted by the Bedellus (above, p. 21). *Vir nobilissimus Georgius Keith Scotiae comes Mareschallus lapidem hunc donavit Academiae Novae Abredonensi* (sic) *quae eundem cum consensu eiusdem Comitis dono dedit Academiae Glasguensi Ann. Dom. MDCCLXI* (University of Glasgow 1768, pl. xiv).

Condition: The slab is pockmarked and worn at the edges. It is broken horizontally into two almost equal parts. Damage has been suffered in the vicinity of the break, especially to letters of lines 3–4. The earliest detailed drawings (by Adair, Gordon, and Horsley) show it unbroken; the break had occurred by 1768 (University of Glasgow 1768, pl. xiv; cf. Gough 1789, pl. xxv.2). The observation in December 1761 that the slab was difficult to lift because it was 'very hevie' (above, p. 21) could suggest that it was then still in one piece.

Description: The inscribed panel is contained within plain mouldings, and framed to left and right by *peltae*, their necks covered by plumage, and horns terminating in griffin-heads with gaping beaks, surmounted by rosettes. Above and below the inscribed panel is a horizontal line of ivy tendrils. There are two dovetail crampholes in the top of the slab. H: 0.87 m; W: 0.97 m; D: 0.105 m. Buff sandstone.

There is evidence of gilding. The early antiquaries make it clear that this was not of Roman origin: 'In a porch here is to be seen that ancient inscription above mentioned of a *Company* belonging to the *XXth Legion*, the letters whereof the most honourable the present Earl, a great admirer of antiquity, caused to be gilded' (Camden 1607, 711–12, as translated in Gibson 1695, 939). 'Cambden tells us that in his time the stone was built up in the castle of *Dunnotyre*, and that the then Earl *Mareschal* being an admirer of antiquity had caused the letters to be gilded. I doubt our present antiquaries would scarce thank the noble Lord for this expression of his value and zeal for antiquity. There is now some black colouring as well as gilding upon it' (Horsley 1732, 204). '. . . the then Earl Marsichall being an admirer of such remains of Antiquity had caused the Letters to be gilded. It is proper to take note of this lest it be imagined that this foppery was added to it since it came into Glasgow College' (Anderson 1771, f. 40). 'The gilding has very properly now been washed off' (Gibb 1902d, 80). In fact the gilding became visible after cleaning in 1976. The frame

enclosing the inscribed panel was also gilded; the floral motifs above and below, and the *peltae* to left and right, had been painted in a dark colour. The slab must therefore have had a quite colourful and dramatic appearance at Dunnottar Castle.

Inscription: *Imp(eratori) Caesari | T(ito) Aelio Hadr | iano Antonino | Aug(usto) Pio p(atri) p(atriae) | vexillatio | leg(ionis) X̄X̄ Val(eriae) Vic(tricis) f(ecit) | per mil(lia) p(assuum) III.* 'For the emperor Caesar Titus Aelius Hadrianus Antoninus Augustus Pius, Father of his Country, a detachment of the Twentieth Valiant and Victorious Legion built (this) over a distance of 3000 paces'.
Line 2: ADRIANO (R. Gordon of Straloch); line 4, P.PP (Gordon of Straloch); line 5: VEXILLATIO (Camden, Anon. 1627), VEXILLATIO Ⓝ (Adair, Gordon, Horsley) with Ⓝ later deleted (Gordon), VEXILLATION (University of Glasgow 1768, Hübner), VEXILLATIO followed by triangular interpunct (Collingwood & Wright, Keppie); subsequently, the gap at the end of line 5 has been filled by a letter which seems to be N, later altered to O, both gilded. Horsley supposed that the N was added in antiquity by the stonecutter, and later excised (1732, 204; cf. Hübner 1873 on *CIL* VII 1143), but while there is a pronounced hollow in the stone here, no letters appear to have been fully incised; line 6: XX VAL VIC E (BM MS Cotton Julius).
Letter heights: 1: 0.06 m; 2–7: 0.05 m.

Discussion: This distance slab, erected by a detachment of the Twentieth Legion, commemorated completion of 3,000 paces of the Wall. In style the slab is very different from those erected by detachments of the same legion west of Castlehill, so that it may belong to a different season or phase of the building process, and be the work of a different sculptor (above, p. 64). The decorative tendrils are a feature common on tombstones; parallels can be found on the Danube and in Britain (*RIB* 832).

CIL VII 1143; *ILS* 2482; *RIB* 2173 *CSIR* 158
Bibliography: BM Cotton Julius F.VI, f. 295, 311; Camden 1607, 699; Anon. 1627, 68; Blaeu 1654, 4, 69; Gibson 1695, 919; Dalrymple 1695, 99 with fig.; Sibbald 1707, 50; Gordon 1726, 62, pl. xii.2; Horsley 1732, 204, no. xxvi; pl. (Scotland) xxvi; University of Glasgow 1768, pl. xiv; Anderson 1771, f. 39–40; Gough 1789, vol. 3, 360, pl. xxv.2; Roy 1793, 165; Nimmo 1817, 640, no. 6 on fig.; Orelli 1828, no. 3565; Hodgson 1840, 263, no. cclxi; Stuart 1845, 356, pl. xv.8; Pococke 1887, 209 with fig.; Haverfield 1892, 334, no. 1094; Macdonald 1895, 12-14, no. 1; Macdonald 1897, 46–9, no. 16, pl. iv.1; Glasgow Archaeological Society 1899, 9, no. 18; Gibb 1902d, 79–81 with pl.; Macfarlane 1907, 336–42;

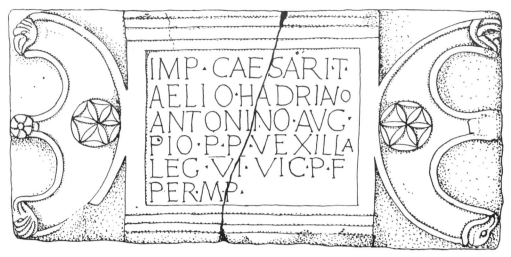

2

Scale 1:12

Macfarlane 1908, 239; Haverfield 1911, 371–3; Macdonald 1911, 300–1, no. 14, pl. xl.2; Haverfield 1913b, 630; Macdonald 1934, 365–6, no. 2, pl. lxii.1; Toynbee 1964, 149–50; Simpson 1976, 43; Keppie 1979, 12, no. 2; Keppie & Arnold 1984, 58, no. 158, pl. 39; Vasey 1993, 65–72.

2. DISTANCE SLAB OF THE SIXTH LEGION PL. I

EASTERMAINS, Kirkintilloch, Dunbartonshire (East Dunbartonshire), 20 March 1740. Inv. no. F.2.

Findspot: NS 667 747. 'This day a Roman Stone was found about half-a-mile east of Kirkintilloch in the Wall . . . it was found broken through the middle where the line is drawn' (unknown author, SRO GD 18/5053 with fig.). 'The next curiosity I must acquaint you of is a stone five foot long, found near our Roman wall, with inscription . . . I have not sent a drawing to you very nice, for want of time, and the person who took it, I believe, had not copyed [it] right about the end, and the number of paces is defaced', Sir John Clerk to Roger Gale, 16 July 1740 (Lukis 1885, 419; this is likely to be the drawing preserved as SRO GD 18/5054). 'His correspondent [someone who had sent details to an acquaintance of Clerk] assures him that there are no numeralls after M.P., having observed that particularly, so that he concludes it to have been onely (sic) one mile', Thomas Routh to Gale, 28 February 1742 (Lukis 1887, 419). 'A few years since, a little bewest of the aforesaid bridge of Inchbelly, a legionary stone was dug up' (Maitland 1757, 178). *Inventus est hic lapis prope Oppidum de Kirkintilloch* (University of Glasgow 1768, pl. xx).

Donation: 26 June 1744 (by purchase). 'A precept was signed to pay Robert Simson thirty six Shill[ings] Sterl[ing] for Expenses laid out by him in purchasing and bringing from Kirkintilloch a large Stone of the Roman Wall with an Inscription' (GUA 26648, p. 163); 'now in the College of Glasgow' (Maitland 1757, 178).

Condition: The slab, which has an angular break across the middle of the inscribed panel, is worn at the edges; the horns of the *peltae* are broken away.

Description: The inscribed panel is contained within broad, plain mouldings, triple-ribbed above and below, and flanked by *peltae* whose horns terminate in griffin heads and whose central projections end in rosettes. Large six-pointed rosettes surmount each *pelta*. There are two large dovetail crampholes in the top of the slab. H: 0.77 m; W: 1.59 m; D: 0.165 m. Gritty buff sandstone.

Inscription: *Imp(eratori) Caesari T(ito) | Aelio Hadriãno | Antonino Aug(usto) | Pio p(atri) p(atriae) vexilla(tio) | leg(ionis) VI Vic(tricis) p(iae) f(idelis) | per m(illia) p(assuum).* 'For the emperor Caesar Titus Aelius Hadrianus Antoninus Augustus Pius, Father of his Country, a detachment of the Sixth Victorious, Loyal and Faithful Legion (built this) over a distance of . . . thousand feet'.

Line 2: HADRINO (Clerk); HADRIÃNO (Clerk, University of Glasgow 1768, etc.); line 5: P·P (Clerk), P·F (University of Glasgow 1768; Hübner, etc.). Letter heights: 1–4: 0.07 m; 5-6: 0.06 m.

Discussion: This distance slab, erected by a detachment of the Sixth Legion, commemorated the completion of an unknown length of the Wall, presumably running eastwards from the findspot (Macdonald 1934, 367). The numerals to record the distance were never inserted (so Macdonald 1921, 15; but later he argued that the distance recorded was *mille passus*, i.e. 1,000 paces; Macdonald 1934, 367, 395; so *RIB* 2185). How-

ever, it must be likely that the inscription was cut in the quarry, with the exception of the precise distance which was not yet known (cf. above, p. 55). This slab must have stood beside or adjacent to No. 3.

CIL VII 1121; *RIB* 2185 *CSIR* 122
Bibliography: Maitland 1757, 178; University of Glasgow 1768, pl. xx; Anderson 1771, f. 42; Gough 1789, vol. 3, 360, pl. xxv.7; Nichols 1790, 343f., with pl. vi.14 (at p. 239); Hodgson 1840, 271–2, no. ccxcv; Stuart 1845, 317-18, pl. x.5; Nimmo 1880, 30; Lukis 1887, 419; Pococke 1887, 52, 209; Macdonald 1895, 24; Macdonald 1897, 55-6, no. 18, pl. vii.3; Glasgow Archaeological Society 1899, 6, no. 3; Gibb 1902a, 124–6; Macdonald 1911, 301–2, no. 15, pl. xl.3; Haverfield 1913b, 626; Macdonald 1934, 366–7, no. 3, pl. lxii.2; Keppie 1979, 13, no. 3; Keppie & Arnold 1984, 45, no. 122, pl. 31; Tomlin 1995, 797.

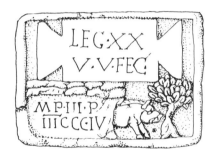

3 *Scale 1:12*

3. DISTANCE SLAB OF THE TWENTIETH LEGION PL. II

EASTERMAINS, Kirkintilloch, Dunbartonshire (East Dunbartonshire), 1789. Inv. no. F.3.

Findspot: NS 667 747. 'It was lying, on its inscribed face, about three feet under the surface, in the very centre of the Roman ditch, which had been ploughed crosswise, at this locality, from time immemorial, and was discovered during a deeper course of ploughing' (Stuart 1852, 325, fn. (a)). '. . . In a pigsty, at a farmhouse, near Kirkintilloch', W.D. Wilson of Glenarbach to John Hodgson, in a letter dated 29 September 1837 (Hodgson 1840, 439). 'For many years this curious relic remained exposed on the top of an outhouse in the vicinity of the place where it was found. Thanks, however, to its present proprietor [John Buchanan], it was rescued in time from the destructive effects of the weather and is still in very fair preservation' (Stuart 1852, 326, fn.(a)). 'The stone remained many years in his [the farmer's] possession, and came into mine, 1840', John Buchanan October 1871 (GUL MR 50/49, no. 1).

Donation: October 1871, by John Buchanan (GUL MR 50/49, no. 1). Placed upon arrival in the 'basement passage' below the University cloisters, it was rediscovered there in 1899 (above, p. 38). *In penetralia substructionum coniectus diu latebat* (Haverfield 1913b, 627). It was thus omitted from Macdonald 1897. The first published photograph (Gibb 1902a, 122; Macdonald 1911, pl. xli.1) shows it badly scuffed.

Condition: Worn and chipped at the edges.

Description: The slab takes the form of a substantial tapering block, most obviously intended for insertion into a masonry structure. Within a plain narrow outer moulding, the upper half of the front face is taken up by an ansate panel in relief bearing the first two lines of the inscription. In the lower half, a boar is seen running right towards a tree in full bloom, from behind or from within a rocky outcrop or cave seemingly topped by flat slabbing. '[T]he figure of a lusty boar, making for a bush or tree to the right hand; emblematical no doubt of the Caledonian forest' (Gibb 1902a, 120). H: 0.44 m; W: 0.59 m; D: 0.38 m. Buff sandstone.

Inscription: *leg(io) XX | V(aleria) V(ictrix) fec(it)| m(illia) p(assuum) III p(edum) | IIICCCIV*. 'The Twentieth Valiant and Victorious Legion built 3,000 paces, 3,304 feet'.

Letter heights: 1–2: 0.045–0.055 m; 3: 0.03–35 m; 4: 0.035–40 m.

Discussion: Despite its shape, it can hardly be doubted that this is a distance slab. The boar and tree, which can be paralleled on No. 8, are familiar in Celtic and Roman art (above, p. 62). The length of the work-sector being commemorated here, generally supposed to run westwards from the findspot (Macdonald 1934, 369, 399), has been variously computed: earlier commentators supposed that there was some duplication by the stonecutter in the numerals, the total distance being 3,304 paces (Hübner 1873 ad loc.; Macdonald 1911, 303; 1921, 8). We could indeed suppose that the letters M P III were inscribed at the quarry, but when the time came to insert the precise distance, the letters P III were inadvertently repeated. However, C.J. Bates argued that there was a combination here between measurement in paces (3,000) and in feet (3,304) (Bates 1898, 107); subsequently a student in the 1931–32 Class of Roman History at Glasgow University, Mr John E. Harrison, noticed that if 3,000 paces and 3,304 feet were added together, the total was 3,660 $4/5$ paces, very close indeed to the distance of 3,666 $1/2$ paces reported on four other stones (Nos 2, 5, 6; *RIB* 2194). This suggestion was communicated by S.N. Miller to Sir George Macdonald, who enthusiastically endorsed it (above, p. 44; Macdonald 1934, 368 n. 2). More recently Dr A.

Strang (1990, 27ff.) has suggested that the numerals recorded two separate lengths (of 3,000 paces and 3,304 paces) running east and west of the findspot; but it may be doubted whether readers of the text in Roman times would have grasped the intended meaning. The findspot indicates that it must have stood near or next to No. 2.

CIL VII 1122; *RIB* 2184 *CSIR* 123
Bibliography: Hodgson 1840, 271, no. ccxciii. 439; Stuart 1845, 320, pl. x.4; Stuart 1852, 325, fn. (a); Bates 1898, 107; Glasgow Archaeological Society 1899, 6, no. 4; Gibb 1902a, 119-22 with photo; Macdonald 1911, 302–4, no. 16, pl. xli.4; Haverfield 1913b, 627; Macdonald 1934, 367-9, no. 4, pl. lxiii.1; Keppie 1979, 13, no. 4; Keppie & Arnold 1984, 45, no. 123, pl. 32.

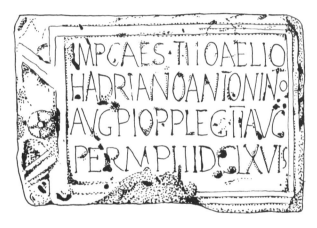

4 *Scale 1:12*

4. DISTANCE SLAB OF THE
SECOND LEGION PL. II

At or near CAWDER, Bishopbriggs, Glasgow (City of Glasgow), before *c.* 1603. Inv. no. F.4.

Findspot: First seen *c.* 1603 built into a tower-house at Cawder, Bishopbriggs, as reported by the German traveller Crispin Gericke to Gruter (Leiden MS *Papenbroekianus* 6, f. 110; Hübner on *CIL* VII 1126) and to Scaliger (Scaliger 1607, *Animadversiones*, 175) and by Servaz Reichel to Camden: *Ad Cadir parieti domus infixa* (Camden 1607, 699). *In domo cuiusdam viduae de Cader prope Glasco in Scotia, in turri vetusta circa fenestram* (BM MS Cotton Julius VI, f. 293); cf. a manuscript marginal note by Camden, in his own copy of the 1607 edition of *Britannia* (1607, 699 = MS Smith 1, now in the Bodleian Library, Oxford). The slab was later set into the fabric of Cawder House, presumably on its construction in 1624. It was seen there by John Adair, John Urry, and Edward Lhwyd in 1696-99 (Vasey 1993, 66; Sharp 1937, 37, no. xix; above, p. 9). 'In ye Wall of Kalder

House, the west side of ye House (BM MS Stowe 1024, f. 111). 'When Mr Gordon saw this stone, it was built up in the west end of the house; but it is now taken down and placed within' (Horsley 1732, 198), presumably sometime between 1723–25 and 1728–29. (Presented by John Napier to Sir James Stirling of Keir: so *RIB* 2186 in error, by confusion with *RIB* 2209.)
Donation: 1735. 'Mr Stirling of Kier caused take this stone out of the wall of his house, being much spoiled by being exposed to the weather, and sent it to the University of Glasgow, where it now stands with the rest. A.D. 1735' (marginal note in a Glasgow University Library copy of Gordon 1726, at p. 54).
Condition: The slab is badly pitted and pock-marked; damage has been sustained at the lower margin, where an area is infilled with cement, presumably reflecting its former location, built into a masonry wall at Cawder House. At first sight the slab appears to have lost its left side-panel; but the dressing of the surviving left edge matches the other sides, and dovetail crampholes in the top of the slab are placed symmetrically for the stone as we have it (Sibbald 1695, fig. at p. 1103 shows *ansae* to both left and right).
Description: The slab is carved to show an inscribed panel contained within narrow raised mouldings, flanked to the left by an *ansa* similarly bordered and containing a six-pointed rosette. There are two broad, shallow dovetail crampholes in the top of the slab. H: 0.63 m; W: 0.93 m; D: 0.175 m. Buff sandstone.
Inscription: *Imp(eratori) Caes(ari) Tito Aelio | Hadriano Antonino | Aug(usto) Pio p(atri) p(atriae) leg(io) II Aug(usta) | per m(illia) p(assuum) IIIDCLXVIS.* 'For the emperor Caesar Titus Aelius Hadrianus Antoninus Augustus Pius, Father of his Country, the Second Augustan Legion (built this) over a distance of 3,666 ½ paces'.
Line 1: TIT.IO (Camden, Anon. 1627), TITO (Gericke, Gruter, Sibbald, Gordon, Horsley etc.); line 2: HADRIAÑNO (University of Glasgow 1768, Stuart); line 4: DCIXVIS (Camden), DCLXVI (Gordon, Horsley); DCLXVII (Sibbald), DCLXVIS (Adair, BM MS Stowe, University of Glasgow 1768, J. Macdonald).
Letter heights: 1–2: 0.08 m; 3: 0.085 m; 4: 0.08 m.
Discussion: This distance slab, erected by a detachment of the Second Legion, commemorated the completion of a sector of the Wall between Summerston and Cadder, and was localized by Macdonald (1934, 371) at Bogton (NS 623 728) east of Cadder fort. It is one of the earliest stones reported by antiquaries. The western end of the same sector was marked by No. 5. The same distance, 3,666 ½ paces, is reported on two slabs

commemorating the sector immediately to the west, erected by a detachment of the Sixth Legion (No. 6; *RIB* 2194).

CIL VII 1126; *RIB* 2186 *CSIR* 127
Bibliography: Camden 1607, 699; Scaliger 1606, *Animadversiones*, 175; Anon. 1627, 68; Blaeu 1654, 4, 69; Dalrymple 1695, 99 with fig.; Sibbald 1695, 919, 1102 with fig.); Sibbald 1697, 205; Sibbald 1707, 29, 50; Gibson 1722, 1221; Gordon 1726, 54, pl. x.2 ; Horsley 1732 p. 198, no. x, pl.(Scotland) x; Maitland 1757, 179; University of Glasgow 1768, pl. xi; Gough 1789, vol. 3, 359, pl. xxiv.7; Nimmo 1817, 640; Hodgson 1840, 267, no. cclxxvii; Stuart 1845, 317–18, pl. x.2; Macdonald 1895, 24 no. 7; Macdonald 1897, 44–6, no. 15, pl. vii.2; Glasgow Archaeological Society 1899, 6, no. 5; Gibb 1902b, 171–3; Macdonald 1911, 292-8, no. 12, pl. xxxix.3; Haverfield 1913b, 627; Macdonald 1934, 369–72, no. 5, pl. lxiii.2; Keppie 1979, 13, no. 5; Keppie & Arnold 1984, 46, no. 127, pl. 32; Vasey 1993, 66.

5. DISTANCE SLAB OF THE SECOND LEGION PL. III

Probably near SUMMERSTON, Glasgow (City of Glasgow), in or before 1694. Inv no. F.5

Findspot: NS 574 725. '. . . from Dougalston', Gregory, April 1698 ex Urry (EUL Dk. 1.2, A74, no. 9; above, p. 6); likewise Tanner, April 1699 ex Urry (EUL MS La. II. 644/7, no. 6 = Nichols 1809, 338*, no. 6). Long assigned by antiquaries to Castlehill (by confusion with No. 6), its likely provenance was established by Macdonald (1911, 292), at Summerston on the Dougalston estate.
Donation: 1694, by John Graham of Dougalston. *ex dono Io. Graham de Dugalstoun, 1694* (BM MS Stowe 1024, f. 88; so University of Glasgow 1768, pl. iii); '. . . to be seen in the Library of Glasgow Colledge', Gregory April 1698 ex Urry (EUL

Dk.1.2, A74). '. . . the heuen stone with inscription, gifted by Dougalstoun, 1694, to the Colledge' (Wodrow 1843, 66). '. . . presented in the year 1694 by Mr Graham of Dougalston to the university of *Glasgow*, where it is now carefully preserved' (Horsley 1732, 195).
Condition: The slab has fractured diagonally across the inscribed panel, apparently after discovery (Horsley 1732, 195; shown in two parts by Adair and Sibbald), with the loss of a small fragment at the top and a larger fragment at the bottom of the break with damage to adjacent lettering. It is generally rather worn and chipped on the upper and lower borders.
Description: The central panel, enclosed above and below by thicker mouldings, contains the inscription, flanked by sculptured scenes. The left-hand panel is carved to show various figures: above, a female, with wings (now very worn) above her right shoulder, holds a circular laurel wreath in both hands, intending to set it on the head of a horseman galloping right. The latter wears a crested helmet, holds a shield, and has a short sword at his waist. His spear is poised to transfix two bound naked, bearded captives, who crouch below, facing front, hands secured behind their backs, hardly his equals in the contest. Two shields and two short swords or daggers (one described as a 'Durk or Whinger' by Sibbald 1707, 49) lie on the ground nearby. The right-hand panel shows three figures, ranged vertically: an eagle, wings outstretched, head and beak turned to left, seems perched on the back of a capricorn, which swims right. Below is a captive sitting with his legs extended to the left, facing front, and with hands tied behind him; there is a shield to his right. During cleaning in 1976 traces of paint were visible in the left-hand side-panel and in the lettering of the inscription. There are large dovetail crampholes in the sides of the slab, and a small cramphole centrally placed in its top. After the letters CAES in line 1, AVG in lines 3 and 4, and after PEP and M P in line 4 are simple ivyleaf

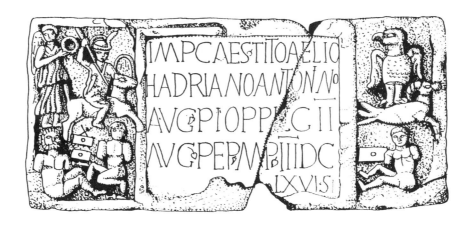

5 *Scale 1:12*

interpuncts. H: 0.6 m; W: 1.34 m; D: 0.14 m. Buff sandstone.

Inscription: *Imp(eratori) Caes(ari) Tito Aelio | Hadriano Antonino | Aug(usto) Pio p(atri) p(atriae) leg(io) II | Aug(usta) pep(!) m(illia) p(assuum) IIIDC | LXVIS.* 'For the emperor Caesar Titus Aelius Hadrianus Antoninus Augustus Pius, Father of his Country, the Second Augustan Legion (built this) over a distance of 3666 ½ paces'.

Line 2: ANT[O]NINO (Stukeley), ANTONNO (Stuart in fig.); line 3: PIO PI [O L]EG II (Stukeley); line 4: FEP (Stukeley), PFR (Gordon), PER (Horsley, Maitland, Stuart), PEP (Sibbald), PEP intended for PER (J. Macdonald, G. Macdonald, Collingwood & Wright); Hübner states, wrongly, that PEP has been corrected to PER in modern times); line 5: IIIDCXVI ❧ S (Horsley); AVG PFR (Gordon). The vertical stroke visible at the end of line 5 is modern.

Letter heights: 1: 0.075 m; 2: 0.081 m; 3:0.084 m; 4: 0.08 m; 5: 0.045 m.

Discussion: The slab, which was erected by the Second Legion, commemorated the completion of a sector between Balmuildy and Bogton (Macdonald 1934, 377) and marked its western end, presumably standing adjacent to *RIB* 2194. The sculptured scenes, with Victory crowning a Roman cavalryman and with representatives of the native population in defeat, symbolise Roman military success which, we can suppose, preceded the building of the Wall, and the Second Legion's role in it. Victory here lacks her normal globe, unless the latter is concealed behind the head of the adjacent captive.

CIL VII 1130; *RIB* 2193 *CSIR* 137

Bibliography: Sibbald 1707, 49; Stukeley 1720, 10, no. v with fig.; Gordon 1726, 52, pl. xi.3; Horsley 1732, 195–6, no. iii, pl. (Scotland) iii; Maitland 1757, 181; University of Glasgow 1768,

pl. iii; Anderson 1771, ff. 32–3; Gough 1789, vol. 3, 359, pl. xxiv.1; Pennant 1774b, 138; Nichols 1809, *338, no. 6; Laskey 1813, 76, no. 3; Hodgson 1840, 268, no. cclxxxv; Wodrow 1843, 66; Stuart 1845, 303–4, pl. ix.1; Wilson 1851, 374; Nimmo 1880, 26–7; Bruce 1893, 47–8, pl. iii.4; Haverfield 1893, 305, no. 163; Macdonald 1895, 25 no. 12; Macdonald 1897, 34–5, pl. iii.2; Glasgow Archaeological Society 1899, 6, no. 6; Gibb 1902b, 173–82, with pl.; Macdonald 1911, 288–92 no. 11, pl. xxxix.2; Haverfield 1913b, 628; Macdonald 1934, 373–6, no. 6, pl. lxiv.1; Toynbee 1964, 149; Keppie 1979, 14, no. 6; Keppie & Arnold 1984, 49–50, no. 137, pl. 34; Vasey 1993, 65.

6. DISTANCE SLAB OF THE SIXTH LEGION PL. III

CASTLEHILL, Dunbartonshire (East Dunbartonshire), in or before 1696–98. Inv. no. F.6.

Findspot: NS 524 728. First reported by John Urry, 1696-98: '. . . to be seen at Castlehill, near East Kilpatrick, in the end of a small thatched cottage', Gregory April 1698 ex Urry (EUL Dk. 1.2, A74, no. 5); so Tanner April 1699 ex Urry (EUL MS La.II. 644/7, no. 3 = Nichols 1809, 338*, no. 3); '. . . found at Castletoun wher ther was a Tour upon the South side of the Roman Wall', Alexander Edward (SRO GD 45/26/140, with 'Sep[tember] 1699' in margin). 'In ye wall of Castlehill Dike House upon Greams Dike in the New p[a]rish of Kilpadrick in Dunbartonshire 6. miles from Glasgow' (BM MS Stowe 1024, f. 107). *In Colle Castelli. quod Balvierlandiae in Scotia est* (Fabretti 1699, 756) [Castlehill was on land then owned by the Colquhouns of nearby Balvie; see Gibb 1902c, 30ff.]. '. . . said, in Mr *Lluyd's* Collections, to be in the wall of *Castlehill Dike*

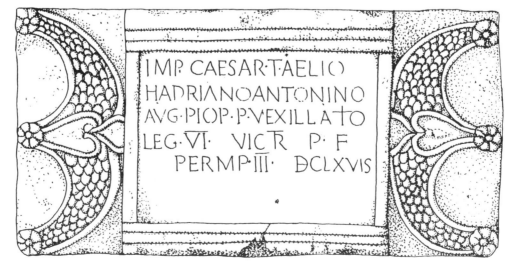

6 *Scale 1:12*

House upon Graham's Dike' (Stukeley 1720, 10). *Inventus est hic lapis prope villam de Summerstoun ad ripam fluminis Kelvin* (University of Glasgow 1768, pl. iv, by confusion with No. 5). 'We have Dr Simson's authority that it was found at Simerston' (Anderson 1771, f. 33).

Donation: by 1720. 'Dr *Jurin* saw it at *Glascow* and transcribed it' (Stukeley 1720, 10).

Condition: The gritty sandstone is very worn, giving a dull appearance.

Description: The inscribed panel is contained within a heavy plain moulding, triple-ribbed above and below, and flanked to left and right by *peltae*, carved to represent plumage; the horns and central projections terminate in rosettes, each surmounted by a large ivy leaf. The heavy ridging above is protective of the inscribed panel. H: 0.76 m; W: 1.49; D: 0.18 m. Gritty buff sandstone.

Inscription: *Imp(eratori) Caesar(i) T(ito) Aelio / Hadriano Antonino / Aug(usto) Pio p(atri) p(atriae) vexillatio / leg(ionis) VI / Victr(icis) p(iae) f(idelis) / per m(illia) p(assuum) III DCLXVIS*. 'For the emperor Caesar Titus Aelius Hadrianus Antoninus Augustus Pius, Father of his Country, a detachment of the Sixth Victorious Loyal and Faithful Legion (built this) over a distance of 3666 ½ paces'.

Line 4: VICITR·OP·F (Edward MS), VIC·R·I·F (Fabretti), VICT (Maitland), VICTR̂·P·F (Gordon, Horsley, Hübner, Collingwood & Wright), P·P (J. Macdonald, G. Macdonald, as error by stonecutter for P·F); lines 5–6: PER·M·I· III·DCLXVI (Fabretti), DCLXVb (Lhwyd), DCIXVIS (Sibbald), DCLXV (Gordon); DCLXVI (Edward), DCLXV·S (Horsley, Maitland); DCLXVIS (University of Glasgow 1768, Stuart, Hübner, Collingwood & Wright).
Letter heights: 1–2: 0.045 m; 3–5: 0.05 m.

Discussion: This slab, erected by a detachment of the Sixth Legion, commemorated the completion of a sector of the Antonine Wall, which ran eastwards from Castlehill to the vicinity of Summerston. The eastern end of the same sector was marked by *RIB* 2194, found at Low Millichen.

CIL VII 1132; *RIB* 2196 *CSIR* 145

Bibliography: Fabretti 1699, 756, no. 620; Lluyd 1700, 790; Sibbald 1707, 29 no. 7 with pl. iii; Stukeley 1720, 9–10, no. iiii on fig.; Gibson 1722, 1291 with fig.; Gordon 1726, 53, pl. xi.1; Horsley 1732, 196, no. iv, pl.(Scotland) iv; Maffei 1749, 446, no. 12; Maitland 1757, 180; University of Glasgow 1768, pl. iv; Anderson 1771, ff. 33–4; Gough 1789, vol. 3, 359, pl. xxiv.3; Nichols 1809, 338★, no. 3; Laskey 1813, 76–7, no. 4; Hodgson 1840, 267, no. cclxxx; Orelli 1828, no. 3388; Stuart 1845, 308–9, pl. ix.3; Bruce 1893, 49–50, pl. iv.1, Macdonald 1895, 25 no. 14; Macdonald 1897, 43–4, no. 14, pl. v.2; Glasgow Archaeological Society 1899, 7, no. 8; Gibb 1900, 85f., no. 3; Gibb 1902c, 30ff., with pl. at p. 35; Macdonald 1911, 287f., no. 10, pl. xxxix.1; Macdonald 1934, 377–81, no. 8, pl. lxv.1; Keppie 1979, 15, no. 8; Keppie & Arnold 1984, 52, no. 145, pl. 36; Maxwell 1989, 6 with fig. 1.2; Vasey 1993, 65–72.

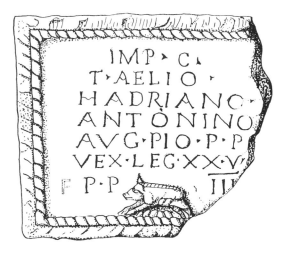

7 *Scale 1:12*

7. DISTANCE SLAB OF THE TWENTIETH LEGION PL. IV

CASTLEHILL, Dunbartonshire (East Dunbartonshire), 1847. Inv. no. F.7.

Findspot: NS 522 727. 'In the spring of 1847, the present tenant of the farm, W.G. Alexander, while ploughing a sloping field which bounds the station on the south or Roman side, had his plough arrested by a large stone firmly set in the ground. He found it to be covered with letters, and removed it to the courtyard . . . They [this and No. 72] are both in the possession of Mr John Buchanan, of the Western Bank of Scotland, Glasgow' (Stuart 1852, 310 fn. (a)). 'The stone lay on its edge in the stiff clay within a few yards south from the fort . . . It came into my possession only a few months after its discovery', John Buchanan, October 1871 (GUL MR 50/49, no. 2). The findspot is marked on the Ordnance Survey (first edition) six-inch map, *Dumbarton* Sheet xxiii, surveyed 1861, and on subsequent maps, indicating a position on the berm, just south of the (then) visible alignment of the Antonine Ditch, *c.* 200 m south-west of the fort.

Donation: October 1871, by John Buchanan (GUL MR 50/49, no. 2).

Condition: The right-hand border and a part of the inscribed panel have been broken away, perhaps by the plough at the moment of discovery.

The edges are slightly chipped, especially at the lower right corner.

Description: The inscribed panel is set within a double moulding, of which the inner is decorated with cable patterns. A centrally placed boar, its feet resting on the lower moulding, runs towards the left. There is a single dovetail cramphole in the top of the slab. H: 0.72 m; W: 0.82 m; D: 0.13 m. Buff sandstone.

Inscription: *Imp(eratori) C(aesari) | T(ito) Aelio | Hadriano | Antonino | Aug(usto) Pio p(atri) p(atriae) | vex(illatio) leg(ionis) XX V(aleriae) [V(ictricis)] | f(ecit) p(er) p(edum) III.* 'For the emperor Caesar Titus Aelius Hadrianus Antoninus Augustus Pius, Father of his Country, a detachment of the Twentieth Valiant and Victorious Legion built (this) over a distance of 3000 feet.'
Line 7: P·P (Stuart, Wilson, Hübner, J. Macdonald, G. Macdonald, Collingwood & Wright), F P·P (Keppie).[1]
Letter heights: 1–5: 0.045 m.

Discussion: The distance slab, erected by a detachment of the Twentieth Legion, commemorated the completion of 3,000 feet of the Wall, between Castlehill and Hutcheson Hill. The slab must have stood near No. 6; the western end of the same sector was marked by Nos 8-9.

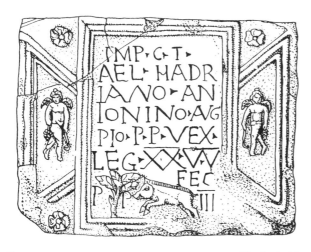

8 *Scale 1:12*

[1]In line 7 what appears to be an additional letter, F, can be made out, to the left of the visible lettering, partly inscribed, but unfinished. It does not seem a modern addition, and indeed the indentations can be clearly seen on the earliest photograph of the stone (Macdonald 1897, pl. xiv.1, Macdonald 1934, pl. lxv.2), taken in 1872. The known distance slabs of the Twentieth Legion where the inscription survives intact (i.e. all except No. 15) all include the verb *fecit*, abbreviated to F (No. 1) or (more usually) FEC (Nos 3, 8, 9, 10, 16); given that the inscription here is symmetrically arranged without this additional letter F, it may be therefore that its inscribing was halted by the stonecutter (but not subsequently chiselled off). What can be seen on the stone seems deliberately incised, rather than a casual insertion later when the slab was in place on the Wall.

CIL VII 1133; *RIB* 2197 *CSIR* 146
Bibliography: Wilson 1851, 369, 376f. with fig.; Stuart 1852, 310–11, fn. (a), pl. ix.3; Bruce 1893, 48-9, pl. iii.3; Macdonald 1895, 25, no. 13; Macdonald 1897, 37-8, no. 12, pl. xiv.1; Glasgow Archaeological Society 1899, 7, no. 9; Haverfield 1913b, 628; Gibb 1902d, 72–3 with pl.; Macdonald 1911, 282–7, no. 9, pl. xxxviii.3; Macdonald 1934, 381–3, no. 9, pl. lxv.2; Keppie 1979, 15, no. 9; Keppie & Arnold 1984, 52–3, no. 146, pl. 36.

8. DISTANCE SLAB (CAST) OF THE TWENTIETH LEGION PL. IV

HUTCHESON HILL, Dunbartonshire (East Dunbartonshire), 1865. Inv. no. F.8.

Findspot: Approx. NS 516 723. 'In the spring of 1865, the farmer, while trenching a field on the southern slope, came upon a large stone at a depth of about three feet below the surface. It was lying flat in the stiff "till" . . . The stone was thrown aside in the farmyard as of little consequence, and it lay unheeded a considerable time, till acquired by a Glasgow gentleman, by whom it has recently been transferred to a friend at Newcastle-on-Tyne' (Buchanan 1883a, 14). The 'friend' is later identified as Professor J.H. McChesney, US Consul at Newcastle (above, p. 35). 'The stone was bought from the farmer by a Mr James Thomson, who had it conveyed to the office in which he was employed in St Enoch's Square. He made vain efforts to induce the University authorities to take it over from him at what he had paid for it (£2). But neither they nor any of the local antiquaries whom he approached would relieve him of it, and he finally sold it for that sum to McChesnay (sic). It is a pity that Dr Buchanan did not hear of the offer' (Macdonald 1934, 383 fn). The slab was promptly removed to Chicago 'for the alleged purpose of being placed in a museum, with which Mr McChesnay is in some way associated' (Buchanan 1883a, 27), and shortly afterwards destroyed in 'the Great Chicago Fire', 8–10 October, 1871 (see above, p. 35). The slab soon became known in Glasgow as the Chicago Stone.

Donation: A number of plaster casts were made at Newcastle by Dr J. Collingwood Bruce, one of which was presented to the Glasgow Archaeological Society, which deposited it (at a date unknown) in the 'Roman Room' of the Museum. 'While thus disappointed in recovering for Scotland the original slab, which properly belongs to this Country, the Council have pleasure in stating that an excellent cast of it in plaster of Paris, taken by the Antiquarian Society of Newcastle

from the original while it was in that town, has with much courtesy been gifted by that learned body to our Society and was forwarded to Glasgow a short time since', Annual Report of the Glasgow Archaeological Society, dated 1 February 1879 (GUA DC 66 2/1/1, pp. 66–7; cf. Macdonald 1895, 14; 1897, 38, no. 13).

Condition: The top left corner of the slab had evidently been broken off in two fragments, but repaired. There is some damage to the outer mouldings, especially on the left-side and lower mouldings where a rosette is lost. 'The spade has broken off a small but unimportant portion of the upper left corner' (Buchanan 1883a, 17).

Description: The inscribed panel is set within a broad, triple-beaded moulding, and flanked by *ansae* similarly bordered, which are occupied by winged Cupids each carrying a sickle and a bunch of grapes. The four angles, between the *ansae* and the main frame, are occupied by rosettes. Below the inscription a boar runs left towards a tree in full bloom. There are two small dovetail cramp-holes in the top of the slab, and one in each side. H: 0.67 m; W: 0.85 m; 0.12 m. Presumably local yellowish-buff sandstone (but nowhere recorded).

Inscription: *Imp(eratori) C(aesari) T(ito) | Ael(io) Hadr | iano An | tonino Aug(usto) | Pio p(atri) p(atriae) vex(illatio) | leg(ionis) XX V(aleriae) V(ictricis) | fec(it) | p(er) p(edum) III.* 'For the emperor Caesar Titus Aelius Hadrianus Antoninus Augustus Pius, Father of his Country, a detachment of the Twentieth Valiant and Victorious legion completed (the work) over a distance of 3,000 feet'. PL. IV shows the cast as painted in 1979. The letter P has been shown there several times as 'closed' when in fact it is 'unclosed'; for a photograph of the cast, unpainted, see Macdonald 1897, pl. vi.1; Macdonald 1934, pl. lxvi.1.

Letter heights: 1: 0.045 m; 2–8: 0.05 m.

Discussion: This distance slab, erected by a detachment of the Twentieth Legion, com-memorated completion of a length of 3,000 feet of the Wall between Castlehill and Hutcheson Hill. It must have stood adjacent to No. 9; the eastern end of the same sector was marked by No. 7.

CIL VII 1133a, *Addit.* p. 313;
RIB 2198 *CSIR* 148
Bibliography: Buchanan 1883a, 11–28; Macdonald 1895, 14–16, no. 2; Macdonald 1897, 38–40, no. 13, pl. vi.1; Glasgow Archaeological Society 1899, 7, no. 10; Bruce 1893, 46–7, pl. iv.3; Gibb 1902d, 73–7 with pl.; Macdonald 1911, 280–2, no. 8, pl. xxxviii.2; Haverfield 1913b, 628; Macdonald 1934, 383–4, no. 10, pl. lxvi.1; Toynbee 1964, 149; Keppie 1979, 16, no. 10; Keppie & Arnold 1984, 53, no. 148, pl. 36.

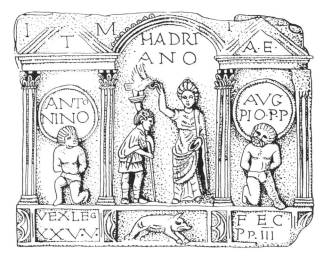

9 *Scale 1:12*

9. DISTANCE SLAB OF THE TWENTIETH LEGION PL. V

HUTCHESON HILL, Bearsden, Dunbartonshire (East Dunbartonshire), March 1969. Inv. no. F.1969.22.

Findspot: NS 5154 7234. On west side of Hutcheson Hill, Bearsden, an estimated 3 m south of the line of the Antonine Wall, 'lying face downwards in what the ploughman, Mr D. McInnes, thought was a shallow pit' (Steer & Cormack 1969, 122).

Donation: 1969, by Mr J. McIndeor, Cleddans Farm.

Condition: The stone has sustained some damage to the sculptured figures and at its corners, but otherwise shows little signs of weathering. Slight damage to the boar figure was repaired in 1969.

Description: The front face of the slab is carved to show an elaborate architectural façade. The central rounded archway is triple-ribbed, enriched above by a series of roundels. The side-arches are topped by triangular pediments. Arch and pediments are supported on fluted pilasters topped by Corinthian capitals which are carried round on to the sides of the slab. The central arch contains two figures. On the right a tall female, gracefully attired in a high-waisted dress, and with a cloak which falls from her left shoulder, faces the front. Her hair is piled high on her head. In her left hand she holds a sacrificial dish, and in her right a miniature laurel wreath which she places into the beak of the eagle-topped legionary standard (*aquila*) held by its bearer, the *aquilifer*. The latter, head dutifully bowed, faces right, smaller in stature than the divine figure opposite him. He wears a tunic and short cloak, with a dagger at his waist. In niches to either sides are kneeling bound captives who look inwards to the central scene. Above the captives are large roundels, or shields,

which they support, Atlas-like, on their shoulders. On the plinth below, a centrally placed boar runs towards the right; to either side are rectangular panels, within plain mouldings flanked by simple *peltae*. There are two symmetrically placed dovetail crampholes in the top of the slab, and one each in the sides. H: 0.75 m; W: 0.95 m; D: 0.14 m. Yellowish-buff sandstone.

Inscription: *Imp(eratori) C(aesari) | T(ito) Ae(lio) | Hadri | ano | Anto | nino | Aug(usto) | Pio p(atri) p(atriae) | vex(illatio) leg(ionis) | XX V(aleriae) V(ictricis) | fec(it) | p(er) p(edum) III.* 'For the emperor Caesar Titus Aelius Hadrianus Antoninus Augustus Pius, Father of his Country, a detachment of the Twentieth Valiant and Victorious Legion built (this) over a distance of 3,000 feet.'

Letter heights: 1–6: 0.035–0.04 m.

Discussion: This distance slab, which commemorated work by a detachment of the Twentieth Legion, recorded completion of a length of 3,000 feet of the Antonine Wall, between Castlehill and Hutcheson Hill. It must have stood beside or adjacent to No. 8; the east end of the same sector was marked by No. 7. The lettering is scattered in vacant spaces around the stone. The sculptured scenes symbolise Roman victory and the defeat of the local tribesmen, reluctant witnesses to Roman celebration. The identity of the female is uncertain. We might look for Victory (as on No. 16). But the figure here lacks the normal wings, a globe, or a palm frond. Perhaps therefore she should be identified with *Britannia* who, as representative of the Romanised population of the province, congratulates the army on its success (Henig in Ackermann and Gisler 1986, vol. 3.1, 167-9 with pls 140–2). A standing figure of *Britannia*, in civilian (rather than military) guise holding a saucer (*patera*), appears on coinage issued at Rome in A.D. 134–38 (Toynbee 1924, pl. xxiv.3; 1934, 53–65 with pl. iii.16; Mattingly & Sydenham 1926, *Hadrian* no. 882), which may therefore have provided inspiration to the stonemason (cf. above, p. 64, on No. 11). An identification with Faustina, the recently deceased wife of Antoninus (Robertson 1969; Hassall 1977, 338) or with Roma (Henig, loc. cit.) has also been proposed. An eagle with a wreath already in its beak is found frequently on sculpture and coins (e.g. Rinaldi Tufi 1983, no. 106; Srejović 1993, 211, no. 53).

AE 1971, 225 *CSIR* 149

Bibliography: *Glasgow Herald*, 13 October 1969 with fig.; Robertson 1969, 1 with pl.; Steer & Cormack 1969, 122–6, pl. 8; Selkirk 1970, 196-7 and front cover; Wright & Hassall 1970, 309f., no. 19, pls xviii, xxxviii; Hassall 1977, 327; Keppie 1979, 16, no. 11, pls 4–5; Keppie 1983, 401, no. 13; Keppie & Arnold 1984, 53f., no. 149, pl. 37.

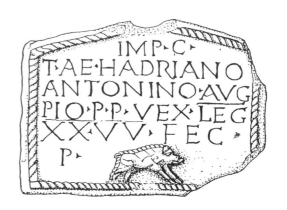

10 *Scale 1:12*

10. DISTANCE SLAB OF THE TWENTIETH LEGION PL. V

Unknown provenance, in or before October 1699 (1695, Horsley 1732, Macdonald 1897, 28–9, *RIB*, in error, probably by assimilation to Nos 14–15). Inv. no. F.11.

Findspot: The slab is assumed from the identity of the donor, Hamilton of Barns, to have been found in the vicinity of Duntocher (Macdonald 1921, 16; 1934, 387). '. . . found on the Wall, somewhere in that Gentleman's Ground' (Gordon 1726, 61).

Donation: October 1699. 'Ther is just nou come to my hands a large clear Roman inscription with very curiose sculpture about it', Wodrow to Sibbald, 28 October 1699 (Sharp 1937, 27, no. xiii; above, p. 10). *ex dono Hamilton de Barns* (University of Glasgow 1768, pl. v). The date of presentation indicates that the donor must have been Claud Hamilton of Barns (Hamilton 1933, 121).

Condition: The outer mouldings are damaged at the gable angle, at the top right and especially at the bottom right where a small portion of the inscribed panel is lost.

Description: The slab, whose five-sided shape resembles No. 16, is bordered by a double moulding, the inner of which is decorated with cable patterns. Centrally placed on the bottom margin is a boar running right. There is a dovetail cramphole in the gable-angle of the slab. H: 0.57 m; W: 0.77 m; D: 0.12 m. Buff sandstone.

Inscription: *Imp(eratori) C(aesari) | T(ito) Ae(lio) Hadriano | Antonino Aug(usto) | Pio p(atri) p(atriae) vex(illatio) leg(ionis) | XX V(aleriae) V(ictricis) fec(it) | p(edum).* 'For the emperor Caesar Titus Aelius

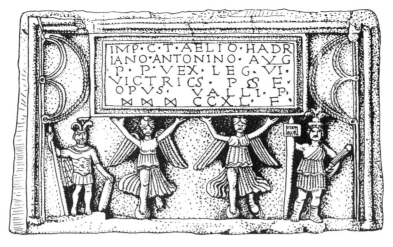

11 *Scale 1:12*

Hadrianus Antoninus Augustus Pius, Father of his Country, a detachment of the Twentieth Valiant and Victorious Legion built . . . feet'.

Line 4: LEG (University of Glasgow 1768, Hübner), L̄ĒG (Horsley, Stuart, Collingwood & Wright); line 5: XX̄·V V (Stuart)

Letter heights: 1–4, 6: 0.05 m; 5: 0.055 m.

Discussion: This distance slab, which commemorated work by a detachment of the Twentieth Legion, marked the completion of a sector of unknown length. The number of feet was not inserted, but there is no reason to regard the stone as a 'waster' (as Macdonald 1921, 16; 1934, 387). It presumably belonged to one of the two sectors west of Castlehill completed by the Twentieth Legion.[2]

CIL VII 1137; *RIB* 2199 *CSIR* 157

Bibliography: Sibbald 1707, 49f.; Gordon 1726, 61, pl. ix.3; Horsley 1732, 196-7, no. v, pl. (Scotland) v; University of Glasgow 1768, pl. v; Anderson 1771, ff. 34–5; Gough 1789, vol. 3, 359, pl. xxiv.2; Hodgson 1840, 267, no. cclxxxi; Stuart 1845, 296, pl. viii.5; Bruce 1893, 43, pl. ii.2; Macdonald 1895, 25, no. 11; Macdonald 1897, 28–9, no. 6, pl. xiii.2; Glasgow Archaeological Society 1899, 8, no. 13; Gibb 1902d, 77–8; Macdonald 1911, 279–80, no. 6, pl. xxxvii.3; Macdonald 1934, 387, no. 13, pl. lxvii.2; Sharp 1937, 27, no. 13; 62, no. 26 with fig.; Keppie 1979,

19, no. 18; Keppie & Arnold 1984, 57f., no. 157, pl. 38.

11. DISTANCE SLAB OF THE SIXTH LEGION PL. VI

BRAIDFIELD, Duntocher, Dunbartonshire (West Dunbartonshire), 1812. Inv. no. F.9.

Findspot: NS 501 721. 'A few days ago there was found in the farm of Braidfield, near Graham's Dyke, in the Parish of Old Kilpatrick, a Stone in the highest state of preservation' (*Glasgow Courier* 7 July 1812); June 1812 (Stuart 1852, 300).

Donation: 30 July 1812. 'A Stone with an inscription on it, found in the tract of the Roman Wall, in the Parish of Old Kilpatrick. Presented by Sir Charles Edmonstone of Duntreath, Bart.' (Museum Donation Book, GUL MR 49/1, f. 16; MR 49/2, f. 169).

Condition: Damage has been suffered to the upper and lower border, with some scoring, perhaps caused by the plough.

Description: Within a plain moulding the slab is carved to show an ansate panel held aloft by two winged Victories who are flanked by Mars and Imperial Valour. The inscribed panel is contained within triple mouldings and flanked to left and right by *peltae* whose horns and central projections terminate in plain small roundels. The two figures of Victory, with billowing draperies, one leg exposed to the thigh, and piled up hair, rest one foot on a globe, supporting the inscribed panel with their palms. To the left is a bearded Mars in full panoply, with muscle cuirass, round shield, plumed helmet, and greaves; he faces front and holds a spear in his right hand. To the right, Imperial Valour, in Amazonian attire, with right breast exposed, holds a short sword (*parazonium*)

[2]In documents dating to 1579, 1594, and 1617, the owner of the Cochno estate is described also as of 'Hutcheson', presumably farms in the vicinity of Hutcheson Hill east of Duntocher (Bruce 1893, 90, 277–8). Thus the slab might have come from the stretch between Hutcheson Hill and Castlehill completed by the Twentieth Legion, but the latter is already noticeably populated with sufficient slabs of the Twentieth Legion (no. 9). It may be that further research can clarify landholding in this area.

reversed in the crook of her left arm and an inscribed *vexillum*-flag, tasselled below, in her right hand. There are regular angled chisel-marks on the sides, top and bottom of the slab. H: 0.765 m; W: 1.19 m; D: 0.17 m. Whitish-buff sandstone.

Inscription: *Imp(eratori) C(aesari) T(ito) Aelio Hadr | iano Antonino Aug(usto) | p(atri) p(atriae) vex(illatio) leg(ionis) \overline{VI} | Victric<i>s p(iae) f(idelis) | opus valli p(edum) | MMM CCXL f(ecit).* On *vexillum: Virt(us) Aug(usti).* 'For the emperor Caesar Titus Aelius Hadrianus Antoninus Augustus, Father of his Country, a detachment of the Sixth Victorious Loyal and Faithful Legion built the work of the wall over a distance of 3,240 feet'. On *vexillum:* 'Valour of the Emperor'.

Line 4: VICTRICIS (Hodgson), VICTRICS (Stuart, Hübner, J. Macdonald, G. Macdonald); line 6: CCXL·P (Stuart, Irving), CCXL·F (Hodgson, Hübner, etc.).

Small plain interpuncts are used, except for a leafstop between the letters P P in line 5. Letter heights (main text): 1–6: 0.03 m. Letter heights (on *vexillum*): 0.01 m.

Discussion: This distance slab, commemorating work by a detachment of the Sixth Legion, recorded completion of a sector of 3,240 feet, which we can be sure ran from Hutcheson Hill to Braidfield. The inscription matches in detail that on No. 14, also erected by the Sixth Legion, where *Pio* is likewise omitted from the titles of the emperor and the phrase *opus valli* employed (above, p. 51); on both slabs the numerals for thousands are expressed by symbols. (On the iconography of Mars and *Virtus Augusti*, see above, p. 64.)

CIL VII 1135; *RIB* 2200 *CSIR* 150

Bibliography: *Glasgow Courier* 7 July 1812; Laskey 1813, 77; Hodgson 1840, 271, no. ccxc; Smith 1841, fig.; Stuart 1845, 296ff., pl. viii.7; Irving 1860, 10ff., fig. 2; Bruce 1893, 43f., pl. ii.4; Macdonald 1895, 24; Macdonald 1897, 27, no. 5, pl. iii.1; Glasgow Archaeological Society 1899, 7, no. 11; Haverfield 1913b, 628; Gibb 1903a, 127ff. with pl.; Macdonald 1911, 278f., no. 5, pl. xxxvii.2; Macdonald 1934, 384ff., no. 11, pl. lxvi.2; Toynbee 1964, 149; Keppie 1979, 17, no. 12; Keppie & Arnold 1984, 54–5, no. 150, pl. 37.

12. DISTANCE SLAB OF THE SECOND LEGION PL. VII

Probably DUNTOCHER, Dunbartonshire (West Dunbartonshire), 1826–44. Inv. no. F.10.

Findspot: NS 595 728. 'We are not certain, however, that [the stone] was found at Duntocher; most probably it belongs to some of the other

12 *Scale 1:12*

stations; but, as no memoranda have been preserved in regard to the time or place of its discovery, we have thought proper to mention it here on account of its singular resemblance to the preceding slab [No. 13]' (Stuart 1845, 295, later quoted by Hübner *CIL* VII 1138; accepted by Macdonald 1934, 386). The findspot (apparently of this slab) is marked on the Ordnance Survey (first edition 1861) 25 inch-sheet (*Dumbartonshire* no. xxiii). See also *Ordnance Survey Name Book* 15 (1860), 86.

Donation: Before 1845 (Stuart 1845, 295 fn.(b)).

Condition: The slab is unworn, but part of the top right corner-angle, including much of a rosette, is broken away and the outer border is damaged.

Description: The square panel to which the inscription is confined is bordered by rope-patterns and flanked by *peltae* whose horns terminate in griffin-heads and the central projections in plain roundels, within a plain outer moulding. Above, a capricorn swims left; below, a pegasus flies left. The four corners are occupied by rosettes. There are two dovetail crampholes in the top of the slab. H: 0.5 m; W: 0.73 m; D: 0.19 m. Buff sandstone.

Inscription: *leg(io) | \overline{II} | Aug(usta) f(ecit) | p(edum) \overline{IIII} CXL.* 'The Second Augustan Legion built 4,140 feet'.

Line 4: P \overline{IIII} CXI (Stuart), P \overline{IIII} CXL (Hübner, J. Macdonald, etc.).

Letter heights: 1, 3: 0.04 m; 2, 4: 0.025 m.

Discussion: This distance slab, commemorating work by the Second Legion, recorded completion of 4,140 feet of the Wall, probably between Braidfield and Duntocher.

CIL VII 1138; *RIB* 2203 *CSIR* 152

Bibliography: Stuart 1845, 295, 298, pl. viii.1; Bruce 1893, 43, pl. ii.1; Macdonald 1895, 27–9, no. 2; Macdonald 1897, 30, no. 7, pl. xiii.1; Glasgow Archaeological Society 1899, 8, no. 14; Gibb 1901d, 62–6; Macdonald 1911, 280, no. 7, pl. xxxviii.1; Haverfield 1913b, 629; Macdonald 1934, 386–7, no. 12, pl. lxvii.1; Toynbee 1964, 149; Keppie 1979, 17, no. 13; Keppie & Arnold 1984, 55, no. 152, pl. 37.

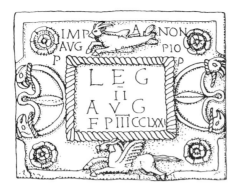

13 *Scale 1:12*

13. DISTANCE SLAB OF THE
SECOND LEGION PL. VII

CARLEITH, Dunbartonshire (West Dunbartonshire), in or before 1696–8. Inv. no. F.12.

Findspot: NS 481 731. 'This stone is to be seen at Cochneugh. Twas found at Caer-Lieth' (Gregory April 1698, ex Urry (EUL Dk.1.2, A74, no. 3); so Tanner April 1699, no. 4 ex Urry (EUL MS La. II. 644/7 = Nichols 1809, 338*, no. 4), and Stukeley (1720, 9) ex Lhwyd). 'Above the gate of Cochno Castle: ANTONIN PIVS II LEGION XX. Besides it is half an eagle and a Boar's head' (Robert Gordon of Straloch, in Sibbald MS quoted by Haverfield 1913b, 629; cf. Gibb 1902d, 77f.);[3] 'At Cockings house Antonin pius legion XXII', (Lhwyd, Bod. Lib. MS Carte 269, f. 134); 'at Cochnay Gate' (Stukeley, MS note on flyleaf of Stukeley 1720, copy in Ashmolean Library); 'now above the gate of Cochnoch House, which belongs to Mr *Hamilton* of *Barns*' (Horsley 1732, 195).
Donation: 1732–c.1759, by James Hamilton of Barns, owner of Cochno House. *ex dono Jacobi Hamilton de Barns Armigeri* (University of Glasgow 1768, pl. 2). Though known since the end of the seventeenth century, the slab remained for several decades at Cochno House, presumably because it was built into a masonry structure. The death of James Hamilton in c.1759 establishes a *terminus ante quem* for the donation.
Condition: The slab is rather worn, and chipped at the lower margin.
Description: The centre of the slab is occupied by a rectangular panel framed by rope-mouldings, and flanked to left and right by *peltae*, their horns terminating in griffin heads, with projecting beards and plain central bosses. Above is a capricorn running left; below is a pegasus flying left. The four corner-angles are occupied by double rosettes. The plain outer moulding is interrupted by the *peltae* and the pegasus. There is a small triangular

[3] I was unable to check the wording among the Sibbald MSS in the National Library of Scotland. Dr I.G. Brown searched for it unsuccessfully on my behalf.

dovetail cramphole in the top of the slab. H: 0.55 m; W: 0.68 m; D: 0.16 m. Buff sandstone.
Inscription: *Imp(eratori) Anton(ino) | Aug(usto) Pio | p(atri) p(atriae) | leg(io) | II | Aug(usta) | f(ecit) p(edum) IIICCLXXI.* 'For the emperor Antoninus Augustus Pius, Father of his Country, the Second Augustan Legion built 3,271 feet.'
Line 7: IIICCLXX (University of Glasgow 1768, Hübner), IIIICCLXX (Stuart), IIICCLXXII (Adair, Urry, Stukeley), IIICCIXXI (Gordon); IIICCLXXI (Horsley, Haverfield, Collingwood & Wright).
Letter heights: 1–3: 0.025 m; 4: 0.05; 5: 0.025 m; 6: 0.025–0.05 m; 7: 0.025–0.035 m.
Discussion: This distance slab, which commemorated work by the Second Legion, recorded the completion of a sector of 3,271 feet of the Antonine Wall, between Duntocher and Carleith. Initially the inscription was limited to the name of legion and the distance recorded (like No. 12), which were placed centrally; later it was decided to add some part of the emperor's names and titles which were squeezed into the available space, to either side of the capricorn.

CIL VII 1136; *RIB* 2204 *CSIR* 154
Bibliography: Stukeley, 1720, 9 with fig., no. iii; Gordon 1726, 51, pl. x.1; Horsley 1732, 195, no. ii, pl. (Scotland) ii; Maffei 1749, 446 no. 14; University of Glasgow 1768, pl. ii; Anderson 1771, ff. 31–2; Gough 1789, vol. 3, 359; Roy 1793, 165; Nichols 1809, 338, no. 4; Laskey 1813, 76, no. 2; Nimmo 1817, 640, no. 3 on fig.; Hodgson 1840, 268, no. cclxxxvi; Stuart 1845, 294-5, pl. viii.6; Irving 1860, 11; Haverfield 1893, 305, no. 163; Bruce 1893, 41-2, pl. iii.2; Macdonald 1895, 24-5; Macdonald 1897, 25-7, no. 4, pl. ii.3; Glasgow Archaeological Society 1899, 7, no. 12; Gibb 1900, 86 no. 4; Gibb 1903b, 188 with fig.; Macdonald 1911, 276-8, no. 4, pl. xxxvii.1; Haverfield 1913b, 629; Macdonald 1934, 387-8, no. 14, pl. lxviii.1; Toynbee 1964, 149; Keppie 1979, 18, no. 14; Keppie & Arnold 1984, 56, no. 154, pl. 38; Vasey 1993, 67.

14. DISTANCE SLAB OF THE
SIXTH LEGION PL. VI

OLD KILPATRICK, Dunbartonshire (West Dunbartonhire), 1695. Inv. no. F.13.

Findspot: *invent[um] 1695 apud Kilpatrick*, Alexander Edward, 1700 (SRO GD 45/26/146). 'This inscription was found by ploughing in ye Parish of Kilpatrick in the Shire of Lennox between Glasgow and Dunbarton Castle, not far from the River Cliuyd in the lands of Wm. Hamilton of Orbiston Esq., I am informed that in

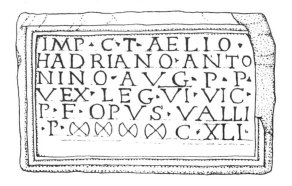

14 *Scale 1:12*

this place the Wall ended' (marginal note, perhaps in hand of John Anstis, in BM MS Stowe 1024, f. 87, beside a drawing sent by 'Mr Strachan'; above, p. 12; similar wording in Stukeley 1720, 8). The slab was briefly transferred to Hamilton's country house at Erskine, south of the Clyde: '[This slab] came from Areskin upon Clyd', Gregory April 1698 ex Urry (EUL Dk.1.2, A74, no. 7); *Marmor Erskini Scotiae urbe repertum* (Fabretti 1699, 756 no. 619; cf. Gibson 1722, 1214f.).

Donation: 1695, by William Hamilton of Orbiston. *Ex dono D. Wil. Hamilton de Orbestoun* (BM MS Stowe 1024, f. 93; similar wording and spelling used in University of Glasgow 1768, pl. vii); 'to be seen in the library of Glasgow Colledge', Gregory April 1698, ex Urry (EUL Dk. 1.2, A74); *in bibl[iotheca] Glas[guensi]*, Alexander Edward, 1700 (SRO GD 45/26/146); 'in the library at Glasgow' (Sibbald 1707, fig. at p. 52).

Condition: The slab is well preserved, except for the loss of some parts of the outer moulding on the right margin.

Description: The inscribed panel is contained within a double plain moulding, not entirely symmetrical. Guidelines are faintly visible above and below all six lines and above a 'seventh' which was not in the end required. The slab is scored across its front surface. There is a regular series of angled chisel-marks on the sides of the slab, except where subsequently removed at the left side. There is a single dovetail cramphole in the top of the slab. H: 0.53 m; W: 0.83 m; D: 0.18 m. Greyish sandstone (similar to No. 11).

Inscription: *Imp(eratori) C(aesari) T(ito) Aelio / Hadriano Anto / nino Aug(usto) p(atri) p(atriae) / vex(illatio) leg(ionis) VI Vic(tricis) / p(iae) f(idelis) opus valli / p(edum) / MMMMC XLI .* 'For the emperor Caesar Titus Aelius Hadrianus Antoninus Augustus, Father of his Country, a detachment of the Sixth Victorious, Loyal and Faithful Legion (built) the work of the wall over a distance of 4,141 feet'. Line 4: LEG V (Edward), line 6: P P ⊗ ⊗ ⊗ ⊗ (Gordon).

Letter heights: 1–6: 0.045 m.

Discussion: This distance slab, which com-

memorated work by a detachment of the Sixth Legion, recorded completion of a sector of 4,141 feet, probably between Carleith and Dalnotter Burn which was proposed as its original location by Macdonald (1934, 389). For the use of the phrase *opus valli*, see above, p. 51. In the titulature of Antoninus, the title *Pius* is omitted, as on No. 11, also erected by the Sixth Legion.

CIL VII 1140; *ILS* 2481; *RIB* 2205

Bibliography: Fabretti 1699, 756 no. 619; Sibbald 1707, pl. only; Stukeley 1720, 8, no. i with fig.; Gibson 1722, 1215, with fig.; Gordon 1726, 62, pl. ix.2; Horsley 1732, 197, no. vii, pl. (Scotland) vii; Maffei 1749, 446, no. 11; University of Glasgow 1768, pl. vii; Anderson 1771, ff. 35–6; Gough 1789, vol. 3, 359, pl. xxiv.4; Hodgson 1840, 267, no. cclxxxiii; Stuart 1845, 285-6, pl. vii.3; Bruce 1893, 33, pl. i.3; Macdonald 1895, 16–18, no. 3; Macdonald 1897, 22-3, no. 2, pl. I, fig. 2; Glasgow Archaeological Society 1899, 8, no. 15; Gibb 1901c, 28–9; Macfarlane 1908, 255; Macdonald 1911, 276, no. 3, pl. xxxvi.3; Haverfield 1913b, p. 629; Macdonald 1934, 388–9, no. 15, pl. lxviii.2; Keppie 1979, 19, no. 5.

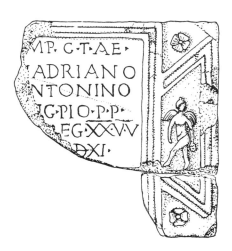

15 *Scale 1:12*

15. DISTANCE SLAB OF THE TWENTIETH LEGION PL. VIII

At or near OLD KILPATRICK, Dunbartonshire (West Dunbartonshire), in or before 1695. Inv. no. F.14.

Findspot: '[This slab] came from Areskin upon Clyd', Gregory April 1698, ex Urry (EUL Dk.1.2, A74, no. 8). The donor, William Hamilton of Orbiston, who lived at Erskine House, had extensive property around Old Kilpatrick (see also No. 14).

Donation: 1695, by William Hamilton of Orbiston. *ex dono D. Wil. Hamilton, 1695* (BM MS

Stowe 1024, f. 112; similar wording in University of Glasgow 1768, pl. vi). '. . . to be seen in the Library of Glasgow Colledge', Gregory April 1698, ex Urry (EUL, loc.cit). 'In Glasgow Library' (Sibbald 1707, fig.). 'In the Repository of the Colledge of Glasgow' (Stukeley 1720, 8).

Condition: The worn slab is partially preserved in two adjoining fragments, with damage sustained to outer triple mouldings of the right-hand ansate panel. The smaller fragment is mentioned by several early authorities; it preserved the lower right-hand corner of the slab. The drawing in BM MS Stowe 1024, f. 112 shows the two fragments as a single piece of stone; Sibbald (1707, pl. at p. 52) shows what survives today as two fragments, but with a perfect join. It may be therefore that the small fragment broke off some time after discovery (cf. Horsley 1732, 197: 'tis now broken off, but the piece of stone is preserved, and fits the corner'). The smaller fragment escaped the notice of other writers from the early eighteenth century onwards (Gibson 1722, 1215 with fig.; Gordon 1726, pl. xiv.3). It survived, however, but later lost its association with this slab, and was assigned to another stone (Macdonald 1897, 94). Thereafter it was ignored, until recognised by Keppie (1979, 19, no. 16; 1983, 395, no. 8). The face of the Cupid has been disfigured, presumably in Roman times.

Description: The inscribed panel is set within a triple moulding and flanked to the right by an *ansa*-panel similarly ornamented and occupied by a winged, naked, male figure, to be identified as a Cupid, carrying a bunch of grapes and a sickle (above, p. 64). The corner-angles are occupied by rosettes. There is a small triangular cramphole in the top of the slab, right of centre. A matching cramphole, to the left of centre, is presumably lost. H: 0.66 m; W: 0.62 m; D: 0.1 m (both fragments together). Yellowish-buff sandstone. The original width of the slab, when complete, was probably *c.* 0.9 m.

Inscription: *[I]mp(eratori) C(aesari) T(ito) Ae(lio) | [H]adriano | [A]ntonino | [A]ug(usto) Pio p(atri) p(atriae) | [vex(illatio) l]eg(ionis) XX̄ V̄(aleriae) V̄(ictricis) | [p(er) p(edum) IIII C]DXI | [fec(it)].* 'For the emperor Caesar Titus Aelius Hadrianus Antoninus Augustus Pius, Father of his Country, a detachment of the Twentieth Valiant and Victorious Legion built (this) over a distance of 4,411 feet'.

Line 2: HADRIANO (University of Glasgow 1768, Horsley, Hübner), [H]ADRIANO (Collingwood & Wright); line 5: [LE]G·XX·V·V (Stukeley, Gordon), [L]EG XX̄ VV (Horsley, Stuart), XX̄·V̄·V̄ (Sibbald, University of Glasgow 1768, Hübner, Collingwood & Wright).

Letter heights· 1–6 ; 0.035 m.

Discussion: This distance slab, which commemorated work by a detachment of the Twentieth Legion, recorded completion of a sector of 4,411 feet, between Dalnotter and Old Kilpatrick. It may have stood beside or close to No. 14, with which it was donated in 1695.[4] The overall design and dimensions are matched on No. 8 from Hutcheson Hill, from which it can be presumed that the inscription here was flanked to both left and right by ansate panels, both occupied by Cupids, with the figure of a wild boar below, probably leaping towards a tree. The numerals can be restored by reference to No. 16, which marked the western end of the same sector. Although this and No. 14 were presented to Glasgow College together in 1695, we should beware of assuming that they were found at the same time (see Macdonald 1934, 389–90); the early antiquaries do not consider them together.

CIL VII 1142; *RIB* 2206 *CSIR* 155

Bibliography: Sibbald 1707, fig. only; Stukeley 1720, 8f., no. 2, with pl., no. ii; Gibson 1722, 1215 with fig.; Gordon 1726, 62, pl. xiv.3; Horsley 1732, 197, no. vi, pl. (Scotland) vi; University of Glasgow 1768, pl. vi; Anderson 1771, f. 35; Gough 1789, vol. 3, 359, pl. xxiv.5; Roy 1793, 165; Hodgson 1840, 267, no. cclxxxii; Stuart 1845, 285-6, pl. vii.2; Irving 1860, 10; Macdonald 1895, 23- 4, no. 6; Macdonald 1897, 23–5, no. 3, pl. ii.2; Glasgow Archaeological Society 1899, 8, no. 17; Gibb 1901b, 205–7; Gibb 1901d, 53–9; Macfarlane 1908, 255; Macdonald 1911, 274–6, no. 2, pl. xxxvi.2; Haverfield 1913b, 629–30; Macdonald 1934, 390, no. 16, pl. lxix.1; Toynbee 1964, 149; Keppie 1979, 19, no. 16; Keppie 1983, 395, no. 8, fig. 8; Keppie & Arnold 1984, 56–7, no. 155, pl. 38; Vasey 1993, 66; Tomlin 1995, 798 with fig.

16. DISTANCE SLAB OF THE TWENTIETH LEGION PL. VIII

OLD KILPATRICK, Dunbartonshire (West Dunbartonshire), before 1684. Inv. no. F.15.

Findspot: NS 458 731. '. . . it certainly was dug out of *Graham's Dike*, and lay a long time at the Duke of *Montros*'s House at Mugdock; from whence it was carried to the College of *Glasgow*' (Gordon 1726, 51). 'Taken out of Graham's Dyke' (Sibbald 1697, 207); '. . . said in Mr Lluyd's

[4]However, since we know now that both ends of some sectors, certainly those west of Castlehill, were marked by two slabs, it remains conceivable that No. 15 was in fact found at Old Kilpatrick, and marked the west rather than the east end of the sector completed by the Twentieth Legion. But see next footnote.

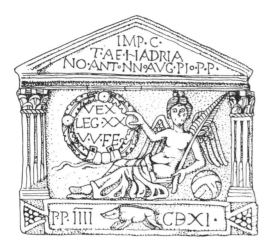

16 *Scale 1:12*

extending to her ankles. In her left hand she holds a palm frond upright resting on her upper left arm. In her right hand she holds, at shoulder level, a large laurel wreath, decorated with fruit, with a dependant fillet visible to the left; she rests her left elbow and lower arm against a globe, symbol of her dominion, on which criss-cross bands are faintly visible. Below, stretching across the full width of the stone, is an elongated ansate panel containing a centrally-placed wild boar and with the *ansae* surmounted by small rosettes. There is a dovetail cramphole set into the top of the slab at the gable-angle. H: 0.69 m; W: 0.73 m; D: 0.12 m. Buff sandstone.

Inscription: *Imp(eratori) C(aesari) | T(ito) Ae(lio) Hadria | no Antonino Aug(usto) Pio p(atri) p(atriae) | vex(illatio) | leg(ionis) XX | V(aleriae) V(ictricis) fec(it) | p(er) p(edum) ĪĪĪĪCDXI.* 'For the emperor Caesar Titus Aelius Hadrianus Antoninus Augustus Pius, Father of his Country, a detachment of the Twentieth Valiant and Victorious Legion built (this) over a distance of 4,411 feet'.
Line 3: ANTONNO (Sibbald, Maitland), ANTONINO (Stukeley, Gordon, Horsley); line 4: P·IOPP (Sibbald); line 6: FE (Sibbald, Stukeley, Gordon, Maitland), FEC (Horsley, Hübner, Collingwood & Wright); line 7: P·ĪĪĪĪ (Gordon) P·P·ĪĪĪĪ (Sibbald, Stukeley, Horsley).
Letter heights: 1–6: 0.03 m; 7: 0.035 m.

Discussion: This distance slab, which commemorated work by a detachment of the Twentieth Legion, recorded the completion of a sector of 4,411 feet of the Wall, between Old Kilpatrick and Dalnotter Burn. The inscription is carefully arranged so that the titles of the emperor are contained within the pediment, and the name and titles of the legion enclosed by the laurel wreath. The overall design recalls No. 9, and the shape No. 8. This is a partner for No. 15 which may have recorded the east end of the same sector (but see above, p. 87). Victory is here shown in unusual pose, not flying with one foot on a globe, but at rest, very much in the manner of a river god, which presumably alludes to the proximity of the adjacent River Clyde (cf. above, p. 64).[5]

CIL VII 1141; *RIB* 2208 *CSIR* 156
Bibliography: Sibbald 1695, 1101, fig. only; Sibbald 1697, 207; Sibbald 1707, pp. 49–50; Stukeley 1720, 10–11, no. vi with fig.; Gibson 1722, 1290 with fig.; Gordon 1726, 51, pl. ix.1; Horsley 1732, 194–5, no. 1, pl. (Scotland), 1; Maffei 1749, 446, no. 14; Pennant 1774b, 138; Maitland 1757, 182–3; University of Glasgow 1768, pl. i; Anderson

Collections to be in the West side of the Wall of Calder House (Stukeley 1720, 10, in error for No. 4). 'I suppose this to be the same mentioned in *Blaeu's Atlas*, in these words, *Extat in porticu Dunotrii, quae Comitis Marscelli arx est in Provincia Mernia*' (Stukeley 1720, 11, in error for No. 1). Found at Old Kilpatrick (Gordon 1726, 50; cf. Horsley 1732, 194f.); at 'Fenydike' (i.e. Ferrydyke), Old Kilpatrick (Maitland 1757, 182). Though the Marquesses (later Dukes) of Montrose held substantial estates to the north and west of Glasgow, they did not own the land at Old Kilpatrick where the stone itself is thought to have been found (see above, p. 68).
Donation: Before 1684 (when the donor, the Third Marquis of Montrose, died). 'Given to Glascow by the Marquis of Montros' (Stukeley 1720, 10). *ex dono nobiliss. et potentiss. principis Jacobi Marchionis Montis-Rosarum* (University of Glasgow 1768, pl. i). Mugdock Castle was wrecked in the wars of the 1640s, but subsequently rebuilt; by 1680 the Third Marquess had moved to Buchanan Castle (Paul 1909, 257ff.; RCAHMS 1963, 11, 253), so that the donation could well belong before that date.
Condition: The slab is much worn, noticeably more so than the majority of the distance slabs, presumably as a result of lying 'a long time' at Mugdock Castle (Gordon 1726, 51), before reaching the College towards the end of the seventeenth century. There has been some damage sustained to the hindquarters of the boar, subsequently repaired.
Description: The slab is carved to show a temple-façade, with the pediment supported on fluted pilasters topped by Corinthian capitals. The carving of the pilasters is extended round the side faces of the slab. The gap between the pilasters is occupied by the reclining female figure of winged Victory, hair piled on her head (in the fashion of the time), naked to the thighs, but with draperies

[5]Another stone, possibly a distance slab, was seen at Ferrydyke in the mid-eighteenth century, but has long since disappeared (Maitland 1757, 183; Macdonald 1934, 392; Keppie 1979, 20, no. 20).

1771, f. 30; Gough 1789, vol. 3, 359; Laskey 1813, 76, no. 1; Nimmo 1817, 639, no. 1 on fig.; Hodgson 1840, 268, no. cclxxxvii; Stuart 1845, 289f., pl. vii.1; Irving 1860, 10, fig. i; Bruce 1893, 34–5, pl. i.2; Macdonald 1895, 23 no. 5; Macdonald 1897, 20-2 no. 1, pl. i.1; Glasgow Archaeological Society 1899, 8, no. 16; Gibb 1901b, 200 with fig.; Macdonald 1911, 272-4, no. 1, pl. xxxvi.1; Haverfield 1913b, 629; Macdonald 1934, 390-2, no. 17, pl. lxix.2; Toynbee 1964, 149, pl. xxxixb; Keppie 1979, 19, no. 17, pl. 3; Keppie & Arnold 1984, 57, no. 156, pl. 38.

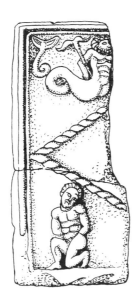

17 *Scale 1:12*

17. COMMEMORATIVE TABLET (DISTANCE SLAB?) PL. VIII

ARNIEBOG, Cumbernauld, Dunbartonshire (North Lanarkshire), 12 June 1868. Inv. no. F.16.

Findspot: NS 770 777. 'An interesting relic of antiquity was, on Friday 12th instant, discovered on the farm of Arniebog in the parish of Cumbernauld on the line of the old Roman Wall of Antoninus which runs across that farm. On the day mentioned, the farmer, Mr William Chalmers, and several of his family, were collecting and removing the stones from a field under potatoes, bounded on the north by "Grim's Sheugh" as it is colloquially called, which at this spot appears to be still in the state in which it was left by the Romans 1500 years ago and on the very top of the agger, or "gathered heap" as Ossian the Caledonian bard contentiously called it. One of the daughters turned over a large stone which had been loosened by the plough for the purpose of getting it lifted into the cart, when she discovered something upon its undersurface which excited her curiosity, and after scraping away the adhering earth, she called out to

her father that she had found a man. The stone, on being removed to the farm and cleaned, proved to be part of an ancient altar slab on which was beautifully and most artistically sculptured in *alto relievo*, within a square moulding, the naked figure of a Caledonian hero in captivity, bending on one knee in a suppliant attitude, with his hands tied behind his back . . . We trust that a photogram will be taken of the figure for the inspection of ethnologists and archaeologists as well as a specimen of Roman provincial art. The stone was found on an eminence from which an extensive survey of all the neighbouring country can be got, about a Roman mile west of the great station at Castlecary . . . and between that and the fort at Westerwood at both which places many Roman remains have been discovered . . . Doubtless an examination of the spot by trenching would reveal other interesting antiquities, and perhaps the remaining portion of the altar' (*Glasgow Herald*, 15 June 1868). 'The farmer . . . resolved to root out two large flat stones, which were embedded about one foot under the surface, and had long interfered with his field work. They lay a few feet apart, and about 34 yards from the south or Roman side of the fosse' (Buchanan 1872, 473; cf. Buchanan 1883b, 66f.). The first account mentions only one fragment, but the second fragment was clearly found soon after. Both had been lying face down. Buchanan on his visit to the site, soon after the discovery, found that the two fragments made a perfect fit (Buchanan 1872, 473). The description of the findspot in the *Glasgow Herald* indicates that the fragments were not found at Arniebog farm itself, but *c.* 450 m further east, on an eminence now known as Hag Knowe (Keppie 1974, 154).

Donation: 1872 (above, p. 36). John Buchanan, in a letter donating other items, dated October 1871, observes: 'It is to be regretted that these interesting relics are allowed to lie uncared for and liable to injury, if not to destruction, in one of the outhouses of Arniebog farm, the property of Mr Cornwallis Fleming of Cumbernauld, a minor, whose guardian is Lord Hawarden. Efforts have been made, without effect, to have these sculptures put in some place of safety' (GUL MR 50/49, no. 5; cf. Buchanan 1872, 481). They might have reached a different institution: Miss C. Maclagan, in a letter to the Society of Antiquaries of Scotland, Edinburgh, read 13 March 1871, observes: 'I also offered to purchase the stone for the Museum [the National Museum of Antiquities, Edinburgh!], but was told that "The laird" was making a collection of such things, and of course the farmer must esteem his claim as the first. A few months ago it was still in the milk-house of the farm' (Maclagan 1872, 178).

Condition: Two adjoining fragments preserve

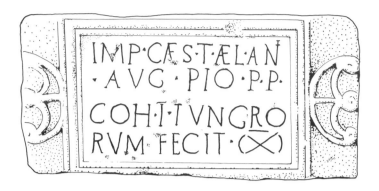

18

Scale 1:12

the left side of the slab. The outer mouldings are badly chipped, but the sculptured figures are well preserved.[6]

Description: Within a framework of triple beaded mouldings was a diamond-shaped or hexagonal panel, enclosed by cable patterns. The top left corner was occupied by a bearded Triton with thick curly hair and beard, and splendid twisted fish-tail, holding an anchor reversed in the crook of his right arm. The bottom left corner was occupied by a bound and naked captive, resting on one knee, with his head inclined to the right. 'The countenance is that of a young man, about twenty-two years of age' (Buchanan 1872, 473). There is a single dovetail cramphole in the left side of the slab. H: 0.845 m; W: 0.36 m; D: 0.145 m. Yellow sandstone.

Discussion: The fragments constitute the left side of what must have been a square or rectangular slab recording building work, almost certainly by a legion. From its dimensions, and findspot on the line of the Antonine Wall, but away from a known installation, it may be identified as a distance slab. The kneeling captive is an appropriate image, paralleled on Nos 5 and 9, symbolising native defeat and subjection. Various suggestions have been made as to the legion responsible: the kneeling captive and the triple border both recall the workmanship of the Twentieth Legion (see Nos 8, 9, 15). The signficance of the Triton, a maritime symbol, is unclear here, unless it is thought of as a legionary emblem (Keppie 1982, 100). There is no river or meaningful mass of water near the findspot, unless the relatively small Loch Barr (below, No. 45) is meant.[7]

CSIR 84

Bibliography: *Glasgow Herald*, 15 June 1868;

MacLagan 1872, 178 with fig.; Buchanan 1872, 472–81 with fig.; Buchanan 1883b, 66f.; Macdonald 1895, 26; Macdonald 1897, 76, no. 32, pl. xvi.1, ibid. 94; Gibb 1901c, 24–7; Macdonald 1911, 306, pl. xlviii.4; Macdonald 1934, 392, pl. lxxii.6; Keppie 1979, 20, no. 19; Keppie & Arnold 1984, 32, no. 84, pl. 24.

B. FORT-BUILDING RECORDS

18. BUILDING RECORD OF THE FIRST COHORT OF TUNGRIANS PL. IX
CASTLECARY, Stirlingshire (Falkirk), 1764. Inv. no. F.20.

Findspot: NS 790 783. 'Upon the Roman wall near Castle Cary' (Anderson, 1771, f. 43; cf. Anderson 1793, 200); transferred soon after discovery to the 'brew house at Castle Cary' (Anderson 1771, f. 45).

Donation: 10 October 1774, by Sir Lawrence Dundas (GUA 26690, p. 258), together with Nos 27, 28, 54 (above, p. 29). *Inventum apud Castlecary, AD 1764, et a Laurentio Dundas Baronetto academiae donatum* (University of Glasgow 1792, pl. xxvii).

Condition: The slab is badly worn and pockmarked, most probably the result of natural weathering rather than shotgun pellets (as suggested by Collingwood & Wright, *RIB* ad loc.). The horns of the *peltae* are especially worn.

Description: The inscribed panel is contained within a plain triple moulding and flanked by *peltae* in outline form, whose horns and central projections terminate in plain bosses. H: 0.55 m; W: 1.065 m; D: 0.15 m. Buff sandstone.

Inscription: *imp(eratori) Caes(ari) T(ito) Ael(io) Ant(onino)* | *Aug(usto) Pio p(atri) p(atriae)* | *coh(ors)* *I Tungro* | *rum fecit (milliaria).* 'For the emperor Caesar Titus Aelius Antoninus Augustus Pius, Father of his Country, the First Cohort of

[6]James Macdonald reports 'a fragment of a third stone so clearly resembling No. 32 [this stone] that it may have been part of it' (Macdonald 1897, 94), but there is no surviving fragment bearing any resemblance; perhaps he was describing the small fragment belonging, it is suggested here, to No. 50.

[7]The diamond-shape could recall the stone screens fronting offices in the *Principia* at Vindolanda.

Tungrians built (this), one thousand strong'. The name *Hadriano* is omitted.

Line 1: AN (Anderson 1771, f. 43; 1793, 200, pl. xxxix), ANT (University of Glasgow 1792, Hübner, Collingwood & Wright); line 3: COH·T·TVNGRO (University of Glasgow 1792), I·TVNGRO (Anderson, Stuart, Hübner, etc.). Letter heights: 1–4: 0.06m.

Discussion: This is a building record erected by the *cohors I Tungrorum* in honour of the emperor Antoninus Pius. The cohort, of auxiliary infantry originally recruited in the Low Countries, in the area of modern Tongres, served in Britain from the Flavian period onwards (Jarrett 1994, 48f.; Nouwen 1997). In A.D. 95–105 it was at Vindolanda (Bowman & Thomas 1994, 22ff., 91ff.; *RIB* 2401.9); probably during the third century it was in garrison at Housesteads on Hadrian's Wall (*RIB* 1578 etc.; Jarrett 1994, 49); however, Bowman and Thomas (1983, 119) suggest that it had gone to Housesteads already under Hadrian, before moving north into Scotland.

The unusual position here of the notation ∞ for *milliaria* ('one thousand strong'), which would normally precede rather than follow the verb *fecit*, has led to the suggestion that this cohort, like *cohors II Tungrorum*, had been subdivided into two cohorts of about 500 men, and had only recently been restored to its full strength (Birley 1974, 512 = Birley 1988, 366; Jarrett 1994, 49), so that the sign for *milliaria* was inserted as an after-thought. Alternatively it may be wondered whether the unusual word-order derived from a last minute decision by the stonecutter: realising that the text would end awkwardly, halfway along the line, he decided to inscribe *fecit* in full and insert ∞ to fill up the available space. The sign ∞ confused early commentators who supposed that the cohort had completed a length of 1,000 paces of the Antonine Wall (Hübner 1873 on *CIL* VII 1099 and at p. 193).

The inscription records building work, but whether this belongs to the construction phase at the fort, or a period of subsequent reconstruction, remains uncertain. It is usually supposed from this evidence that the cohort formed for a time the garrison at Castlecary. The site has also yielded a record of the *cohors I Fida Vardullorum* (*RIB* 2149). In 1980 a diploma to Amandius, a time-served soldier of the *cohors I Tungrorum*, dated A.D. 146, was found at Vindolanda, a former posting, to which the soldier had perhaps retired after service (*RIB* 2401.9); the commander in A.D. 146 is named as Paternius (Devijver 1987, p. 1675, no. P 15 bis).

CIL VII 1099; *RIB* 2155 *CSIR* 80
Bibliography: Anderson 1771, f. 43 with fig.; Gough 1789, vol. 3, 361; University of Glasgow 1792, pl. xxvii; Anderson 1793, 200, pl. 39; Nimmo 1817, 640; no. 9 on fig.; Hodgson 1840, 265, no. cclxiv; Stuart 1845, 340–1, pl. xv.10; Macdonald 1895, no. 15; Macdonald 1897, 72–3, no. 29, pl. xi.3; Macdonald 1911, 325–8, no. 28, pl. xliii.3; Macdonald 1934, 412–14, no. 30, pl. iii.1; RCAHMS 1963, vol. 1, 105–6, no. iv, fig. 44; Keppie & Arnold 1984, 31, no. 80, pl. 23.

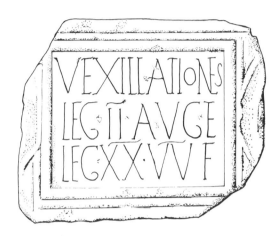

19 *Scale 1:12*

19. BUILDING RECORD OF THE SECOND AND TWENTIETH LEGIONS PL. IX

BAR HILL, Twechar Dunbartonshire (East Dunbartonshire), *c.* 1790–96. Inv. no. F.17.

Findspot: NS 707 769. Long assigned to Duntocher (Stuart 1845, 357; Macdonald 1897, 31; Macdonald 1911, 311), its correct provenance was established by a MS note in a 'late 18th century hand' in an Ashmolean Library copy of the *Monumenta* (University of Glasgow 1792; see Macdonald 1934, 403).

Donation: After 1790–92 (absent from new edition of the *Monumenta*), but before 1807 (absent from Hunterian Museum Donation Books); in fact probably before 1796 (above, p. 32).

Condition: The slab is chipped and worn at the edges; the top left and bottom right corners are broken away.

Description: The inscribed panel is contained within a double plain moulding and flanked by *ansae* enclosed by a single plain moulding. The tall and spindly serifed lettering (above, p. 59) may reflect the style of the draft written version. Interpuncts take the form of ivy leaves. H: 0.57 m; W: 0.78 m; D: 0.13 m. Yellowish-buff sandstone.

Inscription: *vexillationes | leg(ionis) II Aug(ustae) et | leg(ionis) XX V(aleriae) V(ictricis) f(ecerunt).* 'Detachments of the Second Augustan Legion and

of the Twentieth Valiant and Victorious Legion built (this)'.

Line 1: VEXILLATIONS (Stuart); line 2: LEG II AVG E (Stuart); line 3: LEG XX·V·V (Stuart, Collingwood & Wright, Keppie), LEG XX·V·V (Hübner, J. Macdonald, G. Macdonald), LEG XX F (Hodgson).

Letter heights: 1: 0.05–0.105 m; 2–3: 0.105 m.

Discussion: The slab testifies to building work undertaken at Bar Hill by detachments of the Second and Twentieth Legions. The same detachments may also be commemorated on a lost inscription from the site, traditionally identified as a milestone, but more probably a column from the headquarters building, with broadly similar text and lettering (*RIB* 2312; see Keppie 1983, 397; 1986, 55; Tomlin 1995, 799).

CIL VII 1139; *ILS* 2480; *RIB* 2171

Bibliography: University of Glasgow 1792 (Ashmolean Library copy); Hodgson 1840, 271, no. ccxcii; Stuart 1845, 357, fn (a), pl. xv.6; Macdonald 1895, 29; Macdonald 1897, 31–2, no. 8, pl. iv.2; Gibb 1902a, 121–4, with fig. at 124; Macdonald 1911, 311–12, no. 18, pl. xli.2; Macdonald 1934, 403, no. 23, pl. lxxiii.1; Robertson, Scott & Keppie 1975, 33, no. 5.

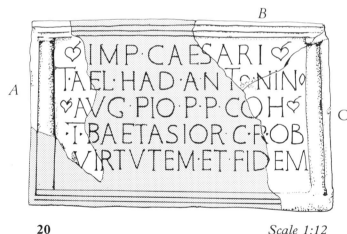

20 *Scale 1:12*

20. BUILDING RECORD OF THE FIRST COHORT OF BAETASII PL. IX

BAR HILL, Twechar, Dunbartonshire (East Dunbartonshire), 20–24 November 1902 (1903, Haverfield, Collingwood & Wright in *RIB*). Inv. no. F.1936.1.

Findspot: NS 707 769. During excavation of the well of the headquarters building, at a depth of 17 ft (Macdonald & Park 1906, 8f.).

Donation: 1933–1936, by Mr Alexander Whitelaw of Gartshore, along with other material from Bar Hill excavated 1902–05.

Condition: The slab is only partially preserved,

in three fragments (a–c), of which (b) and (c) adjoin.

Description: The inscribed text was set within a plain moulding, flanked to left and right by engaged pillars with plain capitals. Leaf stops are used at the beginning and end of lines 1 and 3. (a): H: 0.515 m; W: 0.22 m; D: 0.14 m; (b and c): H: 0.605 m; W: 0.43 m; D: 0.14 m. Whitish-buff sandstone.

Inscription: *[Imp(eratori) Cae]sari | T(ito) Ae[l(io) Had(riano) An]tonino | Au[g(usto) Pio p(atri) p(atriae) c]oh(ors) | I B[aetasior(um) c(ivium)] R(omanorum) ob | vi[rtutem et fi]dem.* 'For the emperor Caesar Titus Aelius Hadrianus Antoninus Augustus Pius, Father of his Country, the First Cohort of Baetasii, Roman Citizens because of their Valour and Loyalty, (built this)'.

Line 1: I[MP·CAE]SARI (Haverfield); line 2: T·A[EL·HADR·AN]TONINO (Haverfield), HAD (Macdonald & Park), HADR (Collingwood & Wright); line 3: AV[G·PIO·P·P·C]OH (Haverfield); line 4: I·B[AETASIOR·C·]R·OB (Haverfield); line 5: VI[RTVTEM·ET·FI]DEM (Haverfield), VIR[TVTEM] (Collingwood & Wright); line 6: APPELLATA (Collingwood & Wright), *vacat* (Haverfield, Keppie, Tomlin).

Letter heights: 1–5: 0.065 m.

Discussion: The slab recorded construction probably (from its findspot) of the headquarters building of the fort. Similarity of lettering with No. 31 makes it fairly certain that Haverfield's bold restorations (Macdonald & Park 1906, 83; Haverfield 1913b, no. 1245) can be accepted with acclaim, so that responsibility can be assigned to the *cohors I Baetasiorum*. When complete the slab probably measured 0.605 by *c.* 0.96 by 0.14 m.

The cohort was originally raised in the Rhineland, and is likely to have served in Britain from the Flavian period onwards (Jarrett 1994, 53). Later, after its sojourn on the Antonine Wall, it garrisoned Maryport in Cumbria (Jarrett 1966; 1976; Jarrett & Stephens 1987); whether it was at Bar Hill during the primary or secondary phases of occupation is disputed (Macdonald 1934, 258; Keppie 1983, 53–7; Jarrett 1994, 53–4).

The emphasis given here to possession by the cohort of Roman citizenship may indicate that the award was recent, and we could think of the campaigns of Lollius Urbicus immediately preceding the building of the Antonine Wall, in A.D. 139–42 (Jarrett 1994, 54).

The word *appellata* proposed in line 6 is unnecessary and grammatically difficult.[8] Presumably, from the findspot, the slab was levered from position when the fort was being dismantled,

[8]Notice *RIB* 897, *ala Augusta Gordiana ob virtutem appellata*; *CIL* III 11931, *cohors I Breucorum v(aleria) v(ictrix) bis torquata ob virtutem appellata* (restored text).

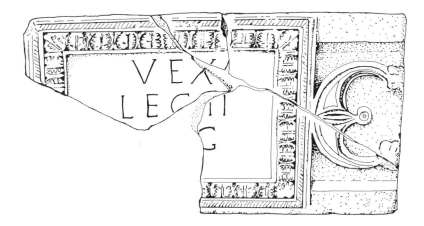

21 *Scale 1:12*

at the close of the fort's occupation and use. Parts, but perhaps not all of the slab, found their way into the well (see Robertson, Scott & Keppie 1975, 14).

AE 1904, 31; *RIB* 2170 *CSIR* 102
Bibliography: Haverfield 1903, 203, no. 5; Haverfield 1904, 185; Macdonald & Park 1906, 8f., 82, fig. 29; Macdonald 1911, 323–4, no. 26, pl. xx.3; Haverfield 1913b, 626, no. 1245; Macdonald 1934, 414–15, no. 31, pl. liii.1; Robertson, Scott & Keppie 1975, 35, no.9; Keppie & Arnold 1984, 38, no. 102, pl. 28; Tomlin 1995, 797.

21. BUILDING RECORD OF THE SECOND LEGION PL. X

SHIRVA, Dunbartonshire (East Dunbartonshire), August 1726. Inv. no. F.18.

Findspot: NS 692 755. During investigation of a stone-built 'tumulus', east of Shirva House (see also Nos 49–51; above, p. 15). 'On one [stone] is the legio 2da Augusta eligantly engraven but the stone broke in 3 parts and part of it where the noble ornaments are is still lying in the ground undugg' (Alexander Gordon to Sir John Clerk, 24 September 1726; SRO GD 18/5023/3/36). 'The stone is in two or three pieces, which were lying at a distance from one another' (Horsley 1732, 199, no. xii). The top right fragment goes unmentioned by Gordon (1732, pl. lxvi) and Horsley (1732, 199, no. xii, pl. (Scotland) xii); it may therefore have been found a little later (noted first in University of Glasgow 1768, pl. xii).
Donation: Shortly before 5 March 1728, by Thomas Calder of Shirva, together with Nos 49–51 (GUA 26635, p. 31; Horsley 1732, 198). *ex dono Thomae Calder de Shirva, mercatoris Glasguensis* (University of Glasgow 1768, pl. xii).
Condition: Some two-thirds of the slab survive, in four adjoining fragments. They are all worn and chipped. The fragment sometimes shown as constituting the lower left corner of the slab (Macdonald 1897, pl. x.1; 1934 pl. lxxiii.2; and PL. XII) is a modern support. Indeed, the top left and bottom right fragments have both been trimmed to produce smooth, regular edges, to allow for a neat fit (compare University of Glasgow 1768, pl. xii, Stuart 1845, pl. xii.1 with Macdonald 1897, pl. x.1, indicating perhaps that the modern fragment was added in the mid-/later nineteenth century). At the join between the top left and centre top fragments the stone has been recessed to support an angled bracket, presumably also in modern times.
Description: The slab was carved to show an inscribed panel enclosed within an ornate border, of which the outer consisted of cable patterns and the inner of acanthus leaf decorations. It was flanked to the right by a *pelta*, whose horns terminate in griffin-heads and the central projection in a plain circular boss. At first sight there seems no matching left-hand side panel, but the edge here is rough (contra Keppie & Arnold 1984, 42–3, No. 114, in error), and a missing panel showing a *pelta* can be assumed. Above and below are plain broad mouldings. Traces of red paint are visible in the hollows of the lettering. H: 0.685 m; W: 1.205 m; D: 0.18 m. Buff sandstone.
Inscription: *vex(illatio)* | *leg(ionis) II* | *[Au]g(ustae) [f(ecit)]*. 'A detachment of the Second Augustan Legion built (this)'.
Line 2: LLG (University of Glasgow 1768); line 4: [F] (G. Macdonald, Keppie), [FECIT] (Hübner, J. Macdonald), followed by numerals to indicate length of Wall completed (Hübner); *vacat* (Collingwood & Wright).
Letter heights: 1–3: 0.075 m.
Discussion: The slab recorded building work by a detachment of the Second Legion. Hübner, believing this to be a distance slab, supposed (1873 on *CIL* VII 1117) that a further line contained a record of the number of paces completed; but this

is unlikely. Rather it commemorated building work at a fort, probably Bar Hill or Auchendavy, from which it had been carried to Shirva for re-use. The decorative border recalls the distance slab of the Second Legion from Bridgeness (*RIB* 2139), two smaller distance slabs from Duntocher (Nos 12, 13), and others erected by the Second Legion in northern Britain at this time (*RIB* 1147, 1148).

CIL VII 1117; *RIB* 2180 *CSIR* 114
Bibliography: Gordon 1732, *Additions*, 5–6, pl. lxvi.1; Horsley 1732, 199, no. xii, pl. (Scotland) xii; University of Glasgow 1768, pl. xii; Anderson 1771, f. 39; Gough 1789, vol. 3, 359, pl. xxiv, no. 8; Hodgson 1840, 265-6, no. cclxix; Stuart 1845, 330, pl. xii.1; Macdonald 1895, 26, no. 1; Macdonald 1897, 64–5, no. 24, pl. x.1; Macdonald 1911, 314, no. 21, pl. xliii.2; Macdonald 1934, 403–4, no. 24, pl. lxxiii.2; Keppie & Arnold 1984, 42–3, no. 114, pl. 31; Tomlin 1995, 797.

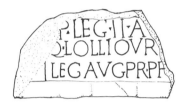

22 *Scale 1:12*

22. BUILDING RECORD OF THE SECOND LEGION PL. X

BALMUILDY, Lanarkshire (City of Glasgow), in or before 1696-98. Inv. no. F.19.

Findspot: NS 581 717. 'It was at Balmulden, A°1697', Stukeley (MS note in own copy of Stukeley 1720, Ashmolean Library, at p. 11); '. . . to be seen at a little village [called] Balmulden, in the sole of a byer window', Gregory April 1698 ex Urry (EUL Dk.1.2, A74, no. 1); so Tanner April 1699 ex Urry (EUL Laing MS La.II.644/7, no. 1); '. . . lain long neglected in a farmer's house' (Anderson 1771, f. 36).

Donation: In or shortly before August 1699 (above, p. 10), by Charles Maitland, a brother of the Earl of Lauderdale, who resided at Cawder House. *ex dono D. Caroli Maitland, Fratris Germani Comitis Laudeliae* (University of Glasgow 1768, pl. viii). 'The most remarkable inscription we have is kept in Glasgow library' (Sibbald 1707, 49). 'Seen and copied by Dr *Jurin* at the College of *Glascow*, the Gift of Mr *Charles Maitland*' (Stukeley 1720, 11). James Macdonald suggested (1897, 53; followed by Macdonald 1934, 404f.) that as Charles Maitland is known to have gifted a book to the College Library in 1693, the stone may have reached Glasgow at the same time; but the publica-

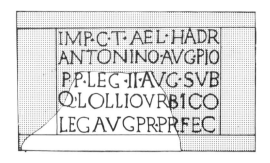

22 (restored) *Scale 1:12*

tion of the Wodrow correspondence provides the correct date (Sharp 1937, 25, no. xi; above p. 10).
Condition: Only part of the stone survives, preserving parts of three lines of an inscription, together with the lower border and lower left corner. It is much worn at the edges and scraped and scored on the bottom moulding. The surviving fragment is currently placed within a wooden frame.
Description: The inscribed panel was enclosed below and to the left, and presumably therefore on all four sides, by plain mouldings. H: 0.25 m; W: 0.51 m; D: 0.09 m. When complete the slab would have measured *c.* 0.76 m long by 0.46 m high. Buff sandstone.
Inscription: *[Imp(eratori) C(aesari) T(ito) Ael(io) Hadr(iano) | Antonino Aug(usto) Pio | p(atri)] p(atriae) leg(io) II A[ug(usta) sub] | Q(uinto) Lollio Ur[bico] | leg(ato) Aug(usti) pr(o) pr(aetore) [fec(it)].* 'For the emperor Caesar Titus Aelius Hadrianus Antoninus Augustus Pius, Father of his Country, the Second Augustan Legion under the command of Quintus Lollius Urbicus, the emperor's legate with praetorian powers, built (this).'
Line 1: [IMP·C·T·AELIO·HADR] (J. Macdonald, G. Macdonald), [IMP·C·T·AEL·HADR] (Collingwood & Wright, Keppie); line 2: [ANTONINO·AVG·PIO] (J. Macdonald, G. Macdonald, Collingwood & Wright); line 3: P· LEG II·A[VG] (Sibbald, Gordon), P·LEG·II· AV[G] (Stukeley), [P]·P·LEG·II·AV[G·SVB] (J. Macdonald, G. Macdonald, Collingwood & Wright); line 4: Q·LOLLIO VR[BICO] (Horsley); line 5: LEG·AVG·PR·PL (BM MS Stowe), LEG· AVG·PR·PE (Sibbald), LEG AVG PR RE (Stukeley), LEG AVG PR PR (Gordon, Hübner), LEG AVG PR PR [F] (J. Macdonald, G. Macdonald), LEG AVG PR PR FEC (Horsley, Collingwood & Wright, Keppie).
Letter heights: 3 (as restored): 0.06 m; 4–5: 0.05 m.
Discussion: The slab recorded building work by the Second Legion, while Q. Lollius Urbicus was governor of Britain, i.e. in A.D. 139–43 (A.R. Birley 1981, 112ff. and above, p. 48; see also No. 23).

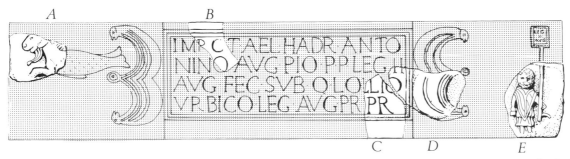

23 *Scale 1:24*

The discovery of this stone was rapturously greeted by antiquaries as securely establishing the location the Antonine Wall (above, p. 10): 'The most remarkable inscription we have' (Sibbald 1707, 49); 'The most invaluable Jewel of Antiquity, that ever was found in the Island of *Britain*, since the time of the *Romans*' (Gordon 1726, 63). The missing lines can be restored to show a dedication in honour of Antoninus Pius. See PL. X for a faulty arrangement of the missing text; the figure on this page is to be preferred (cf. Keppie 1976a, 100, fig. 1). Given the width of the left-hand moulding, there could be room for a small *ansa*, or another decorative feature.

CIL VII 1125; *RIB* 2191

Bibliography: Sibbald 1707, 8, 28, no. 5, 49 with fig.; Stukeley 1720, 11, pl., no. vii; Gordon 1726, 63 and pl. xi.2; Horsley 1732, 197–8, no. viii, pl. (Scotland) viii; University of Glasgow 1768, pl. viii; Anderson 1771, ff. 36–7; Gough 1789, vol. 3, 359, pl. xxiv.6; Nimmo 1817, 639, no. 2 on fig.; Hodgson 1840, 267-8, no. cclxxxiv; Stuart 1845, 312–13, pl. x.3; Wilson 1851, 374; Macdonald 1895, 18–23, no. 4; Macdonald 1897, 49–53 no. 17, pl. vii.1; Glasgow Archaeological Society 1899, 5; Gibb 1900, 85-7; Nichols 1809, *338, no. 1; Macdonald 1911, 313, no. 20, pl. xliii.1; Haverfield 1913b, 627; Macdonald 1934, 404–5, no. 27, pl. lvii.3; Keppie 1976a, 99-102 with fig.; Vasey 1993, 65-72.

23. BUILDING RECORD OF THE SECOND LEGION PL. X

BALMUILDY, Lanarkshire (City of Glasgow), 1912. Inv. no. F.1922.1-3.

Findspot: NS 518 717. During excavation in front of the north gate, among other stone debris on top of a road surface (Miller 1922, 17, 59).
Donation: 1922, by Gen. A.S. Stirling of Keir.
Condition: The surviving five fragments are chipped, worn, and scarred.
Description: Fragment (a) shows the head and foreparts of a capricorn swimming left; fragments (b), (c), and (d) each preserve a few letters of the inscription, flanked on the right (on frag. d) by a *pelta* ornament. Fragment (e), which preserves the bottom right-hand corner of the slab, shows a standard-bearer, in tunic and military cloak, probably bearded, facing the front. He holds the pole of a standard in his right hand, with a handle near its bottom; in his left hand is a handled box. (a) H: 0.3 m; W: 0.33 m; D: 0.265 m; (b) H: 0.495 m; W: 0.405 m; D: 0.265 m; (c) H: 0.645 m; W: 0.24 m; D: 0.265 m; (d) H: 0.495 m; W: 0.465 m; D: 0.265 m; (e) H: 0.475 m; W: 0.375 m; D: 0.265 m. Buff sandstone.

Inscription: *[Im]p(eratori) C(aesari) [T(ito) Ael(io) Hadr(iano) Anto | nin]o [Aug(usto) Pio p(atri) p(atriae) leg(io)] II | [Aug(usta) fec(it) sub | Q(uinto) Lo]llio | [Urbico leg(ato) Aug(usti) pr(o)] pr(aetore).* 'For the emperor Caesar Titus Aelius Hadrianus Antoninus Augustus Pius, Father of his Country, the Second Augustan Legion built (this) under the command of Quintus Lollius Urbicus, the emperor's legate with praetorian powers'.
Lines 1–4 as restored by Miller. Line 1: RC (Haverfield); line 2: [LEG] II or [COS] II (Haverfield), [LEG] II (Miller).
Letter heights: 1–4: 0.1 m.

Discussion: This very substantial slab, which may have measured 0.76 by 3.5 m when complete, was erected over the north gateway at Balmuildy, presumably to record its construction *c.* A.D. 142. The surviving fragments suggest an oblong panel flanked by *peltae* and by sculptured scenes. On the left was the capricorn emblem of the Second Legion. The male figure on the right held the pole of a *vexillum*-standard, perhaps topped by a tasselled flag bearing the inscription *LEG II AVG* (as on *RIB* 2139 and elsewhere). The handled box identifies the soldier as a clerk (Keppie 1976a, 101; cf. Šašel Kos 1978, 23). There is room for additional sculptures (see Keppie 1976a for suggested restorations).

RIB 2192 *CSIR* 135
Bibliography: Haverfield 1913a, 290–1; Haverfield 1913b, 690, no. 1390; Miller 1922, 56-7, pl. xxv–xxvi; Macdonald 1934, 405–10, no.

28, pl. lvii.1; Toynbee 1964, 187; Keppie 1976a, 99–102 with fig.; Keppie 1983, 395, no. 7, fig. 7; Keppie & Arnold 1984, 49, no. 135, pl. 34; Tomlin 1995, 798 with fig.

382, no. 15, pl. xxxviiiB; Keppie 1981, 72–3, no. 8, pl. 13, fig. 18; Keppie 1983, 400, no. 4; Keppie & Arnold 1984, 16, no. 42, pl. 14.

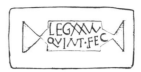

25 *Scale 1:8*

24 *Scale 1:12*

24. BUILDING RECORD OF AN AUXILIARY COHORT PL. XI

BOTHWELLHAUGH, Lanarkshire (North Lanarkshire), August 1975. Inv. no. F.1982.2.

Findspot: NS 729 579. *In situ* in the Cold Room of the extramural bath-house, during rescue excavation.
Donation: 17 February 1978, by Scottish Development Department, Ancient Monuments (now Historic Scotland).
Condition: The slab is rather worn and chipped, especially at the left edge and along the lower margin.
Description: Only the left-hand portion of the slab survives. The inscribed panel was set within a plain moulding, flanked to the left (and presumably also to the right) by stylised chip-carved leaves, with a plain moulding below. Of the inscription only a few letters survive. Above the inscription is what seems to be a human figure, advancing to the right; an elbow, lower trunk and leg can be made out. H: 0.41 m; W: 0.355 m; D: 0.135 m. Pinkish-buff sandstone.
Inscription: *(four lines lost) I[---]/coh[---].* '(For the emperor . . .) the . . . Cohort of . . .'
Letter heights: 0.05 m.
Discussion: The slab recorded building work, presumably at the bath-house itself, and identified the auxiliary regiment responsible. The upper part of the inscribed panel, now lost, was doubtless occupied by the names and titles of an emperor, presumably Antoninus Pius (for a suggested restoration, see Keppie 1981, 72–3). Unfortunately we cannot say which cohort undertook the work. The chip-carved motifs recall the workmanship of No. 73.

CSIR 42
Bibliography: Wright, Hassall & Tomlin 1976,

25. CENTURIAL STONE OF THE TWENTIETH LEGION PL. XI

BEARSDEN, Dunbartonshire (East Dunbartonshire), 1976.

Findspot: NS 546 721. Unstratified, close to the North Granary, during excavation of the fort-site.
Donation: 17 February 1978, by Scottish Development Department, Ancient Monuments (now Historic Scotland).
Condition: The stone is slightly chipped.
Description: On the front face of this tapering building stone is a recessed ansate panel bearing an inscription. H: 0.125 m; W: 0.265 m; D: 0.29 m. Buff sandstone.
Inscription: *leg(ionis) XX V(aleriae) V(ictricis) / Quint(.....) fec(it).* 'The century of Quint(.....), of the Twentieth Valiant and Victorious Legion, built (this)'.
Letter heights: 1: 0.016–0.13 m; 2: 0.16–0.025 m.
Discussion: This is a 'centurial' stone recording building work, of the type familiar from the line of Hadrian's Wall and also known in Scotland (*RIB* 2113, 2137, 2138, 2156, 2162, 2164, 2202, 2210). The stone identifies the builders of one of the masonry structures within the fort, perhaps the North Granary close by its findspot. The second line of the text presumably conceals the name of the centurion, who could be Quintinus or Quintianus, less probably Quintius. In this context, notice Quintinus or Quintinius, a centurion presumably of the Second Augustan Legion at Caerleon (*RIB* 349) and L. Aurelius Quintus, centurion of Legion VII Gemina recorded at Rome in A.D. 160 (*ILS* 4776; cf. *CIL* VI 3224). A lead bread-stamp at Caerleon reports the century of Quintinus Aquila (*RIB* 2409.7). The centurion's name on such stones is usually preceded by the sign ⁊, notation for 'centurion' (as on Nos 33–36, 43), but it is omitted here.

AE 1977, 526
Bibliography: Hassall & Tomlin 1977, 433-4, no. 32, pl. xxix.A; Keppie 1983, 401, no. 12; Breeze 1984, 40, fig. 17; Keppie, in Breeze forthcoming 1.

26 *Scale 1:8*

26. BUILDING STONE OF THE SECOND LEGION PL. XI

CASTLEDYKES, Lanarkshire (South Lanarkshire), August 1950. Inv. no. F.1950.35.

Findspot: NS 929 442. Unstratified, during excavation of the fort-site, from 'loose soil in Principia' (Robertson 1964, 154).

Donation: 1950, by Mr D. and Mr A. Stewart, Corbiehall Farm.

Condition: The front face of the stone has sustained some damage at top and bottom, with some minor pockmarks elsewhere.

Description: The front face of this building stone has been carved to show a rectangular panel, recessed for an inscription, within a plain moulding. At the lower left is the incised outline of a capricorn, swimming left. The panel is flanked to right and left by incised lines to give the impression of *ansae*. H: 0.18 m; W: 0.29 m; D: 0.29 m. Grey sandstone.

Discussion: As the capricorn is the emblem of the Second Augustan Legion, activity or at least the presence of some of its soldiers at Castledykes is demonstrated. Whether the capricorn was to accompany the intended inscription, or was added to a blank panel sometime later, remains uncertain.[9]

CSIR 41

Bibliography: Taylor 1951, 120; Robertson 1964, 154, no. 1, pl. 6; RCAHMS 1978, 127; Keppie & Arnold 1984, 15f., no. 41, pl. 14.

2. ALTARS

27. ALTAR TO FORTUNA PL. XI

CASTLECARY, Stirlingshire (Falkirk), November 1769, together with No. 54. (For the date, see Roy 1793, 161; above, p. 28.) Inv. no. F.21 (1771, GUA 26690, p. 238, above, p. 29; University of Glasgow 1792, pl. xxviii).

Findspot: NS 790 783. 'About fourteen months

[9]The site has recently yielded a lead sealing of a cavalry regiment, the *ala Sebosiana*, in addition to numerous copper-alloy harness-fittings.

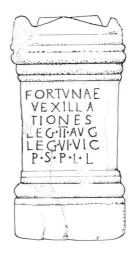

27 *Scale 1:12*

ago the workmen who wanted Stones for the Canal discovered at the east end of the Fort at Castle Cary circular buildings which seem to have been a Sudatorium . . . These circular buildings were quite covered over with earth . . . In one of them was found an altar that was very entire' (Anderson 1771, ff. 43–4; above, p. 28). The altar was shortly afterwards transferred to the 'Summer house at Kerse', home of the proprietor, Sir Lawrence Dundas (Anderson 1771, f. 45).

Donation: 10 October 1774 (together with Nos 18, 28, 54) by Sir Lawrence Dundas (GUA 26690, p. 258; cf. Anderson 1771, f. 45). *Inventum est cum statua in tabula xxix, apud Castlecary AD 1771, et a Laurentio Dundas Baronetto academiae donatum* (University of Glasgow 1792, pl. xxviii).

Condition: The altar has sustained damage to its mouldings and at the edges and corners of the capital, shaft, and base. There are some vertical cracks on the front face, especially on the base. The focus and bolsters are chipped and broken.

Description: The altar is devoid of decoration except for multiple plain mouldings separating the capital from the shaft, and the shaft from the base. The mouldings extend round three sides of the altar; the back is plain. There is a raised focus with prominent central boss between small bolsters. H: 0.785 m; W: 0.35 m; D: 0.31 m. Buff sandstone.

Inscription: *Fortunae / vexilla / tiones / leg(ionis) II Aug(ustae) / leg(ionis) VI Vic(tricis) / p(ecunia) s(ua) p(osuerunt) l(aetae) l(ibentes)*. 'To Fortune, detachments of the Second Augustan Legion (and) the Sixth Victorious Legion willingly and gladly set (this) up at their own expense'.

Line 6: P·S·P·L·L (Anderson, Hübner, J. Macdonald, G. Macdonald, Keppie), PS·P·LL (Nimmo), P·S·P[.]L (University of Glasgow 1792, Stuart). P·F·P·L·L (Collingwood & Wright, at *RIB* 2146 with notes ad loc.). For inverted A cut in place of V (line 2), see also *RIB* 890, 895.

Letter heights: 1–6: 0.03 m.

Discussion: The altar was erected by detachments of two of the legions known to have formed part of the garrison of Roman Britain in the Antonine period. Legionaries of the Sixth Legion are attested at Castlecary on *RIB* 2148, for whose presence there a date after *c.* A.D. 180 has been proposed (Mann 1986). We can say of the present altar only that it testifies to the presence of legionaries sometime in the Antonine period; whether they were engaged in construction work, or were in garrison over a longer period, remains unknown. The dedication to Fortuna suits the findspot in what appears to have been the internal bath-house (Birley 1986, 24f.). The meaning of the final line has never been properly explained. Macdonald, followed by Collingwood and Wright, suggested that P S was written here in error for *P(iae) F(idelis)*, the titles of the legion; but the careful arranging of the lines suggests a self-contained five-letter formula was intended.[10]

CIL VII 1093, with *Addit.* p. 313; *RIB* 2146
Bibliography: Anderson 1771, f. 44 with fig.; Anderson 1773, f. 95; Gough 1789, vol. 3, 361; University of Glasgow 1792, pl. xxviii; Anderson 1793, 200–1, pl. 39; Anderson 1800, 3; Nimmo 1817, 641, no. 10 on fig.; Hodgson 1840, 265, no. cclxv; Stuart 1845, 338, pl. xiv.10; Macdonald 1895, 30, no. 6; Macdonald 1897, 73–5, no. 30, pl. x.2; Christison, Buchanan and Anderson 1903, 343, no. 1; Macdonald 1911, 342–3, no. 41, pl. xlvi.1; Macdonald 1934, 419–20, no. 35, pl. lxxiv.2; RCAHMS 1963, vol. 1, 105, no. i, fig. 42.

28 *Scale 1:12*

28. ALTAR TO A GODDESS PL. XI

CASTLECARY, Stirlingshire (Falkirk), possibly November 1769 (above, p. 28). Inv. no. F.22. In the Faculty Minutes (above, p. 29) no date of discovery is assigned to this stone, unlike Nos 18, 27, 54; similarly, in the presumably derivative *Monumenta* no date is mentioned on the plate (University of Glasgow 1792, pl. xxx).

[10]Note PR S P S S (*RIB* 1543), expanded as *pr(o) s(alute) p(osuit) s(umptu) s(uo)*.

Findspot: NS 790 783. '. . . found a few years ago near Castle Cary' (GUA 26690, p. 258).

Donation: 10 October 1774 (together with Nos 18, 27, 54) by Sir Lawrence Dundas (GUA 26690, p. 258). *Inventum apud Castlecary, et a Laurentio Dundas academiae donatum* (University of Glasgow 1792, pl. xxx).

Condition: The altar has been broken horizontally across the shaft; only the upper half survives. The altar is worn at the edges and corners, especially of the capital.

Description: The capital and shaft are separated by plain mouldings. The *focus* is carved to represent a two-handled metal dish. H: 0.38 m; W: 0.38 m; D: 0.29 m. Buff sandstone.

Inscription: *Deae* / [---]. 'To the goddess . . .'
Letter heights: 1: 0.035 m.

Discussion: The name of the goddess does not survive.

CIL VII 1097; *RIB* 2150
Bibliography: Gough 1789, vol. 3, 361; University of Glasgow 1792, pl. xxx; Stuart 1845, 339, pl. xiv.9; Macdonald 1897, 75, no. 31, pl. xi.2; Christison, Buchanan and Anderson 1903, 343, no. 5; Macdonald 1911, 346, no. 44, pl. xlvi.3; Macdonald 1934, 422, no. 38, pl. lxxiv.4; RCAHMS 1963, vol.1, 106, no. vi.

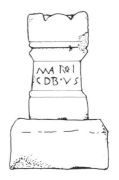

29 *Scale 1:12*

29. ALTAR TO MARS, WITH PLINTH PL. XII

CROY HILL, Dunbartonshire (North Lanarkshire), August 1912 (plinth) and 15 August 1913 (altar). Inv. no. F.1913.1.

Findspot: NS 735 765. 'Both parts were found 237 yards South of the Roman Wall and 30 yards to the East of the Dry Stone Dyke running from Nethercroy Quarry to the house on top of Nethercroy Hill', at a depth of *c.* 6 ft (1.8 m) below the modern surface, the plinth 6 ft further south than the altar (Letter from Carron Company manager, 25 October 1913, to S.N. Miller, now in Haverfield Archive, Ashmolean Museum, Oxford). '. . . near the Wall of Pius on Croy Hill,

barely 100 yards south of the Roman fort there, at the Carron Company's Whinstone Quarry' (Haverfield 1914, 28).

Donation: October 1914, by The Carron Company, in response to a request by Professor T.H. Bryce, Keeper of the Museum (GUL MR 55/4); a letter from the Company, dated February 1914, asks whether the inscription has been yet deciphered (GUL MR 55/5).

Condition: The altar is worn and damaged at the corners of the capital, shaft, and base. The plinth is similarly damaged.

Description: The capital, shaft, and base of this small altar are separated by simple mouldings. The plinth has a hollow central rectangular depression (0.18 by 0.145 m) evidently to receive the altar, though it is marginally too small.[11] The front of the plinth is bevelled at the top. Altar: H: 0.35 m; W: 0.2 m; D: 0.14 m; plinth: W: 0.32 m; D: 0.27 m; H: 0.14 m. Buff sandstone.

Inscription: *Mar(t)i | C D B v(otum) s(olvit).* 'To Mars, C(......) D(......) B(......) fulfilled his vow'. Letter heights: 1–2: 0.02 m.

Discussion: The dedication is to the war god Mars. Line 2 has defied secure interpretation. Haverfield argued that the dedication was by a person whose names are given only as initial letters, i.e. C(aius) D(......) B(......) (cf. *RIB* 1024, 731, 1045). Other possibilities might be a dedication to Mars coupled with a native warrior god such as Mars Camulus (Ross 1967, 180; but rejected by Birley 1986, 47 n 226), or Mars Condates.

RIB 2159
Bibliography: Haverfield 1914, 28, no. 2; Macdonald 1934, 424, no. 40, fig. 52.

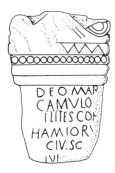

30 *Scale 1:12*

30. ALTAR TO MARS CAMULUS PL. XII

BAR HILL, Dunbartonshire (East Dunbartonshire), 1733–34. Inv. no. F.25.

[11]It is assumed here that the plinth belongs to this altar, but as archival evidence now shows that they were not found together, as hitherto believed, some doubt doubt remain.

Findspot: 'About 3 years ago, Mr Robb, Minister at Kilsyth, found in the wall of a countrey-house, hard by the Roman fort on Barhill, near Kilsyth, a Roman alltar which had been dug out of the ruins of the famous wall built there in the reign of Antoninus Pius ...'. (*Daily Gazetteer*, 7 September 1736, as quoted by Lukis 1887, 411). '... hard by the Ro. fort on Barhill by Kilsyth, this imperfect inscription found 1736, now in Glasgow Library' (Wm. Stukeley, MS note in his own copy of Stukeley 1720, opp. p. 8, in the Ashmolean Library). *Inventus est hic lapis prope Oppidum de Kilsyth* (University of Glasgow 1768, pl. xix). The 'countrey house' could perhaps be Auchenvole Castle, from which *RIB* 2167 was removed in 1723 to Penicuik House, the home of Sir John Clerk (Gordon 1726, 55).

Donation: Before September 1736, by Rev. James Robb (or Robe), Kilsyth. 'Mr Robb gave this altar to the university at Glasgow, where it is preserved with other monuments of that kind' (*Daily Gazetteer*, 7 September 1736 quoted by Lukis 1887, 412). On 12 November 1736, Professor John Simson enquired of Sir John Clerk whether he should employ a 'designer' to draw the altar (as had been done with other stones five years earlier) or whether 'any friend that can write well' could be asked 'to copy the letters exactly' (SRO GD 18/5047). '... sent to the university of Glasgow by Mr James Rob, minister at Kilsyth, not farr from which it was found' (unknown correspondent to Clerk, 9 May 1737, reproduced by Lukis 1887, 412).[12]

Condition: The surviving upper half of the altar is badly worn and damaged at the corners of the shaft and the capital, where the left-hand bolster is broken away. There are a number of angled cuts, perhaps ploughmarks, on the capital. The front of the shaft is darkened, perhaps as a result of burning.

Description: The capital and a considerable portion of the shaft are preserved, but the lettering of the inscription is very worn. The horizontal mouldings between capital and shaft are decorated round all four sides of the altar with roundels and on the front and both sides with chevrons (not a cable pattern as on *RIB* 2166). On the left side of the shaft is a sacrificial knife, on the right side a circular saucer. H: 0.49 m; W: 0.32 m; D: 55m. Buff sandstone.

[12]'Our News Papers inform us of an Altar lately discovered near Kilsyth and presented to the University of Glasgow, as there is no trusting to the Authority of Publick Papers, if you have had any Drawing of it transmitted to you, I should be highly Obliged to you for a Copy of it, with any Observations which Occurr to you upon it', Smart Lethieullier, from London, writing to Sir John Clerk, 14 October 1736 (SRO GD 18/5032/8).

Inscription: *Deo Mar(ti) | Camulo | [m]ilites coh(ortis) [I] | Hamioru[m] | [---]CIV[.]SC | [---]IVI[---]* 'To the god Mars Camulus, soldiers of the First Cohort of Hamii, . . .'

Line 1: DPO·MAT (Clerk), DEO·MAR (Hübner, University of Glasgow 1768, Collingwood & Wright), DEO MAR[TI] (*Daily Gazetteer*); line 2: [T]I CAMVLO (Hübner), [TI] (Collingwood & Wright), AMVLO (Clerk), CAMILLVS C (*Daily Gazetteer*), CAMVLO (University of Glasgow 1768, Haverfield, Keppie); line 3: C IIII (Clerk), III[..]C (University of Glasgow 1768), [...]HI[..]C[..] (Hübner), [LE]G $\overline{\text{II}}$ AVG $\widehat{\text{TI}}$ (Haverfield), [L.F]G II [AV]G (Collingwood & Wright), [M]ILITES COH I (Keppie); line 4: [---] O[---] (University of Glasgow 1768), [.....]ORI (Hübner), [...]MARIO (Haverfield), HAMIORV[M] (Keppie); line 5: [---]SC[---] (University of Glasgow 1768, Haverfield), [..]IFC[.](Hübner), [---] V S (Collingwood & Wright), [---]CIV[.]SC[---] (Keppie); line 6: [..] (Hübner), [---]IVI[---] (Keppie).

Letter heights: 1–5: 0.03 m.

Discussion: The dedication is to Mars Camulus, a combination of the Roman god Mars and a Celtic war god, Camulus, the latter especially popular in Gaul (Birley 1986, 47 no. 7). Improvements to the readings of the text, after cleaning in 1976, show that the altar was erected not by the Second Augustan Legion (so Haverfield, Collingwood & Wright on *RIB* 2166, etc.) but by soldiers of the *cohors I Hamiorum*, known to have been in garrison at Bar Hill, from the evidence of an altar and a gravestone as well as from the discovery of arrowheads during excavation of the well in 1902 (Macdonald & Park 1906, 115f.; Robertson, Scott & Keppie 1975, 24–7). The cohort was originally raised from inhabitants of Hama, a town in the Roman province of Syria, modern Hamath (Haverfield 1899a, 153–68; Haynes 1994, 149–50). First attested in Britain in A.D. 122, it was by 136 stationed at Carvoran on Hadrian's Wall, and had returned there, presumably after withdrawal from the Antonine Wall, by A.D. 165 (Jarrett 1994, 61). The precise dates of its sojourn at Bar Hill within the Antonine period have been disputed (Robertson, Scott and Keppie 1975, 24–7; Davies 1977a, 170–1; Keppie 1986, 85; Jarrett 1994, 61; Haynes 1994, 149–50).

The name of a prefect or centurion is likely to be concealed in lines 5–6, but neither of the known prefects who commanded *cohors I Hamiorum* at Bar Hill, C. Julius Marcellinus and Caristanius Justianus, appears to fit here (*RIB* 2167, 2172 = No. 32). On the other hand, the names of the prefect Tanicius Verus (*RIB* 2187; Keppie 1978, 19–24), recorded on an altar of uncertain provenance, but possibly to be associated with Bar

Hill, could perhaps fit in the form [TANI]CIVS C [F] V[ERVS].

The chevron or dog's-tooth decoration on the capital recurs on other altars from Bar Hill (*RIB* 2165, ?2168), on an altar erected by *cohors I Hamiorum* at Carvoran on Hadrian's Wall in A.D. 136–138 (*RIB* 1778), as well as on column capitals at Bar Hill (below, Nos 67–68). Such motifs were especially popular in Rome's eastern provinces, so their appearance here could be a memory of the Syrian homeland (Keppie 1986, 54).

CIL VII 1103; *RIB* 2166 *CSIR* 93

Bibliography: Stukeley 1720, marginal note at p. 8 (Ashmol. Mus. copy); University of Glasgow 1768, pl. xix; Anderson 1771, f. 42; Anderson 1773, f. (3); Gough 1789, vol. 3, 360, pl. xxv.6; Nichols 1790, 307-9, pl. vi.10; Hodgson 1840, 271, no. ccxciv; Stuart 1845, pl. xiii.9; Watkin 1884, 184–5; Lukis 1887, 411–12; Haverfield 1892, no. 1093; Haverfield 1893, 304, no. 161; Macdonald 1897, 69-70, no. 28, pl. xii.3; Macdonald & Park 1906, 85f.; Macdonald 1911, 339ff., no. 39, pl. xlv.3; Haverfield 1913b, 624; Macdonald 1934, 426, no. 43, pl. liii.4; Robertson, Scott & Keppie 1975, 32, no. 2; Keppie 1983, 393–5, fig. 4; Keppie & Arnold 1984, 35-6, no. 93, pl. 27; Hassall & Tomlin 1985, 332 no. (l); Keppie 1986, 54, fig. 1; Tomlin 1995, 797 with fig.

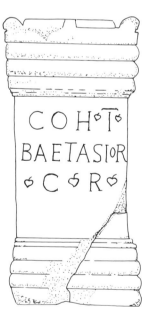

31 *Scale 1:12*

31. ALTAR PL. XII

BAR HILL, Dunbartonshire (East Dunbartonshire), 26 November 1902 (1903, Haverfield, Collingwood & Wright, *RIB*). Inv. no. F.1936.2.

Findspot: NS 707 769. During excavation of the well in the headquarters building, at a depth of 33 ft (10 m) (Macdonald & Park 1906, 7ff.).

Donation: 1933–1936, by Alexander Whitelaw of Gartshore, along with other material from Bar Hill excavated 1902–05.

Condition: Damage has been sustained to the corners of capital and bolsters, perhaps when the altar was tipped into the well. The lower right segment was broken away at the moment of discovery, but subsequently re-attached. Some small fragments near the break are lost. Upon discovery in 1902, attempts were made to arrest what was seen as a rapid deterioration in its condition: 'I am sorry to say that the altar is decaying considerably. We have removed it to the Schoolhouse [in Twechar Village] and have been keeping the stove going to dry it, after which we are to wash it with a mixture of three parts of raw linseed oil to one part of naphtha which is the best method of preservation recommended by the British Museum authorities as ascertained and communicated to me by Mr McDonald', Alexander Park to Alexander Whitelaw, 27 January 1903 (GUA UGD 101 2/10, p. 720A). 'The altar is now almost quite dry', Park to Whitelaw, 3 March 1903 (GUA ibid., p. 774).

Description: The altar is plain; the sides are undecorated. H: 0.93 m; W: 0.43 m; D: 0.42 m. Yellow-buff sandstone.

Inscription: *coh(ors) Ī | Baetasior(um) | c(ivium) R(omanorum)*. 'The First Cohort of Baetasii, Roman Citizens'.

Letter heights: 1–3: 0.05 m.

Discussion: There is no specific dedication to a god, but the findspot in the well suggests that the altar stood in the *aedes principiorum*, or in the courtyard of the *principia*. The *cohors I Baetasiorum* is also attested undertaking building work at Bar Hill (see discussion at No. 20). The lettering on this stone (and on No. 20) recalls dedications by *cohors I Baetasiorum* at Maryport (Wenham 1939, 19-30; Jarrett 1966, 37ff.), where it was stationed later in the second century.

AE 1904, 30; *RIB* 2169

Bibliography: Haverfield 1903, 203 no. 4; 1904, 185; Macdonald & Park 1906, 7ff., 81, fig. 18; Macdonald 1911, 337–8, no. 37, pl. xlv.2; Haverfield 1913b, 626, no. 1244; Macdonald 1934, 424–5, no. 41, pl. liii.2; Robertson, Scott & Keppie 1975, 35, no. 8.

32. ALTAR TO SILVANUS, WITH PLINTH PL. XII

BAR HILL, Dunbartonshire (East Dunbartonshire), 1895. Inv. no. F.24.

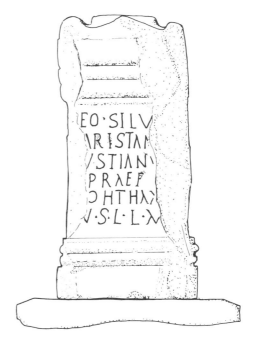

32 *Scale 1:12*

Findspot: NS 710 761. 'At the end of the year 1895 Mr James Wilson, tenant of the Castlehill field, while ploughing that field, struck with his plough against a weighty stone . . . It had originally stood, Mr Park reports, with the inscription facing east, and was found lying face downwards on the east side of the base, which remained in position, and which was, of course, dug out also. The point where the altar stood was about 240 yards north-east of the gateway or entrance of Barr Hill camp or station, about 55 yards north of the line of the military way, and about 115 yards south of the fosse of the vallum' (Glasgow Archaeological Society 1899, 95; cf. Haverfield 1899a, 153). 'Mr G. Neilson exhibited photographs of a Roman Altar recently found at Bar Hill Station, Croy, bearing an inscription to the god Silvanus' Glasgow Archaeological Society Minute Book, 18 November 1897 (GUA DC 66 2/1/3). 'Mr Park caused the stones to be put in a temporary place of safety at Easterton of Gartshore, home farm of Mr Alexander Whitelaw of Gartshore, where it remained until the summer of 1898' (Glasgow Archaeological Society 1899, 95).

Donation: June 1898, by Alexander Whitelaw. 'Professor John Young, M.D., Keeper of the Museum, having discussed the matter [of its donation] with the Very Reverend Professor—now Principal—Story, the latter on behalf of the University wrote to Mr Whitelaw on the subject, with the result that . . . in June 1898, the altar was safely set up in the Museum, where, with the very rare distinction of resting upon its original base, it now stands . . .' (Glasgow Archaeological Society 1899, 95-6). On 21 July 1898, 'Dr Young reported

to the Senate the gift of . . . a Roman altar stone found at Gartshore, from Mr Whitelaw' (GUA 26717, p. 53).

Condition: The altar is badly worn and the corners of the capital, shaft, and base are broken away. A small corner-piece has been cut out of the plinth, perhaps in Roman times.

Description: On the right side of shaft is a bow, on the left an oblong feature, perhaps intended as a quiver, but the stone is very worn. The plinth, bevelled at the edges and not of uniform thickness, had its central part recessed and roughened to support the altar. (For the altar atop the plinth, see Haverfield 1899, 153 with fig.) Altar: H: 0.92 m; W: 0.45 m; D: 0.265 m; plinth: W: 0.6; D: 0.72; H: 0.1 m. Buff sandstone.[13]

Inscription: *[D]eo Silv[ano | C]aristan[ius]| I]ustianu[s] | praef(ectus) | [c]oh(ortis) Ī Ham(iorum) | v(otum) s(olvit) l(aetus) l(ibens) m(erito).* 'To the god Silvanus, Caristanius Justianus, prefect of the First Cohort of Hamii, willingly, gladly and deservedly fulfilled his vow'.

Line 5: HAMIOR (Haverfield, G. Macdonald, Collingwood & Wright), HAM (Keppie).

Letter heights: 1–6: 0.05 m.

Discussion: The dedication to the Roman god of woodland (Birley 1986, 36–40; Dorcey 1992) was by a prefect of the *cohors I Hamiorum* (see above, No. 30). Other dedications to Silvanus are known in Scotland (No. 37, *RIB* 2124, 2167, 2178, *AE* 1965, 175). The prefect, Caristanius Justianus, is very probably a member of the well-attested colonist-family at Pisidian Antioch in southern Turkey, originally settled there in 25 B.C., of which one branch reached the Senate in the Flavian period, when Caristanius Fronto served as legate of the Ninth Legion in Northern England under Agricola; subsequently he became governor of Lycia in A.D. 81–84 and consul in A.D. 90 (Cheesman 1913, 253; Levick 1967, 63, 111ff.; A.R. Birley 1981, 233–4). We could suppose that Caristanius Justianus belonged to a collateral, less successful branch of the family, or was descended from one of its freedmen. The name is sufficiently rare for a link to the Antiochian Caristanii to be virtually certain (Devijver 1976, 226, no. C 83; Devijver 1986, 174, no. 16). The appointment of an officer of Anatolian background to command a cohort originally raised in the East may be noticed.

AE 1898, 152; *RIB* 2167

Bibliography: Haverfield 1899a, 153 with fig.; Macdonald & Park 1906, 85; Macdonald 1911,

[13]A plaster cast, presumably made soon after discovery, was retained for many years at Gartshore House where it was seen by the present writer in the 1970s.

338f., no. 38, pl. xlv.4; Haverfield 1913b, 625, no. 1242; Macdonald 1934, 425f., no. 42, pl. liii.3; Robertson, Scott & Keppie 1975, 32, no. 3.

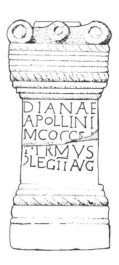

33 *Scale 1:12*

33. ALTAR TO DIANA AND APOLLO PL. XIII

AUCHENDAVY, Kirkintilloch, Dunbartonshire (East Dunbartonshire), May 1771. Inv. no. F.28.

Findspot: NS 678 748. In a pit south of Auchendavy fort, during building of the Forth & Clyde Canal, together with Nos 34-37, 59 and two large iron mallets (now lost).

Donation: July 1771, by the Commissioners of the Forth & Clyde Canal, through the good offices of Sir Lawrence Dundas, 1771 (SRO FCN 1/2, p. 181; cf. GUA 58282; above, p. 27). *Hasce quatuor (sic) aras, apud Achendavie effossas, Academiae Glasguensi donarunt honorabiles Canalis Navigabilis inter Fortham et Glottam procuratores Ann. Dom. MDCCLXXI* (University of Glasgow 1792, pl. xxi).

Condition: The altar is largely unworn. It is broken horizontally across the shaft, but repaired since discovery, with only slight damage evident and loss of adjacent lettering.

Description: Two of the horizontal mouldings round the capital, and one on the base, are decorated with cable-patterns round all four sides. The bolsters and the central projection terminate in front in simple roundels, and on the rear face in six-pointed rosettes. H: 0.75 m; W: 0.32; D: 0.225 m. Buff sandstone.

Inscription: *Dianae | Apollini | M(arcus) Cocce[i(us)] | Firmus | (centurio) leg(ionis) ĪI Āug(ustae).* 'To Diana (and) to Apollo, Marcus Cocceius Firmus, centurion of the Second Augustan Legion'.

Line 3: COCCE (Anderson, Gough, University of

Glasgow 1792, Collingwood & Wright); COCCEI (Hübner).

Letter heights: 1–5: 0.03 m.

Discussion: This altar, together with Nos 34–37, 59 and two iron mallets, was found in a deep pit, evidently just south of the fort defences, where they must have been deposited at the end of the fort's lifetime, or when judged no longer needed. Four of the altars (and presumably also the fifth, which is broken off before the name of the dedicator could be given) were erected by one man, M. Cocceius Firmus, a centurion of the Second Legion (above, p. 57). His family name Cocceius presumably derives from a grant of citizenship to an ancestor, in A.D. 96–98 when M. Cocceius Nerva was emperor. In a stimulating paper Professor Eric Birley (1936, 363-77) drew attention to a passage in the *Digest* (49.15.6), referring to a legal case in which a woman slave, condemned to labour in a saltworks, was captured by bandits from across the frontier, and eventually bought back by her original owner, a centurion named Cocceius Firmus, at a date between A.D. 160–180. Birley argued strongly for an identification of the two men, and for locating the episode in Britain, on and beyond the Antonine Wall. He also drew attention to a Cocceius Firmus, attested in A.D. 169 at Histria on the Black Sea (*AE* 1924, 143), suggesting that the centurion returned to his home there after service in Britain.

Birley also proposed that the plethora of deities venerated on the surviving altars, which we need not assume were the complete digest of Firmus' religious concerns, suggests prior service in the emperor's Horse Guards at Rome, the *Equites Singulares Augusti* (Birley 1936, 363; Birley 1989, 117f. with *ILS* 2213 cited as a similar case; cf. Speidel 1994a, 50, 140).

Dedications to Diana and Apollo jointly are common in Thrace (von Domaszewski 1895, 53; Birley 1986, 20), though surprisingly there is no parallel in Britain.[14]

CIL VII 1112; *ILS* 4831a; *RIB* 2174 *CSIR* 115

Bibliography: Anderson 1771, f. 45, ff. 50-1; Anderson 1773, f. 95; Gough 1775, 118–24 with fig.; Gough 1789, vol. 3, 358, pl. xxiii, no. 4; University of Glasgow 1792, pl. xxiv; Anderson 1793, 203–4, no. 4, pl. xxxviii; Anderson 1800, 6; Hodgson 1840, 266, no. cclxxiii; Stuart 1845, 323, pl. xi.2; Buchanan 1883a, 18; Macdonald 1895, 30, no. 3; Macdonald 1897, 58-9, no. 19, pl. viii.1; Macdonald 1911, 333–4, no. 34, pl. xliv.4; Macdonald 1934, 429, no. 46, pl. liv.3; Birley 1936, 363; Keppie & Arnold 1984, 43, no. 115, pl. 31.

[14]For a link to the worship of Jupiter Dolichenus, see Speidel 1978, 21f.

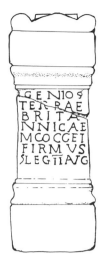

34 *Scale 1:12*

34. ALTAR TO THE SPIRIT OF THE LAND OF BRITAIN PL. XIII

AUCHENDAVY, Kirkintilloch, Dunbartonshire (East Dunbartonshire), May 1771. Inv. no. F.29.

Findspot: NS 678 748. In a pit south of Auchendavy fort, during building of the Forth & Clyde Canal, together with Nos 33, 35–37, 59 and two large iron mallets (now lost).

Donation: July 1771, by the Commissioners of the Forth & Clyde Canal, through the good offices of Sir Lawrence Dundas, 1771 (cf. above, No. 33).

Condition: Some damage has been sustained to the capital, at the bolsters and the central boss. The altar is broken horizontally half-way down the shaft, but is now repaired. Some lettering near the break is lost.

Description: The altar is plain except for plain mouldings between capital, shaft and base, round three sides. The back is plain. H: 0.76 m; W: 0.28 m; D: 0.205 m. Gritty buff sandstone.

Inscription: *Genio /terrae / Brita / nnicae / M(arcus) Coccei(us) / Firmus / (centurio) leg(ionis) II Aug(ustae).* 'To the presiding spirit of the land of Britain, Marcus Cocceius Firmus, centurion of the Second Augustan Legion'.

Line 6: FIRMYS (Anderson)

Letter heights: 1–7: 0.02 m. There is a leafstop at end of line 1, but no other interpuncts.

Discussion: This is one of a group of altars erected at Auchendavy by the centurion Marcus Cocceius Firmus (above, p. 57). Surprisingly perhaps, there is no parallel dedication known from Roman Britain (Birley 1986, 26; cf. Alcock 1986, 113).

CIL VII 1113; *ILS* 4831b; *RIB* 2175

Bibliography: Anderson 1771, f. 45, f. 50; Anderson 1773, f. 95; Gough 1775, 118–24, with

fig.; Gough 1789, vol. 3, 358, pl. xxiii, no. 3; University of Glasgow 1792, pl. xxiii; Anderson 1793, 203, no. 3, pl. xxxviii; Anderson 1800, 7 with fig.; Orelli 1828, no. 1686; Hodgson 1840, 266 no. cclxxiv; Stuart 1845, 325, pl. xi.1; Buchanan 1883a, 18; Macdonald 1895, 30, no. 5; Macdonald 1897, 60–1, no. 21, pl. viii.3; Macdonald 1911, 334f., no. 35, pl. xliv.5; Macdonald 1934, 429–30, no. 47, pl. liv.4.

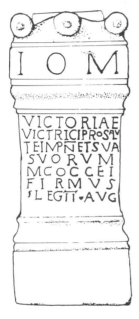

35 *Scale 1:12*

35. ALTAR TO JUPITER AND VICTORIOUS VICTORY PL. XIII

AUCHENDAVY, Kirkintilloch, Dunbartonshire (East Dunbartonshire), May 1771. Inv. no. F.26.

Findspot: NS 678 748. In a pit south of Auchendavy fort, during building of the Forth & Clyde Canal, together with Nos 33–34, 36–37, 59 and two large iron mallets (now lost).
Donation: July 1771, by Commissioners of the Forth & Clyde Canal, through the good offices of Sir Lawrence Dundas, 1771 (cf. above, No. 33).
Condition: Some slight damage has been sustained to the capital, in the vicinity of the bolsters, and to the left side of the shaft.
Description: The altar is plain except for mouldings between capital, shaft and base. The fronts and backs of the bolsters, and the central boss, terminate in plain roundels with a central boss. The bolsters are divided by a two-ribbed central strap. H: 0.92 m; W: 0.37 m; D: 0.32 m. Buff sandstone.
Inscription: *I(ovi) O(ptimo) M(aximo) / Victoriae / victrici pro salu/te imp(eratoris) n(ostri) et sua / suorum / M(arcus) Coccei(us) / Firmus / (centurio) leg(ionis) II Aug(ustae).* 'To Jupiter Best (and) Greatest (and) to Victorious Victory, for the

safekeeping of our emperor and that of his own family, Marcus Cocceius Firmus, centurion of the Second Augustan legion.'
Line 3: PR· (University of Glasgow 1792), PRO (Stuart, Hübner): SAV (University of Glasgow 1792), SALV (Hübner); line 4: IMP ANT (Stuart), IMP N (Anderson, Gough, University of Glasgow 1792, Hübner, etc.); line 5: SYORYM (Anderson).
Letter heights: 1: 0.07 m; 2: 0.035; 3–8: 0.03 m.
Discussion: This is one of a group of altars erected at Auchendavy by the centurion Marcus Cocceius Firmus (above, p. 57). The dedication here is to Jupiter and Victory, for the well-being of the emperor, here presumably Antoninus Pius (cf. *RIB* 1316 etc.); such dedications to the emperor are often found combined with a plea on behalf of the dedicator's own family (*RIB* 2124, of Antonine date; *RIB* 661, 926, 1030, 1589, 2045; Speidel 1994b, no. 215; 1994c).

CIL VII 1111; *ILS* 4831; *RIB* 2176
Bibliography: Anderson 1771, ff. 45-7; Anderson 1773, f. 95; Gough 1775, 118–20; Gough 1789, 358, pl. xxiii, no. 7; University of Glasgow 1792, pl. xxi; Anderson 1793, 202 no. 1, pl. xxxviii; Anderson 1800, 5 with fig.; Hodgson 1840, 266, no. cclxxii; Stuart 1845, 324, pl. xi.3; Stuart 1852, 330 fn. (b); Irving 1860, 13 with tab., fig. 3; Buchanan 1883a, 18; Macdonald 1895, 30, no. 2; Macdonald 1897, 61–2, no. 22, pl. viii.4; Macdonald 1911, 331-2, no. 32, pl. xliv.2; Macdonald 1934, 427–8, no. 44, pl. liv.1.

36. ALTAR TO MARS, MINERVA, THE GODDESSES OF THE PARADE-GROUND, HERCULES, EPONA, AND VICTORY PL. XIII

AUCHENDAVY, Kirkintilloch, Dunbartonshire (East Dunbartonshire), May 1771. Inv. no. F.27.

Findspot: NS 678 748. In a pit south of Auchendavy fort, during building of the Forth & Clyde Canal, together with Nos 33–35, 37, 59 and two large iron mallets (now lost).
Donation: July 1771, by the Commissioners of the Forth & Clyde Canal, through the good offices of Sir Lawrence Dundas, 1771 (cf. above, No. 33).
Condition: The mouldings on the capital are worn, especially on top. The altar is broken across the shaft, with the resulting loss of some letters near the break; but since repaired.
Description: The altar is quite plain. H: 0.845 m; W: 0.31 m; D: 0.2 m. Buff sandstone.
Inscription: *Marti / Minervae / Campestri / bus Herc<u>l(i) / Eponae / Victoriae / M(arcus) Coccei(us) / Firmus / (centurio) leg(ionis) II Aug(ustae).* 'To

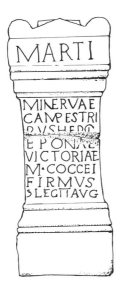

36 *Scale 1:12*

37 *Scale 1:12*

with fig.; Orelli 1828, no. 1355; Stuart 1845, 324, pl. xi.4; Hodgson 1840, 266; Buchanan 1883a, 18f.; Macdonald 1895, 30, no. 4; Macdonald 1897, 59–60, no. 20, pl. viii.2; Macdonald 1911, 332–3, no. 33, pl. xliv.3; Macdonald 1934, 428–9, no. 45, pl. liv.2.

Mars, Minerva, the Goddesses of the Parade-ground, Hercules, Epona, (and) Victory, Marcus Cocceius Firmus, centurion of the Second Augustan Legion'.
Line 4: HEROI (Anderson, Gough, University of Glasgow 1792), HERCL (Orelli, Hübner, Collingwood & Wright); line 5: EPONAE (University of Glasgow 1792); line 6: YICTORIAE (Anderson); line 8: FIRMYS (Anderson). No interpuncts are present except between M and COCCEI, line 7.
Letter heights: 1: 0.05 m; 2-8: 0.035 m; 9: 0.03 m.
Discussion: This is one of a group of altars erected at Auchendavy by the centurion Marcus Cocceius Firmus (above, p. 57). The wide-ranging dedication here combines gods of the classical pantheon (Mars, Minerva) with a demigod (Hercules), personifications (Victory and the Goddesses of the Parade-ground; cf. No. 41), and the native Celtic horse-goddess Epona, much favoured by cavalry (Magnen and Thévenot 1953; Linduff 1979, 823; Oaks 1986; Birley 1986, 46-7; Euskirchen 1993).[15]

CIL VII 1114; *ILS* 4831c; *RIB* 2177
Bibliography: Anderson 1771, f. 45, ff. 47–9; Anderson 1773, f. 95; Gough 1775, 118-24 with fig.; Gough 1789, vol. 3, 358, pl. xxiii, no. 2; University of Glasgow 1792, pl. xxii; Anderson 1793, 202–3, no. 2, pl. cclxiv; Anderson 1800, 6

37. ALTAR TO SILVANUS PL. XIII
AUCHENDAVY, Kirkintilloch, Dunbartonshire (East Dunbartonshire), May 1771. Inv. no. F.30.

Findspot: NS 678 748. In a pit south of Auchendavy fort, during building of the Forth & Clyde Canal, together with Nos 33–36, 59 and two large iron mallets (now lost).
Donation: (Assumed) 1771, by Commissioners of the Forth & Clyde Canal, through good offices of Sir Lawrence Dundas (cf. above, p. 27). *Effossum simul cum aris in tabulis antecedentibus et ab iisdem Academiae donatum* (University of Glasgow 1792, pl. xxv).
Condition: Only the capital and upper part of shaft survive. Damage has been sustained to the bolsters and mouldings between capital and shaft.
Description: The altar is quite plain. H: 0.275 m; W: 0.190 m; D: 0.16 m. Buff sandstone.
Inscription: *Silva/no/*[---]. 'To Silvanus . . .'
Discussion: The altar was dedicated to the Roman god of the woodland (recorded in Scotland also on No. 32, *RIB* 2124, 2187). There can be little doubt, from the findspot and the style of lettering, that the lower half of the shaft bore a dedication by the centurion M. Cocceius Firmus (see No. 33).

CIL VII 1115; *RIB* 2178
Bibliography: Anderson 1771, f. 45, f. 51; University of Glasgow 1792, pl. xxv; Anderson 1793, 204, no. 5, pl. xxxviii; Anderson 1800, 4, 8; Hodgson 1840, 266, no. cclxxvi; Stuart 1845, 325, pl. xi.7; Macdonald 1897, 62-4, no. 23, pl. xii.4; Macdonald 1911, 335, no. 36, pl. xlv.1; Macdonald 1934, 430, no. 48, pl. liv.5.

[15]Notice *RIB* 1777, Carvoran; for the *Campestres* see Frere 1967, 327 with map of distribution; Davies 1968; Birley 1976, 108–10; Barnard, 1985.

38 *Scale 1:12*

38. ALTAR TO JUNO REGINA (?)

PL. XIV

Probably CADDER, Lanarkshire (East Dunbartonshire), in or shortly before August 1773 (see above, p. 29). Inv. no. F.34.

Findspot: NS 616 725. 'In digging the Canal near the village of Cadder close upon the track of the Roman Wall, the workmen found the top of an altar together with an upper and the half of a nether quernstone' (Anderson 1773, f. 103).[16]

Donation: October 1773, by Commissioners of the Forth & Clyde Canal (Anderson 1773, f. 103; above, p. 29; cf. SRO, FCN 1/2, p. 344). Sir George Macdonald (1934, 298) identified the altar described above with the present stone. The quernstones (but not this altar) are illustrated in the 1792 edition of the *Monumenta* (University of Glasgow 1792, pl. xxvi), where they are said, incorrectly, to derive from Auchendavy.

Condition: 'The top of the Altar is greatly mutilated, and the inscription so much defaced that only some parts of a few letters are to be seen. It is impossible therefore to guess at the Deity to whom it was erected or by what person' (Anderson 1773, f. 105). The front face and corners of the capital and shaft are chipped and worn.

Description: The capital and a small part of the shaft survive. There has clearly been an inscription but its lettering is barely discernible. H: 0.46 m; W: 0.39 m; D: 0.27 m. Buff sandstone.

Inscription: *Iunoni R*[---]. 'To Juno R(egina?) . . .'

Letter heights: 1: 0.05 m.

Discussion: When published a few years ago the visible lettering prompted a dedication to Mercury, or less certainly to Neptune (Keppie 1983, 398, no. 1 with fig. 10, pl. 27B). However, fresh photography during preparation of this monograph suggested a dedication to Juno (cf. *RIB* 813, Maryport), perhaps to Juno Regina. The same lettering is faintly visible also on a photograph

taken in 1872 (above, p. 37; FIG. 17). Juno Regina was the consort of Jupiter Dolichenus, who became popular among soldiers of the Roman army from the second century onwards (Speidel 1978). The cult of Jupiter Dolichenus is attested several times at Corbridge on Hadrian's Wall (Harris & Harris 1965, 55–73; Birley 1978, 1517–19), and in Scotland is already documented at Croy Hill (*RIB* 2158) and Birrens (*RIB* 2099). At Croy Hill the fragmentary inscription is accompanied by relief sculpture showing both Jupiter Dolichenus and Juno Regina (Keppie & Arnold 1984, no. 88). Dedications to Juno Regina alone are uncommon (see *CIL* VI 365, 465*, XIII 11779; *AE* 1920, 60; 1939, 274).

Bibliography: Anderson 1773, ff. 103, 105, 107; Macdonald 1897, 78, no. 35, pl. xvi.4; Clarke 1933, 1; Macdonald 1934, 298–9; Keppie 1983, 398, no. 1, fig. 10, pl. 27b.

39 *Scale 1:12*

39. ALTAR TO FORTUNA

PL. XIV

BALMUILDY, Lanarkshire (City of Glasgow), 16 May 1913 (Postcard from S.N. Miller to Haverfield, now in Haverfield Archive, Ashmolean Museum, Oxford, bearing that date). Inv. no. F.1922.4.

Findspot: NS 582 717. During excavation, 'in the bath-house, inside the north-east rampart of the fort, lying face downwards over the foundation of the south wall' (Haverfield 1914, 27; cf. Miller 1922, 59–60).

Donation: 1922, by Gen. A.S. Stirling of Keir.

Condition: The capital is badly damaged with the loss of much of the bolsters and part of the focus; part of the base, at the back, is broken away.

Description: The altar is devoid of decoration, with capital, shaft and base separated by broad

[16]The likeliest findspot is west of the fort, where the Canal swings southwards just clear of the fort defences.

plain mouldings. H: 0.76 m; W: 0.34 m; D: 0.26 m. Buff sandstone.

Inscription: *Deae Fortunae / Caecilius Nepos / trib(unus)*. 'To the goddess Fortuna, Caecilius Nepos, tribune'.

Letter heights: 1: 0.045 m; 2–3: 0.05 m.

Discussion: The altar was dedicated by Caecilius Nepos, otherwise unknown (Devivjer 1976, 195 no. C17). While it is possible that he was the tribune in command of a thousand-strong cohort of auxiliary infantry in garrison at Balmuildy, on balance it is more likely that he was an officer in a legion, perhaps of the Second Legion which we know was engaged on building work at the fort (cf. Nos 22–23).

AE 1914, 290; *RIB* 2189
Bibliography: Haverfield 1913b, 290–1; Haverfield 1914, 27, no. 1; Miller 1922, 60, pl. xxvii.5; Macdonald 1934, 432f., no. 50, pl. lxxv.2.

40 *Scale 1:12*

40. ALTAR TO MARS PL. XIV

BALMUILDY, Lanarkshire (City of Glasgow), 1914. Inv. no. F.1922.5.

Findspot: NS 593 717. During excavation of the fort, 'in the annexe to the south east of the fort proper' (Haverfield 1915, 29); 'a little to the north of the Military Way about halfway across the annexe' (Miller 1922, 61), together with Nos 60–61.

Donation: 1922, by Gen. A.S. Stirling of Kier.

Condition: The surviving upper portion of the altar is worn and chipped, and when found was broken into five fragments, one of which does not survive. Further damage was accidentally incurred, 1976. PL. XIV shows the altar after recent conservation and repair. The base of an altar, found during the same excavation (Inv. no. F.1922.6), may well belong with this fragment.

Description: Between the bolster terminals on the front of the capital is a male bust, helmeted and bearded (so Miller 1922, 61, but the features are now very worn) within a semicircular ribbed archway, wearing a cloak over his left shoulder, leaving the right shoulder bare. There are faint guidelines above and below line 1 of the inscription. H: 0.43 m; W: 0.36 m; D: 0.21 m. Buff sandstone.

Inscription: *Dio / Mar(ti)[---]* 'To the god Mars . . .'

Line 1: DIIO for DEO (Collingwood & Wright), DIO (Miller, Macdonald, Keppie); DIO S[ANCTO] (Haverfield from photograph supplied by Miller); line 2: [MA]RTI (Haverfield, Keppie), [MA]RTI SAN[CTO] (Collingwood & Wright). No lettering is visible after [MA]RTI, only irregularities in the rough surface of the stone (Keppie).

Letter heights: 1–2: 0.035 m.

Discussion: The altar was dedicated to Mars (or to Mars combined with a local Celtic deity) by person or persons unknown. The bust is presumably the god who is shown here naked except for a cloak fastened at his left shoulder. Balmuildy also yielded a statue of Mars (below, No. 60). For the spelling DIO, see above, p. 60; Smith 1983, 901; *Britannia* 1973, 325, no. 3; DIE for DEAE, see *RIB* 1543, 1897.

RIB 2190 *CSIR* 130
Bibliography: Haverfield 1915, 29, no. 1; Miller 1922, 61, no. 9, pl. xxix.9; Macdonald 1934, 433, no. 51, pl. lvii.2; Keppie & Arnold 1984, 47-8, no. 130, pl. 33.

41. ALTAR TO GODDESSES OF THE PARADE-GROUND AND TO BRITANNIA PL. XIV

CASTLEHILL, Bearsden, Dunbartonshire (East Dunbartonshire), 1826. Inv. no. F.31.

Findspot: NS 527 727. Found 'by a ploughman Robert Watson, while ploughing a field a few hundred yards eastwards from the station, firmly fixed on its edge in the ground, a few feet below the surface, close to, and on the south or Roman side of, the Wall' (Stuart 1852, 308 fn. (b)).

Donation: 25 July 1827. 'The Principal laid a Letter before the Meeting from Dr. Will. Couper, Joint-Keeper of the Museum, intimating that, by order of James Glassford Esq of Dougalston, a Roman Altar in a state of high preservation, dug up in his Property of Castle Hill, which was a station in the line of the Roman Wall between the Forth and Clyde, had been transmitted to the Hunterian Museum'. The Principal was requested to write a letter of grateful thanks (GUL MR 48/1, f. 56).

Condition: The altar is chipped and worn at the edges, especially at the corners of the capital. There has been some flaking away of the upper layers of the sandstone surface.

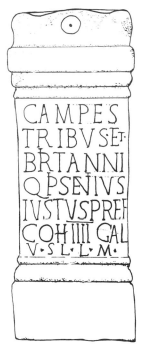

41 *Scale 1:12*

Description: The altar is devoid of decoration, except for a raised boss in the centre of the front face of the capital, and a plain circular moulding to represent a *focus*. H: 1.04 m; W: 0.4 m; D: 0.26 m. Buff sandstone.

Inscription: *Campes/tribus et | Britanni(ae) | Q(uintus) Pisentius | Iustus pr(a)ef(ectus) | coh(ortis) IIII Gal(lorum) | v(otum) s(olvit) l(aetus) l(ibens) m(erito).* 'To the goddesses of the parade-ground and to Britannia, Quintus Pisentius Justus, prefect of the Fourth Cohort of Gauls, willingly, gladly and deservedly fulfilled his vow'.

Line 4: Q P SENTIVS (Hodgson), Q PISENTIVS (Stuart, Hübner, J. Macdonald, G. Macdonald, Collingwood & Wright); line 6: CAE (Henzen). Hübner, who visited Glasgow in 1866, suggested that the lettering had been recently recut (1873, on *CIL* VII 1129), but there is nothing to support this view. On the spelling *prefectus* for *praefectus*, see above, p. 60.

Letter heights: 1–5: 0.05 m; 6: 0.05 m; 7: 0.035 m.

Discussion: The altar was dedicated to the goddesses of the Parade-ground, who were especially venerated by cavalry (Birley 1976; Barnard 1985; Birley 1986, 49ff.), and to Britannia, tutelary deity of the people of Roman Britain. The *cohors IV Gallorum* included a cavalry contingent; but the customary epithet *equitata* is omitted on this stone. Dedications to Britannia are surprisingly quite rare (*RIB* 643; Birley 1986, 66). The cohort was at Templeborough fort under the Flavians, and later (after its sojourn in Scotland) at Risingham on Dere Street (Stephens & Jarrett 1985, 77–80; Jarrett 1994, 60, no. 29). The prefect

Pisentius Justus is otherwise unattested (Devijver 1976, 643, no. P 36).

CIL VII 1129; *ILS* 4829; *RIB* 2195

Bibliography: Hodgson 1840, 271, no. ccxci; Smith 1841; Stuart 1845, 304–5, pl. ix.2; Stuart 1852, 308–10, fn.(b); Orelli 1856 (ed. Henzen), no. 5942; Bruce 1893, 47–8, pl. iii.2; von Domaszewski 1895, 50; Macdonald 1895, 30, no. 1; Macdonald 1897, 35–7, no. 11, pl. v.1; Macdonald 1911, 329–30, no. 30, pl. xliv.1; Macdonald 1934, 433–4, no. 52, pl. lxxv.4.

42 *Scale 1:12*

42. ALTAR TO JUPITER PL. XV

DUNTOCHER, Dunbartonshire (West Dunbartonshire), 1829. Inv. no. F.32.

Findspot: NS 492 729. 'Discovered by Archibald Bulloch, son of the old miller of Duntocher, in the spring of 1829, while cutting drains in a marshy portion of the farm of Easter Duntiglennan, about half-a-mile north from the line of the *Wall*, and in the vicinity of the *Fort*. It was lying flat in the earth about two feet below the surface. The finder removed it from its hiding-place, and put it up on the eaves of his father's antique cottage, where it was seen by the author in 1843. The cottage has since been demolished; but the Altar was rescued, and is now in the possession of Mr John Buchanan, Glasgow' (Stuart 1852, 300 fn.(a)).[17]

Donation: October 1871, by John Buchanan. 'It has been in my possession about twenty years' (GUL MR 50/49, no. 4).

Condition: The altar is extremely worn and chipped at the edges; the shaft is badly pockmarked. The lettering can be read only with the greatest difficulty (contrast the comments of

[17]The farmhouse of Easter Duntiglennan lies almost atop the Wall, in the village of Duntocher (see OS 1st edn *Dumbartonshire*, Sheet xxvi, surveyed 1861); the farm of Wester Duntiglennan lies about 800 m north of the Wall.

Macdonald 1897, 32 with those of Macdonald 1911, 328). But for citation by earlier authorities, the altar could easily be supposed as uninscribed.

Description: There are plain mouldings round three sides, separating the capital, shaft, and base; the rear face is plain. The bolster-cylinders are ornamented with straps. On the left side of the shaft is a jug and a knife, on the right a circular saucer. H: 0.635 m; W: 0.32 m; D: 0.39 m. Buff sandstone.

Inscription: *I(ovi) O(ptimo) [M(aximo)/---]* 'To Jupiter, Best (and) Greatest . . .'

'When first found, the letters IOM . . . were visible and recognised by the minister of a neighbouring parish, but they have been obliterated by twenty years' exposure to the weather' (Stuart 1852, 300 fn. (a)).

Letter heights: 1 (estimated): 0.045 m.

Discussion: The dedication is to Jupiter, king of the gods, also commemorated in Scotland on altars from Birrens (*RIB* 2097, 2098), Jedburgh (*RIB* 2117), Newstead (*RIB* 2123), Auchendavy (*RIB* 2176 = No. 35) and Old Kilpatrick (No. 43), and frequently elsewhere in the military zone in northern Britain.

CIL VII 1134; *RIB* 2201 *CSIR* 153

Bibliography: Stuart 1845, 296; Stuart 1852, 300 fn. (a); Irving 1860, 11; Bruce 1893, 44; Macdonald 1897, 32 no. 9; pl. xv.2; Macdonald 1911, 328–9, no. 29, pl. xv.2; Macdonald 1934, 434, no. 53; Keppie & Arnold 1984, 55–6, no. 153, pl. 38.

43. ALTAR TO JUPITER PL. XV

OLD KILPATRICK, Dunbartonshire (West Dunbartonshire), 3 December 1969. Inv. no. F.1969.23.

Findspot: NS 461 732. During digging of an inspection pit, within premises at Weir's Garage, Dumbarton Road, Old Kilpatrick. It lay in the fill of the outermost (fourth) defensive ditch of the fort, on the north-east side (Robertson 1970, 9; Barber 1971, 117).

Donation: December 1969, by Mr Weir, Weir's Garage, and Mr J. Boyle, Old Kilpatrick.

Condition: The front face of the altar is almost undamaged and the lettering pristine in its freshness. Red paint was observed in the letter-shapes when the altar was cleaned in 1976. Damage has been sustained to the right-hand side, where a bolster is broken away, at the right corner-angle of the shaft and to mouldings of the base, a segment of which is likewise broken away at the back.

Description: The altar is largely devoid of ornamentation. Base and capital are divided into two bands by horizontal lines incised round three sides, and by mouldings. The bolsters terminate at the front in plain roundels, between which is a triangular pediment. The *focus* sits within a squared-off plinth, with a slight internal depression and a central boss. The sides of the altar are plain; the back is not finished off. The lettering becomes more irregular from line 5 onwards, perhaps because the stonecutter became concerned about fitting all the prescribed text into the space available. H: 1.31 m; W: 0.48 m; D: 0.4 m. Pinkish sandstone.

Inscription: *I(ovi) O(ptimo) M(aximo) | coh(ors) I Bae/tasiorum | c(ivium) R(omanorum) cui pr | aeest Publicius | Maternus praef(ectus) | c(uram) a(gente) Iulio Can | dido (centurione) leg(ionis) I̅ Italicae | v(otum) s(olvit) l(aeta) l(ibens) m(erito).* 'For Jupiter Best (and) Greatest, the First Cohort of Baetasii, Roman citizens, which the prefect Publicius Maternus commands, under the interim control of Julius Candidus, centurion of the First Legion Italica, gladly, willingly and deservedly fulfils its vow.'

Letter heights: 1: 0.06 m; 2–4: 0.07 m; 5: 0.025–0.06 m; 6: 0.055 m; 7–8: 0.05 m; 9: 0.03 m.

Discussion: The altar is dedicated to Jupiter by the *cohors I Baetasiorum*, known to have been in garrison at Bar Hill during the Antonine period (above, Nos 20, 31), but not otherwise attested at Old Kilpatrick. It was perhaps one of those

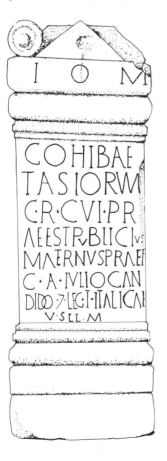

43 *Scale 1:12*

dedications made annually by regiments of the Roman army, renewing their loyalty to the gods and the emperor (above, p. 57). However, from its findspot in the outermost of four ditches, it must have been tipped in from an annexe, or a civil settlement; at the time of disposal it did not stand within the fort. The prefect Publicius Maternus is not otherwise known (Devijver 1976, 682, no. P110). The name Julius Candidus is fairly common in Britain and elsewhere: a centurion with the names Julius Candidus was in charge, at a date unknown, of a work-party on Hadrian's Wall (*RIB* 1674, 1632, 1646 near Housesteads; *RIB* 1173 tomb- stone, Corbridge; *RIB* 2427.13 silvered disc at Chester). Notice also *CIL* XIII 267 (chief centurion of *leg. XIII Gemina*); *ILS* 2326 (centurion of *leg. III Augusta*).

The centurion at Old Kilpatrick identifies himself as serving in a legion which lay during the Antonine period at Novae (now Svishtov in Bulgaria), on the southern bank of the River Danube, in the province of Lower Moesia. The legion is not known to have served in Britain, or ever to have sent detachments there.[18]

Professor Eric Birley suggested that Candidus came to Britain among reinforcements brought from the Danube provinces by the emperor Septimius Severus who campaigned in Scotland in A.D. 208–210 (Birley 1983, 73) and reinstated a number of previously abandoned garrison posts; but we have no evidence that Old Kilpatrick was among them. The carving of the first line of the inscription on the front of the capital is a feature more commonly found in the third century than during the second (Kewley 1973, 129ff.; Birley 1983). However, small finds, including coins, from excavations at Old Kilpatrick (Miller 1928, 51–9) indicate that the site was occupied only in the Antonine period. A different context for this dedication, early in the reign of Marcus Aurelius, is allowed for by Davies (1981, 197 n. 67). Breeze and Dobson have suggested that Candidus was in fact centurion in a legion of the British garrison, here recording a recently announced posting to Moesia, which he had not yet taken up (1970, 120, n. 48). It may have been the volume of information to be imparted which encouraged the stonemason to begin the inscription on the

capital; notice also Nos 35–36 (from Auchendavy) where the inscriptions also start on the front of the capital.

The circumstances which led to the presence of a centurion commanding auxiliaries at Old Kilpatrick remain unknown. It could be argued that the cohort was temporarily split between two sites, the larger part with the prefect at Bar Hill, and the smaller portion under a temporary commander, Julius Candidus, at Old Kilpatrick, an arrangement which testifies to a manpower shortage in Britain as the army struggled to maintain its garrisons in the North (Davies 1981). The situation is paralleled at Rough Castle (*RIB* 2144; cf. also *RIB* 814, 1299, 1880, *AE* 1908, 46).

AE 1971, 226
Bibliography: *Glasgow Herald*, 4 Dec. 1969; *Glasgow Herald*, 27 Jan. 1970, 21 with photo; Robertson 1970, 9 with pl.; Selkirk 1970, 196–7 with pl.; Wright & Hassall 1970, 310–11, no. 20, pl. xxxvi.B; Barber 1971, 117–19, with pl. i; Keppie 1983, 401–2, no. 14; Birley 1983, 76–83

44 *Scale 1:12*

= Birley 1988, 221–31; Keppie, Bailey *et al.* 1995, 658–9.

44. ALTAR PL. XV

Unknown provenance, probably after 1792 but before 1844 (Stuart 1845, pl. xv.2 but not in text). Inv. no. F.33.

Findspot: The findspot is unknown, but see above, p. 69, where the possibility of a link with Cramond is explored.
Donation: ?1814 (see above, p. 69). It was part of the Hunterian collection by 1897 (Macdonald 1897, 77).
Condition: Badly chipped and pitted; the front of the shaft has partly flaked away.
Description: The capital and upper part of the shaft are preserved. A *focus* survives between two bolsters. H: 0.38 m; W: 0.265 m; D: 0.235 m. Buff sandstone.
Inscription: *[..]peri ve[x(illatio)]* | *[leg(ionis) I]I Au[g(ustae)]* | *[---]V[---]*. 'To . . . a detachment of the Second Augustan Legion . . . [fulfilled its] vow'.
Line 1: TRI V Γ (Haverfield), [DEO·VIT]ERI

[18]L. Maximius Gaetulicus, a centurion of the Twentieth Legion attested in Scotland at Newstead (*RIB* 2120) and at Greatchesters on Hadrian's Wall (*RIB* 1725), later appears as chief centurion (*primus pilus*) of Legion I Italica at Novae on the Lower Danube, where he recorded his promotion to this pinnacle after fifty-seven years of army service, in A.D. 184 (Mrozewicz 1984, 181–4; 1986, 304–8); whether he was transferred there directly from Britain, or saw service elsewhere in the Empire in the intervening years, remains as yet unknown.

(Haverfield, J. Macdonald), [D]IB(VS)· [T]RIVI[IS] (Hübner), VE[X] (Keppie); line 2: [LEG·I]I·AV[G] (Haverfield, Keppie); line 3: V (Haverfield).

Letter heights: 1: 0.04 m; 2: 0.025 m.

Discussion: Various suggestions have been made regarding the name of the deity being venerated. It could be possible to think here of the *Di Vitires* or *Veteres*, frequently attested on altars from northern England (Haverfield 1918, 22; Ross 1967, 371–5; Birley 1986, 62ff.); but dedications to them are generally on small and roughly finished stones. Other restorations, e.g. to Ceres, could be worth considering (so Keppie 1983, 397; cf. Phillips 1977, no. 3). It is suggested here that the dedication was by a detachment of the Second Legion.

CIL VII 1145; *RIB* 2214

Bibliography: Stuart 1845, pl. xv. 2 (not in text); Macdonald 1897, 77–8, no. 34, pl. xii.5; Haverfield 1913b, 630; Keppie 1983, 397, no. 9, fig. 9, pl. 27a; Tomlin 1995, 798.

Donation: October 1871, by John Buchanan (GUL MR 50/49, no. 5).

Condition: The altar is rather worn, with mouldings broken away, especially on the base. There is a diagonal crack through the capital and front of the shaft which is badly pockmarked.

Description: The altar is completely plain, except that the *focus* is shaped to represent a handled metal vessel. Each bolster is divided in two by a single incised line. The capital is noticeably larger than the base. The sides are plain. H: 0.57 m; W: 0.275 m; D: 0.22 m. Buff sandstone.

Discussion: The altar is uninscribed. A fragment of a commemorative tablet (No. 17) derives from the same general area.

Bibliography: Stuart 1852, 351–2, fn. (c); Macdonald 1897, 77, no. 33, pl. xv.1.

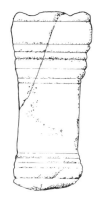

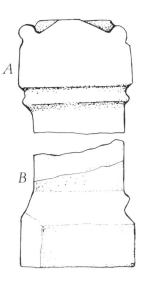

A

B

45 *Scale 1:12* 46 *Scale 1:12*

45. UNINSCRIBED ALTAR

ARNIEBOG, Cumbernauld, Dunbartonshire (North Lanarkshire), 1842. Inv. no. F.23.

Findspot: NS 768 772. 'In 1842 a small altar, without any inscription, was found on the farm of Arnibog, about 400 yards south from the Roman vallum, during the formation of a drain through a piece of marshy land. Till within a few years prior to this discovery, the spot was covered by a sheet of water called *Loch-Barr*, but is now drained' (Stuart 1852, 351–52 fn. (c)).[19] The altar was acquired almost immediately by John Buchanan.

[19]The first edition OS map of *Dumbartonshire*, Sheet xx, surveyed 1853, shows 'Loch Bar' 500 m south-east of Arniebog farmhouse. Roy 1793, pl. xxxv (surveyed 1755) shows a farmstead named Loch Bar 300 m SE of Westerwood fort. For a recent small-scale excavation hereabouts, in advance of development, see *Discovery & Excavation in Scotland 1990, 79*.

46. UNINSCRIBED ALTAR

BEARSDEN, Dunbartonshire (East Dunbartonshire), 1973.

Findspot: NS 546 721. In rubble and burning overlying the floor of the Cold Room (*Frigidarium*) during excavation of the annexe bath-house.

Donation: 17 February 1978, by the Scottish Development Department, Ancient Monuments (now Historic Scotland).

Condition: About three-quarters of the altar are preserved in two non-joining fragments, which are worn and chipped.

Description: The first fragment preserves the capital and upper portion of the shaft, and the second the base and a small portion of the shaft. Capital, shaft and base are separated by plain mouldings. The capital is ornamented by plain bolsters divided by an incised line half way along their length. Between them is a high-sided *focus*

with central plain boss. Fragment (a): H: 0.35 m; W: 0.36 m; D: 0.23 m; fragment (b): H: 0.38 m; W: 0.3 m; D: 0.3 m. Buff sandstone. When complete the altar may have measured *c.* 0.8 m high.[20]

Discussion: There is no evidence that the altar was ever inscribed. The findspot suggests that it stood in the bath-house.

Bibliography: Keppie, in Breeze forthcoming 1.

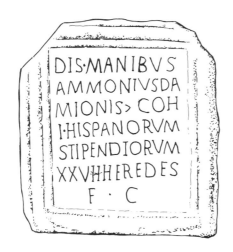

47 *Scale 1:12*

3. GRAVESTONES

47. GRAVESTONE OF AMMONIUS
PL. XVI

ARDOCH, Perthshire (Perth & Kinross), before 1672. Inv. no. F.52.

Findspot: NN 839 099. 'Ther was found a Stone ther upon which uas cut an inscription to show that a captain of the Spanish Legion died ther. If yow please I shall coppie it for yow. It is rudly cut', James Lord Drummond to Mr Patrick Drummond, 15 January 1672 (HMC 1885, 130f., reproduced in Christison 1898, 401). 'The inscription we have given the figure of, was taken up out of the Praetorium of the Praetentura; below which are Caves, out of which some pieces of a shield were taken up' (Sibbald 1695, 1097). 'I am informed that in the middle of this Camp there is a large hole, which leads down to a subterranean passage, and my Lord Perth, the Chancellor, is said to have procured a pardon to some capital

criminal, upon condition that he would go down and make search after what might be found in this cavern. He was let down into it by ropes, and the first time brought up a stone with a Roman inscription, which I am told is now to be seen in the garden wall at Drummond Castle', Rev. Thomas, relating a visit to Ardoch by Lord Oxford's party, 1725 (HMC 1901, 114- 15). The findspot was presumably the walled enclosure, a mediaeval graveyard, which can still be made out in the centre of the fort. 'This Stone is the same of which a figure is engraved in Mr John Adair's Mapp of Straithern [1685] and was gifted by Sir Henry Stirling of Airdoch to the Grandfather {of} the Ancestor of the Honourable person who now sent it to be preserved in the University' (GUA 26648, p. 32, dated 1738); '. . . which is yet kept at the Castle of *Drummond*, and may be seen there whereon is engraven the Inscription following . . . Mr *Adair* in his map of *Strathern* hath printed this Inscription with some small difference, whee rhe (sic) hath also a draught of the *Roman* Camp beforementioned' (Dalrymple 1695, 136 with fig.); *Lapis inscriptus est ex ipso praetorio castri Romani erutus qui in arce Drumondiae asservatur* (Sibbald 1706, 25); 'At Drummond Castel I found an inscription which copy from the original I send you and is the only one I have', Alexander Gordon, to Sir John Clerk, 8 November 1723 (SRO GD/18 5023/3/2); at Drummond Castle, 1749 (Clerk 1892, 219, 258, in error).

Donation: 19 January 1738. 'Robert Simson acquainted the Faculty that the Hon. Mr Drummond at Drummond Castle had as a token of his regard to the University, sent from his Seat at Castle Drummond an Old Roman Stone with an inscription upon it found several years ago in the Praetorium of the Roman Camp at Airdoch, and which hitherto was preserved in the Arch of the wall in his Garden' (GUA 26648, p. 32; above, p. 38). *Inventus fuit lapis hic in castris Romanis prope villam de Airdoch et pontem de Kneach; Dom. Stirling de Airdoch eum donavit Comiti de Perth cuius nepos eundem dono dedit Academiae Glasguensi Anno Dom. MDCCXLIV. atque unicus est lapis inscriptionem habens Romanam inventus ad septentrionem fluminis Forthae* (University of Glasgow 1768, pl. xv). This unusually lengthy Latin caption was presumably taken from an accompanying label.

Condition: The slab is much worn and chipped, with parts of the outer moulding broken away, especially at the top left and top right corners.

Description: The inscribed panel is contained within a triple plain moulding. H: 0.7 m; W: 0.67 m; W: 0.12 m. Whitish-grey sandstone.

Inscription: *Dis Manibus | Ammonius Da | mionis (centurio) coh(ortis) | I Hispanorum | stipendiorum |*

[20]A plinth, 0.62 by 0.41 by 0.11 m thick with plain mouldings round three sides, was found in 1973 in the fill of the Cold Bath at Bearsden. It could have supported this altar, but the style of the chiselling precludes it being the work of the same craftsman.

XXVII heredes / f(aciundum) c(uraverunt). 'To the spirits of the departed Ammonius, son of Damio, centurion of the First Cohort of Spaniards, of 27 years service. His heirs had this erected'.
Lines 1-7: DIS MANIBUS/ ANTONIUS / DAIMONIUS/ COHORTIS I. / LEGIONIS / XVII. HISPANORUM / HEREDES / F.C (Dalrymple); line 2: AMONIVS (Sibbald), AMMONIVS (Gordon, Horsley, etc.)
Letter heights: 1–7: 0.04–0.05 m.

Discussion: This tombstone of a centurion in the *cohors I Hispanorum* was presumably part of a larger monument in a cemetery outside one of the fort gates; it is likely to have reached its recorded findspot in more modern times (Christison 1898, 402; Ross 1898). Scholarly opinion has divined the presence of two cohorts with this name and title in Britain, of which one was at Maryport, Cumbria, under Hadrian (Davies 1977b, 7–16; Jarrett 1994, 56–8).

The writing out in full of the formula *Dis Manibus* has long been held as indicative of a first-century date for this stone, so that the presence of the cohort at Ardoch, presumably as its garrison, can be adjudged as falling within the Flavian period *c.* A.D. 80–90. There are no other diagnostic features, except that the centurion lacks names indicative of Latin or Roman citizenship, whose use had become universal by the mid-second century. The name Ammonius (and that of his father Damio) could suggest an Oriental or North African origin for the centurion (A.R. Birley 1988, 93, n. 185), and might open up the possibility that the cohort itself had seen service in the East before transfer to Britain in the Flavian period (Jarrett 1994, 46ff.). Ammonius' length of service, above the twenty-five-year norm for ordinary rankers, is explained by promotion to the centurionate; centurions could serve for very long periods.[21]

CIL VII 1146; *RIB* 2213
Bibliography: Dalrymple 1695, 136 with fig.; Sibbald 1695, 1097, with fig. at 1101; Sibbald 1706, 25; Sibbald 1707, 18, 37, 49 with fig.; Gibson 1722, 1239, with fig.; Gordon 1726, pl. xv.1 (not in text); Horsley 1732, 205, no. xxxi, pl. (Scotland) xxxi; Maffei 1749, 447, no. 1; Maitland 1757, 195; University of Glasgow 1768, pl. xv; Anderson 1771, f. 40; Gough 1789, vol. 3, 381, pl. xxv.8; Laskey 1813, 77, no. 15; Orelli 1826, no. 3387; Hodgson 1840, 257, 269, no. cclxxxix;

[21]The centurion Ammonius is now the subject of an historical novel with the title: *Vie et mort d'Ammonius, centurion romain: voyages dans l'Empire romain au Ier siècle de notre ère* (Paris/Montreal, 1997), from the pen of Claude Dumas, a retired Professor of Spanish at the University of Toulouse.

Stuart 1845, 192, pl. v.5; HMC 1885, 130–1; Macdonald 1895, 31–2, no. 4; Macdonald 1897, 80–5, no. 36, pl. vi.2; Christison *et al.* 1898, 464–5, fig. 16; Vasey 1993, 65–72.

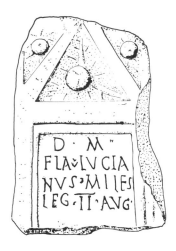

48 *Scale 1:12*

48. GRAVESTONE OF FLAVIUS LUCIANUS PL. XVII

SHIRVA, Kirkintilloch, Dunbartonshire (East Dunbartonshire), shortly before 25 June 1731 (above, p. 16). Inv. no. F.36.

Findspot: NS 692 755. During investigation of a stone-built 'tumulus', east of Shirva House, at the same time as Nos 52–53.
Donation: Shortly before 26 July 1731 (above, p. 18), by Thomas Calder of Shirva (who had earlier presented Nos 21, 49–51). *Ex dono Thomae Calder de Shirva, mercatoris Glasguensis* (University of Glasgow 1768, pl. xviii).
Condition: The upper part of the gravestone is preserved. It is chipped and worn, with damage sustained at the right-hand side.
Description: The slab is sculpted to show an inscribed panel within a plain moulding topped by a triangular pediment with a centrally-placed rosette; there are other rosettes in the top left and top right corners. H: 0.69 m; W: 0.48 m; D: 0.215 m. Buff sandstone.
Inscription: *D(is) M(anibus) / Flav(ius) Lucia / nus miles / leg(ionis) II Aug(ustae).* 'To the spirits of the departed, Flavius Lucianus, soldier of the Second Augustan Legion'.
Line 2: FLAV (University of Glasgow 1768, Stuart, Keppie), FLA (Hübner, J. Macdonald, G. Macdonald, Collingwood & Wright). A small V-shaped indentation is present, with a further angled line separately incised above it. It is not a leafstop (as *RIB*); perhaps this was intended as a small letter V, with an interpunct above. Line 5: P[---] (Hübner), *vacat* (Collingwood & Wright,

Keppie). The letter seen by Hübner in line 5 is in fact a vertical scrape, not as deep as letters in earlier lines.

Letter heights: 1–4: 0.04 m.

Discussion: This is the gravestone of a soldier named Flavius Lucianus who served in the Second Legion. The inscription is brief, lacking any details about the man's military service or age at death. A building-record by the Second Legion (No. 21) was among the inscribed stones recovered at Shirva.

CIL VII 1118; *RIB* 2181 *CSIR* 108

Bibliography: Gordon 1732, *Additions*, 7, pl. lxvi.6; Horsley 1732, 339, no. xxxiii, pl. (Scotland) xxxiii; University of Glasgow 1768, pl. xviii; Anderson 1771, ff. 41–2; Gough 1789, 360, pl. xxv.3; Hodgson 1840, 265, no. cclxvii; Stuart 1845, 328, pl. xii.6; Macdonald 1895, 31 no. 3; Macdonald 1897, 65–6, no. 25, pl. xiv.3; Macdonald 1911, 350, no. 47, pl. xlvii.1; Macdonald 1934, 437, no. 57, pl. lxxvi.1; Keppie & Arnold 1984, 40, no. 108, pl. 29.

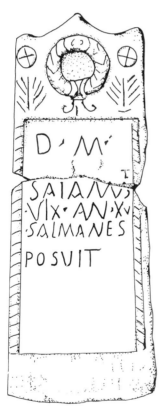

49 *Scale 1:12*

49. GRAVESTONE OF SALAMANES
PL. XVII

SHIRVA, Kirkintilloch, Dunbartonshire (East Dunbartonshire), August 1726. Inv. F.37.

Findspot: NS 692 755. During investigation of a stone-built 'tumulus', east of Shirva House (see also Nos 21, 50–51). 'This monument is also in two pieces, which were lying separate one from the other' (Horsley 1732, 199, no. xiii).

Donation: Shortly before 5 March 1728, by Thomas Calder of Shirva, together with Nos 20, 50–51 (GUA 26635, p. 31). *ex dono Thomae Calder de Shirva, mercatoris Glasguensis* (University of Glasgow 1768, pl.xii).

Condition: Chipped and worn. There is a horizontal break across the inscribed panel.

Description: The inscribed panel is contained within a plain narrow border, adapted as rope patterns to right and left. The pediment above, with slight acroterial projections at top left and top right, is decorated with a centrally-placed laurel wreath with dependant fillets, flanked by simple palm fronds and rosettes above. H: 1.215 m; W: 0.49 m; D: 0.11 m. Gritty buff sandstone.

Inscription: *D(is) M(anibus)* / *Salaman"e"s* / *vix(it)* *an(nis) XV* / *Salamanes* / *posuit.* 'To the spirits of the departed. Salamanes lived 15 years. Salamanes put (this) up'.

Line 2: SΛLMΛN (Gordon), SΛLMΛN̂ (Horsley, Stuart), SΛIMANE̱ (University of Glasgow 1768), SΛLMANE̱ (Hübner), SALMAN̂E̱ (Collingwood & Wright), SΛIΛMΛN̂E̱ (Keppie); line 4: SΛIMANES (University of Glasgow 1768), SΛLMΛNES (Horsley), SΛLMΛNES (Hübner, Collingwood & Wright).

Letter heights: 1–2: 0.055 m; 3: 0.05 m; 4–5: 0.045 m.

Discussion: This is clearly a tombstone, bearing the name of the deceased, a boy who died aged fifteen, and that of the person responsible for the erection of the stone. Both names have been read consistently by previous commentators as Salmanes, but, on the basis of line 2, if indeed the same name is intended in both lines 2 and 4, then Salamanes seems preferable. In line 2 *Salamans* has been corrected in antiquity to *Salamanes*. The relationship, though unspecified, is presumably father and son. The name itself is clearly Semitic.[22] No military rank is indicated, so that Salamanes père was a civilian, perhaps even, as has been suggested, a trader. He appears not to have been a Roman citizen.

CIL VII 1119; *RIB* 2182 *CSIR* 109

Bibliography: Gordon 1732, *Additions*, 6, pl. lxvi.2; Horsley 1732, 199 no. xiii, pl. (Scotland), xiii; University of Glasgow 1768, pl. xii; Anderson

[22]On the name Salmanes, see Collingwood & Wright 1965 on *RIB* 2182; A.R. Birley 1988, 128. Wright's notes, on *RIB* 2182, may in any case indicate that Salamanes is the more common form of the name. Mócsy 1983, 250 lists only this example from the north-western Roman provinces.

1771, ff. 37–8; Gough 1789, vol. 3, 359, no. 10, pl. xxiv; Hodgson 1840, 266, no. cclxxi; Stuart 1845, 328, pl. xii.8; Macdonald 1895, 30–1, no. 1; Macdonald 1897, 66–7, no. 26, pl. xv.3; Macdonald 1911, 350–1, no. 48, pl. xlvii.2; Macdonald 1934, 438–9, no. 59, pl. lxxvi.2; Keppie & Arnold 1984, 40–1, no. 109, pl. 30.

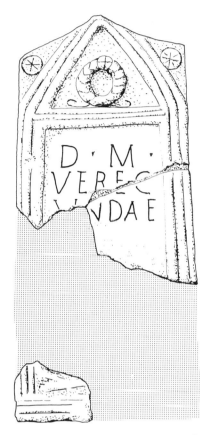

50 *Scale 1:12*

50. GRAVESTONE OF VERECUNDA
PL. XVII

SHIRVA, Kirkintilloch, Dunbartonshire (East Dunbartonshire), August 1726. Inv. no. F.38.

Findspot: NS 692 755. Of the two adjoining fragments, the upper was found in 1726, during investigation of a stone-built 'tumulus', east of Shirva House (see also Nos 21, 49, 51); the lower (not reported by Gordon or Horsley) was presumably found at a rather later date. They are first noted together in University of Glasgow 1768, pl. xiii.

Donation: By Thomas Calder of Shirva, 1729 or later. 'All these stones [i.e. Nos 21, 49–51], except N.XIV [this stone] are now removed to the university of *Glasgow*' (Horsley 1732, 198). 'It still remains at Skirvay' (Horsley 1732, 199). *ex dono Thomae Calder de Shirva, mercatoris Glasguensis* (University of Glasgow 1768, pl. xiii).

Condition: The two adjoining fragments are worn and chipped. There is a third small fragment, perhaps from the lower border, which has traditionally been catalogued with this stone in the museum ledgers (Keppie and Arnold 1984, no. 110; above, p. 69).

Description: The inscribed panel is enclosed within a triple plain moulding, which extends to form a pediment above. Within the latter is a laurel wreath. Above, to left and right, are rosettes. On the small fragment a sculptured figure can be discerned, but it defies identification. Here it is shown as preserving the lower left-hand corner of the tombstone. Two adjoining fragments: H: 0.915 m; W: 0.54 m; D: 0.14 m. Third (small) fragment: H: 0.19 m; W: 0.23 m; D: 0.13 m. Gritty buff sandstone.

Inscription: *D(is) M(anibus) | Verec | undae.* 'To the departed spirits of Verecunda'.

Line 1: VEREO (Gordon, Stuart), VEREC (Hübner, J. Macdonald, G. Macdonald, Collingwood & Wright); line 3 VSNDAE (University of Glasgow 1768), VNDAE (Stuart, Hübner, J. Macdonald, G. Macdonald, Collingwood & Wright).

Letter heights: 1–3: 0.07 m.

Discussion: The gravestone was erected to a female, Verecunda, whose identity and status remain uncertain. Verecunda has been seen as the wife of the commanding-officer at a nearby fort (Robertson 1960, 38), but the use of a *cognomen* alone, without a *nomen*, could suggest a slave or local girl given a Roman name.

CIL VII 1120; *RIB* 2183 *CSIR* 110

Bibliography: Gordon 1732, *Additions*, 6, pl. lxvi.3; Horsley 1732, 199–200, no. xiv, pl. (Scotland) xiv; University of Glasgow 1768, pl. xiii; Anderson 1771, f. 39; Gough 1789, vol. 3, 359–60, pl. xxv; Hodgson 1840, 266, no. cclxxi; Stuart 1845, 328, pl. xii.7; Macdonald 1895, 31, no. 2; Macdonald 1897, 67–8 no. 27, pl. xv.4; Macdonald 1911, 351, no. 49, pl. xlvii.3; Macdonald 1934, 439, no. 60, pl. lxxvi.3; Keppie & Arnold 1984, 41, no. 110, pl. 30.

4. FUNERARY RELIEF SCULPTURE

51. GRAVESLAB OF A SOLDIER PL. XVI

SHIRVA, Dunbartonshire (East Dunbartonshire), August 1726. Inv. no. F.41.

Findspot: NS 692 755. During investigation of a

51 *Scale 1:12*

stone-built 'tumulus', east of Shirva House (see also Nos 21, 49–50; above, p. 15).

Donation: Shortly before 5 March 1728, by Thomas Calder of Shirva (together with Nos 21, 49–50). *ex dono Thomae Calder de Shirva, mercatoris Glasguensis* (University of Glasgow 1768, pl. x).

Condition: The slab is worn and chipped. The right-hand border is broken away. Some damage to the box held in the soldier's left hand has been infilled (1998).

Description: The slab depicts, within a broad plain border, the standing figure of a soldier. He seems to be bearded. He wears a tunic and over it a soldier's cloak *(paenula)*, with perhaps a neckerchief, knotted at the neck. He holds at shoulder height a spear in his right hand and has a handled box in his left. H: 0.69 m; W: 0.55 m; D: 0.18 m. Gritty buff sandstone.

Discussion: This is presumably the upper half of a tombstone. The handled box is of a type often shown held by standard-bearers or clerks at unit headquarters; it probably held documents relating to the man's post (cf. above, No. 23). An inscription below presumably recorded his name and service. This is a rather roughly finished example of the familiar *stehende Soldaten* group, popular in military contexts on the Roman frontiers in the first and second centuries A.D. (Rinaldi Tufi 1984; 1988). Though Gordon (1732, pl. lxix.1) and Horsley (1732, 339f., pl. xxxiii) show a second almost identical stone from Shirva, evidently communicated to them by Robe (above, p. 16), there can be no doubt that there was but a single such slab found.

CSIR 111

Bibliography: Gordon 1732, *Additions*, 6, pl. lxvi.iv, lxix.1; Horsley 1732, 198–9, no. xi, pl. (Scotland), xi, 339f., pl. xxxiii; University of

Glasgow 1768, pl. x; Anderson 1771, f. 38; Gough 1789, vol. 3, 359, pl. xxiv.9; Laskey 1813, 77, no. 10; Hodgson 1840, 265; Stuart 1845, 328, pl. xii.5; Macdonald 1895, 33, no. 3; Macdonald 1897, 89–90, no. 39, pl. xiv.2; Macdonald 1911, 362–3, pl. xlvii.4; Macdonald 1934, 448, pl. lxxvi.4; Toynbee 1964, 187 n. 3; Keppie & Arnold 1984, 41, no. 111, pl. 30.

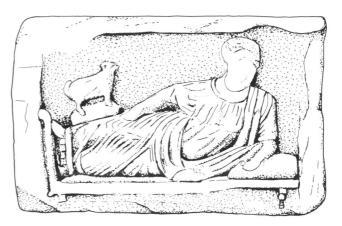

52 *Scale 1:12*

52. FUNERARY MONUMENT PL. XVIII

SHIRVA, Dunbartonshire (East Dunbartonshire), shortly before 25 June 1731. Inv. no. F.29.

Findspot: NS 692 755. During investigation of a stone-built 'tumulus', east of Shirva House, together with Nos 48, 53. (See also Nos 21, 49–51 found earlier at the same site.) 'Upon the Wall on the South-side near the Bottom' (Gordon 1732, *Additions*, 7), with the sculptured face towards the north, i.e. towards the interior of the 'tumulus'.[23]

Donation: Shortly before 26 July 1731 (above, p. 18), by Thomas Calder of Shirva (together with Nos 48, 53). *ex dono Thomae Calder de Shrirva, Mercatoris Glasguensis* (University of Glasgow 1768, pl. xvii).

Condition: The slab is chipped and worn, with the outer moulding broken away at the top left. The face of the deceased and the animal's body are defaced, perhaps in ancient times.

Description: This substantial block is carved to show a figure, here identified as female (see above, p. 67), reclining on a plain four-legged couch with curving end-board at the left; her left elbow rests on a pillow and her right arm on her upper leg. The figure is clad in a tunic, over which is a formal toga-type garment which extends to the ankles, and covers the upper arms; she rests both feet, which

[23]Gordon's drawing (1732, pl. lxvi; here FIG. 8) could be throught to show it set into the north wall of the 'tumulus'; but more probably he is (correctly) depicting No. 53.

are seen as though from above, against the vertical end-board of the couch. Above her right leg is a four-legged animal, with curled tail, perhaps intended as a dog, perched on a base. This and the following slab (No. 53) are distinguished more by their size than any skill shown by the stonemason (cf. above, p. 65). H: 0.68 m; W: 0.98 m; D: 0.29 m. Buff sandstone.

Discussion: The scene is of the familiar sepulchral banquet type (Haverfield 1899b, 320; above p. 66). Often the figure is shown with a three-legged table in front, piled with foodstuffs. There would normally be an inscription below; here it must be presumed to have occupied a separate slab. A monument from Cologne provides a partial parallel (*CIL* XIII 8312; Keppie 1991, 83, fig. 47). It could be therefore that this slab and its partner represent the same person, perhaps the wife of a commanding-officer (for a fuller discussion, see above, p. 67).

CIL VII, p. 199 *CSIR* 112

Bibliography: Gordon 1732, *Additions*, 7, pl. lxix.2; Horsley 1732, 339, no. xxxiii, pl. (Scotland) xxxiii; University of Glasgow 1768, pl. xvii; Anderson 1771, f. 41; Gough 1789, vol. 3, 360, pl. xxv.5; Laskey 1813, 77, no. 17; Hodgson 1840, 265; Stuart 1845, 327, pl. xii. 2; Macdonald 1895, 32–3; Macdonald 1897, 86–90, no. 38, pl. ix.2; Haverfield 1899b, 328; Macdonald 1911, 362, pl. l.2; Macdonald 1934, 435, 447, pl. 55.2; Toynbee 1964, 195; Keppie & Arnold 1984, 41–2, no. 112, pl. 30; Mattern 1989, 788–9.

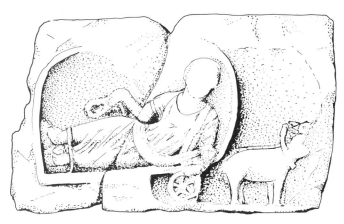

53 *Scale 1:12*

53. FUNERARY MONUMENT PL. XVIII

SHIRVA, Dunbartonshire (East Dunbartonshire), shortly before 25 June 1731 (above, p. 16). Inv. no. F.40.

Findspot: NS 692 755. During investigation of a stone-built 'tumulus', east of Shirva House, together with Nos 48, 52 (see also Nos 21, 49–51,

found earlier at the same site.) 'Upon the North-wall opposite to the carv'd Stone was another Stone much the same dimensions' (Gordon 1732, *Additions*, 7), facing northwards, i.e. away from the interior of the 'tumulus'.

Donation: Shortly before 26 July 1731 (above, p. 18), by Thomas Calder of Shirva (together with Nos 48, 52). *ex dono Thomae Calder de Shirva, Mercatoris Glasguensis* (University of Glasgow 1768, pl. xvi).

Condition: The slab is badly chipped and worn. It is broken diagonally across the middle. The faces of the figure and animals are disfigured.

Description: Within what appears to be a canopied carriage, a figure, here interpreted as female, in tunic overtopped by a formal toga-like garment reaching to the ankles, lies with her left arm on the outer border, with her right hand holding a small wreath or garland. To the right a four-legged animal stands facing right, yoked to the carriage; there is the outline of a second animal behind. Though bovine in appearance, they may be identified as mules. The ears of both can be made out. Below at the right is a six-spoked wheel. H: 0.65 m; W: 1.015 m; D: 0.26 m. Buff sandstone.

Discussion: Early observers correctly identified the scene (Pennant 1774b, 139; Hodgson 1740, 265; Stuart 1845, 334), but later scholars saw this as a further example of a sepulchral banquet (so Macdonald 1897, 87; Haverfield 1899b, 328; Macdonald 1934, 447; Toynbee 1964, 195), a partner for No. 52. There was, however, some uncertainty over the meaning of the symbols employed. Pennant commented on the 'wheel, denoting that at the time of his death he [the deceased] was engaged with a party on the road; and by him is an animal resembling the musimon or Siberian goat' (1774b, 139, no. xvi); this observation was expanded by Laskey (1813, 77, no. 16): '. . . at the time of his death he was engaged with a party on the road; behind the figure is an animal said to resemble the Musimon or Siberian Goat, probably a Highland Sheep. The opinion of the writer of this catalogue is that it is emblematic of the Clyde'.

We might suppose that the sculptor here intended to show the two-wheeled *carpentum*, often associated with ladies of rank, on sculpture and on coins (so Keppie & Arnold 1984, no. 113; cf. Daremberg & Saglio 1887, 926 with fig.). However, the wheel shown is impossibly positioned if the carriage is to be driven. Four-wheeled carriages and carts are shown in funerary contexts; we may rather think that the sculptor unintentionally omitted two wheels at the back of the carriage. (For further discussion, see above, pp. 65–7).

CIL VII, p. 199 *CSIR* 113
Bibliography: Gordon 1732, *Additions*, 7, pl. lxix.3; Horsley 1732, 339, no. xxxiii, pl. (Scotland) xxxiii; University of Glasgow 1768, pl. xvi; Anderson 1771, f. 41; Pennant 1774b, 138–9, no. xvi; Gough 1789, vol. 3, 360, pl. xxv.4; Laskey 1813, 77, no. 16; Hodgson 1840, 265; Stuart 1845, 327, pl. xii.3; Macdonald 1895, 32–3, nos 1–2; Macdonald 1897, 86–90, no. 37, pl. ix.1; Haverfield 1899b, 328; Macdonald 1911, 361f., pl. l.1; Macdonald 1934, 447, pl. lv.1; Toynbee 1964, 195; Keppie & Arnold 1984, 42, no. 113, pl. 30; Mattern 1989, 788–9.

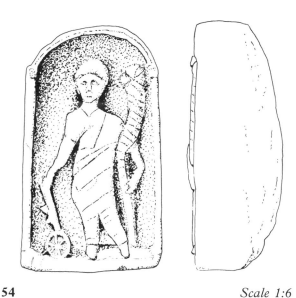

54 *Scale 1:6*

5. RELIEF SCULPTURE AND SCULPTURE IN THE ROUND

54. STATUETTE OF FORTUNA PL. XIX

CASTLECARY, Stirlingshire (Falkirk), November 1769. Inv. no. F.43.

Findspot: NS 790 783. Within the internal bath-house, during stone robbing by workmen seeking building materials for the adjacent Forth & Clyde Canal (Anderson 1771, f. 44), together with No. 27 (for the date, Roy 1793, 161; above, p. 28); later 'in the Summer house at Kerse' (Anderson 1771, f. 45).
Donation: 10 October 1774, by Sir Lawrence Dundas (together with Nos 18, 27, 28) (GUA 26690, p. 258; cf. Anderson 1771, 45). *Inventum cum statua in tabula xxix apud Castlecary AD 1771, et a Laurentio Dundas Baronetto Academiae donatum* (University of Glasgow 1792, pl. xxviii).
Condition: The stone is slightly chipped and damaged, with the loss of parts of the outer moulding of the niche.

Description: Within a niche topped by a double-ribbed arch resting on plain capitals, a female figure clad in a robe marked by angled ribbings to the ankle, with one shoulder bare, carries a long-stemmed cornucopia in her left hand and supports with her right hand a rudder resting on a six-spoked wheel. She has a small head, a long neck, simple hairstyle, lentoid eyes and a straight nose. The body is out of alignment with the head and shoulders. There are traces of a thin coating of white plaster on the figure and in the hollow of the niche. H: 0.39 m; W: 0.25 m; D: 0.12 m. Buff sandstone.
Discussion: The cornucopia, rudder and wheel are the familiar attributes of Fortuna, symbolising dominion over human affairs (cf. Frenz 1992, nos 30–1; Phillips 1977, no. 183; also Espérandieu 1931, 86, no. 129, from Wiesbaden). Fortuna was frequently venerated in military bath-houses in North Britain.

CSIR 76
Bibliography: Anderson 1771, f. 44; Gough 1789, vol. 3, 361; University of Glasgow 1792, pl. xxix; Anderson 1793, 201; Anderson 1800, 3; Nimmo 1817, 641; Stuart 1845, 339, pl. xiv.8; Macdonald 1895, 33, no. 4; Macdonald 1897, 90–1, no. 40, pl. xi.1; Macdonald 1911, 359, pl. xlviii.2; Macdonald 1934, 446, pl. lxxvii.2; RCAHMS 1963, 105, no. i, pl. 9D; Toynbee 1964, 164–5; Keppie & Arnold 1984, 30, no. 76, pl. 23.

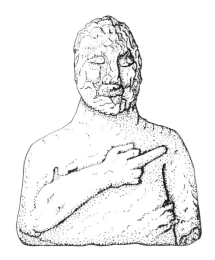

55 *Scale 1:6*

55. BUST OF ?SILENUS PL. XIX

BAR HILL, Twechar, Dunbartonshire (East Dunbartonshire), 1903. Inv. no. F.1936.4.

Findspot: NS 707 769. 'Among the ashes of a rudely constructed hearth', in the north-east corner of the fort, during excavation. 'Mr McIntosh's new "finds" include three stone busts—one without

head and two with heads, but broken off', Alexander Park to Alexander Whitelaw, 24 September 1903 (GUA UGD 101 2/11, p. 180). Presumably these can be equated with Nos 55–7.

Donation: 1933–1936, by Mr A. Whitelaw of Gartshore.

Condition: Worn and chipped. The back of the head is sheared away, perhaps when the bust was found, but it was evidently soon repaired (see Macdonald and Park 1906, fig. 31).

Description: The bust is of an older man, facing front, head tilted slightly upwards and to the right, bearded, with lentoid eyes and a broad nose. His left arm terminates at the elbow; his left forearm is extended across his chest at an angle, with the middle finger extended. Neatly squared off below, for setting on a plinth or ledge. H: 0.35 m; W: 0.29 m; D: 0.15 m. Gritty greyish-buff sandstone. The bust has been subjected to burning.

Discussion: This bust together with Nos 56–58, though found at separate locations within the fort, have been seen as a group, all representing Silenus, the elderly, normally bald-headed and frequently inebriated companion of the wine-god Bacchus. Professor J.M.C. Toynbee preferred to see these figures as native deities (1964, 107). The protruding fingers of Nos 55 and 56 were intended to ward off the evil eye. It may be that they were intended, more generally, to represent the powers of nature.[24]

CSIR 97

Bibliography: Macdonald & Park 1906, 86-8, no. 2, fig. 31; Macdonald 1911, 359, pl. xlix.2; Macdonald 1934, 445-6, pl. lxxvii.6; Toynbee 1964, 107; Robertson, Scott & Keppie 1975, 36, no. 12, fig. 9; Keppie & Arnold 1984, 37, no. 97, pl. 28; Hutchinson 1986, 161ff., pl. ii.a.

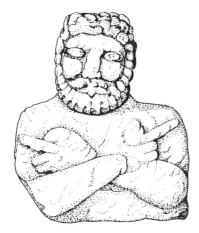

56 *Scale 1:6*

[24]Dr Martin Henig kindly supplied useful notes on the iconography and possible identification of these figures.

56. BUST OF ?SILENUS PL. XIX

BAR HILL, Twechar, Dunbartonshire (East Dunbartonshire), 1903. Inv. no. F.1936.5.

Findspot: NS 707 769. 'Among the ashes of a rudely constructed hearth', north of the granary, during excavation of the fort-site. See No. 55.

Donation: 1933–1936, by Mr A. Whitelaw of Gartshore.

Condition: The bust is chipped and worn. The head was broken off, but is now replaced. Damage was also suffered at the lower left corner where part of the elbow is lost.

Description: The bust is of a naked, bearded, older man, facing front, with lentoid eyes and a broad nose. The head is angled to the left. His arms are crossed on his chest, each with the middle finger extended. H: 0.34 m; W: 0.275 m; D: 0.12 m. Buff sandstone.

Discussion: See under No. 55.

CSIR 98

Bibliography: Macdonald & Park 1906, 86-8, no. 4, fig. 31; Macdonald 1911, 359, pl. xlix.4; Macdonald 1934, 445-6, pl. lxxvii.6; Toynbee 1964, 107; Robertson, Scott & Keppie 1975, 38, no. 13, fig. 10; Keppie & Arnold 1984, 37, no. 98, pl. 28; Hutchinson 1986, 161–3, pl. ii.a.

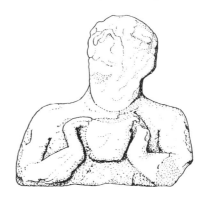

57 *Scale 1:6*

57. BUST OF ?SILENUS PL. XIX

BAR HILL, Twechar, Dunbartonshire (East Dunbartonshire), 1903. Inv. no. F.1936.3.

Findspot: NS 707 769. 'Among the ashes of a rudely constructed hearth', in the south-east corner of the fort, during excavation of the fort-site. See No. 55.

Donation: 1933–1936, by Mr A. Whitelaw of Gartshore.

Condition: The bust is badly chipped and worn. The front of the face is almost totally broken away, and the bottom-right corner is missing.

Description: The bust is of a bald-headed male, very probably bearded, facing front, with arms bent inwards across his chest, holding a wine cup

(*scyphus*) between his palms just below his chin. H: 0.27 m; W: 0.295 m; W: 0.135 m. Buff sandstone.

Discussion: See under No. 55.

CSIR 99

Bibliography: Macdonald & Park 1906, 86–8, no. 1, fig. 31; Macdonald 1911, 359, pl. xlix.1; Macdonald 1934, 445–6, pl. 77.6; Toynbee 1964, 107; Robertson, Scott & Keppie 1975, 36, no. 11, fig. 9; Keppie & Arnold 1984, 37, no. 99, pl. 28; Hutchinson 1986, 161–3, pl. ii.a.

58 *Scale 1:6*

58. HEAD OF ?SILENUS PL. XIX

BAR HILL, Twechar, Dunbartonshire (East Dunbartonshire), 1902–05. Inv. no. F.1936.6.

Findspot: NS 707 769. 'Among the ashes of a rudely constructed hearth', north of the granary, during excavation of the fort-site. See No. 55.
Donation: 1933–1936. Presented by Mr A. Whitelaw of Gartshore.
Condition: The head is badly worn and chipped. The features are barely discernible.
Description: The head shows a bald-headed older man, with lentoid eyes and a broad nose. Though sheared off at the neck, the head presumably belonged to a bust like Nos 55–57. H: 0.12 m; W: 0.095 m; D: 0.1 m. Local buff sandstone.
Discussion: See under No. 55.

CSIR 100

Bibliography: Macdonald & Park 1906, 86ff., no. 3, fig. 31; Macdonald 1911, 359, pl. xlix.3; Macdonald 1934, 445–6, pl. 77.6; Toynbee 1964, 107; Robertson, Scott & Keppie 1975, 38, no. 14,

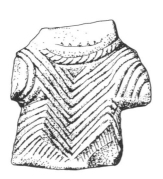

59 *Scale 1:6*

fig. 10; Keppie & Arnold 1984, 38, no. 100, pl. 28; Hutchinson 1986, 161–3, pl. ii.a.

59. TORSO PL. XIX

AUCHENDAVY, Dunbartonshire (East Dunbartonshire), May 1771. Inv. no. F.45.

Findspot: NS 678 748. Found together with Nos 33–37 and two large iron mallets (now lost) in a pit south of Auchendavy fort, during building of the Forth & Clyde Canal. For a time it was believed that this sculpture derived from Auchentoshan (Duntocher), and that the Auchendavy torso had been lost (Stuart 1845, 291). *Inventum apud Auchentoshan juxta Kilpatrick* (University of Glasgow 1768, pl. xxxi).
Donation: July 1771, by Commissioners of the Forth & Clyde Canal, through the good offices of Sir Lawrence Dundas (above, p. 25), together with Nos 33–37.
Condition: Badly worn and chipped. Presumably the head is lost. The torso is neatly finished off at the arms and below.
Description: The front of the torso is carved in a series of angled, zig-zag lines which perhaps represent segmented armour. At the neck is a cable pattern, above which is a series of raised bosses or dots, perhaps a necklace. H: 0.23 m; W: 0.235 m; D: 0.11 m. Yellowish-buff sandstone.
Discussion: The torso may represent Mars or a local war god. Armless statues recur in Celtic art in Gaul (Megaw 1970, no. 232), and can appear in the form of busts shown in relief on tombstones (e.g. *RIB* 1180; Letta & D'Amato 1975, 244, no. 148).

CSIR 119

Bibliography: Anderson 1771, f. 51; Gough 1775, 123; University of Glasgow 1792, pl. xxxi; Anderson 1793, 201, 204, pl. xxxviii; Stuart 1845, 291, pl. vii.4–5; Bruce 1893, 37f., pl. iv.4; Macdonald 1895, 34, no. 8; Macdonald 1897, 92, no. 42, pl. ii.1; Macdonald 1911, 185, 358, pl. xlviii.3; Macdonald 1934, 445, pl.lxxvii.2; Keppie & Arnold 1984, 44, no. 119, pl. 31.

60. STATUE OF MARS PL. XX

BALMUILDY, Lanarkshire (City of Glasgow), 1914. Inv. no. F.1922.8.

Findspot: NS 581 717. In the annexe, east of the fort-site, during excavation (together with Nos 40, 61).
Donation: 1922, by Gen. A.S. Stirling of Keir.
Condition: The statue survives in three fragments which preserve (a) the head, (b) the torso, and (c)

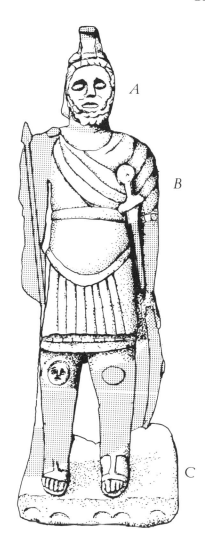

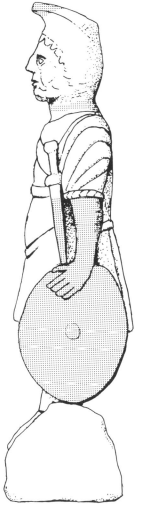

A

B

C

60

Scale 1:6

the feet attached to a substantial plinth. The statue was restored in 1978–79 (Keppie, Arnold, and Ingham 1982). The above drawing shows the statue restored, with shield and spear.

Description: The statue is of a heavily bearded male in military attire. He wears a Corinthian helmet with crest, a muscle cuirass with dependant tassels, and an apron to the knees; and a cloak held in place by a brooch (restored) at his right shoulder. Shield and spear are restored from similar representations elsewhere. On his lower legs were greaves; the surviving knee-piece on his right leg is embosssed with a gorgon-head. The sword (partly restored) at his waist, on the left side, was secured by a horizontal belt. Semicircular incisions on the base are unlikely, as once thought (see *RIB* 2337*), to represent lettering. On his feet is a pair of openwork sandals. H: 0.79 m; W: 0.27 m; D: 0.175 m (as restored). Buff sandstone.

Discussion: The god Mars is attired in familiar panoply. The statue may once have stood, with Nos 40 and 61, in a temple or shrine within the fort's east annexe.

RIB 2337* *CSIR* 129

Bibliography: Miller 1922, 61, no. 10, pl. xxix.10; Macdonald 1934, 434–5, no. 54, pl. lxxv.3; Toynbee 1964, 68 n. 4; Keppie, Arnold and Ingham 1982, 73–5; Keppie & Arnold 1984, 47, no. 129, pl. 33.

61. STATUE OF VICTORY PL. XXI

BALMUILDY, Lanarkshire (City of Glasgow), 1914. Inv. no. F.1922.9.

Findspot: NS 581 717. In the annexe east of the fort-site, during excavation (together with Nos 40, 60).

Donation: 1922, by Gen. A.S. Stirling of Keir.

Condition: The statue is broken at the waist; the head and lower legs are lost. The surviving fragments, broken into two parts but repaired, are much worn.

Description: The statue is of a winged female, clad in a tunic, with draperies over her left leg, but leaving her right leg bare, carrying a palm frond held vertically in her left hand, and with right

61 *Scale 1:6*

arm raised. The back of the statue is not finished off. H: 0.55 m; W: 0.33 m; D: 0.1 m. Buff sandstone.

Discussion: This is the familiar pose of Victory. Doubtless she once held a laurel wreath in her right hand (cf. Nos 5, 16) and rested her right foot on a globe. The statue probably stood in a small temple or shrine in the fort's east annexe (with Nos 40, 60). There is a close parallel to the upright pose of this figure at Palmyra (see Sebesta and Bonfante 1994, fig. 10.8).

CSIR 131

Bibliography: Miller 1922, 56, 60–1, nos 7–8, pl. 28, nos 7–8; Macdonald 1934, 446, pl. lxxvii.4; Keppie & Arnold 1984, 48, no. 131, pl. 33.

62 *Scale 1:6*

62. HEAD OF A GODDESS PL. XXI

BALMUILDY, Lanarkshire (City of Glasgow), 1914. Inv. no. F.1922.10.

Findspot: NS 581 716. In the Cold Bath (*Frigidarium*) of the annexe bath-house, during excavation.
Donation: 1922, by Gen. A.S. Stirling of Keir.
Condition: The head is worn. The lower left jaw is broken away.
Description: The head is female, about half life-size. The hair, swept back from the forehead, is rigidly patterned. The eyes and nose betray Celtic inspiration. H: 0.13 m; W: 0.09 m; D: 0.095 m. Buff sandstone.
Discussion: The head presumably derives from a bust or statue, perhaps of a local deity, unless it represents Fortuna, often venerated in military bath-houses (above, Nos 27, 39, 54).

CSIR 133

Bibliography: Miller 1922, 60, no. 6, pl. 27; Macdonald 1934, 446, pl. 77.3; Keppie & Arnold 1984, 48, no. 133, pl. 33.

63 *Scale 1:6*

63. FRAGMENT OF TORSO PL. XXI

BALMUILDY, Lanarkshire (City of Glasgow), 1914. Inv. no. F.1922.10.

Findspot: NS 582 716. In the Cold Bath (*Frigidarium*) of the annexe bath-house, during excavation.
Donation: 1922, by Gen. A.S. Stirling of Keir.
Condition: The upper half of a torso survives.
Description: The figure is clad in a tunic, with sleeves to the elbow. H: 0.24 m; W: 0.29 m; D: 0.13 m. Local buff sandstone.
Discussion: If the figure supported a shell, as on No. 66, she could represent a water nymph (cf. Phillips 1977, no. 46). The excavator supposed that this torso belonged with the head (No. 62), but the type of sandstone is different.

CSIR 134

Bibliography: Miller 1922, 60, no. 6, pl. 27; Macdonald 1934, 446, pl. 77.3; Keppie & Arnold 1984, 48f., no. 134, pl. 33.

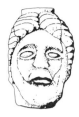
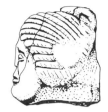

64 *Scale 1:6*

64. HEAD OF A GODDESS PL. XXI

BEARSDEN, Dunbartonshire (East Dunbartonshire), 1973.

Findspot: NS 546 721. Among debris in the Cold Plunge of the annexe bath-house, during excavation.

Donation: 17 February 1978, by the Scottish Development Department, Ancient Monuments (now Historic Scotland).

Condition: The head presumably derives from a statue of about half life-size. It is only slightly worn, but the nose is broken away. The front of the face, sheared off at the moment of discovery, has since been repaired.

Description: The head is female, with broad lips and full lentoid eyes, waved hair, centrally parted at the front. Rising from the head at the back is a roll of hair or a headdress with criss-cross braiding or binding. H: 0.16 m; W: 0.11 m; D: 0.15 m. Yellow-buff sandstone.

Discussion: Generally identified, from its findspot in the annexe bath-house, as 'the head of Fortuna', the statue could represent a local goddess (cf. Espérandieu 1911, no. 3379, from Vertault, France; Krüger 1967, no. 47, from Carnuntum, Austria; Green 1995, fig. at p. 129, from Sarrebourg, France).

CSIR 139

Bibliography: Breeze 1974a, 213 with pl. on p. 209; Breeze 1974b, front cover; Wilson 1974, 405; Breeze 1984, 54, fig. 25; Keppie & Arnold 1984, 50–51, no. 139, pl. 35; Keppie in Breeze, forthcoming 1.

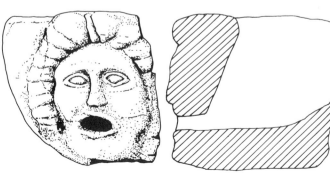

65 *Scale 1:6*

65. FOUNTAINHEAD PL. XXII

BEARSDEN, Dunbartonshire (East Dunbartonshire), 1973.

Findspot: NS 546 721. Unstratified, just south of the Changing-room, during excavation of the annexe bath-house.

Donation: 17 February 1978, by the Scottish Development Department, Ancient Monuments (now Historic Scotland).

Condition: The right-hand side is broken away. The head is otherwise rather worn, with damage to nose, lips, and chin.

Description: The fountainhead is carved to show a human head with gaping mouth, lentoid eyes, and thick, loosely waved hair. The back is hollowed out. H: 0.25 m; W: 0.26 m; D: 0.29 m. Yellowish-buff sandstone.

Discussion: The head recalls fountainheads at Pompeii, Herculaneum, Glanum, and elsewhere. It was presumably set within a niche, fed by a pipe, with water cascading into a basin below (cf. Espérandieu 1918, no. 5543, from Brumath, France.

CSIR 140

Bibliography: Breeze 1974a, 213 with pl.; Breeze 1974b, 19 with pl.; Keppie & Arnold 1984, 51, no. 140, pl. 35; Keppie, in Breeze forthcoming 1.

66. STATUE OF WATER NYMPH

PL. XXII

DUNTOCHER, Dunbartonshire (West Dunbartonshire), 1775. Inv no. F.44.

Findspot: NS 494 728. 'Some professors in the University of Glasgow, and other gentlemen, having unroofed the whole, discovered the appearance of a Roman hot-bath . . .; in the bath was placed the figure of a woman cut in stone' (Knox 1785, 611). This was the extra-mural bath-house west of the fort (above, p. 29).

Donation: ?1775. '[The statuette], with a set of tiles and other curiosities found in this place, is deposited in the University' (Knox 1785, 611); above, p. 29.

Condition: Complete, though broken into three parts; generally rather worn. Carbon marks on the body are indicative of burning.

Description: A female figure, naked to the waist, with wavy hair swept back from the forehead and extending to the shoulders, faces front, holding a pierced oval shell with striations. On her upper arms is a pair of armlets. The perforation, 4 cm in diameter, was intended to receive a metal pipe.

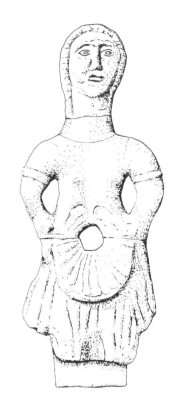
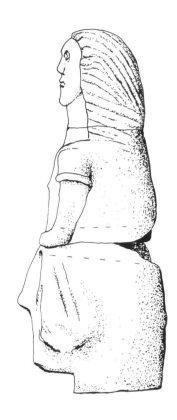

66 *Scale 1:6*

The back of the figure is not finished off. H: 0.58 m; W: 0.21 m; D: 0.19 m. Buff sandstone.

Discussion: The statuette was evidently a gurget in the fort bath-house (cf. Phillips 1977, no. 35). Water passed through the centre of the shell, presumably into a basin. The folds of her drapery seem to represent flowing waters. There are clear signs of Celtic influence in the workmanship.

CSIR 151

Bibliography: Knox 1785, 611n; Stuart 1845, 357, pl. xv.3; Macdonald 1895, 33, no. 6; Macdonald 1897, 93, no. 44, pl. xii.3; Macdonald 1911, 158, 358, pl. xlviii.1; Macdonald 1934, 444–5, pl. lxxvii.5; Robertson 1957, 4–5; Keppie & Arnold 1984, 55, no. 151, pl. 37.

67 *Scale 1:12*

6. ARCHITECTURAL SCULPTURE

67. COLUMN CAPITAL

BAR HILL, Twechar, Dunbartonshire (East Dunbartonshire), November 1902. Inv. no. F.1936.9.

Findspot: NS 707 769. In the well of the Headquarters Building, during excavation of the fort-site.

Donation: 1933–1936, by Mr A. Whitelaw of Gartshore.

Condition: The capital is slightly worn.

Description: The stone preserves a capital, together with a *torus* moulding and a small portion of the shaft. It is neatly squared off below with a circular hole for a plug. The capital is not placed centrally but to one side of the shaft. The *abacus* is divided into two horizontal bands; the lower band is decorated with chevrons, five on two of the opposing faces, and six on the others. There are traces of red paint in the recessed areas of the chevrons. Smaller circular holes in the top and bottom of the capital appear modern. H: 0.445 m; W: 0.325 m; D: 0.32 m. Gritty buff sandstone.

Discussion: This capital, together with Nos 68–69, and many unornamented captials, shafts (including Nos 70–71) and bases, was recovered from the well. Formerly considered to have stood round the sides

of the internal courtyard of the Headquarters Building (Robertson, Scott & Keppie 1975, 11), they are currently interpreted as forming a colonnade along the north front of the building, facing onto the *via principalis* (Keppie 1985, 71–5). The use of the chevron motif here and on No. 68 may indicate craftsmen of the *cohors I Hamiorum* (so Keppie 1986, 53-7; above, p. 100).

CSIR 103
Bibliography: Macdonald & Park 1906, 136, fig. 47; Macdonald 1911, 197, fig. 5, 358; Macdonald 1934, 279 fig. 38; Schleiermacher 1960, 377–8, Taf. 48.3; Robertson, Scott & Keppie 1975, 40, no. 22, fig. 11; Keppie & Arnold 1984, 39, no. 103, pl. 29; Keppie 1986, 55, fig. 3.

68 *Scale 1:12*

68. COLUMN CAPITAL

BAR HILL, Twechar, Dunbartonshire (East Dunbartonshire), November 1902. Inv. no. F.1936.8.

Findspot: NS 707 769. In the well of the Headquarters Building, during excavation of the fort-site.
Donation: 1933–1936, by Mr A. Whitelaw of Gartshore.
Condition: The stone is chipped at the edges and part of the *abacus* is broken away.
Description: The *abacus* is divided into two bands by a horizontal incised line. The lower band is decorated with large chevrons, four on the longer sides, three on the shorter. A hole drilled centrally into the flat underside of the capital appears modern. H: 0.37 m; W: 0.3 m; D: 0.27. Gritty buff sandstone.
Discussion: See under No. 67.

CSIR 104
Bibliography: Macdonald & Park 1906, 136, fig. 48; Macdonald 1911, 197, fig. 4, 358; Macdonald 1934, 279 fig. 38; Robertson, Scott & Keppie 1975, 40, no. 21, fig. 11; Keppie & Arnold 1984, 39, no. 104, pl. 29; Keppie 1986, 55, fig. 4.

69 *Scale 1:12*

69. COLUMN CAPITAL

BAR HILL, Twechar, Dunbartonshire (East Dunbartonshire), November 1902. Inv. no. F.1936.7.

Findspot: NS 707 769. In the well of the Headquarters Building, during excavation of the fort-site.
Donation: 1933–1936, by Mr A. Whitelaw of Gartshore.
Condition: The capital is chipped and worn at the edges, with some small fragments lost.
Description: The capital, *torus*, and part of the shaft are carved as a single block. The *echinus* is decorated, on three sides, with tall upright leaves, nine in all. The fourth side is blank. There is a squarish hole in the top of the capital, and a circular hole in the flat underside of the capital, presumably for a plug. H: 0.59 m; W: 0.35 m; D: 0.37 m. Buff sandstone.
Discussion: See under No. 67.

CSIR 105
Bibliography: Macdonald & Park 1906, 136, fig. 46; Macdonald 1911, 358, pl. xx.2; Macdonald 1934, 444, pl. 51.3; Schleiermacher 1960, 377–8, Taf. 48.4; Robertson, Scott & Keppie 1975, 40, no. 20, fig. 11; Keppie & Arnold 1984, 39, no. 105, pl. 29.

70. COLUMN SHAFT WITH CORBEL

BAR HILL, Twechar, Dunbartonshire (East Dunbartonshire), November 1902. Inv. no. F.1936.27.

Findspot: NS 707 769. In the well of the Headquarters Building, during excavation of the fort-site.
Donation: 1933–1936, by Mr A. Whitelaw of Gartshore.
Condition: The shaft is broken below the corbel, and just above it, across the mortise-pocket. On the left side of the shaft, level with the corbel, is a

70 *Scale 1:12*

Discussion: See under No. 70.

CSIR 107
Bibliography: Macdonald & Park 1906, 138–9, fig. 52; Macdonald 1934, 444; Robertson, Scott & Keppie 1975, 38, no. 17, fig.10 (left); Keppie & Arnold 1984, 40, no. 107, pl. 29.

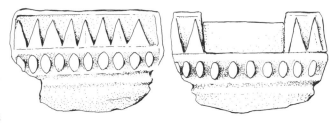

72 *Scale 1:12*

small squarish hole. The surviving fragment is worn.

Description: The corbel took the form of a stylised bull's head (*bucranium*), only roughly finished off. H: 0.85 m; W: 0.32 m; D: 0.41 m. Buff sandstone.

Discussion: This and No. 71 could have supported a horizontal timber beam in a prominent position, perhaps over the entrance on the north side of the Headquarters Building.

CSIR 106
Bibliography: Macdonald & Park 1906, 138–9, fig. 52; Macdonald 1934, 444; Robertson, Scott & Keppie 1975, 38, no. 17, fig.10 (right); Keppie & Arnold 1984, 39–40, no. 106, pl. 29.

72. COLUMN CAPITAL PL. XXIV

CASTLEHILL, Bearsden, Dunbartonshire (East Dunbartonshire), 1847. Inv. no. F.46.

Findspot: NS 522 727. 'In the same year, and in the same field, only a few feet off, the farmer turned up the square base of a broken pillar, neatly ornamented, lying on its edge about 3 feet under the surface, and nearly in line with the spot where the inscribed tablet [No.7] was found . . . They are both in the possession of John Buchanan' (Stuart 1852, 310 fn.(a)). Cf. above, p. 37.

Donation: October 1871, by John Buchanan (GUL MR 50/49, no. 3).

Condition: Chipped and worn, with the loss of some of the lower mouldings.

Description: On two parallel sides, the capital is richly decorated in two bands, showing tall upright chevrons, below which, separated by a horizontal dividing line, is a line of simple upright leaves. Of the other two sides, where the capital has been channelled, one shows a series of eight chevrons, the other has an oblong panel below the channel, flanked by two chevrons. The decoration respects the channel (which is 220 mm wide and 30 mm deep); the latter is thus part of the original design. H: 0.33 m; W: 0.46 m; D: 0.46 m. Local buff sandstone.

Discussion: Early commentators interpreted the block as a sculptured column base. However, it clearly is a column capital (Macdonald 1934, 327 correcting Macdonald 1911, 161), which has been channelled very probably to support a horizontal timber beam.

71 *Scale 1:12*

71. COLUMN SHAFT WITH CORBEL

BAR HILL, Twechar, Dunbartonshire (East Dunbartonshire), November 1902. Inv. no. F.1936.28.

Findspot: NS 707 769. In the well of the Headquarters Building, during excavation of the fort-site.
Donation: 1933–1936, by Mr A. Whitelaw of Gartshore.
Condition: The shaft is broken off across the top of the corbel. No part of a mortise-pocket survives.
Description: The corbel takes the form of a stylised bull's head (*bucranium*). It forms a pair with No. 70. H: 1.05 m; W: 0.33 m; D: 0.33 m. Buff sandstone.

CIL VII at no. 1133 *CSIR* 147
Bibliography: Wilson 1851, 377 with fig.; Stuart 1852, 310 fn. (a), pl. ix.4; Bruce 1893, 48, pl. iii.1;

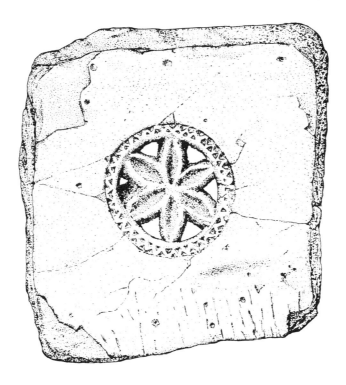

73 *Scale 1:12*

Macdonald 1895, 33–4, no. 7; Macdonald 1897, 91–2, no. 41, pl. xvi.3; Macdonald & Park 1906, 137, fig. 49; Macdonald 1911, 161, pl. xx.1; Macdonald 1934, 327, pl. li.2; Schleiermacher 1960, 377; Keppie & Arnold 1984, 53, no. 147, pl. 36.

73. DRAIN COVER-SLAB PL. XXIII

BOTHWELLHAUGH, Lanarkshire (North Lanarkshire), July 1973. Inv. no. F.1982.6.

Findspot: NS 729 579. *In situ* in the paved floor of the Cold Room (*Frigidarium*) of the extramural bath-house revealed by trial-trenching 1973; totally excavated 1975–76.
Donation: 17 February 1978, by Scottish Development Department, Ancient Monuments (now Historic Scotland). It was removed from the site for safekeeping with the permission of Strathclyde Regional Council.
Condition: The slab was badly fractured by exposure to water, then by removal, 1978; since restored.[25] A replica placed *in situ*, when the bath-house was re-excavated and consolidated for permanent public display, 1981, was subsequently vandalised; the fragments have disappeared.
Description: The centre of this square flooring slab is carved as a rosette; six petals are enclosed

by a ring of chip-carvings. W: 0.94 m; D: 1.05 m; H: 0.14 m. Buff sandstone.
Discussion: The slab, much thicker than its neighbours in the floor of the Cold Room of the bath-house, was intended as a drain-cover slab. Water flowed through gaps between the petals into a stone-lined drain below, and from there towards the adjacent South Calder Water. The style of chip-carving recalls No. 24. The use of floral rosettes as drain-covers can be paralleled at Bearsden (only partly cut; *in situ*), at Caerleon (Boon 1972, 102), and at sites in several continental provinces.

CSIR 43
Bibliography: Keppie & MacKenzie 1975, 154–6; Maxwell 1975, 34–5, fig. 6; Keppie 1981, 72, no. 6, pl. 11, fig. 17; Keppie & Arnold 1984, 16, no. 43, pl. 14.

7. MISCELLANEOUS

74. SCULPTURED RELIEF PL. XXIV

Unknown provenance, before *c*.1790. Inv. no. F.42.

Findspot: Unknown. Macdonald (1934, 448) suggested that it derived from Shirva, but without supporting evidence.

[25]A further programme of restoration is in progress (1997–98).

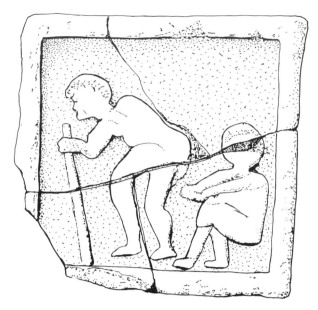

74 *Scale 1:6*

pl. xv.4; Macdonald 1895, 33, no. 5; Macdonald 1897, 93, no. 43, pl. xii.1; Macdonald 1911, 363, pl. xlviii.5; Macdonald 1934, 448, pl. lxxvii.5; Keppie & Arnold 1984, 58, no. 159, pl. 39.

75 *Scale 1:6*

Donation: Before *c*.1792 (University of Glasgow 1792, pl. xxxii, without any caption).
Condition: Broken into four adjoining parts; the edges are much worn. The outer moulding is broken away at lower left corner. At some time after discovery it was set within a wooden frame.
Description: Within a plain outer moulding, a man with his head facing the front, back bent almost double, walks towards the left, leaning on a staff. Behind is a small male figure, of which the face is lost, in tunic or breeches to the knees, sitting with his legs to the left. He seems to be pulling back the figure in front. H: 0.45 m; W: 0.45 m; D: 0.085 m. Gritty greyish-buff sandstone.
Discussion: Resembling in shape a metope from a Doric temple, the panel was long ago supposed to represent 'Youth and Old Age' (Laskey 1813, 77; Stuart 1845, 357). Alternatively, it might derive from a tomb (Macdonald 1934, 448). Again, the scene may be obscene, and from the shrine of a local fertility cult (cf. Oswald 1936–37, pl. xc, fig. T; Espérandieu 1915, no. 5040). The general assumption is that the slab must be Roman. Certainly it is of local sandstone, and presumably it was believed Roman at the time of initial publication (University of Glasgow 1792, pl. xxxii). The possibility that it could be of mediaeval or post-mediaeval date, made either for an ecclesiastical building, or (even later) as a garden feature, might be kept open.[26]

CSIR 159
Bibliography: University of Glasgow 1792, pl. xxxii; Laskey 1813, 77, no. 32; Stuart 1845, 357,

[26]I am glad to have been able to discuss the possibilities with Mr John Higgitt and Dr Glenys Davies.

75. CARVED BUILDING STONE
PL. XXIV
BEARSDEN, Dunbartonshire (East Dunbartonshire), 1973.

Findspot: NS 546 721. Among debris in the annexe bath-house, during excavation.
Donation: 17 February 1978, by the Scottish Development Department, Ancient Monuments (now Historic Scotland).
Condition: Worn.
Description: On the front face of this dressed building stone is a crude human figure with large head, portruding ears, and deep-set eyes. The legs terminate in horizontal strokes representing feet. To the right is a vertical pole, from which downward angled lines emerge. H: 0.27 m; W: 0.2 m; D: 0.225 m. Buff sandstone.
Discussion: This could represent a soldier holding a military standard (though his arm is not shown), or a Celtic 'outline figure', in which case the object on the right may be a club or a tree.[27]

CSIR 143
Bibliography: Keppie & Arnold 1984, 51–2, no. 143, pl. 36; Keppie in Breeze, forthcoming 1.

8. FRAGMENTS

76. FRAGMENT OF BUILDING RECORD
PL. XXIV
CADDER, Lanarkshire (East Dunbartonshire), 1929–31. Inv. no. F.1933.1.

[27]See Ross 1967, 172, 185, pl. 60A for the Celtic god Olludius (cf. at Chedworth, Henig 1993, no. 127; at Maryport, Ashmore 1991, p. (11) with fig.).

76 *Scale 1:6*

Findspot: NS 716 726. Near the front entrance to the Headquarters Building, during excavation of the fort-site.
Donation: 1933, by the Rev. A.R.E. Macinnes.
Condition: The fragment is worn and chipped.
Description: The fragment shows the segment of a laurel wreath, with dependant fillet to the left; below is a section of outer moulding, decorated with acanthus leaves and a cable pattern above. H: 0.175 m; W: 0.15 m; D: 0.1 m. Buff sandstone.
Discussion: The fragment preserves part of a commemorative tablet, probably a building record, including a segment of its lower margin. It was perhaps erected over the entrance to the Head-quarters Building. The acanthus leaf design of the border recalls the Bridgeness distance slab (*RIB* 2139), erected by the Second Augustan Legion, which is already attested at Cadder (*RIB* 2188).

 CSIR 125
Bibliography: Clarke 1933, 36, 81; Keppie & Arnold 1984, 46, no. 125, pl. 32.

77 *Scale 1:6*

77. FRAGMENT OF ?BUILDING
RECORD PL. XXIV
CADDER, Lanarkshire (East Dunbartonshire), 1929–31. Inv. no. F.1933.2.

Findspot: NS 716 726. In a pit near the north gateway, during excavation of the fort-site. The excavator concluded that, since it was found 1.8 m deep, beneath other debris, it had been discarded early in the life of the fort (Clarke 1933, 81).
Donation: 1933, by the Rev. A.R.E. Macinnes.
Condition: Chipped, scored, and worn.
Description: The fragment shows one corner of a slab. Within a broad plain border are two S-

shaped spirals, separated by a bead-and-reel motif, with traces of a further spiral to the right. On the bottom face of the fragment is a small square depression, with a hollowed-out channel leading away from it at right angles. H: 0.125 m; W: 0.17 m; D: 0.06 m. Buff sandstone.
Discussion: The fragment probably preserved one corner of a commemorative slab, perhaps a building record or decorated screen, which had been broken and later re-used.

 CSIR 126
Bibliography: Clarke 1933, 43, 81; Keppie & Arnold 1984, 46, no. 126, pl. 32.

78 *Scale 1:6*

78. FRAGMENT OF STATUE
BALMUILDY, Lanarkshire (City of Glasgow), 1912–14. Inv. no. F.1922.11/1.

Findspot: NS 582 717. During excavation of the fort-site.
Donation: 1922, by Gen. A.S. Sterling of Keir.
Condition: Not much worn.
Description: The fragment preserves the fingers of a right hand, grasping an object. It is not clear whether it was orientated upwards, to hold a spear, or downwards, to support a shield. H: 0.105 m; W: 0.045 m; D: 0.075 m. Buff sandstone.
Discussion: It might easily be supposed, from considerations of style and dimensions, that this fragment, which went unmentioned in the published report of the excavations (Miller 1922) and which is assigned to the site by virtue of an entry in the Museum accessions ledger, belonged to the fragmentary statue of Mars (above, No. 60); but attempts at incorporating it into the recon-struction of the latter proved unsuccessful; so it is catalogued separately here.

 CSIR 132
Bibliography: Keppie & Arnold 1984, 48, no. 132, pl. 33.

79 *Scale 1:6*

80 *Scale 1:6*

79. FRAGMENT OF BOLSTER

BEARSDEN, Dunbartonshire (East Dunbartonshire), 1973.

Findspot: NS 546 721. Among debris in the cold plunge of the annexe bath-house, during excavation.
Donation: 17 February 1978, by the Scottish Development Department, Ancient Monuments (now Historic Scotland).
Condition: Rather worn.
Description: The fragment is cylindrical and incorporates a strap decorated with a plain boss. H: 0.07 m; W: 0.105 m; D: 0.08 m. Buff sandstone.
Discussion: The fragment seems to preserve the central part of a bolster from the capital of an altar (cf. *RIB* 2176).

CSIR 141

Bibliography: Keppie & Arnold 1984, 51, no. 141, pl. 35; Keppie in Breeze, forthcoming 1.

80. FRAGMENT OF DECORATIVE BORDER

BEARSDEN, Dunbartonshire (East Dunbartonshire), 1978.

Findspot: NS 546 721. Among debris in the cold plunge of the annexe bath-house, during excavation.
Donation: 17 February 1978, by the Scottish Development Department, Ancient Monuments (now Historic Scotland).
Condition: Worn and chipped.
Description: The fragment is decorated with a frieze of leaves and tendrils, within a raised moulding. H: 0.065 m; W: 0.145 m; D: 0.04 m. Buff sandstone.
Discussion: This appears to be from the outer border of a sculptured slab.

CSIR 142

Bibliography: Keppie & Arnold 1984, 51, no. 142, pl. 35; Keppie in Breeze, forthcoming 1.

EPIGRAPHIC CONVENTIONS

(abc) Letters within round brackets are those omitted by the stonecutter, but inserted to fill out an abbreviation, e.g. *leg(ionis)*

[abc] Letters within square brackets are those lost on the stone, because of damage or weathering, but which can be restored with certainty, e.g. *[l]eg(ionis)*

<abc> Letters accidentally omitted on the stone, e.g. *Victric<i>s*

a̠b̠c̠ Letters underdotted are doubtful because of damage or weathering; they cannot be restored with certainty

"abc" Letters added in antiquity by way of correction of an existing text

a͡b or a͡b͡c Letters joined together (ligatured)

a̅b̅c̅ Letters with a superscript bar indicating numerals or an abbreviated word (see also p. 60)

ABC Letters which appear on the stone, which are not understood by the epigrapher

[....] Letters lost on the stone, by damage or weathering, which cannot be restored; each dot to represent one missing letter

[---] Letters lost on the stone, by damage or weathering, which cannot be restored; the number of missing letters is uncertain.

(centurio) Word inserted by the editor in place of a symbol used by the stonecutter, e.g. *(centurio)* in place of ⊃ , *(milliaria)* in place of ∞

/ marks division between lines of text on a stone

vac. or *vacat* represents a space or a whole line left blank

(!) indicates a mispelling or other peculiarity to which the editor wishes to draw the reader's attention

GLOSSARY

abacus	squared-off upper moulding on a column capital
ansa	triangular or trapezoidal projection to left and right of inscribed panel
bolster	cylindrical 'cushion' atop the capital of an altar, to either side of *focus*
bucranium	moulding or motif in the form of a bull's head
diploma	bronze folding document listing privileges granted to soldiers on completion of 25 years' service
echinus	lower, convex moulding on column capital
corbel	supporting bracket projecting from wall or column
focus	circular 'hearth', on top of altar capital, set between bolsters
pelta	crescentic projection to left and right of inscribed panel
torus	convex moulding on a column base (or capital)
voussoir	arch-stone from roof of bath-house, shaped to support roof tiles

ABBREVIATIONS

ARCHIVAL SOURCES

Ash.Lib	Ashmolean Library, Oxford
Bod.Lib.	Bodleian Library, Oxford
BL	British Library, London
EUL	Edinburgh University Library
GUA	Glasgow University Archives
GUL	Glasgow University Library
NLS	National Library of Scotland, Edinburgh
SRO	Scottish Record Office, Edinburgh
TCD	Trinity College, Dublin

EPIGRAPHIC CORPORA

AE L'Année Epigraphique (Paris, 1888–)

CIL Corpus Inscriptionum Latinarum, vol. VII, *Britannia*, ed. E. Hübner (Berlin, 1873)

ILS Inscriptiones Latinae Selectae, ed. H. Dessau (Berlin, 1892-1916)

RIB Roman Inscriptions of Britain, vol. 1, ed. R.G. Collingwood & R.P. Wright (Oxford, 1965); vol. 2, ed. S.S. Frere *et al.* (Stroud, 1990–1995)

Notice also:

CSIR Corpus of Sculpture of the Roman World (Corpus Signorum Imperii Romani), Great Britain, vol. 1, fasc. 4, *Scotland*, L.J.F. Keppie & B.J. Arnold (London, 1984)

BIBLIOGRAPHY

Ackermann, H.C. & Gisler, J.-R. *et al.* 1986 *Lexicon Iconographicum Mythologiae Classicae* vol. 3.1 (Zürich)

Alcock, J. 1986 'The concept of Genius in Roman Britain', in M. Henig and A. King (eds), *Pagan Gods and Shrines in the Roman Empire* (Oxford), 113–34

Allason-Jones, L. & McKay, B. 1985 *Coventina's Well: A Shrine on Hadrian's Wall* (Gloucester)

Amedick, R. 1991 *Vita Privata auf Sarcophagen* (Berlin)

Anderson, A.S. 1984 *Roman Military Tombstones* (Princes Risborough)

Anderson, J. 1771 *Of the Roman Wall between the Forth & Clyde; and of some Discoveries which have lately been made upon it* (Andersonian Library, University of Strathclyde=Anderson MS 22A, ff. 1–52)

Anderson, J. 1773 Supplementary pages to Anderson 1771 (Andersonian Library, University of Strathclyde=Anderson MS 22A, ff. 93–119)

Anderson, J. 1793 'Observations by Mr Anderson, Professor of Natural Philosophy in the University of Glasgow, upon the Roman Antiquities lately discovered between the Forth and the Clyde', in Roy 1793, 200–4

Anderson, J. 1800 *Observations upon Roman Antiquities discovered between the Forth & Clyde* (Edinburgh)

Andreae, B. 1980 *Die Sarcophage mit Darstellungen aus dem Menschenleben. 2. Die römischen Jadgsarcophage* (Berlin)

Andreas, A.T. 1886 *History of Chicago* (Chicago)

Anon. 1627 *Respublica sive status regni Scotiae et Hiberniae diversorum auctorum* (Leiden)

Anon. 1886 *Memoirs and Portraits of One Hundred Great Glasgow Men* (Glasgow)

Anon. 1908 'A joint excursion . . . on the Antonine Wall', *Proc. Soc. Ant. Newcastle*[3] 3 (1907–08), 229–35

Anton, P. 1893 *Kilsyth: a Parish History* (Glasgow)

Ash, M. 1981 'A fine, genial, hearty band: David Laing, Daniel Wilson and Scottish Archaeology', in A.S. Bell (ed.), *The Scottish Antiquarian Tradition* (Edinburgh)

Ashmore, B. 1991 *Senhouse Roman Museum, Maryport* (Maryport)

Barber, R.L.N. 1971 'A Roman altar from Old Kilpatrick', *Glasgow Archaeol. J.* 2 (1971), 117–19

Barnard, S. 1985 'The Matres of Roman Britain', *Archaeol. J.* 142 (1985), 237–45

Bates, C. 1898 'The distance-slabs of the Antonine Wall and the Roman names of its fortresses', *Archaeol. Aeliana* 19 (1898), 105–14

Birley, A.R. 1981 *The Fasti of Roman Britain* (Oxford)

Birley, A.R. 1988 *The People of Roman Britain* (London)

Birley, E. 1936 'Marcus Cocceius Firmus: an epigraphic study', *Proc.Soc.Antiq.Scot.* 70 (1936–37), 363–77 (= *Roman Britain and the Roman Army* (Kendal, 1953), 87–103)

Birley, E. 1958 'John Horsley and John Hodgson', *Archaeol. Aeliana*[4] 36 (1958), 1–46

Birley, E. 1974 '*Cohors I Tungrorum* and the altar of the Clarian Apollo', *Chiron* 4 (1974), 511–13 (= Birley 1988, 365–7)

Birley, E. 1976	'An inscription from Cramond and the *matres campestres*', *Glasgow Archaeol. J.* 4 (1976), 108–10 (= Birley 1988, 433–5)
Birley, E. 1978	'The religion of the Roman army: 1895–1977', in W. Haase (ed.), *Aufstieg und Niedergang der römischen Welt* 2.16.2 (Berlin/New York), 1506–41 (= Birley 1988, 397–432)
Birley, E. 1983	'A Roman altar from Old Kilpatrick and interim commanders of auxiliary units', *Latomus* 42 (1983), 78–83 (= Birley 1988, 221–31)
Birley, E. 1986	'The deities of Roman Britain', in W. Haase (ed.), *Aufstieg und Niedergang der römischen Welt* 2.18.1 (Berlin/New York), 3–112
Birley, E. 1988	*The Roman Army: Papers 1929–1986* (Amsterdam)
Birley, E. 1989	'Some legionary centurions', *Zeitschrift für Payrologie und Epigraphik* 79 (1989), 117–28
Blaeu, J. 1654	*Theatrum Orbis Terrarum,* vol. 5 (Amsterdam)
Boon, G.C. 1970	'Excavations on the site of the *Basilica Principiorum* at Caerleon, 1968-69', *Archaeologia Cambrensis* 119 (1970), 10–63
Boon, G.C. 1972	*Isca: The Roman Legionary Fortress at Caerleon* (3rd edn, Cardiff)
Bowman, A.K. & Thomas, J.D. 1983	*Vindolanda: The Latin Writing Tablets,* Britannia Monograph 4 (London)
Bowman, A.K. & Thomas, J.D. 1994	*The Vindolanda Writing-Tablets (Tabulae Vindolandenses),* vol. 2 (London)
Breeze, D.J. 1974a	'Bearsden', *Current Archaeology* 42 (Jan. 1974), 209–13
Breeze, D.J. 1974b	*The Roman Fort at New Kilpatrick, 1973 Excavations* (Edinburgh)
Breeze, D.J. 1984	'The Roman fort on the Antonine Wall at Bearsden', in D.J. Breeze (ed.), *Studies in Scottish Antiquity presented to Stewart Cruden* (Edinburgh), 32–68
Breeze, D.J. 1989	*The Second Augustan Legion in North Britain (Second Annual Caerleon Lecture)* (Cardiff)
Breeze, D.J. forthcoming 1	*The Roman Fort at Bearsden* (Edinburgh)
Breeze, D.J. forthcoming 2	'The regiments stationed at Maryport and their commanders', in R.J.A.Wilson (ed.), *Roman Maryport and its Setting: Essays in Memory of Michael G. Jarrett* (Kendal)
Breeze, D.J., Close-Brooks, J. & Ritchie, J.N.G. 1976	'Soldiers' burials at Camelon, Stirlingshire, 1922 and 1975', *Britannia* 7 (1976), 73–95
Breeze, D.J. & Dobson, B. 1970	'The development of the mural frontier in Britain from Hadrian to Caracalla', *Proc.Soc.Antiq.Scot.* 102 (1969–70), 109–21
Brilliant, R. 1982	'I piedistalli del giardino di Boboli', *Prospettiva* 31 (1982), 2–17
Brown, I.G. 1974	' "Gothicism, ignorance and a bad taste": the destruction of Arthur's O'on', *Antiquity* 48 (1974), 283–7
Brown, I.G. 1977	'Critick in Antiquity: Sir John Clerk of Penicuik', *Antiquity* 51 (1977), 201-10.
Brown, I.G. 1980a	*The Hobby-Horsical Antiquary* (Edinburgh)
Brown, I.G. 1980b	*Sir John Clerk of Penicuik (1676–1755): Aspects of a Virtuoso Life* (University of Cambridge, unpub. Ph.D. thesis)
Brown, I.G. 1987a	'Chyndonax to Galgacus: new letters of William Stukeley to Alexander Gordon', *Antiquaries J.* 67 (1987), 111–28
Brown, I.G. 1987b	'Modern Rome and ancient Caledonia: the Union and the politics of Scottish culture', in A. Hook (ed.), *The History of Scottish Literature,* vol. 2 (Aberdeen), 33–49
Brown, I.G. 1988	'The Grand Tour', in *The Story of Scotland* (Glasgow), vol. 2, part 26, 724–8
Brown, I.G. 1989	' "This Old Magazine of Antiquities": The Advocates' Library as National Museum', in P. Cadell and A. Matheson (eds), *For the Encouragement of Learning: Scotland's National Library, 1689–1989* (Edinburgh), 149–85
Brown, I.G. 1991	'David Hume's tomb: a Roman mausoleum by Robert Adam', *Proc.Soc. Antiq.Scot.* 121 (1991), 412
Brown, I.G. 1996	'On classic ground: records of the Grand Tour', *Scottish Archives* 2 (1996), 1–12

Brown, I.G. &
 Vasey, P.G. 1989
'Arthur's O'on again: newly discovered drawings by John Adair, and their context', *Proc.Soc.Antiq.Scot.* 119 (1989), 353–60

Bruce, J. 1893
History of the Parish of West or Old Kilpatrick (Glasgow; repr.1995)

Buchanan, G. 1582
Rerum Scoticarum Historia (Edinburgh)

Buchanan, J. 1858
'Notice of the barrier of Antoninus Pius,' *Archaeol. J.* 15 (1858), 25–36

Buchanan, J. 1872
'Notice of two pieces of Roman sculpture found at Arniebog, Dumbartonshire, in June 1868', *Proc.Soc.Antiq.Scot.* 9 (1872), 472–81

Buchanan, J. 1883a
'Recent discovery of a Roman inscription near Glasgow', *Trans. Glasgow Archaeol.Soc.*[1] 2 (1883), 11–28

Buchanan, J. 1883b
'Address to the Glasgow Archaeological Society, at its Annual Meeting on 2nd February, 1869', *Trans.Glasgow Archaeol.Soc.*[1] 2 (1883), 66–77

Burton, J.H. 1863
The Book-Hunter (Edinburgh/London)

Butt, J. 1996
John Anderson's Legacy (East Linton)

Camden, W. 1585
Britannia (London)

Camden, W. 1607
Britannia (London)

Campbell, J. &
 Thomson, D. 1963
Edward Lhuyd in the Scottish Highlands, 1699–1700 (Oxford)

Carman, W.Y. 1989
'Lieutenant-General Sir Adolphus Oughton, K.B.', *J. Soc. Army Historical Research* 67 (Autumn 1989), no. 271, 127–9

Cash, C.G. 1901
'The first topographical survey of Scotland', *Scott.Geog.Mag.* 17 (1901), 399–414

Cash, C.G. 1907
'Manuscript maps by Pont, the Gordons, and Adair, in the Advocates' Library, Edinburgh', *Scott.Geog.Mag.* 23 (1907), 574–92

Celli, B.B. 1984
Imagen y Huella de José Vargas (Caracas)

Charlton, D.B. &
 Mitcheson, M. 1984
'The Roman cemetery at Petty Knowes, Rochester, Northumberland', *Archaeol. Aeliana*[5] 12 (1984), 1–33

Cheesman, G.L. 1913
'The family of the Caristanii at Antioch in Pisidia', *J.Roman Stud.* 3 (1913), 253–66

Cheesman, G.L. 1914
The Auxilia of the Roman Imperial Army (Oxford)

Christison, D. *et al.* 1898
D. Christison, J.H. Cunningham, J. Anderson & T. Ross, 'Account of the excavation of the Roman station at Ardoch, Perthshire, undertaken by the Society of Antiquaries of Scotland in 1896–97', *Proc.Soc. Antiq.Scot.* 32 (1897–98), 399–476

Christison, D., Buchanan, M.
 & Anderson, J. 1903
'Excavations at Castlecary fort on the Antonine Vallum', *Proc.Soc.Antiq.Scot.* 37 (1902–03), 271–346

Clarke, J. 1933
The Roman Fort at Cadder (Glasgow)

Cleland, J. 1816
Annals of Glasgow (Glasgow)

Clerk, G. *et al.* 1860
'Notices of the Roman altars and mural inscriptions presented by the Right Hon. Sir George Clerk of Penicuik, Bart.', *Proc.Soc.Antiq.Scot.* 3 (1857–60), 37–43

Clerk, J. 1892
Memoirs of the Life of Sir John Clerk of Penicuik, ed. J.M. Gray (Edinburgh)

Close-Brooks, J. 1981
'The Bridgeness distance-slab', *Proc.Soc.Antiq.Scot.* 111 (1981), 519–21

Collingwood, R.G. 1939
An Autobiography (Oxford)

Collingwood, R.G. &
 Wright, R.P. 1965
The Roman Inscriptions of Britain, vol. 1 (Oxford)

Compostella, C. 1992
'Banchetti pubblici e banchetti privati nell'iconografia funeraria romana del I secolo d.C.', *Mélanges d'Ecole Française de Rome* 104 (1992), 658–89

Coulston, J.C. &
 Phillips, E.J. 1988
Corpus Signorum Imperii Romani (Corpus of Sculpture of the Roman World), Great Britain, vol. 2, fasc. 6, *Hadrian's Wall West of the North Tyne, and Carlisle* (London)

Coutts, J. 1909
A History of the University of Glasgow, from its Foundation in 1451 to 1909 (Glasgow)

Cummyng, J. 1831
'Letters from George Chalmers . . .', *Archaeologia Scotica* 3 (1831), 294–5

Cumont, F. 1942
Recherches sur le symbolisme funéraire des Romains (=*Bibl. Arch. et Hist.* 35, Paris)

Dalrymple, J. 1695 — *A Second Edition of Camden's Description of Scotland* (Edinburgh)

Dalrymple, J. 1705 — *Collections concerning the Scottish History . . .* (Edinburgh)

Daremberg, C. & Saglio, E. 1887 — *Dictionnaire des antiquités*, vol. 1.2 (Paris)

Davies, R.W. 1968 — 'The training grounds of the Roman cavalry', *Archaeol.J.* 125 (1968), 73–100

Davies, R.W. 1977a — 'Roman Scotland and Roman auxiliary units', *Proc.Soc.Antiq.Scot.* 108 (1976–77), 169–73

Davies, R.W. 1977b — '*Cohors I Hispanorum* and the garrisons of Maryport', *Trans. Cumb.& West. Antiq. & Archaeol. Soc.* n.s. 77 (1977), 7–16

Davies, R.W. 1977c — '*Cohors I Cugernorum*', *Chiron* 7 (1977), 385–92

Davies, R.W. 1981 — 'Some military commands from Roman Britain', *Epigraphische Studien* 12 (1981), 183–214

Deman, A. 1967 — 'A propos du Corpus des inscriptions romaines de Bretagne', *Latomus* 26 (1967), 139–50

De Maria, S. 1988 — *Gli archi onorari di Roma e dell' Italia romana* (Rome)

Denholm, J. 1797 — *An Historical Account and Topographical Description of the City of Glasgow and Suburbs* (Glasgow)

Denholm, J. 1804 — *The History of the City of Glasgow and Suburbs* (Glasgow)

Dentzer, J.-M. 1982 — *Le motif du banquet couché dans le proche-orient et le monde grec du VIIe au IVe siècle avant J.C.*, Bibl. d'Ecole Fr. d'Athènes et de Rome 246 (Rome)

Devijver, H. 1976 — *Prosopographia Militiarum Equestrium* (Louvain, 1976–87)

Devijver, H. 1986 — 'Equestrian officers from the East', in P.W. Freeman and D. Kennedy (eds), *The Defence of the Roman and Byzantine East*, BAR Int.ser. 297 (Oxford), 109–225 (= *The Equestrian Officers*, Mavors vi (Amsterdam, 1989), 273–389)

Dorcey, P.F. 1992 — *The Cult of Silvanus: a Study in Roman Folk Religion* (Leiden)

Duncan-Jones, R.P. 1982 — *The Economy of the Roman Empire* (Cambridge)

Durkan, J. 1977 — 'The early history of Glasgow University Library', *The Bibliotheck* 8 (1977), 102–26

Ellis, R. 1907 — 'Some incidents in the life of Edward Lhuyd', *Trans.Hon.Soc.of Cymmrodion* 1906–07, 1–51

Emerson, R.L. 1988 — 'Sir Robert Sibbald, Kt., the Royal Society of Scotland and the origins of the Scottish Enlightenment', *Annals of Science* 45 (1988), 41–72

Emerson, R.L. 1992 — *Professors, Patronage and Politics: The Aberdeen Universities in the Eighteenth Century* (Aberdeen)

Emerson, R.L. 1995 — 'Politics and the Glasgow professors', in Hook and Sher 1995, 21–39

Emery, F.W. 1969 — 'The best naturalist now in Europe: Edward Lhuyd, F.R.S. (1660–1709)', *Trans. Hon. Soc. of Cymmrodion* 1969, 54–69

Empire Exhibition 1938 — *Official Guide* (Glasgow)

Espérandieu, E. 1911 — *Receuil général des bas-reliefs, statues et bustes de la Gaule romaine*, vol. 4: *Lyonnaise—deuxième part* (Paris)

Espérandieu, E. 1915 — *Receuil général des bas-reliefs, statues et bustes de la Gaule romaine*, vol. 6: *Belgique—deuxième part* (Paris)

Espérandieu, E. 1918 — *Receuil général des bas-reliefs, statues et bustes de la Gaule romaine*, vol. 7: *Gaule Germanique—1. Germanie Supérieure* (Paris)

Espérandieu, E. 1931 — *Receuil général des bas-reliefs, statues et bustes de la Germanie romaine* (Paris)

Euskirchen, M. 1993 — 'Epona', *Bericht der Römisch-Germanischen Kommission* 74 (1993), 607–838

Fabretti, R. 1699 — *Inscriptionum Antiquarum quae in Aedibus Paternis Asservantur Explicatio et Additamentum* (Rome)

Fairley, R. 1988 — *Jemima: Paintings and Memoirs of a Victorian Lady* (Edinburgh)

Fears, J.R. 1981 — 'The theology of Victory at Rome: approaches and problems', in W. Haase (ed.), *Aufstieg und Niedergang der römischen Welt*, 2.17.2 (Berlin/ New York), 736–826

Ferris, I. 1994 'Insignificant others: images of barbarians on military art from Roman Britain', in S. Cottam, D. Dungworth, S. Scott, and J. Taylor (eds), *Proceedings of the Fourth Annual Theoretical Roman Archaeology Conference* (Oxford), 24–31

Florescu, F.B. 1960 *Monumentul de la Adamklissi: Tropaeum Traiani* (Bucharest)

Frenz, H.G. 1992 *Corpus Signorum Imperii Romani, Deutschland II.4: Denkmäler römischen Götterkultes aus Mainz und Umgebung* (Mainz)

Frere, S.S. 1967 *Britannia* (London)

Frere, S.S. 1977 'Roman Britain in 1976: 1. Sites explored', *Britannia* 8 (1977), 356–425

Gabelmann, H. 1972 'Die Typen der römischen Grabstelen am Rhein', *Bonner Jahrbücher* 172 (1972), 65–140

Gabelmann, H. 1973 'Römische Grabmonumente mit Reiterkampfszenen im Rheingebiet', *Bonner Jahrbücher* 173 (1973), 132–200

Gergel, R.A. 1994 'Costume as geographic indicator: barbarians and prisoners on cuirassed statue breastplates', in J.L. Sebesta and L. Bonfante (eds), *The World of Roman Costume* (Madison/London)

Gibb, A. 1900 'Quintus Lollius Urbicus, propraetor of Britain', *Northern Notes & Queries* 15 (Oct. 1900), no. 58, 78–91

Gibb, A. 1901a 'New measurement of the Vallum of Antoninus Pius', *Northern Notes and Queries* 15 (Jan. 1901), no. 59, 123–31

Gibb, A. 1901b 'New measurement of the Vallum of Antoninus Pius', *Northern Notes and Queries* 15 (Apr. 1901), no. 60, 197–210

Gibb, A. 1901c 'New measurement of the Vallum of Antoninus Pius', *Northern Notes and Queries* 16 (Jul. 1901), no. 61, 20–9

Gibb, A. 1901d 'New measurement of the Vallum of Antoninus Pius', *Northern Notes and Queries* 16 (Oct. 1901), no. 62, 53–66

Gibb, A. 1902a 'New measurement of the Vallum of Antoninus Pius', *Northern Notes and Queries* 16 (Jan. 1902), no. 63, 117–26

Gibb, A. 1902b 'New measurement of the Vallum of Antoninus Pius', *Northern Notes and Queries* 16 (Apr. 1902), no. 64, 171–82

Gibb, A. 1902c 'New measurement of the Vallum of Antoninus Pius', *Northern Notes and Queries* 17 (Jul. 1902), no. 65, 26–35

Gibb, A. 1902d 'New measurement of the Vallum of Antoninus Pius', *Northern Notes and Queries* 17 (Oct. 1902), no. 66, 72–81

Gibb, A. 1903a 'New measurement of the Vallum of Antoninus Pius', *Northern Notes and Queries* 17 (Jan. 1903), no. 67, 126–34

Gibb, A. 1903b 'New measurement of the Vallum of Antoninus Pius', *Northern Notes and Queries* 17 (Apr. 1903), no. 68, 188–97

Gibson, E. 1695 W. Camden, *Britannia*, revised by E. Gibson (London)

Gibson, E. 1722 W. Camden, *Britannia*, revised by E. Gibson (London)

Giglioli, G.Q. 1937 *Mostra augustea della romanità: catalogo* (Rome)

Glaister, J. *et al.* 1911 *Palace of History, Catalogue of Exhibits* (Glasgow, Edinburgh, London)

Glasgow Archaeological Society 1899 *The Antonine Wall Report* (Glasgow)

Gordon, A. 1726 *Itinerarium Septentrionale* (London)

Gordon, A. 1732 *Additions and Corrections, by Way of Supplement to the Itinerarium Septentrionale* (London)

Gough, R. 1775 'Observations on some *Roman* altars, found in August, 1771, near Graham's Dyke', *Archaeologia* 3 (1775), 118–24

Gough, R. 1789 W. Camden, *Britannia*, ed. by R. Gough, vol. 3 (London)

Gough, R. 1806 W. Camden, *Britannia*, ed. by R. Gough (London)

Graevius, J.G. 1707 *Jani Gruteri Corpus Inscriptionum ex Recensione et cum Annotationibus Joannis Georgii Graevii* (Amsterdam)

Green, M. 1992 *Animals in Celtic Life and Myth* (London)

Green, M. 1995 *Celtic Goddesses: Warriors, Virgins and Mothers* (London)

Gruter, J. 1602 *Inscriptiones Antiquae Totius Orbis Romanae, in Corpus Absolutissimum Redactae Ingenio et Cura Iani Gruteri, Auspiciis Iosephi Scaligeri ac Marci Velseri* (Heidelberg)

Gunther, R.T. 1945 *Life and Letters of Edward Lhuyd* (=*Early Science at Oxford*, vol. 14, Oxford)

Hamilton, G. 1933 *The House of Hamiltons* (Edinburgh)

Hamilton, W. 1831 *Descriptions of the Sheriffdoms of Lanark and Renfrew* (Glasgow)

Hamilton, Sir W. 1863 *Works of Thomas Reid, D.D.* (Edinburgh)

Hanson, W.S. & Maxwell, G.S. 1983 *Rome's North West Frontier: The Antonine Wall* (Edinburgh)

Harris, E. & J.R. 1965 *The Oriental Cults in Roman Britain* (Leiden)

Hassall, M.W.C. 1977 'Wingless Victories', in J. Munby and M. Henig (eds), *Roman Life and Art in Britain*, BAR 41 (Oxford), 327–41

Hassall, M.W.C. 1983 'The building of the Antonine Wall', *Britannia* 14 (1983), 262–4

Hassall, M.W.C. & Tomlin, R.S.O. 1977 'Roman Britain in 1976: II. Inscriptions', *Britannia* 8 (1977), 426–9

Hassall, M.W.C. & Tomlin, R.S.O. 1985 'Roman Britain in 1984: II. Inscriptions', *Britannia* 16 (1985), 317–32

Haverfield, F. 1892 'Additamenta Quarta ad Corporis Vol. VII', *Ephemeris Epigraphica* 7 (1892), 273–354

Haverfield, F. 1893 'Romano-British inscriptions 1892–1893', *Archaeol. J.* 50 (1893), 279–307

Haverfield, F. 1899a 'On an altar to Silvanus found near Barr Hill and on the Roman occupation of Scotland', in Glasgow Archaeological Society 1899, 153–68

Haverfield, F. 1899b 'The sepulchral banquet on Roman tombstones', *Archaeol. J.* 56 (1899), 326–31

Haverfield, F. 1903 'Römische Inschriften aus Britannien: neuer Statthalter', *Korrespondenzblatt der Westdeutschen Zeitschriften für Geschichte und Kunst* 22 (1903), 201–3

Haverfield, F. 1904 'Roman Britain in 1903', *The Athenaeum*, no. 3980, 6 Feb. 1904, 184–5

Haverfield, F. 1910 'Sir Robert Sibbald's "Directions for his honoured friend Mr. Llwyd how to trace and remarke the vestiges of the Roman wall betwixt Forth and Clyde" ', *Proc.Soc.Ant.Scot.* 44 (1909–10), 319–27.

Haverfield, F. 1911 'Cotton Julius F.VI. Notes on Reginald Bainbrigg of Appleby, on William Camden and on some Roman inscriptions', *Trans. Cumb & West.* n.s. 11 (1911), 343–78

Haverfield, F. 1913a 'Britannien 1912–13', *Jahrbuch des Kaiserlich Deutschen Archäologischen Instituts* 28 (1913), 281–304

Haverfield, F. 1913b 'Additamenta Quinta ad Corporis Volumen VII', *Ephemeris Epigraphica* 9 (1913), 509–690

Haverfield, F. 1914 *Roman Britain in 1913* (Oxford)

Haverfield, F. 1915 *Roman Britain in 1914* (London)

Haverfield, F. 1918 'Early Northumbrian Christianity and the altars to the "Di Veteres" ', *Archaeol. Aeliana*[3] 15 (1918), 22–43

Haynes, I.I. 1994 'The Romanisation of religion in the *auxilia* of the Roman imperial army, from Augustus to Septimius Severus', *Britannia* 25 (1994), 141–57

Henig, M. 1993 *Corpus Signorum Imperii Romani (Corpus of Sculpture of the Roman World)*, vol.1, *Great Britain*, fasc.7, *The Cotswold Region* (London)

Henig, M. 1995 *The Art of Roman Britain* (London)

Henshall, A.S. 1966 'Second report of cist burials at Parkburn sand-pit, Lasswade, Midlothian', *Proc.Soc.Antiq.Scot.* 98 (1964–66), 204–14

Hill, P.R. forthcoming 'The Maryport altars: some first thoughts', in R.J.A. Wilson (ed.), *Roman Maryport and its Setting: Essays in Memory of Michael G. Jarrett* (Kendal)

HMC 1885 *Reports on the Manuscripts of the Earl of Eglinton, . . .*, vol. 1 (London)

HMC 1893 *Report on the Manuscripts of his Grace, the Duke of Portland, KG, preserved at Welbeck Abbey*, vol. 2 (London)

HMC 1901 *Report on the MS of his Grace, the Duke of Portland, KG, preserved at Welbeck Abbey*, vol. 6 (London)

Hoare, P. 1991 'The librarians of Glasgow University over 350 years: 1641–1991', *Library Review* 40 (1991), 27–43

Hodgson, J. 1840 — *History of Northumberland*, part ii, vol. 3 (Newcastle)

Hodgson, J.C. 1918 — 'Remains of John Horsley the historian', *Archaeol. Aeliana*[3] 15 (1918), 57–79

Hodgson, N. 1995 — 'Were there two Antonine occupations of Scotland?', *Britannia* 26 (1995), 29–49

Holder, P. 1982 — *The Roman Army in Britain* (London)

Hölscher, T. 1967 — *Victoria Romana* (Mainz)

Hook, A. & Sher, R.B. (eds) 1995 — *The Glasgow Enlightenment* (East Linton)

Horne, J. (ed.) 1910 — *Kirkintilloch* (Kirkintilloch)

Horsley, J. 1732 — *Britannia Romana* (London)

Horsley, J. 1974 — *Britannia Romana*, reprint, with introduction by E. Birley (Newcastle upon Tyne)

Hübner, E. 1867 — 'Bericht über eine epigraphische Reise nach England, Schottland und Irland', *Monatsbericht der Kgl. Akademie der Wissenschaften* (Berlin 1867), 781–806.

Hübner, E. 1873 — *Corpus Inscriptionum Latinarum*, vol. vii (*Britannia*) (Berlin)

Hülsen, Ch. 1891 — 'Jahresbericht über neue Funde und Forschungen zur Topographie der Stadt Rom 1889-1890', *Röm.Mitt.* 6 (1891), 73–150

Hutchinson, V.J. 1986 — *Bacchus in Roman Britain: the Evidence for his Cult*, BAR Brit.ser. 151 (Oxford)

Ingamells, J. 1997 — *A Dictionary of British and Irish Travellers in Italy, 1701–1800, compiled from the Brinsley Ford Archive* (New Haven/London)

Ireland, R. 1983 — 'Epigraphy', in M. Henig (ed.), *Handbook of Roman Art* (London), 220-33

Irvine, C. 1682 — *Historiae Scoticae Nomenclatura Latino-Vernacula* (Edinburgh)

Irving, J. 1860 — *History of Dumbartonshire* (Dumbarton)

Isaac, B. & Roll, I. 1979 — 'Judaea in the early years of Hadrian's reign', *Latomus* 38 (1979), 54–66

Jarrett, M.G. 1966 — 'The garrison of Maryport and the Roman army in Britain', in M.G. Jarrett and B. Dobson (eds), *Britain and Rome: Essays Presented to Eric Birley* (Kendal), 27–40

Jarrett, M.G. 1976 — *Maryport, Cumbria: a Roman Fort and its Garrison* (Kendal)

Jarrett, M.G. 1994 — 'Non-legionary troops in Roman Britain: part one, the units', *Britannia* 25 (1994), 35–77

Jarrett, M.G. & Stephens, G.R. 1987 — 'The Roman garrisons of Maryport', *Trans. Cumb. & West.* n.s. 87 (1987), 61–6

Kampen, N. 1981 — 'Biographical narration and Roman funerary art', *Amer. Journ. Archaeol.* 85 (1981), 47–58

Keppie, L.J.F. 1974 — 'The building of the Antonine Wall: archaeological and epigraphic evidence', *Proc. Soc. Antiq. Scot.* 105 (1972–74), 151–65

Keppie, L.J.F. 1976a — 'Legio II Augusta and the north gate at Balmuildy', *Glasgow Archaeol. J.* 4 (1976), 99–102

Keppie, L.J.F. 1976b — 'Some rescue excavation on the line of the Antonine Wall, 1973–6', *Proc.Soc.Antiq.Scot.* 107 (1975–76), 61–80

Keppie, L.J.F. 1976c — 'Distance slabs from the Antonine Wall: some problems', *Scottish Archaeological Forum* 7 (1976), 57–65

Keppie, L.J.F. 1978 — 'A Roman altar from Kilsyth', *Glasgow Archaeol. J.* 5 (1978), 19–24

Keppie, L.J.F. 1979 — *Roman Distance Slabs from the Antonine Wall: a Brief Guide* (Glasgow)

Keppie, L.J.F. 1981 — 'Excavation of a Roman bath-house at Bothwellhaugh, 1975–76', *Glasgow Archaeol. J.* 8 (1981), 46–94

Keppie, L.J.F. 1982 — 'The Antonine Wall, 1960–1980', *Britannia* 13 (1982), 91–112

Keppie, L.J.F. 1983 — 'Roman inscriptions from Scotland: some additions and corrections to *RIB* I', *Proc.Soc.Antiq.Scot.* 113 (1983), 391–404

Keppie, L.J.F. 1985 — 'Excavations at the Roman fort of Bar Hill, 1978–82', *Glasgow Archaeol. J.* 12 (1985), 49–81

Keppie, L.J.F. 1986 — 'The garrison of the Antonine Wall: some new evidence from Bar Hill', in C. Unz (ed.), *Studien zu den Militärgrenzen Roms III* (Stuttgart), 53–7

Keppie, L.J.F. 1990 'The Romans in Southern Scotland: future discoveries', *Glasgow Archaeol. J.* 16 (1989–90), 1–27

Keppie, L.J.F. 1991 *Understanding Roman Inscriptions* (London)

Keppie, L.J.F. 1993 *The Origins and Early History of the Second Augustan Legion (The Sixth Annual Caerleon Lecture)* (Cardiff)

Keppie, L.J.F. 1994 'Roman inscriptions and sculpture from Birrens: a review', *Trans. Dumfriesshire & Galloway Nat.Hist. & Antiq.Soc.* 69 (1994), 35–51

Keppie, L.J.F. 1996 'Queen Victoria's visit', *Avenue* 19 (Jan. 1996), 12–15

Keppie, L.J.F. forthcoming 'Objects of stone', in D.J. Breeze, *The Roman Fort at Bearsden* (Edinburgh)

Keppie, L.J.F. & Arnold, B.J. 1984 *Corpus Signorum Imperii Romani (Corpus of Sculpture of the Roman World)*, vol.1, *Great Britain*, fasc. 4, *Scotland* (London)

Keppie, L., Arnold, B.J. & Ingham, J.K. 1982 'A statue of Mars from Balmuildy', *Glasgow Archaeol. J.* 9 (1982), 73–5

Keppie, L.J.F., Bailey, G.B. et al. 1995 'Some excavations on the line of the Antonine Wall, 1985–93', *Proc.Soc. Antiq.Scot.* 125 (1995), 601–71

Keppie, L.J.F. & Breeze, D.J. 1981 'Some excavations on the line of the Antonine Wall, 1957–80', *Proc.Soc. Antiq.Scot.* 111 (1981), 229–47

Keppie, L.J.F. & MacKenzie, J. 1975 'Bothwellhaugh', *Current Archaeology* 52 (Sept. 1975), 154–6

Keppie, L.J.F. & Walker, J.J. 1981 'Fortlets on the Antonine Wall at Seabegs Wood, Kinneil and Cleddans', *Britannia* 12 (1981), 143–62

Keppie, L.J.F. & Walker, J.J. 1985 'Auchendavy Roman fort and settlement', *Britannia* 16 (1985), 29–35

Kewley, J. 1973 'Inscribed capitals on Roman altars from northern Britain', *Archaeol. Aeliana*[5] 1 (1973), 129–31

Kinniburgh, I.A.G. 1968 'A note on Timothy Pont's survey of Scotland', *Scottish Studies* 12 (1968), 187–9

Kinsley, J. (ed.) 1973 *Alexander Carlyle: Anecdotes and Characters of the Times* (London)

Kleiner, D.E.E. 1992 *Roman Sculpture* (Yale)

Kleiner, F.S. 1989 'An arch of Domitian in Rome on coins of Alexandria', *Numismatic Chronicle* 149 (1989), 69–81

Knox, J. 1785 *A View of the British Empire, more especially Scotland* (London)

Koch, G. 1993 *Sarkophage der römischen Kaiserzeit* (Darmstadt)

Kollwitz, J. & Herdejürgen, H. 1979 *Die ravennatische Sarkophage* (Berlin)

Krüger, M.-L. 1967 *Corpus Signorum Imperii Romani, Österreich*, I.2, *Die Rundsculpturen des Stadtgebietes von Carnuntum* (Vienna)

Krüger, M.-L. 1970 *Corpus Signorum Imperii Romani, Österreich*, I.3, *Die Reliefs des Stadgebietes von Carnuntum: 1. Die figürlichen Reliefs* (Vienna)

Laskey, J. 1813 *A General Account of the Hunterian Museum, Glasgow* (Glasgow)

Letta, C., and D'Amato, S. 1975 *L'epigrafia della regione dei Marsi* (Milan)

Lettice, J. 1794 *A Tour through Various Parts of Scotland* (London)

Levi, A.C. 1952 *Barbarians on Roman Coins and Sculpture*, Amer.Num.Soc. Numismatic Notes and Monographs 123 (New York)

Levick, B.M. 1967 *Roman Colonies in Southern Asia Minor* (Oxford)

Levy, F.J. 1964 'The making of Camden's Britannia', *Bibliothèque d'Humanisme et Renaissance* 26 (1964), 70–97

Lhwyd, E. 1713 'Extracts of several letters from Mr. Edward Lhwyd (M.A.), later Keeper of the Ashmolean Museum, in Oxford, to Dr. Rich. Richardson (M.D.) of North Bierly in Yorkshire', *Phil.Trans.* 28 (1713), 93–101

Linduff, K. 1979 'Epona: a Celt among the Romans', *Latomus* 38 (1979), 817–37

Lluyd, E. 1700 '*An Account of some* Roman, French *and* Irish *Inscriptions and Antiquities found* in Scotland *and* Ireland *by Mr* Edw. Lluyd, *Communicated to the Publisher from Mr* John Hicks, of Trewithier in Cornwall, *by* Dr. William Musgrave, *F.C.P.& R.S.*', *Phil.Trans.* 22 (Feb.1700), 790 with pl.

Lukis, W.C. 1887

The Family Memoirs of the Rev. William Stukeley, M.D., vol. 3 (=*Surtees Soc.* 80) (Durham/London/Edinburgh)

McCaul, J. 1863

Britanno-Roman Inscriptions (Toronto/London)

McCrie, T. 1842

The Wodrow Correspondence, vol. 1 (Edinburgh)

Macdonald, G. 1911

The Roman Wall in Scotland (Glasgow)

Macdonald, G. 1921

'The building of the Antonine Wall: a fresh study of the inscriptions', *J.Roman Stud.* 11 (1921), 1–24

Macdonald, G. 1933

'John Horsley, scholar and gentleman', *Archaeol. Aeliana*⁴ 10 (1933), 1–57

Macdonald, G. 1934

The Roman Wall in Scotland (2nd edn, Oxford)

Macdonald, G. & Park, A. 1906

The Roman Forts on the Bar Hill (Glasgow)

Macdonald, J. 1895

The Roman Room of the Hunterian Museum, University of Glasgow (reprinted from *Scots Lore*) (Glasgow)

Macdonald, J. 1897

Tituli Hunteriani: an Account of the Roman Stones in the Hunterian Museum, University of Glasgow (Glasgow)

Macdonald, J. 1903

'The inscriptions on the distance slabs of the vallum or wall of Antoninus Pius', *Trans.Glasgow Archaeol. Soc.* n.s. 4 (1903), 49–64

Macdonald, J. & Barbour, J. 1897

Birrens and its Antiquities (Dumfries)

McElroy, D.D. 1969

Scotland's Age of Improvement: A Survey of Eighteenth Century Literary Clubs and Societies (Washington State University, Pullman)

Macfarlane, W. 1907

Geographical Collections, vol. 2 (= Scott.Hist.Soc. vol. 52) (Edinburgh)

Macfarlane, W. 1908

Geographical Collections, vol. 3 (= Scott.Hist.Soc. vol. 53) (Edinburgh)

Macinnes, L. 1984

'Brochs and the Roman occupation of Lowland Scotland', *Proc.Soc. Antiq. Scot.* 114 (1984), 235–49

Mackintosh, M. 1986

'The sources of the horseman and fallen enemy motif on the tombstones of the western Roman Empire', *J.Brit.Archaeol.Assoc.* 139 (1986), 1–21

Maclagan, C. 1872

'Notes on a Roman sculptured stone recently discovered at Cumbernauld, and of an inscribed stone at Stirling', *Proc.Soc.Antiq.Scot.* 9 (1872), 178–9

McUre, J. 1872

Glasghu Facies: A View of the City of Glasgow, ed. J.F.S Gordon (Glasgow)

Maffei, S. 1749

Museum Veronense, Hoc est Antiquarum Inscriptionum atque Anaglyphorum Collectio (Verona)

Magnen, R. & Thévenot, E. 1953

Epona, déesse gauloise des chevaux, protectrice des cavaliers (Bordeaux)

Maidment, J. 1834

Analecta Scotica, vol. 1 (Edinburgh)

Maidment, J. 1837

Analecta Scotica, vol. 2 (Edinburgh)

Maitland, W. 1757

History and Antiquities of Scotland (London)

Mann, J.C. 1971

'Spoken Latin in Britain as evidenced in the inscriptions', *Britannia* 2 (1971), 218–24

Mann, J.C. 1986

'The construction of the Antonine Wall', *Proc.Soc.Antiq.Scot.* 116 (1986), 191–3

Mann, J.C. 1988

'The history of the Antonine Wall: a reappraisal', *Proc.Soc.Antiq.Scot.* 118 (1988), 131–7

Mann, J.C. 1992

'Ravennas and the Antonine Wall', *Proc.Soc.Antiq.Scot.* 122 (1992), 189–95

Mattern, M. 1989

'Die reliefverzierten römischen Grabstelen der Provinz Britannia: Themen und Typen', *Kölner Jahrbücher* 22 (1989), 707–801

Mattingly, H. 1940

Coins of the Roman Empire in the British Museum, vol. 4, *Antoninus to Commodus* (London)

Mattingly, H. & Sydenham, E.A. 1926

The Roman Imperial Coinage, vol. 2 (London)

Maxwell, G.S. 1974

'The building of the Antonine Wall', in D.M. Pippidi (ed.), *Actes du IXe Congrès Internationale d'Etudes sur les Frontières Romaines* (Bucharest), 327–32

Maxwell, G.S. 1975	'Excavations at the Roman fort of Bothwellhaugh, 1967–8', *Britannia* 6 (1975), 20–35
Maxwell, G.S. 1983	'Two inscribed Roman stones and architectural fragments from Scotland', *Proc.Soc.Antiq.Scot.* 113 (1983), 379–90
Maxwell, G.S. 1985	'Fortlets and distance slabs on the Antonine Wall', *Britannia* 16 (1985), 25–8
Maxwell, G.S. 1989	*The Romans in Scotland* (Edinburgh)
Megaw, J.V.S. 1970	*Art of the European Iron Age* (Bath)
Mendyk, S.A.E. 1989	*Speculum Britanniae: Regional Study, Antiquarianism and Science in Britain to 1700* (Toronto)
Miller, A. 1864	*The Rise and Progress of Coatbridge and Surrounding Neighbourhood* (Glasgow)
Miller, S.N. 1922	*The Roman Fort at Balmuildy* (Glasgow)
Miller, S.N. 1928	*The Roman Fort at Old Kilpatrick* (Glasgow)
Mócsy, A. 1983	*Nomenclator Provinciarum Europae Latinarum et Galliae Cisalpinae* (Budapest)
Moir, D.G. & Skelton, R.A. 1968	'New light on the first atlas of Scotland', *Scott.Geog.Mag.* 84 (1968), 149–50
Mrozewicz, L. 1984	'Victoria Aug(usta) Panthea Sanctissima', *Zeitschrift für Papyrologie und Epigraphik* 57 (1984), 181–4
Mrozewicz, L. 1986	'Legio I Italica i Legio XX Valeria Victrix: zwiazki wzajemne', *Eos* 74 (1986), 303–8
Muir, J. 1950	*John Anderson, Pioneer of Technical Education and the College he Founded* (Glasgow)
Murray, D. 1913	*Robert & Andrew Foulis and the Glasgow Press* (Glasgow)
Napier, J., of Merchiston 1593	*A Plaine Discovery of the Whole Revelation of Saint John* (Edinburgh)
Neilson, G. 1901	'The Antonine Wall and its inscribed stones', in M. Maclean (ed.), *Archaeology, Education, Medical & Charitable Institutions of Glasgow* (Handbook for British Association Meeting, 1901) (Glasgow), 107–10
Nichols, J. 1790	*Bibliotheca Topographica Britannica*, vol. 3 (London)
Nichols, J. 1809	*Letters on Various Subjects, Literary, Political, and Ecclesiastical, to and from William Nicolson D.D.*, vol. 1 (London)
Nicolson, W. 1702	*The Scottish Historical Library* (London)
Nimmo, W. 1777	*A General History of Stirlingshire* (Edinburgh)
Nimmo, W. 1817	*The History of Stirlingshire* (2nd edn, Stirling)
Nimmo, W. 1880	*The History of Stirlingshire* (3rd edn, London/Glasgow)
Noelke, P. 1974	'Unveröffentliche "Totenmahlreliefs" aus der Provinz Niedergermanien', *Bonner Jahrbücher* 174 (1974), 545–60
Nouwen, R. 1997	'The vexillationes of the *cohortes Tungrorum* during the second century', in W. Groenman-van Waateringe, B.L. van Beek, W.J.H. Willems and S.L.Wynia (eds), *Roman Frontier Studies 1995* (Oxford), 461–6
Oaks, L.S. 1986	'The Goddess Epona', in M. Henig and A. King (eds), *Pagan Gods and Shrines of the Roman Empire* (Oxford), 77–84
Official Guide 1938	*Empire Exhibition, Scotland, 1938: Bellahouston Park, Glasgow, Official Guide* (Glasgow)
Orelli, J.C. 1828 and 1856	*Inscriptionum Latinarum Selectarum Amplissima Collectio*, vols 1, 2 (1828), vol. 3, ed. G. Henzen (1856)
Oswald, F. 1936–37	*Index of Figure-Types on Terra Sigillata ('Samian Ware')* (Liverpool)
Paul, Sir J.B. (ed.) 1909	*The Scots Peerage*, vol. 6 (Edinburgh)
Pennant, T. 1774a	*A Tour in Scotland MDCCLXIX* (Warrington)
Pennant, T. 1774b	*A Tour in Scotland and Voyage to the Hebrides MDCCLXXII* (Chester)
Phillips, E.J. 1974	'The Roman distance slab from Bridgeness', *Proc.Soc.Antiq.Scot.* 105 (1972–74), 176–82
Phillips, E.J. 1977	*Corpus Signorum Imperii Romani (Corpus of Sculpture of the Roman World), Great Britain*, vol. 1, fasc. 1, *Corbridge, Hadrian's Wall East of the North Tyne* (London)

Philpott, R. 1991 — *Burial Practices in Roman Britain: A Survey of Grave Treatment and Furnishing, A.D. 43–410*, BAR Brit.Ser. 219 (Oxford)

Picard, G.C. 1957 — *Les trophées romains*, Bibl. Ec.Fr.d'Athènes et de Rome 187 (Paris)

Piggott, S. 1951 — 'William Camden and the Britannia', *Proc.Brit.Acad.* 37 (1951), 199–217

Piggott, S. 1985 — *William Stukeley: an Eighteenth Century Antiquary* (London)

Piggott, S. & Robertson, M. 1977 — *3 Centuries of Scottish Archaeology* (Edinburgh)

Pococke, R. 1887 — *Tours in Scotland, 1747, 1750, 1760*, ed. D.W. Kemp, Scott.Hist. Soc.ser.1, vol.1 (Edinburgh)

Popović, V. 1989 — 'Une station de bénéficiaires à Sirmium', *Comptes Rendus de l'Académie des Inscriptions et Belles-Lettres* 1989, 116–22

RCAHMS 1956 — *Roxburghshire: An Inventory of the Ancient and Historical Monuments* (Edinburgh)

RCAHMS 1963 — *Stirlingshire, An Inventory of the Ancient Monuments* (Edinburgh)

RCAHMS 1978 — *Lanarkshire, An Inventory of the Prehistoric and Roman Monuments* (Edinburgh)

Reid, T. 1799 — 'University of Glasgow', in Sir John Sinclair (ed.), *The Statistical Account of Scotland*, vol. 21, Appendix, 1–50

Removal Committee 1877 — *Report by the Chairman of the University Removal Committee, with prefatory Notice of the earlier University Buildings* (Glasgow)

Richmond, I.A. & Steer, K.A. 1957 — 'Castellum Veluniate and civilians on a Roman frontier', *Proc. Soc. Antiq. Scot.* 90 (1956-57), 1–6

Rinaldi Tufi, S. 1983 — *Corpus Signorum Imperii Romani (Corpus of Sculpture of the Roman World)*, vol.1, *Great Britain*, fasc. 3, *Yorkshire* (London)

Rinaldi Tufi, S. 1984 — ' "Stehende Soldaten" nella Renania Romana: problemi di iconografia e di produzione artistica', *Prospettiva* 38 (1984), 16–29

Rinaldi Tufi, S. 1988 — *Militari romani sul Reno* (Rome)

Robertson, A.S. 1957 — *An Antonine Fort, Golden Hill, Duntocher* (Edinburgh/London)

Robertson, A.S. 1960 — *The Antonine Wall* (Glasgow)

Robertson, A.S. 1964 — *The Roman Fort at Castledykes* (Edinburgh)

Robertson, A.S. 1969 — 'Distance slab of the Twentieth Legion found on the Antonine Wall, at Hutcheson Hill, 1969', *Glasgow Archaeol.J.* 1 (1969), 1

Robertson, A.S. 1970 — 'A Roman altar from Old Kilpatrick', *Glasgow University Gazette* 62 (March 1970), 9

Robertson, A.S., Scott, M. & Keppie, L.J.F. 1975 — *Bar Hill: a Roman Fort and its Finds*, BAR Brit.ser. 16 (Oxford)

Robinson, D.M. 1926 — 'Roman sculptures from Colonia Caesarea (Pisidian Antioch)', *Art Bulletin* 9 (1926), 5–69

Ronke, J. 1987 — *Magistratische Repräsentation im römischen Relief*, BAR Int.ser. 370 (Oxford)

Ross, A. 1967 — *Pagan Celtic Britain* (London/New York)

Ross, T. 1898 — 'Notice of the remains of a mediaeval chapel found in the Roman station at Ardoch', *Proc.Soc.Antiq.Scot.* 32 (1897–98), 471–6

Roy, W. 1793 — *The Military Antiquities of the Romans in Britain* (London)

Salway, P. 1965 — *The Frontier People of Roman Britain* (Cambridge)

Šašel Kos, M. 1978 — 'A Latin epitaph of a Roman legionary from Corinth', *J.Roman Stud.* 68 (1978), 22–5

Scaliger, J.J. 1606 — *Thesaurus Temporum Eusebii Pamphili* (Leiden)

Schallmayer, E. & Preuss, G. 1994 — 'Die Steinfunde aus dem Heiligtum von Osterburken', in *Der römische Weihebezirk von Osterburken* II (Stuttgart), 15–73

Schleiermacher, W. 1960 — 'Zwei provinzielle Steinmetzarbeiten', *Germania* 38 (1960), 377–9

Schleiermacher, M 1984 — *Römische Reitergrabsteine: Die kaiserzeitlichen Reliefs des triumphierenden Reiters* (Bonn)

Scott, W.R. 1937 — *Adam Smith as Student and Professor* (Glasgow)

Sebesta, J.L. and Bonfante, L. 1994 — *The World of Roman Costume* (Madison/London)

Selkirk, A. 1970 — 'Inscriptions from the Antonine Wall', *Current Archaeology* 18 (Jan. 1970), 196–7

Sharp, L.W. 1937 — *Early Letters of Robert Wodrow 1698–1707*, Scott. Hist. Soc. ser. 3, vol. 24 (Edinburgh)

Sibbald, R. 1684 — *Scotia Illustrata, sive Prodromus Historiae Naturalis* (Edinburgh)

Sibbald, R. 1695 — 'The Thule of the Ancients', in Gibson 1695, 1089–1116

Sibbald, R. 1697 — *Auctarium Musaei Balfouriani e Musaeo Sibbaldiano* (Edinburgh)

Sibbald, R. 1706 — *Introductio ad Historiam* (Edinburgh)

Sibbald, R. 1707 — *Historical Inquiries* (Edinburgh)

Simpson, W.D. 1976 — *Dunnottar Castle, Historical and Descriptive, an Illustrative Guidebook* (Aberdeen)

Skinner, B. 1966 — *Scots in Italy in the Eighteenth Century* (Edinburgh)

Smith, C. 1983 — 'Vulgar Latin in Roman Britain—epigraphic evidence', in W. Haase (ed.), *Aufstieg und Niedergang der römischen Welt*, 2.29.2 (Berlin/New York), 893–948

Smith, J. 1841 — *Three Drawings of Roman Monuments, now in the Hunterian Museum, Glasgow* [by P. Fyfe] (MS in Glasgow University Library)

Speidel, M.P. 1978 — *The Religion of Iuppiter Dolichenus in the Roman Army* (Leiden)

Speidel, M.P. 1994a — *Riding for Caesar: The Roman Emperors' Horse Guards* (London)

Speidel, M.P. 1994b — *Die Denkmäler der Kaiserreiter: Equites Singulares Augusti* (Cologne/Bonn)

Speidel, M.P. 1994c — 'A guardsman as officer of irregulars', *Zeitschrift für Papyrologie und Epigraphik* 103 (1994), 215–16

Srejović, D. (ed.) 1993 — *Roman Imperial Towns and Palaces in Serbia* (Belgrade)

Steer, K.A. & Cormack, E.A. 1969 — 'A new Roman distance slab from the Antonine Wall', *Proc.Soc. Antiq.Scot.* 101 (1969), 122–6

Stemmer, K. 1978 — *Untersuchungen zur Typologie, Chronologie und Ikonographie der Panzerstatuen* (Berlin)

Stephens, G.R. & Jarrett, M.G. 1985 — 'Two altars of *cohors IV Gallorum* from Castlesteads', *Trans.Cumb. & West.* n.s. 85 (1985), 77–80

Stewart, W. (ed.) 1891 — *The University of Glasgow: Old and New* (Glasgow)

Strang, A. 1990 — *The Distance Slabs of the Antonine Wall*, MA Diss. (Nottingham)

Strang, J. 1856 — *Glasgow and its Clubs* (London/Glasgow)

Stuart, R. 1845 — *Caledonia Romana* (Edinburgh/London)

Stuart, R. 1852 — *Caledonia Romana*, ed. D. Thomson (2nd edn, Edinburgh/London)

Stukeley, W. 1720 — *An Account of a Roman Temple and other Antiquities, near Graham's Dike in Scotland* (London)

Susini, G. 1973 — *The Roman Stonecutter* (Oxford)

Szilágyi, J. 1956 — *Aquincum* (Budapest)

Taylor, M.V. 1951 — 'Roman Britain in 1950', *J.Roman Stud.* 41 (1951), 120–40

Thompson, H. 1968 — 'The zoomorphic pelta in Romano-British art', *Antiq.J.* 48 (1968), 47–58

Thönges-Stringaris, R.N. 1965 — 'Das griechische Totenmahl', *Mitteilungen des Deutschen Archäologischen Instituts, Athenische Abteilung*, 80 (1965), 1–99

Thornborrow, J.W. 1959 — 'Report on the excavations at Beacon Street, South Shields', *South Shields Archaeol. & Hist.Soc.* 1.7 (1959), 8–25

Tomlin, R.S.O. 1995 — *The Roman Inscriptions of Britain*, vol. 1, by R.G. Collingwood & R.P. Wright, revised edition with addenda

Toynbee, J.M.C. 1924 — '*Britannia* on Roman coins of the second century A.D.', *J.Roman Stud.* 14 (1924), 142–57

Toynbee, J.M.C. 1934 — *The Hadrianic School: A Chapter in the History of Greek Art* (Cambridge)

Toynbee, J.M.C. 1964 — *Art in Britain under the Romans* (Oxford)

University of Glasgow 1768 — [*Monumenta Romani Imperii*] (Glasgow)

University of Glasgow 1792 — *Monumenta Romani Imperii* (Glasgow)

University of Glasgow 1854 — *Munimenta Alme Universitatis Glasguensis*, vol. 3 (Glasgow)

University of Glasgow 1868 — *The Glasgow University Calendar* (Glasgow)

University of Glasgow 1874 — *The Glasgow University Calendar* (Glasgow)

University of Glasgow 1912 — *The Glasgow University Calendar* (Glasgow)

University of Glasgow 1913 *Glasgow University Students Handbook* (Glasgow)
University of Glasgow 1919 *Glasgow University Students Handbook* (Glasgow)
University of Glasgow 1928 *Glasgow University Students Handbook* (Glasgow)
University of Glasgow 1929 *Glasgow University Students Handbook* (Glasgow)
Vasey, P.G. 1993 'Roman distance slabs: two 17th century drawings based on fieldwork by John Adair FRS and their inter-relationship and content', *Glasgow Archaeol.J.* 18 (1993), 65–72

Von Domaszewski, A. 1895 *Die Religion des römischen Heeres* (Trier)
Wade, W.M. 1821 *The History of Glasgow, Ancient and Modern* (Glasgow)
Wagner, F. 1973 *Corpus Signorum Imperii Romani, Deutschland* I.1, *Raetia und Noricum* (Bonn)

Ware, Bishop 1901 'Bishop Nicolson's Diaries', *Archaeol. Aeliana* n.s. 1(1901), 1–51
Watkin, W.T. 1884 'Roman inscriptions discovered in Britain in 1883', *Archaeol.J.* 41 (1884), 173–88

Watkins, T. 1980 'Excavation of a settlement and souterrain at Newmill, near Bankfoot, Perthshire', *Proc.Soc.Antiq.Scot.* 110 (1978–80), 165–208
Webster, G. 1986 *The British Celts and their Gods under Rome* (London)
Welfare, H. 1984 'The southern souterrains', in R. Miket and C. Burgess (eds), *Between and Beyond the Walls: Essays in Honour of George Jobey* (Edinburgh), 305–23

Wenham, L.P. 1939 'Notes on the garrisoning of Maryport', *Trans. Cumb.& West.* n.s. 39 (1939), 19–30

Wilkes, J.J. 1969 *Dalmatia* (London)
Wilson, D. 1851 *The Archaeology and Prehistoric Annals of Scotland* (Edinburgh)
Wilson, D. 1874 'An account of Alexander Gordon, A.M., author of the Itinerarium Septentrionale, 1726', *Proc.Soc.Antiq.Scot.* 10 (1873–74), 363–82

Wilson, D.R. 1974 'Roman Britain in 1973', *Britannia* 5 (1974), 397–460
Wilton, A. and Bignamini, I. 1996 *Grand Tour: the Lure of Italy in the Eighteenth Century* (London)

Wodrow, R. 1828 *The History of the Sufferings of the Church of Scotland from the Restoration to the Revolution*, ed. R. Burns, vol. 1 (Glasgow/Edinburgh)

Wodrow, R. 1836 *The History of the Sufferings of the Church of Scotland from the Restoration to the Revolution*, ed. R. Burns, vol. 4 (Glasgow/Edinburgh)

Wodrow, R. 1843 *Analecta, or Materials for a History of Remarkable Providence* (=Maitland Club no. 60), vol. 4 (Edinburgh)

Wood, S. 1995 'From humble beginnings: inter-regimental patronage in the 31st and 37th Regiments of Foot in the eighteenth and early nineteenth centuries', *J. of the Princess of Wales's Royal Regiment* 5 (Summer 1995), 75–97

Wright, R.P. 1953 'The Roman inscriptions of Britain', in *Actes du Deuxième Congrès International d'Epigraphie Grecque et Latine 1952* (Paris), 106–11.

Wright, R.P. 1964 'An imperial inscription from the Roman fortress at Carpow, Perthshire', *Proc.Soc.Antiq.Scot.* 97 (1963–64), 202–5

Wright, R.P.& Hassall, M.W.C. 1970 'Roman Britain in 1969: II. Inscriptions', *Britannia* 1 (1970), 305–15

Wright, R.P., Hassall, M.W.C. & Tomlin, R.S.O. 1976 'Roman Britain in 1975. II. Inscriptions', *Britannia* 7 (1976), 378–92

Young, J. 1889 'Hunterian Treasures', *Glasgow University Magazine* no. 1 (5 Feb. 1889), 1–3

CONCORDANCES

(1) with *CIL* VII (=Hübner 1873)

1093 = 27
1097 = 28
1099 = 18
1103 = 30
1111 = 35
1112 = 33
1113 = 34
1114 = 36
1115 = 37
1117 = 21
1118 = 48
1119 = 49
1120 = 50
1121 = 2
1122 = 3
1125 = 22
1126 = 4
1129 = 41
1130 = 5
1132 = 6
1133 = 7
1133a = 8
1134 = 42
1135 = 11
1136 = 13
1137 = 10
1138 = 12
1139 = 19
1140 = 14
1141 = 16
1142 = 15
1143 = 1
1145 = 44
1146 = 47

(2) with *ILS* *(Inscriptiones Latinae Selectae)*

2480 = 18
2481 = 14
2482 = 1
4829 = 41
4831 = 33

4831a = 33
4831b = 34
4831c = 36

(3) with *RIB* I (=Collingwood & Wright 1965)

2146 = 27
2150 = 28
2155 = 18
2159 = 29
2166 = 30
2167 = 32
2169 = 31
2170 = 20
2171 = 19
2173 = 1
2174 = 33
2175 = 34
2176 = 35
2177 = 36
2178 = 37
2180 = 21
2181 = 48
2182 = 49
2183 = 50
2184 = 3
2185 = 2
2186 = 4
2189 = 39
2190 = 40
2191 = 22
2192 = 23
2193 = 5
2195 = 41
2196 = 6
2197 = 7
2198 = 8
2199 = 10
2200 = 11
2201 = 42
2203 = 12
2204 = 13
2205 = 14
2206 = 15

2208 = 16
2213 = 47
2214 = 44
2337* = 60

(4) with *AE* (*l'Année Epigraphique*)

1898, 152 = 32
1904, 30 = 31
1904, 31 = 20
1914, 290 = 39
1971, 225 = 9
1971, 226 = 43
1977, 526 = 25

(5) with *Britannia*

1970, 309, no. 19 = 9
1970, 310, no. 20 = 43
1976, 382, no. 15 = 24

(6) with *CSIR, Great Britain*, vol. 1, fasc. 4, *Scotland* (=Keppie & Arnold 1984)

41 = 26
42 = 24
43 = 73
76 = 54
80 = 18
84 = 17
93 = 30
97 = 55
98 = 56
99 = 57
100 = 58
102 = 20
103 = 67
104 = 68
105 = 69
106 = 70

107 = 71
108 = 48
109 = 49
110 = 50
111 = 51
112 = 52
113 = 53
114 = 21
115 = 33
119 = 59
122 = 2
123 = 3
125 = 76
126 = 77
127 = 4
129 = 60
130 = 40
131 = 61
132 = 78
133 = 62
134 = 63
135 = 23
137 = 5
139 = 64
140 = 65
141 = 79
142 = 80
143 = 75
145 = 6
146 = 7
147 = 72
148 = 8
149 = 9
150 = 11
151 = 66
152 = 12
153 = 42
154 = 13
155 = 15
156 = 16
157 = 10
158 = 1
159 = 74

GENERAL INDEX

EPIGRAPHIC INDEX

Numbers refer to entries in the Catalogue (pp. 72–130)

vexillatio leg(ionis) XX Val(eriae) Vic(tricis) 1
vex(illatio) leg(ionis) XX V(aleriae) [V(ictricis)] 7
vex(illatio) leg(ionis) XX V(aleriae) V(ictricis) 8, 9,
 10, 16
[vex(illatio) l]eg(ionis) XX V(aleriae) V(ictricis) 15

c. Auxiliary cohorts

coh(ors) I Baetasiorum C(ivium) R(omanorum) 31,
 43
[c]oh(ors) I B[aetasiorum C(ivium) R(omanorum]
 20
 curam agente
 Iulius Candidus 43
 praefectus
 Publicius Maternus 43

coh(ors) IIII Gal(lorum) 41
 praefectus
 Q. Pisentius Iustus 41

coh(ors) [I] Hamioru[m] 30
[c]oh(ors) I Ham(iorum) 32
 [m]ilites 30
 praefectus
 [C]aristan[ius] [I]ustianu[s] 32

coh(ors) I Hispanorum 47
 centurio
 Ammonius Damionis 47

coh(ors) I Tungrorum (milliaria) 18
coh(ors) [---] 24

d. Grades

1. legionary
 centurio 25, 33, 34, 35, 36, 43
 miles 48

2. auxiliary
 centurio 47
 [m]ilites 30
 praef(ectus) 32, 41, 43
 trib(unus) 39

5. GODS AND GODDESSES

Apollo 33
Britannia 41
Campestres 36, 41
Diana 33
Epona 36
Fortuna 27, 39
Genius Terrae Britannicae 34
Herc<u>les 36
Iuno R[egina?] 38
I(uppiter) O(ptimus) M(aximus) 35, 42, 43
Mars 29, 36, 40

Mars Camulus 30
Minerva 36
Silv[anus] 32
Silvanus 37
Victoria 36
Victoria Victrix 35
Virt(us) Aug(usti) 11

Dea [---] 28

6. MISCELLANEOUS

a. Measures

1. passus
m(ilia) p(assuum) 2
mil(ia) p(assuum) III 1
m(ilia) p(assuum) III p(edum) IIICCCIV 3
m(ilia) p(assuum) IIIIDCLXVIS 4, 5, 6

2. pedes
p(edum) 10
p(edum) III 7, 8, 9
p(edum) MMM CCXL 11
p(edum) IIII CXL 12
p(edum) MMMM CXLI 14
p(edum) IIII CDXI 16
[p(edum) IIII C]DXI 15
p(edum) III CCLXXI 13

b. Construction work

opus valli 11, 14

c. Life-spans

an(nis) XV
 Salamanes 49

d. Service-spans

stipendiorum XXVII
 Ammonius Damionis 47

e. Divergent spellings

dio, for deo 40
Hercl(i), for Hercul(i) 36
pep, for per 5
pref(ectus), for praef(ectus) 41

f. Notabilia varia

ob vi[rtutem et fi]dem 20
pro salute imp(eratoris) n(ostri) et sua suorum 35

PLATE I

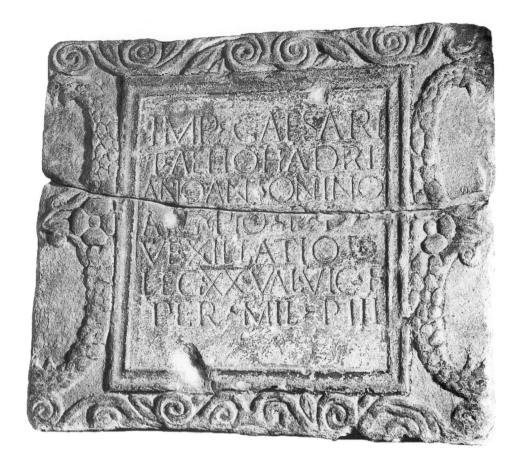

1

Scale:1:8

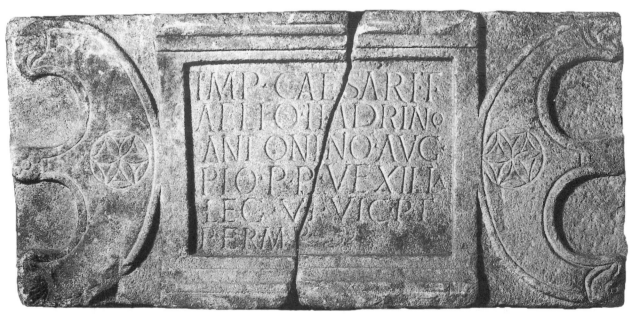

2

Scale: 1:10

No. 1. Distance slab of Twentieth Legion; No. 2. Distance slab of Sixth Legion.

PLATE II

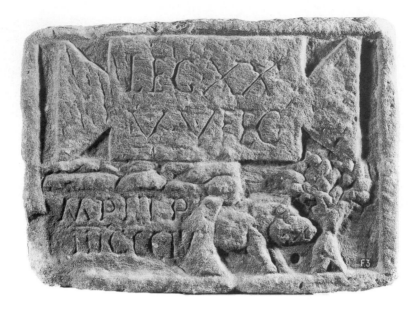

3 *Scale:1:6*

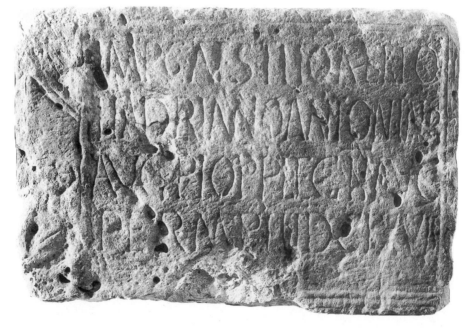

4 *Scale:1:8*

No. 3. Distance slab of Twentieth Legion; No. 4. Distance slab of Second Legion.

PLATE III

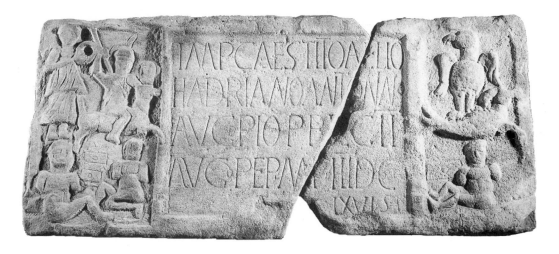

5 *Scale:1:10*

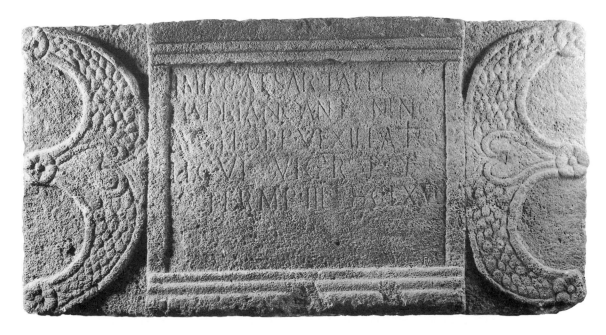

6 *Scale:1:10*

No. 5. Distance slab of Second Legion; No. 6. Distance slab of Sixth Legion.

PLATE IV

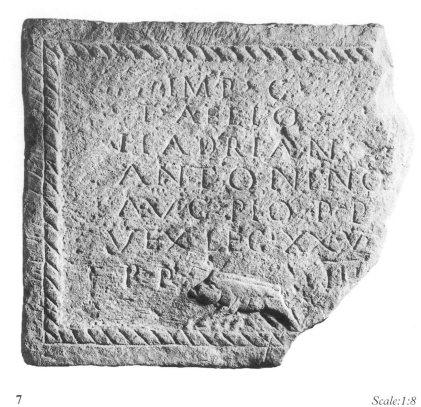

7

Scale:1:8

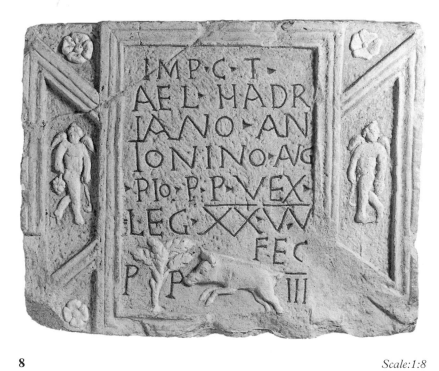

8

Scale:1:8

No. 7. Distance slab of Twentieth Legion; No. 8. Distance slab (cast) of Twentieth Legion.

PLATE V

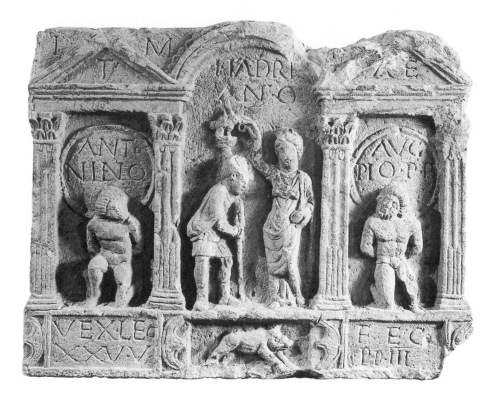

9 *Scale:1:8*

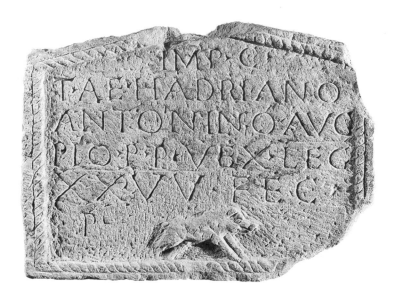

10 *Scale:1:8*

No. 9. Distance slab of Twentieth Legion; No. 10. Distance slab of Twentieth Legion.

PLATE VI

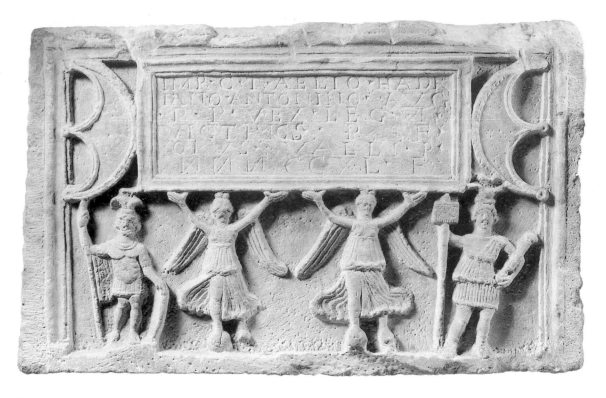

11 *Scale:1:8*

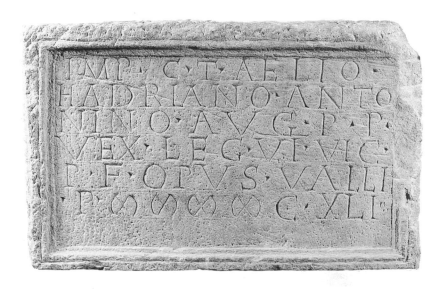

14 *Scale:1:8*

No. 11. Distance slab of Sixth Legion; No. 14. Distance slab of Sixth Legion.

PLATE VII

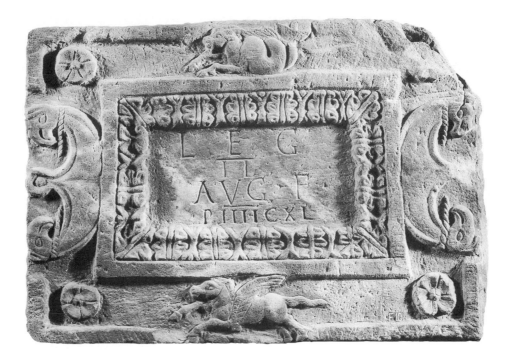

12 *Scale:1:6*

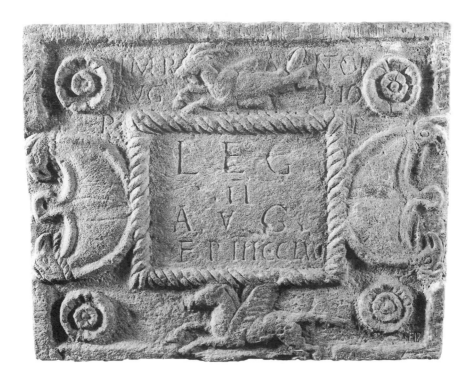

13 *Scale:1:6*

No. 12. Distance slab of Second Legion; No. 13. Distance slab of Second Legion.

PLATE VIII

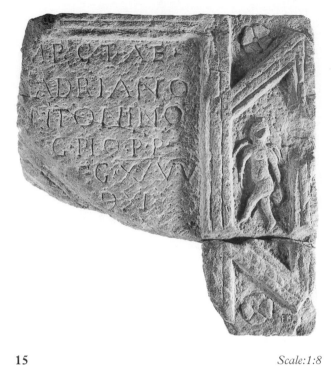

15 *Scale:1:8*

17 *Scale:1:8*

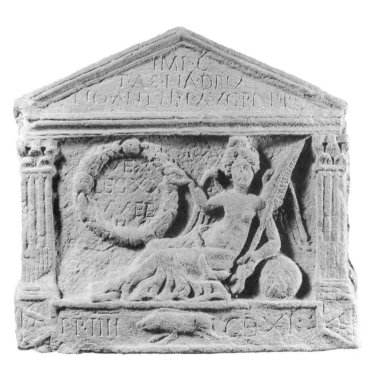

16 *Scale:1:8*

No. 15. Distance slab of Twentieth Legion; No. 16. Distance slab of Twentieth Legion; No. 17. Commemorative slab.

PLATE IX

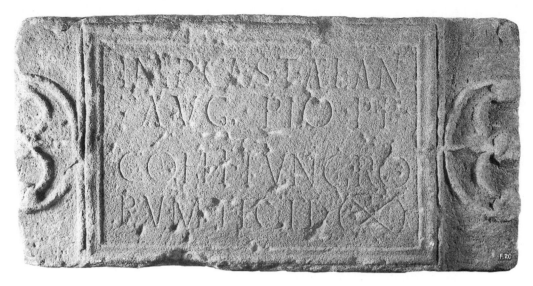

18 *Scale:1:8*

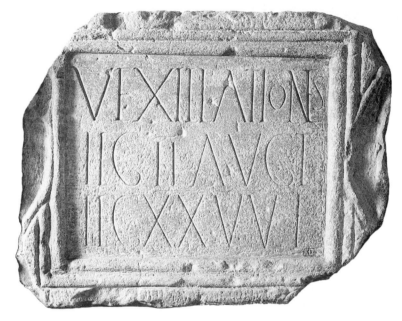

19 *Scale:1:8*

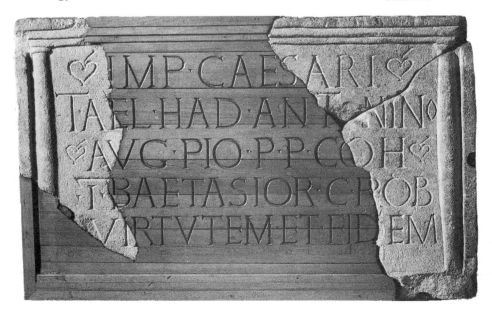

20 *Scale:1:8*

No. 18. Building-record of *cohors I Tungrorum*; No. 19. Building-record of Second and Twentieth Legions;
No. 20. Building-record of *cohors I Baetasorium*.

PLATE X

21 *Scale:1:8*

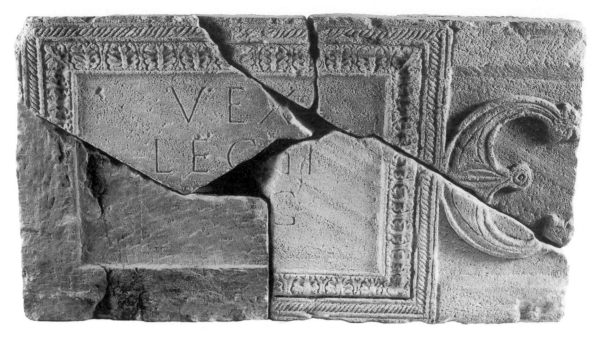

22 *Scale:1:8*

23A *Scale:1:6* **23E** *Scale:1:6*

No. 21. Building-record of Second Legion; No. 22 Building-record of Second Legion;
No. 23. (A, E). Fragments of building-record of Second Legion.

PLATE XI

25 *Scale:1:6*

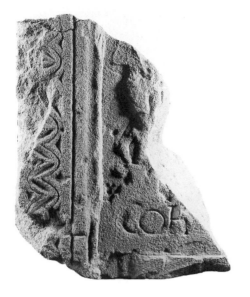

24 *Scale:1:6*

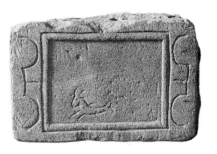

26 *Scale:1:6*

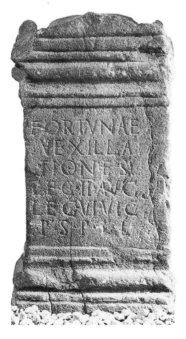

27 *Scale:1:8*

28 *Scale:1:8*

No. 24. Building-record of an auxiliary cohort; No. 25. Centurial stone of Twentieth Legion; No. 26. Building-stone of Second Legion; No. 27. Altar to Fortuna (lower mouldings of base masked by current museum display); No. 28. Altar to Goddess.

PLATE XII

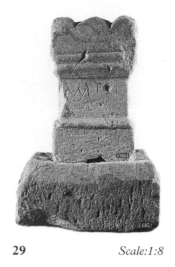

29 *Scale:1:8*

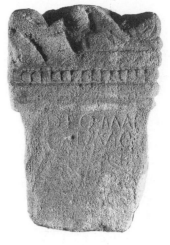

30 *Scale:1:8*

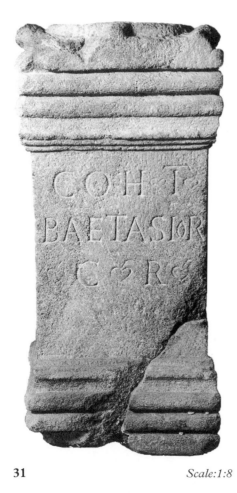

31 *Scale:1:8*

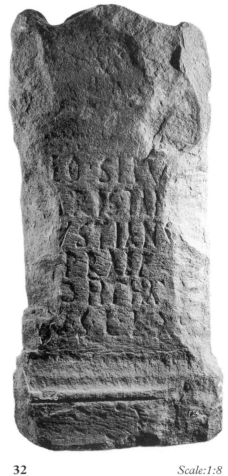

32 *Scale:1:8*

No. 29. Altar to Mars; No. 30. Altar to Mars Camulus; No. 31. Altar erected by *cohors I Baetasorium;*
No. 32. Altar to Silvanus.

PLATE XIII

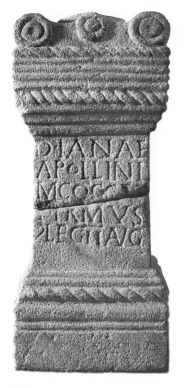

33 *Scale:1:8*

34 *Scale:1:8*

37 *Scale:1:8*

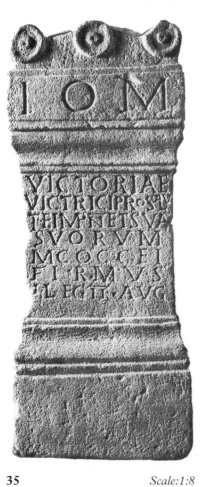

35 *Scale:1:8*

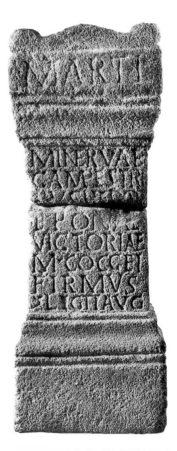

36 *Scale:1:8*

No. 33. Altar to Diana and Apollo; No. 34. Altar to Presiding Spirit of the Land of Britain;
No. 35. Altar to Jupiter and Victory; No. 36. Altar to Mars and other deities; No.37. Altar to Silvanus.

PLATE XIV

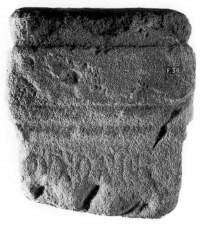

38 *Scale:1:8*

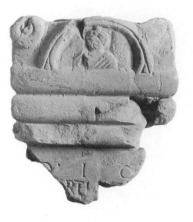

40 *Scale:1:8*

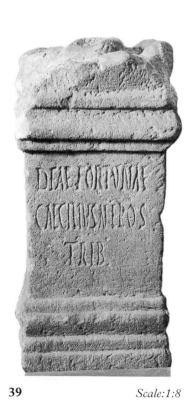

39 *Scale:1:8*

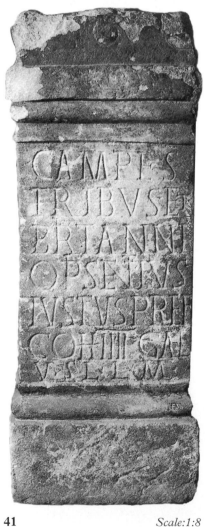

41 *Scale:1:8*

No. 38. Altar to ?Juno Regina; No. 39. Altar to Fortuna (lower mouldings of base masked by wooden support);
No. 40. Altar to Mars; No. 41. Altar to the Goddesses of the Parade-ground and to Britannia.

PLATE XV

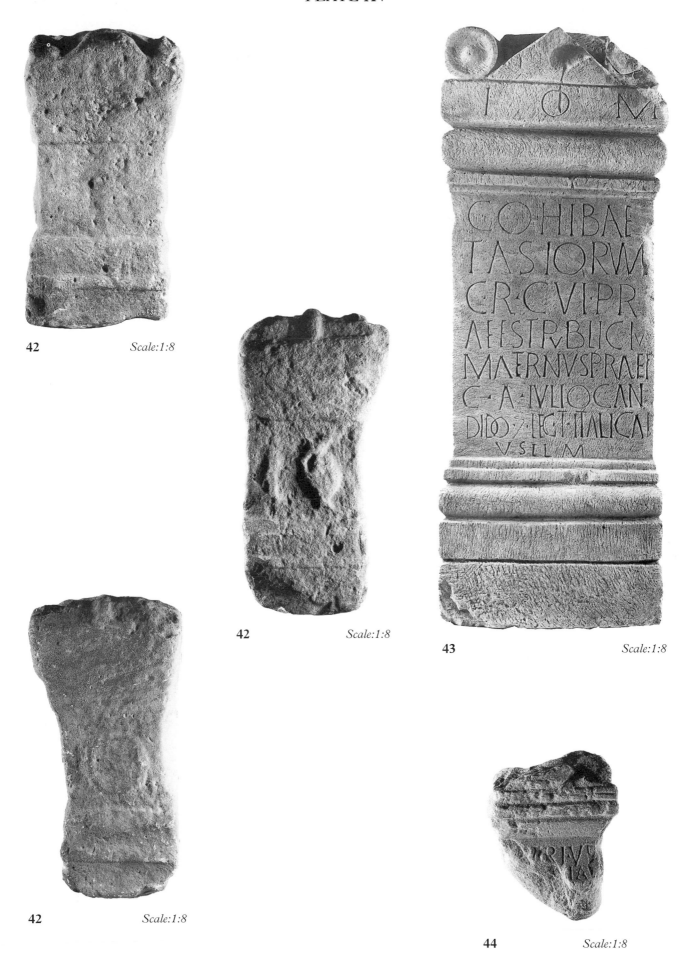

42 *Scale:1:8*

42 *Scale:1:8*

42 *Scale:1:8*

43 *Scale:1:8*

44 *Scale:1:8*

No. 42. Altar to Jupiter (front view, left-side view, right-side view); No. 43. Altar to Jupiter; No. 44. Altar.

PLATE XVI

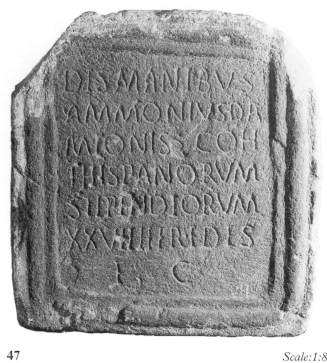

47 *Scale:1:8*

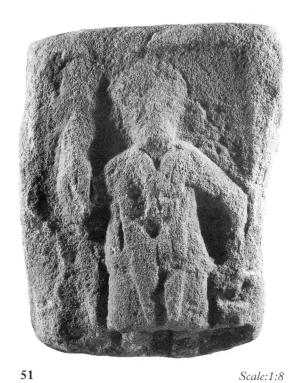

51 *Scale:1:8*

No. 47. Gravestone of Ammonius; No. 51. Graveslab of a soldier.

PLATE XVII

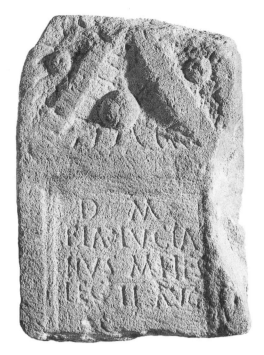

48 *Scale:1:8*

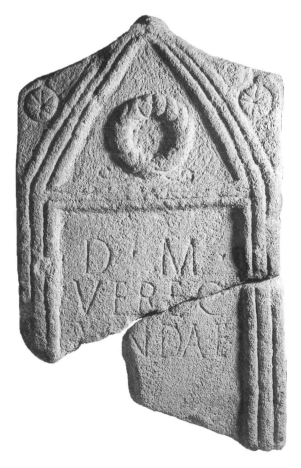

50 *Scale:1:8*

49 *Scale:1:8*

No. 48. Gravestone of Fluvius Lucianus; No. 49. Gravestone of Salamanes; No. 50. Gravestone of Verecunda.

PLATE XVIII

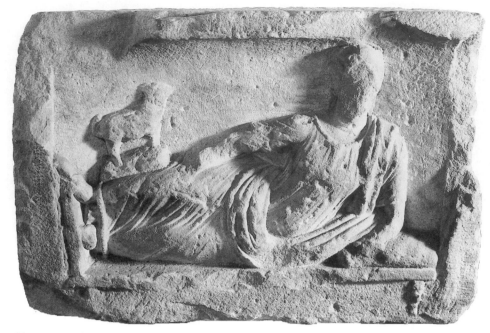

52 *Scale:1:8*

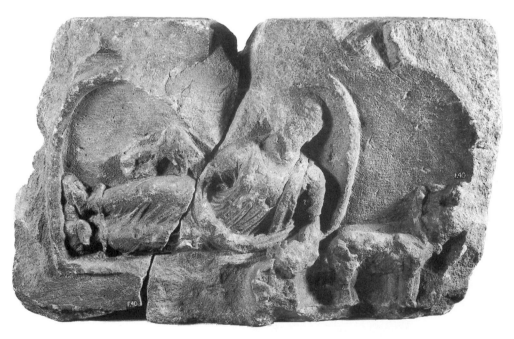

53 *Scale:1:8*

No. 52. Funerary relief showing reclining figure; No. 53. Funerary relief showing lady in a carriage.

PLATE XIX

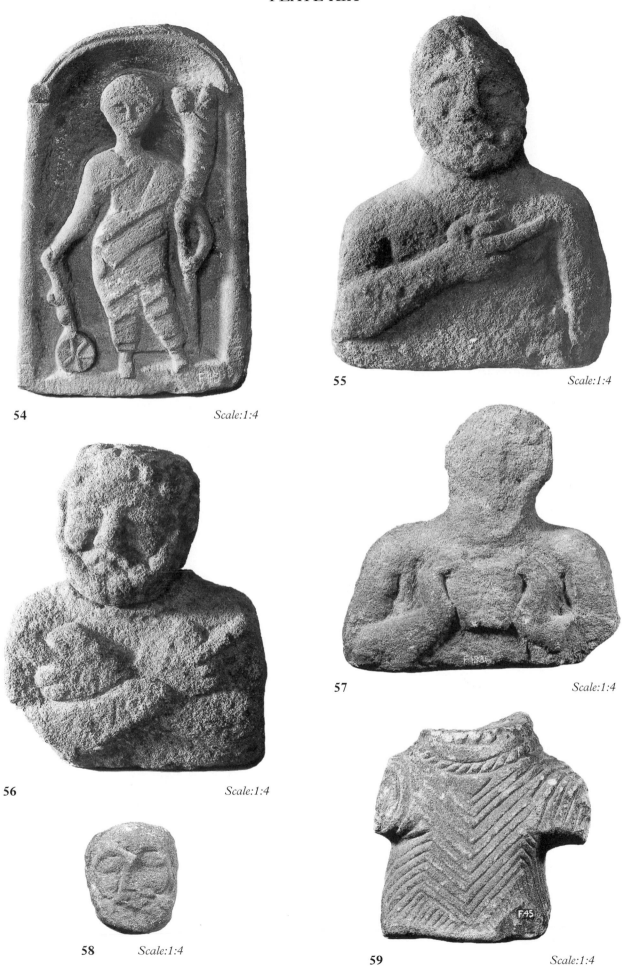

54 *Scale:1:4*

55 *Scale:1:4*

56 *Scale:1:4*

57 *Scale:1:4*

58 *Scale:1:4*

59 *Scale:1:4*

No. 54. Statuette of Fortuna; No. 55. Bust of ?Silenus; No. 56. Bust of ?Silenus; No. 57. Bust of ?Silenus;
No. 58. Bust; No. 59. Torso.

PLATE XX

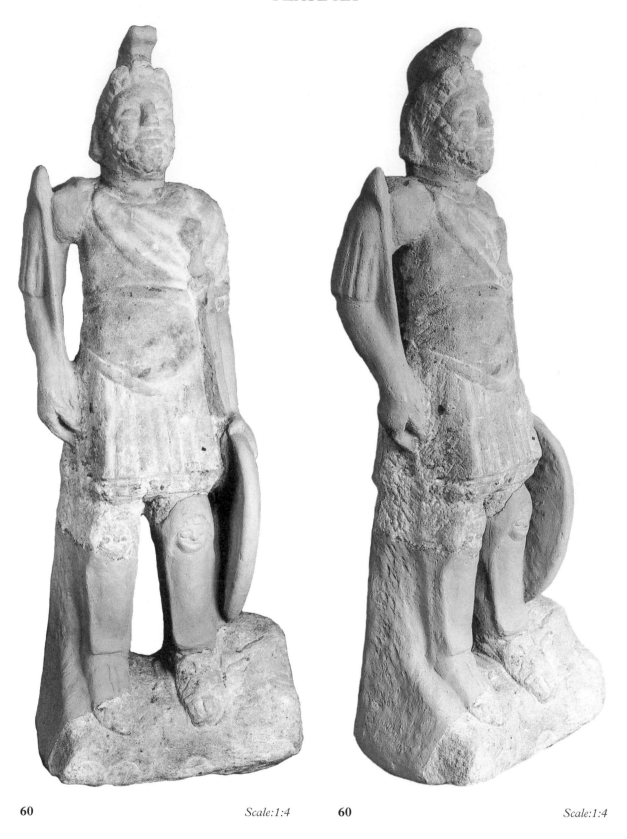

60 *Scale:1:4* **60** *Scale:1:4*

No. 60. Statue of Mars (restored) – front view and angled view.

PLATE XXI

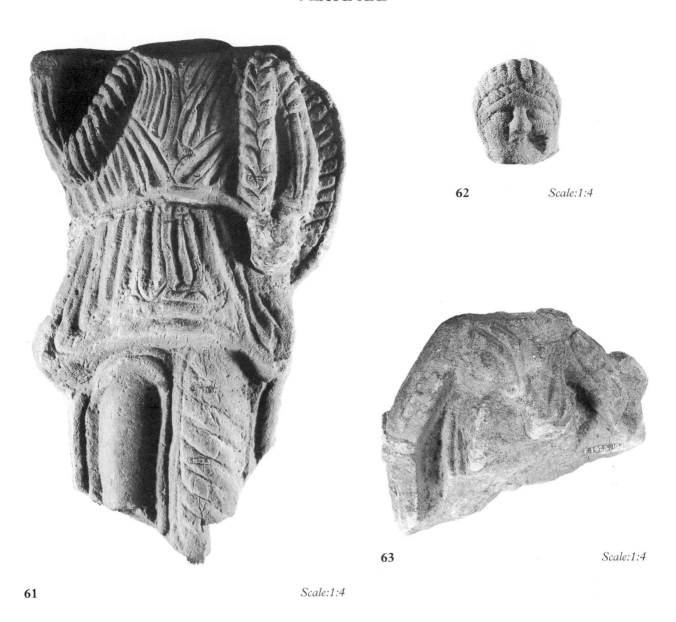

61 *Scale:1:4*

62 *Scale:1:4*

63 *Scale:1:4*

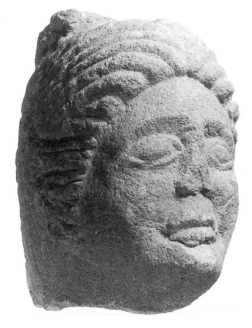

64 *Scale:1:2* **64** *Scale:1:2*

No. 61. Statue of Victory; No. 62. Head of goddess; No. 63. Torso; No. 64. Head of goddess (side view, front view).

PLATE XXII

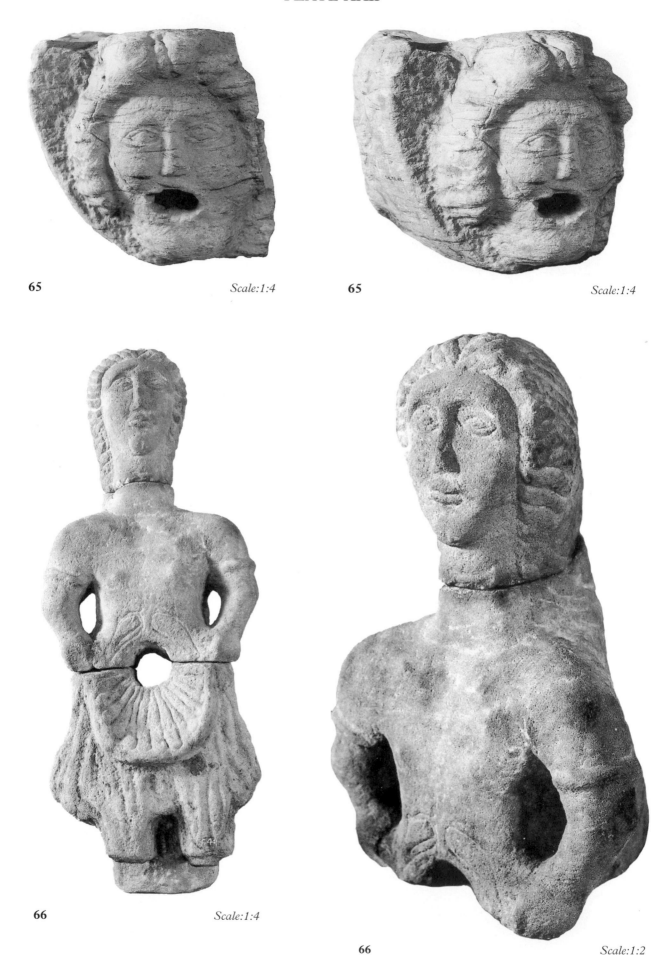

65 *Scale:1:4*

65 *Scale:1:4*

66 *Scale:1:4*

66 *Scale:1:2*

No. 65. Fountainhead (front view, angled view); No. 66. Statue of water nymph (front view, upper half of body).

PLATE XXIII

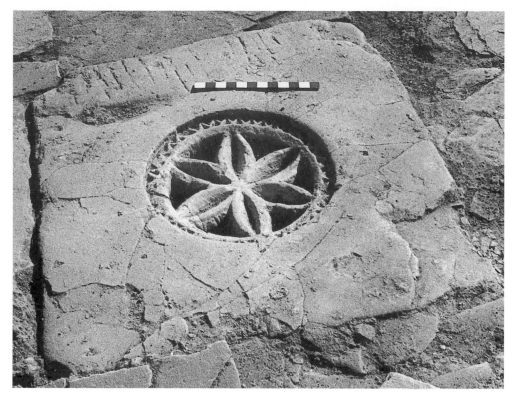

73 *Scale: c. 1:10*

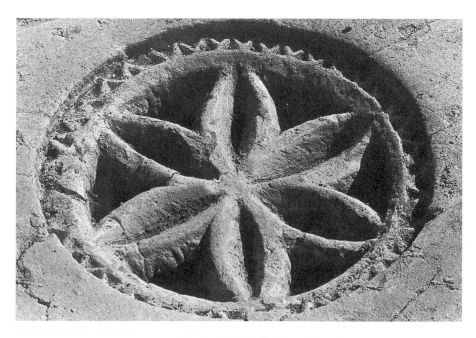

73 *Scale:1:4*

No. 73. Floral drain cover – *in situ* 1975 and detail (scale in inches).

PLATE XXIV

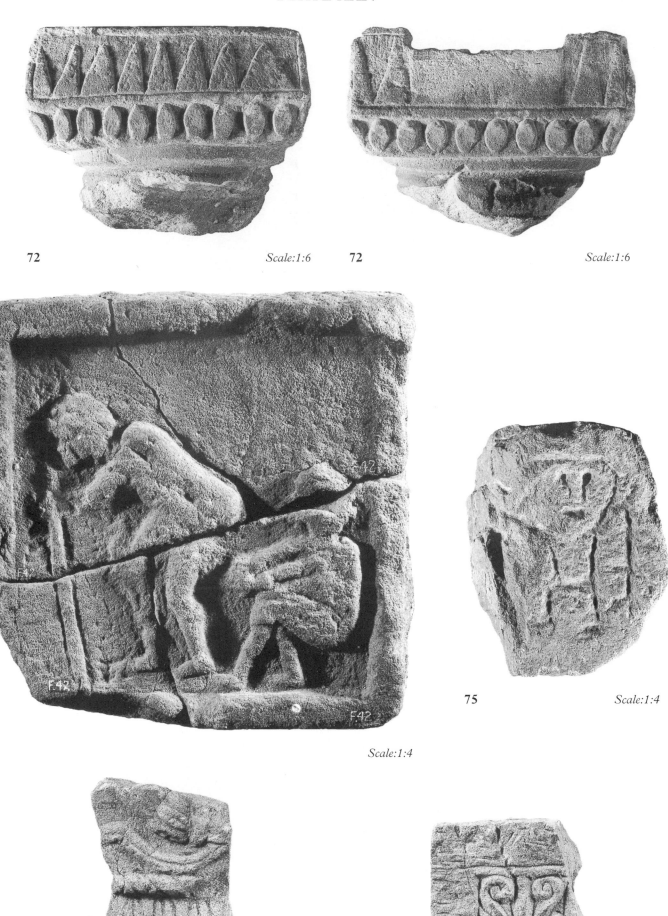

72 *Scale:1:6* 72 *Scale:1:6*

74 *Scale:1:4* 75 *Scale:1:4*

76 *Scale:1:4* 77 *Scale:1:4*

No. 72. Column capital (side view, front view); No.74. Sculptured relief; No.75. Carved building stone; No. 76. Fragment of building-record; No. 77. Fragment of ?building-record.